Folk Art in America

Cover illustration: Marimaid, by Mary Ann Willson, 1800-1820, ink and watercolor on paper, 13 x 16 inches. New York State Historical Association.

Folk Art in America

Painting and Sculpture

Edited by Jack T. Ericson

A Main Street Press Book
Published by Mayflower Books, Inc.
New York City 10022

Articles included in this volume are printed as they appeared in the following issues of *The Magazine* ANTIQUES:

Part I: What Is Primitive and What Is Not?, May, 1942; What Is American Folk Art? A Symposium, May, 1950; Artisan and Amateur in American Folk Art, March, 1951; Print to Primitive, July, 1946; Engraved Sources for American Overmantel Panels, October, 1965; Liberty and Considerable License, July, 1958; How Pictures Were Used in New England Houses, 1825-1850, November, 1974.

Part II: Benjamin Greenleaf, New England Limner, September, 1947; Isaac Sheffield, Connecticut Limner, November, 1963; The Conversation Piece in American Folk Art, November, 1968; New Light on Joseph H. Davis, "Left Hand Painter," November, 1970; J. Evans, Painter, November, 1971; Joseph Goodhue Chandler (1813-1884), Itinerant Painter of the Connecticut River Valley, November, 1972; J. A. Davis, November, 1973; Sheldon Peck, August, 1975; The Landscape of Change, Views of Rural New England, 1790-1865, April, 1976; Mary Ann Willson, November, 1976; Noah North (1809-1880), November, 1977; John S. Blunt, November, 1977.

Part III: John Haley Bellamy, The Woodcarver of Kittery Point, March, 1935; Schimmel the Woodcarver, October, 1943; Aaron Mountz, Primitive Woodcarver, June, 1960; Pierre Joseph Landry, Louisiana Woodcarver, August, 1957; Figures and Figureheads: The Maritime Collection of the State Street Bank and Trust Company, Boston, December, 1966; Cushing and White's Copper Weather Vanes, June, 1976; Winged Skull and Weeping Willow, June, 1936; Massachusetts Gravestones, June, 1975.

First Edition

Library of Congress Catalog Card Number 78-20360

ISBN 8317-3412-4

Produced by The Main Street Press
42 Main Street
Clinton, New Jersey 08809

Published by Mayflower Books, Inc.
575 Lexington Avenue
New York City 10022

Contents

III SCULPTURE

Introduction

The term "American folk art" achieved currency in the late 1920's and referred to American paintings and sculpture produced by untrained or non-academic artists. Soon, decorative and mass-produced folk-like objects were included in the meaning of the term. As the expression assumed a more general character, it became more difficult to arrive at a clearcut definition of folk art. The new scholarly disciplines of folklife research and material culture, with their European antecedents, have caused further confusion. The purpose of the introductions in this anthology is not to unravel this problem. Their focus is on the "art" of folk art, the objects created as art by untrained painters and sculptors. The terms "folk art" and "naive art" are used interchangeably. Since most of us appreciate American folk art as art, the adjective "folk" might well be replaced with "non-academic" or "naive." Decorative arts, those utilitarian objects sometimes decorated in a naive, traditional manner, and popular arts are excluded from this volume. The only exception to this is one article on manufactured weather vanes.

Folk Art in America, an anthology of articles from *The Magazine* ANTIQUES, consists of three sections, each preceded by an introduction. The first section examines some of the definitions of folk art and looks at the printed sources from which some of it is derived. The second section is concerned with paintings, especially portraiture. The introduction to this section characterizes American naive paintings as to provenance, time, content, and purpose. Grave markers, weather vanes, and wood sculpture are the subjects of the third section, the introduction to which includes a comparison between John H. Bellamy and Wilhelm Schimmel.

A bibliography is provided as a stepping-stone for further research and study. The original works of art can be seen at several outstanding institutions, including New York's Museum of American Folk Art, Williamsburg's Abby Aldrich Rockefeller Folk Art Center, The New York State Historical Association at Cooperstown, and among the collections at the Shelburne Museum and the Smithsonian Institution.

Although interest in American folk art is a twentieth-century phenomenon, the centennial celebration of 1876 was responsible for a revival of interest in early American decorative arts. This interest continued to grow through the turn of the century, by which time many fine collections of Americana had been accumulated. A large audience for folk art, however, did not develop until the 1920's. Carl W. Drepperd commented upon this growing interest in *Antiques* (May, 1942):

> In that Halcyon era after the armistice and before the crash, when Americana was rediscovered, early American prints were conspicuous in the parade of rising values. By 1928, Currier and Ives prices had reached the fantastic stage. Prints by these lithographers, which sold for a few cents when issued and for a few dollars in 1920, were selling at auction and in the shops at from several hundred to a thousand dollars. It was dangerous for collectors, some of whom held other paper, out of Wall Street, at comparably inflated prices. A few dealers and far-sighted collectors began to look for other early American pictorial expressions. Their efforts were rewarded by the rediscovery of early American pioneer, amateur art, which they called "primitive" for want of a better name.

This discovery inevitably led to specialized dealers, collectors, and exhibitions.

The first public showing of American folk art was held at the Whitney Studio Club (now the Whitney Museum of American Art) in 1924, under the direction of Juliana Force. Another exhibit, three years later, featured the collection of Isabel Carlton Wilde, a folk art dealer from Cambridge, Massachusetts. In 1930, the Harvard Society for Contemporary Art sponsored a major show of folk painting. These early events drew heavily on the collections of contemporary American artists, such as Elie Nadleman, William Zorach, Charles Sheeler, Charles Demuth, and Robert Laurent. They were the first to appreciate and collect American folk art, which they saw as the predecessor of their own work.

If the activities of the twenties sparked an interest in folk art, it was the shows of the thirties that demonstrated the presence of a movement in the art world. The Newark Museum held the spotlight in 1930 and 1931. In 1932, the focus shifted across the Hudson River to the Museum of Modern Art. Newark's first show was entitled "American Primitives: An Exhibit of the Paintings of Nineteenth Century Folk Artists" and ran from November, 1930, to February, 1931. The show's catalog was prepared by Elinor Robinson, with a foreword by Holger Cahill. In October, 1931, the Museum opened "American Folk Sculpture: The Work of Eighteenth and Nineteenth Century Craftsmen," for which Holger Cahill was largely responsible. The success of each affair enabled Cahill to organize "American Folk Art, The Art of the Common Man in America, 1750-1900," at the Museum of Modern Art. It drew national attention.

All but two of the objects displayed here were borrowed from the collection of Abby Aldrich Rockefeller (Mrs. John D., Jr.). Abby Aldrich Rockefeller was one of the first wealthy people to appreciate and collect American folk art. She was encouraged and aided in developing her acquisitions by Edith Gregor Halpert, founder of the Downtown Gallery in 1931, and by Holger Cahill, who became director of the WPA-sponsored Index of American Design in 1935. It was also in 1935 that Mrs. Rockefeller presented her collection to Colonial Williamsburg, a Rockefeller enterprise. In 1957, the family provided a suitable building for what is now known as the Abby Aldrich Rockefeller Folk Art Center. Its inventory has continued to grow over the years, augmented by such treasures as the collection of J. Stuart Halladay and Herel George Thomas of Sheffield, Massachusetts.

Electra Havemeyer's great assemblage of Americana and American folk art began as early as 1910 when she married J. Watson Webb. The combined resources of the two wealthy families enabled Mrs. Webb to build a collection unprecedented in size and scope. In 1947, the Webbs founded the Shelburne Museum, whose thirty-five buildings house the results of their efforts. During this same period, two sisters, Eleanor and Mabel Van Alstyne (Mrs. Fred Dana Marsh), were amassing a representative collection which was given to the Smithsonian Institution in 1964.

While Mrs. Webb and the Van Alstyne sisters accumulated their own collections, which eventually went to museums, Stephen C. Clark worked expressly with a museum, the New York State Historical Association in Cooperstown. Clark combined his great appreciation for American art with a Singer Sewing Machine fortune, which enabled him to acquire it. In 1949, he purchased thirteen pieces from the Elie Nadleman collection. Two years later, Mary Allis negotiated the sale of Jean and Howard Lipman's 218 piece collection to Clark. In 1958, Mary Allis's arrangements led to the transfer of Mr. and Mrs. William Gunn's 600 piece collection, of which 175 became the property of Cooperstown.

No historical sketch would be complete without mentioning the thousands of paintings accumulated by Edgar William and Bernice Chrysler Garbisch. Parts of this collection have been placed in various public museums, including the National Gallery of Art in Washington, D.C. In recent years, many objects have been dispersed through New York auction houses.

In the last decade, important collections have been formed by Mr. and Mrs. Peter Tillou, who began in 1965, and Mr. and Mrs. William E. Wiltshire III, who started in 1967. Both collections have been widely exhibited and are accompanied by catalogs. Each is noted more for its quality than its size. Even so, these may well be the last sizeable collections to be assembled. High prices and the unavailability of choice examples may force would-be collectors to explore other areas of American art.

I Folk Art in Perspective

Ever since folk art first received the attention of scholars, dealers, and collectors in the 1920's there has been disagreement about what to call the objects we now designate as folk art. Frank O. Spinney takes a humorous look at the range of adjectives in his contribution to "What is American Folk Art? A Symposium." He votes for "non-academic" until something better comes along. We see that the other eleven contributors to the symposium—scholars, curators, dealers, and collectors—failed to reach any common ground. The recent Winterthur Conference had equally inconclusive results. Perhaps we were better off twenty-eight years ago, when we did not have to contend with the emerging disciplines of folklife research and material culture.

The mid-century symposium, however, did offer some useful perspectives. John I. Baur of the Brooklyn Museum viewed American folk art as "the naive expression of a deeply felt reality by an unsophisticated American artist." Holger Cahill, the dean of American folk art exhibitions, felt our concept of folk art must broaden as new material comes into view. Carl W. Drepperd and John A. Kouwenhoven saw folk art as a product of democracy and a machine economy. The noted art historian, James Thomas Flexner, suggested it be described in three major categories: artisan painting, amateur painting, and folk painting. A second, later article by Cahill elaborates on the nature of artisan and amateur. He makes a plea for art:

> I do not believe the frequently repeated explanation that its charm comes from the fact that American folk art was made by free and hardy native Americans who were ignorant of Old World customs and conventions. This is not altogether true, in the first place, and it is usually irrelevant, in the second. American folk art is not Americana. It is art.

Jean Lipman, Nina Fletcher Little, Janet R. MacFarlane, and Louis C. Jones concur with Richardson, despite their more romantic bent.

In the face of all the possible terms enumerated by the symposium's participants, popular consensus has lit on "folk art" as the favored by-word. Whatever designation we accept, we must realize that most of those who appreciate and collect American folk art regard it as "art."

At least as important as arriving at agreeable definitions is the search for the "roots" of American folk art. Jean Lipman, Nina Fletcher Little, and Louis C. Jones provide us with three articles dealing with prints as sources or models for folk paintings. Jean Lipman compares five paintings and their printed sources, the most noted of which is "Mount Vernon in Virginia," published in London in 1800. It served as the model for numerous copies made by girls attending female seminaries. Lipman views the prints as inspirational sparks. She explains that a folk artist was neither concerned with nor technically able to imitate a print. The reproduction became a point of departure for a unique recreation. Ironically, this twice-removed painting often resulted in a work of art more fresh and original than one inspired by direct observation. Nina Fletcher Little supports Lipman's thesis in her examination of overmantel paintings and their print sources. In addition, she points out models derived from other sources, such as illustrative wallpaper.

The issue of derivative folk art or copy-work is also considered by Louis C. Jones in "Liberty and Considerable License." Jones ponders the changing iconography of our national symbols. His starting point is Edward Savage's 1796 print, "Liberty, In the form of the Goddess of Youth; giving Support to the Bald Eagle." He traces its antecedents and illustrates how in the succeeding years this pictorial theme was reinterpreted in American folk art painting. Liberty was indeed portrayed with considerable license.

The intellectual concerns of the first six selections are complemented by the practical contribution of Beatrix T. Rumford's "How Pictures Were Hung in New England Homes, 1825-1850." Although the article focuses on middle-class New England homes, the standards of decorative taste observed there were probably shared by most Americans of similar circumstance regardless of geography. Rumford uses the contents of actual portraits and genre paintings to illustrate where paintings were hung and how they were framed. One can imagine museum curators and collectors re-framing and re-arranging the pictures in their period rooms after having read her selection.

WHAT IS PRIMITIVE AND WHAT IS NOT?

By CARL W. DREPPERD

IN THAT HALCYON ERA after the armistice and before the crash, when Americana was rediscovered, early American prints were conspicuous in the parade of rising values. By 1928, Currier and Ives prices had reached the fantastic stage. Prints by these lithographers, which had sold for a few cents when issued and for a few dollars in 1920, were selling at auction and in the shops at from several hundred to a thousand dollars. It was dangerous for dealers to "hold" Currier and Ives bought at such prices. It was also dangerous for collectors, some of whom held other paper, out of Wall Street, at comparably inflated prices. A few dealers and far-sighted collectors began to look for other early American pictorial expressions. Their efforts were rewarded by the rediscovery of early American pioneer, amateur art, which they called "primitive" for want of a better name. It was not very early and surely not primitive. The only primitive American art is the art of the aborigines — producing such things as totem poles, calumets,

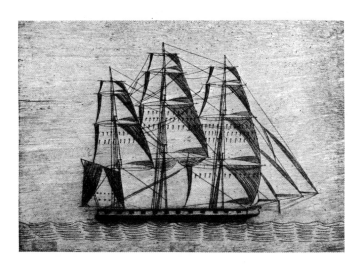

blankets, pottery, engraved gorgets, and Aztec and Mayan sculpture. But there is no question about the pioneer and amateur status of the painters who executed these pictures, especially during the first five or six decades of the nineteenth century.

Discriminating students and collectors now are defining as "primitive" only those expressions which are obviously untutored, crude, and spontaneous. Between this form of art and the work of professional artists stands a vast quantity of honest pioneer amateur effort — good, bad, and indifferent. An American primitive painting, in the sense thus defined, may have been the work of a blacksmith, farm-hand, schoolboy, or retired sea captain; the artist may have come from any level of the social scale. When evidence of schooling or tutoring is shown by the technique of form, line, color, brushwork, or other tool-use the work ceases to have primitive status.

This should not preclude certain early works of those who, later, had schooling and earned high amateur or even professional rank. According to this formula, the first works of the lad Benjamin West were American primitives. Unfortunately, even this philosophy of the American primitive is far from having wide acceptance among collectors. The term primitive has taken on the elasticity of a rubber band.

In the years 1840 to 1880, many schoolgirls painted and cut out paper dolls. Some of them were exquisitely done. Now, even these dolls, when found, are called American primitives. In spite of the fact that these dolls were fashioned under almost identically the same school conditions which obtain today, certain paper doll collectors love to romance about pioneer mothers making the playthings for their daughters by the light of a flickering fire.

Many smartly packaged luxuries were introduced as merchandise during the first half of the nineteenth century. "Empties" which survive are considered desirable antiques. The early John and Jenny Does whose budgets wouldn't stand the price of "boughten" luxuries made their own fancy boxes of wood, paper, and tin. They painted and decorated them. Today these are collected as primitives!

Perspective is lost when we go emotional over our antiques. A far more practical viewpoint is exemplified by Booth Tarkington's character, the *Plutocrat*. This realist saw, in the classic monuments of Roman civilization, exactly what they were: memorials erected in honor of victorious soldier boys, by whatever bodies functioned as the Chamber of Commerce and the Rotary Club in those early days.

American primitive and amateur art — in fact all Americana — are direct reflections of a pioneering state of mind. America was, until after the Civil War, almost wholly a pioneer-minded people. This because the pioneering state of mind is constantly alert for new and better ways of doing things. It means swift

Fig. 1 — Scrimshaw (*American, first quarter of nineteenth century*). On ivory; 7 ½ by 9 ¾ inches. *From the author's collection.*

Fig. 2 — Water Color (*1824*). By George Richardson. Inscribed: *View of the East River or Sound./With a distant view of the Seat of Josh^a. Waddington Esq^u.* 7 ½ by 6 ¼ inches. *From the American Antiquarian Society.*

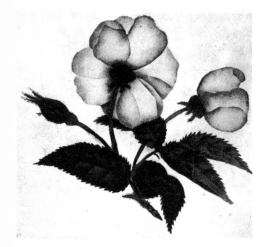

FIG. 3 — MOSS ROSE. Poonah or theorem. Signed and dated *E.P.A. September 1832.* Each petal and leaf of roses separately stencilled. Only moss added freehand. Painted on an album leaf and removed from the book for framing. 7 by 8 ½ inches. *From the author's collection.*

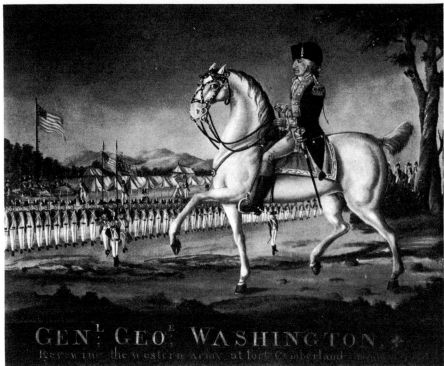

FIG. 4 — OIL PAINTING (*1794*). By Frederick Kemmelmeyer. Inscription reads *Gen¹; Geoᵉ; Washington./Reviewing the western Army at fort Cumberland sepembʳ. 19ᵗʰ 1794. From the collection of Harry MacNeil Bland.*

progress — time saving. The nation was established; settlements of the former century had jelled into cities and towns. The western border people pioneered farther westward and the rest of the country expressed the pioneering urge in personal, commercial, and industrial enterprise. They pioneered in cotton-spinning, clockmaking, pill-rolling, soda-water and ice-cream making, ballooning, and railroad building. They pioneered in every art, science, and vocation. Especially did they pioneer in education and in the attainment of social graces and accomplishments.

In the hands of its subscribers Godey's *Lady's Book*, for example, was a great pioneering effort. Godey's was a success because it mixed prim prose and precise poetry with instructions in the minor arts and domestic sciences. Godey's told how to carve up a buck or a duck, a moose or a goose. It dished out the classic, the faddish, and the practical. At a venture, Godey's inspired the creation of at least a quarter-million objects which today could masquerade as "primitive" American art.

Education in the "arts" — any one of the classic seven — was an almost desperate desire of our American ancestors. Dancing masters; music masters; thespians; painting, drawing, and writing instructors; teachers of stencil painting, sign painting, decorating, and singing; roamed the land dispensing culture, with the assurance of patronage wherever they stopped to assemble a "class." They visited towns and villages, staying a month or a season, then packed their kits and moneybags and pushed on to the next place. Big towns and cities gave continuous "encouragement" to all teachers of art.

Certainly it is no wonder that America could muster thousands of pioneer-minded and amateur artists in any year between 1800 and 1850. Artistic ability had both economic and social significance. If you could not get to be a great portrait painter, you could earn a very good competence painting "likenesses," banners, or scenes on fire engines. You could earn as much as a master tinsmith if you were a painter of curlicues on finished tinware. You could draw as much pay as a master coachmaker if you could paint and decorate a coach. You could do quite well as a sign painter. After 1830, if you failed at all else in art, you could work as a print colorist and earn perhaps a dollar a day — considered "good money" a century ago.

For statistical proof of what this pioneering state of mind ac-

complished, the United States Census of 1850, the first which reports employment by trades, professions, and occupations, lists 2,093 artists, 189 draftsmen, 202 japanners, 54 glass stainers, 8 map makers, 4 stencilers, 226 calico printers, 12 enamelers, 2,208 engravers, and 598 paper stainers. This census also reveals figures which indicate that approximately 1,500 persons were employed as coach painters and 1,500 as tinware painters. Sign, scene, and dial painters were not listed. While this census of 1850 is "official" it is far from correct. A close scanning of city business directories for 1850 shows the number of men employed in the "arts" to be far in excess of the government's figures.

The year 1830 showed a greater percentage of "likeness-limners" per 1,000 of population than did the year 1850. On the other hand, 1850 showed a new profession, "daguerreotypy" quite unknown in 1830. It is a matter of record that many second- and third-rate likeness "painters" became daguerreotypists, ambrotypists, and photographers. In spite of all this, 1850 shows three times as many stores and shops selling artists' material per 1,000 of population as 1830! Thousands of men and women, boys and girls, were painting. There were six stores in Boston in 1850, selling art materials to pioneer and amateur artists.

Artists' material stores were among the earliest American newspaper advertisers in the nineteenth century. At times trade in these essentials was established in stationery, book, and apothecaries' shops. Enough cases have been noted to establish this national pattern: after an instructor in painting and drawing had assembled a "class" in a community, either an art materials store was established or art materials were offered for sale by a shop or shops in that place. Paper, parchment, canvas, frames, brushes, oils, varnishes, and colors were offered by these stores. Instruction books and manuals, sketching books and other literature of the arts were, in most cases, also stocked.

Where no instructors were available, those with an urge to paint, whether gentlemen or apprentices, often depended wholly upon instruction books for their art education. Scores of America's now famous early portrait and genre painters were admittedly self-taught. They began their careers with few tools and a book or

two. They became amateurs by practice which led them into professional status and to mastery of their craft. Mantle Fielding's *Dictionary of American Artists* lists many of note or merit who were self-taught, began as sign or coach painters, or were scene painters or decorators.

The vast company of pioneer amateurs is the source from which come most of what we call primitive art today. Education in the arts and sciences gave people expanded egos. Those who took art instruction in 1790, 1810, 1850, or any of the years between, had as great a thrill starting their first canvas as have had budding artists in every other age. Pride, satisfaction, local fame, social progress, and more money — what greater spurs does one need? Portraits, landscapes, genre subjects, flowers, fruits, game, fish, the judge on his horse, the potter at his kiln, the culprit

meticulous attention to non-essential details, the chances are it is American pioneer or amateur art. And when you find a flint arrow point, that's American primitive art. Impartial justice might eradicate the term "art" entirely. That would be to end its story before the telling really began. It may be that the present-day vogue for the cruder efforts at artistic expression coming from our national past will be considered a silly vagary ten or twenty years hence. Or these very crudities may be the sole and only objects retaining title to the term "primitive." At any rate, more and more Americans are interested in pictures painted on bed ticking, on homespun bagging, on awning canvas, wood panels, cardboard, paper, and artists' canvas; in wood carvings done in cobblers' shops, barnyards, and stables; in anything and everything painted or fabricated in the cradle days of American culture, when the esthete in the pioneer expressed itself with crudity and virility, with vigor, and with vim. There is a story here waiting to be told. Further research in art education and amateur art production in every American village and town is necessary before we know just how much pioneer art our ancestors produced.

FIG. 5 — OVERMANTEL PANEL (*last half of eighteenth century*). Artist unknown. Scene at Lititz, Pennsylvania. *From the collection of Harry Stone.*

FIG. 6 — PORTRAIT (*early nineteenth century*). Oil on canvas, artist unknown. Found in Boston. 28 by 24 inches. *From the collection of Harry Stone.*

on the gallows — these were painted, limned, sketched, and crayoned. Of the thousands who began instruction by teacher or book or both, a few achieved fame and many found jobs. Many of the rest just kept on painting, either for the fun of it or the hell of it.

Whittlers whittled more purposeful subjects. Potters who had studied art applied art to pottery. Better designing went into homely crafts. Some art-minded workman conceived the idea of making painted plaster casts in imitation of china and parian ornaments. Amateur artists began using their knowledge and talents in everything from signboards to altar pieces. Now it is primitive American art!

In advocating a change of the name primitive to "pioneer," I am quite sure the majority of collectors and critics will retain use of the former. The term primitive has had enough publicity to anchor it as a familiar, understandable word. Due to usage of this term in the sophisticated marts of classic art, the word has certain connotations of merit, value, and prestige, which cannot be denied. When we say American primitive we establish relationship with Italian, Dutch, and Flemish primitives. And, it must be admitted, there is some similarity. There is some relationship between the work of a Flemish goldsmith turned painter and the work of an American carpenter who took time out to paint his neighbor's house and barn during the big snow of 1849, and thereafter his neighbor's portrait. Primitive bespeaks more money value than "amateur" or "pioneer." The word with the greatest commercial significance will almost always win.

When you find something crudely lovely, something that looks like an oil painting of a boy's drawing, something quaintly pretty, a portrait that shows talent or charm, much naïveté, and a too

WHAT IS AMERICAN FOLK ART?

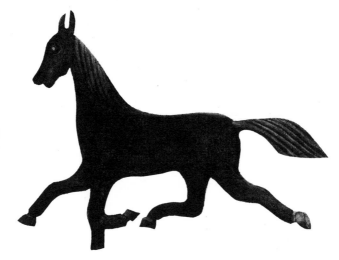

WEATHERVANE, carved wood painted red and black *(c. 1864).*

A Symposium

INTEREST is steadily growing in the paintings, carvings, and other decorative objects that go by the name of American folk art, yet there is still much disagreement as to just what our folk art is. What does it comprise, how and why did it come into being, what are its merits, and what is its significance today? Is it, indeed, truly folk art?

In the hope of clarifying this fascinating but confusing matter ANTIQUES has invited thirteen authorities, who represent almost as many different points of view, to formulate their answers to the question, *What is American folk art?* Here they are, as stimulating as we had expected.

The illustrations were selected for this purpose from the Index of American Design, National Gallery of Art, by its curator, Erwin O. Christensen, who comments on some of them in his own contribution to this symposium.

—THE EDITOR

AMERICAN FOLK ART MIGHT BE DEFINED, I think, as the naïve expression of a deeply felt reality by the unsophisticated American artist. By "naïve expresson" I mean that the pictorial or sculptural forms which the artist uses are uninfluenced or little influenced by traditional styles. By "a deeply felt reality" I would imply that our folk art is primarily realistic in intent but that it is inspired by an emotional rather than a visual realism—that it seeks the essence of a subject as the artist understands it rather than the outward form. Finally, I have used the word "unsophisticated" instead of "untrained" or "unskilled" because much of the art which we generally accept as belonging to the folk tradition is the work of highly skilled men trained in various crafts; only a part is from the hand of artists with no technical background. Both types of artists are alike, however, in that they are unaware of the sophisticated style of their day or, if influenced by it, tend to misunderstand its esthetic and transform it into something quite different.

While it has had its local schools, much of our folk art has come from isolated individuals who have evolved their own forms of expression with relative independence. Considering this, it is strange that, throughout our history, art of this kind has fallen into two rather well-defined categories, each more consistently homogeneous in style than the products of the sophisticated movements. Our largest body of folk art is in a decorative and relatively static vein, placid and idyllic in feeling and inspired by the fond contemplation of familiar things. Personal variations, though apparent, tend to be submerged in those flat and rhythmical designs which are, I suspect, an innate part of our western vision. In contrast, a smaller body of our folk art is dynamic and romantic in character and often makes use of typically expressionist distortions. It appears to be inspired by subjects which have a powerful emotional significance for the artist, too strong to be contained within the gentler patterns of the first kind.

What determines the extraordinary consistency of character in these two major strains of American folk art I do not know. The result is clear, however: in a rapidly changing world our folk art has remained essentially unaltered; its quality has rarely sunk below or risen above a certain middle range of expressive power; it seldom disappoints us, but it seldom surprises us either.

—JOHN I. BAUR
Curator of Paintings and Sculpture, Brooklyn Museum

FOLK OR POPULAR ART, using the term "popular" as the French use it in the phrase *art populaire,* is probably the oldest and certainly the most pervasive art expression we know about. Archaeologists and ethnologists have found it widespread from classical Greece and Italy and the ancient East to contemporary cultures, both primitive and civilized. In the

United States, folk art is one of the springs at the headwaters of our tradition and it has persisted to our day with a period of high production and survival in the nineteenth century. The importance of folk art as history was first recognized by archaeologists and historians. The appreciation of its quality as art is one of the by-products of the modern movement in Germany, France, Scandinavia, Mexico, and the United States and some other countries.

Folk art has usually been considered a provincial, largely rural, expression. This is not so, except as one may find large areas of provincialism in the world's greatest cities. There was folk art in ancient Athens and Rome and there is folk art in New York and Paris today. It has usually been considered *retardataire,* reflecting the style of a past generation, even of past epochs. This is true in the main (and is it not also true of most academic art?), but what is forgotten is that ends may be beginnings. Folk art has also contributed to advanced styles as it did in the transition from late classical to early Christian art, and as it is doing today in the transition from post-Renaissance academicism to modern art. The most obvious influence of folk art has been that upon archaizing artists, usually deplored by critics. A more subtle influence, and one seldom commented upon, is that upon abstract artists, symbolic expressionists, and calligraphic "writing" painters.

So far as a definition of folk art is concerned it is my belief that the material will define itself if one will allow it to do so. My own definitions have been published in *American Primitives,* and *American Folk Sculpture,* Newark Museum; *American Folk Art,* Museum of Modern Art; and *Parnassus,* March 1932. These definitions were based on objects in exhibitions at the museums mentioned and at Colonial Williamsburg, and on other material which I had studied, including the drawings for the Index of American Design.

Up to the second half of the nineteenth century the bulk of American folk art, as it has survived, was an overflow from the work of artisans and craftsmen, with a smaller proportion of work from amateurs, part-time artists, accidental artists, and children. Most of this material is anonymous and has little to do with the fashionable art of its period, with art schools or art movements. It was not produced for a small cultured class of art patrons but for the generality of the people in response to various needs, practical or spiritual. The change from a handicraft system

FIGUREHEAD of Skolfield, Maine *(1883).*

of production in the nineteenth century altered the character of folk art considerably but scarcely decreased its flow. Since then the amount of folk art which is related to the shop practice of artisans and craftsmen has sharply declined (though there are interesting survivals in various fields). The proportion coming from amateurs, and anonymous popular artists whose work leaps at us from fences, walls, hoardings, signs, and city pavements, has increased. It is the last category which has had the most interesting influence in contemporary art.

One difficulty in defining folk art is that there is so little agreement about terminology. In theory it ought to be simple to agree on a nomenclature, a set of verbal symbols as certain sciences do, but in practice it has proved far from simple. Another is that our conceptions of folk art, certainly of its range, must broaden as new material comes into view. The definitions which I set down in the Newark Museum and Museum of Modern Art catalogues need broadening to take in these bodies of new material which, so far, have not been gathered into exhibitions or collections, except in collections of photographs.

—HOLGER CAHILL

Writer, formerly National Director of the Federal Art Project, which included the Index of American Design

A COMPREHENSIVE EXAMINATION of American folk art might reveal that the subject goes beyond the limitations of any subdivision of the material. Judging from wood carving our folk art is simple and primitive; it is spiritually related to early art, and it has an ornamental quality besides. It seeks the line that repeats and the detail that can be developed into a pattern. We see this in the wooden weathervane horse, where the effective repetition of the grooves in mane and tail adds interest through a contrast of textures. The silhouette shows the freedom of the untrained artist who is untroubled by his lack of skill and there is even a suggestion of humor, perhaps unconscious in the round button eye and the ears that stick straight up.

The block-like figures of the *Whipping Post* group are only a step removed from carpentry. Like most adults who are artistically untrained, the carver falls back on infantile forms when attempting the human figure. Though it is put together with more than a child's competence, this toy-like construction shows a partial regression to childhood. Folk art is here close to child art; one might say that folk art is child art on an adult level.

The figurehead of Samuel Skolfield, a shipowner, wearing frock coat and holding a roll of ship's plans in his hand, shows a kind of simplification often present in folk carving. His broad chest, his cylindrical neck, his bulging chin, and rounded head, which make him seem so massive, no doubt looked right when the figure was set in place under the ship's bow. The head of a carrousel horse may not be after any particular illustration, but it calls to mind the sculptured decorations of the Parthenon. It was found, with its color worn to the wood, on a vacant lot in Kansas City where it had been abandoned by the Parker Carnival Supply Company.

The folk sculptor turns the facts of nature into patterns. We should not be disturbed by the way he makes wrinkles or underestimates the size of features. The carver achieves a general resemblance, attractive design compensating for the lack in anatomical correctness.

Folk carving is close to the child level; it occasionally reverts to earlier styles, and accepts only as much representation as it can utilize for its own purpose.

—ERWIN O. CHRISTENSEN
Curator, Index of American Design

"WHAT IS AMERICAN FOLK ART?" is perhaps best answered by "a misnomer." Folk art, at first unorganized, finally became an organized effort on the part of the "have-nots" to convert luxuries into staples, for and by themselves. In almost every field except that of spontaneous expression, such as music and graphic attempts, folk art was a crude imitation of the luxuries enjoyed by the upper classes.

The eternal attempt to convert luxuries into staples rests upon a basic desire to acquire position and possessions. This desire, plus freedom to do, opportunity, and desire for religious and political liberty, caused thousands of Europeans to come to colonial America. Here, almost at once, they made an organized effort to produce things within the category of converting luxuries into staples. The success of this Republic is based on the mass production of things.

Colonial America and the Federal Republic practically eliminated the necessity for folk art by making the desired things available in the shops of artisans and craftsmen. Strictly speaking, the makeshift, homemade candle and candlestick were the chief folk-art products of the Colonies. Only the very indigent, or those squarely on frontiers as pioneers, were forced to produce their own furniture necessities.

Pennsylvania stove plates are not folk art. They are mass-produced plates made in the Norse and Dutch pattern for the Germanic immigrant market. The early pottery was not folk art, but was produced as cheaply as possible by potters working in the tradition of Staffordshire, the Netherlands, Flanders, and France. The so-called tulipwares of Pennsylvania are in imitation of English "blue dash" chargers, or of Staffordshire or Swiss redwares. Chalkware is not folk art

PENNSYLVANIA GERMAN PLATE, sgraffito decoration (c. 1790).

but mass-produced plaster ornaments made in shops and even in factories, and peddled at five-and-ten-cent store prices.

The folk art of America is essentially the beginning of mass production, whether represented in the castings made from bog iron in Massachusetts Bay or in the painted, all-wood chairs produced in scores of factories from 1820 to 1880. Slat-back and ladder-back chairs were mass produced by the parts assembly method.

We might give what we call folk art a more appropriate name if we called it minor art for the people. The only "folk tradition" immigrants to the Colonies were Palatinate refugees who, if they were worth their salt, soon escaped from the folk tradition and became solid citizens.

A great deal of what we are prone to call folk art in America is the remains of the goods and chattels brought by immigrants from 1820 to 1850. Since 1920 tremendous quantities

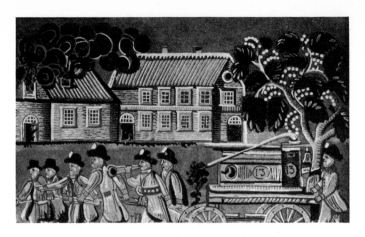

BANDBOX DESIGN, block printed (first half of 1800's).

of what is called folk art have been imported from the Netherlands, Flanders, the upper Rhine states of Germany, and Switzerland. To call this folk and minor art of Europe American is utterly fatuous.

—CARL W. DREPPERD
Author of American Pioneer Arts and Artists,
Pioneer America, *and other books*

I BELIEVE that the tendency to regard as a single cultural unit the objects commonly called American folk or primitive paintings is historically inaccurate and esthetically misleading. In an article published in the April 1942 issue of ANTIQUES I argued that we should recognize three major categories:

1. *Artisan Painting:* Pictures made by workmen who were just as much professionals as members of a national academy, but who served simpler people, had less formal training, and were in their conscious minds primarily concerned with use rather than beauty.

2. *Amateur Painting:* Pictures created by non-professionals for personal pleasure, to earn a good mark at school, or to secure the admiration of their neighbor; but not primarily for sale. That artisans and amateurs were subject to different social, economic, and esthetic pressures is self-evident. Artisan as well as fine arts painters taught the amateurs, creating border-line cases, but as a general proposition the work of the amateur artists reflects in a recognizable manner (which there is not room to describe here) the special conditions under which the objects were produced.

3. *Folk Painting:* Art that is passed down practically without change from generation to generation by simple people who live in a static society that can be expressed by traditional symbols. Folk painting was brought to this country by immigrant groups, notably the Pennsylvania Dutch, and practiced by them as long as they kept intact the cultural conceptions they had carried with them from abroad. Unsuited to a rapidly evolving bourgeois society, folk painting tended to wither at contact with American life.

The contention that there is indigenous American folk painting comparable to the long-lived European folk painting depends on an assumption which is being made increasingly untenable by advancing scholarship. Once it was generally believed that our simple artists, uninfluenced by the dominant fine arts conceptions of their periods, worked in an independent manner that was a unique product of the American soil. However, writers who are determined to

adhere to this premise now find themselves reduced to the lame expedient of arguing that when a primitive painter copied the work of an academic painter, he transmuted it into something altogether different. Every day it is becoming more clear that most landscape and genre scenes by amateur

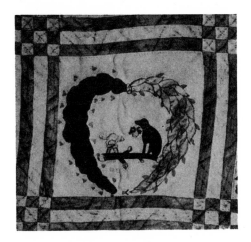

Detail of applique "friendship" quilt (mid-1800's).

or artisan painters are copies, close or free, of conventional originals, often European in origin. Portraiture, which was almost exclusively artisan work, followed, if a little belatedly, sophisticated fashions; the influence of Gilbert Stuart, for instance, penetrated to every level of American art.

Significantly, the amateur or artisan painters, who eagerly copied engravings after such English artists as William Henry Bartlett and Fanny Palmer, seem to have been largely impervious to the influence of true folk art. This blindness is demonstrated in the work of Edward Hicks. Although he lived on the edge of the Pennsylvania Dutch country and like his European peasant neighbors used animal figures for allegorical purposes, he did not turn for inspiration to fracturs and wedding chests but cut pictures of animals out of newspapers and magazines. He copied the works of the most academic American painters, John Trumbull and Benjamin West.

—James Thomas Flexner
Author of American Painting: First Flowers of Our Wilderness; America's Old Masters, *and other books*

FORTUNATELY FOR HISTORIANS, professional writers, curators, and technical experts, there are no absolute definitions in art, not many indisputable attributions—not even a standard terminology. A large percentage of the art produced in this country before the mid-nineteenth century is variably known as folk, pioneer, primitive, or provincial art. Until the study of semantics is fully developed, such differences in appellation will keep many typesetters busy, and add zest to art discussions.

Since my initial purchases of early American paintings and sculpture in 1926, I have used the term "folk" art and have continued to do so despite the controversial literature which evolved in the 1930's and has appeared in profusion more recently. To me, American "folk" art most accurately explains the character of the material and the people who produced it. ("Folk" in this country does not denote "peasant.")

Basically, American folk art was the art of the middle class—kindred folk with a kindred philosophy. Folk art includes the work of professionals as well as amateurs, of adults and minors, of the taught and untaught, produced commercially or as an avocation, in both urban and rural communities.

American folk art developed logically as an authentic expression of the community for the community, in contradistinction to the established art of the few for the few. The latter, a small group of wealthy colonists, merely transplanted themselves into a new setting, importing from the home country building materials, furniture, accessories, fashions, and so on. For their portraits and decorations, this "aristocracy" employed European artists or Americans trained abroad. On the other hand, the large mass of settlers had a rugged task to perform. In their new environment, they were forced upon their immediate resources, combining the limited materials with amazing ingenuity in building simple homes and creating the objects for their daily use. Always, use was the primary motivation. Style was dictated by need, but inevitably the creative impulse managed to emerge.

As the arduous task of pioneering relaxed, the human desire for embellishment became evident in the architectural trim, decorated furniture, pictorial vital statistics, ship carvings, weathervanes, coach panels, and in the indispensable trade signs. By the beginning of the eighteenth century, numerous carvers, metalworkers, "limners," and other painters, were gainfully employed. In time, amateurs had leisure to whittle or paint, and young women began to produce the fascinating still lifes, "fancy pieces," landscapes, and genre, while their brothers created elaborate drawings "executed entirely with the pen." Unhampered by conventional art training or a selfconscious desire for posterity, their art—whether original in conception or creatively imitative—was an honest statement of life as they knew it. The quantity and quality of folk art developed until the mid-nineteenth century, when just as consistently it started on its rapid decline. Obviously, the simultaneous advent of photography, mass printing, and machine production, eliminated the *need* for handmade originals. Industrial progress established new values in life and in art.

Carefully culled, the best of the American folk paintings and sculptures present not only historical and social records, but also a genuine art which can well hold its own esthetically with the best professional work of the period.

—Edith Gregor Halpert
Director, The Downtown Gallery

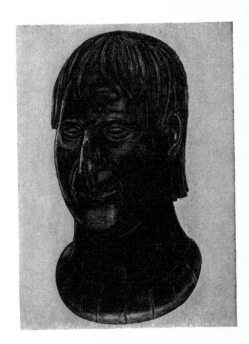

Self Portrait of P. J. Landry, carved from elm (1833).

THE STRANGE THING about the collectors and students of American folk art is that the folk art most of them are interested in is not, in any very meaningful sense, American. Whether they specialize in Pennsylvania Dutch chests, or songs of the Kentucky mountains, or hooked rugs, they are, after all, dealing with the products of cultures much older than ours.

It is true, of course, that even though the art of hooking rugs was brought to America by Scandinavian immigrants, it spread rapidly among Americans of other origins, and before long took on characteristics of design and technique which grew out of American influences. All the old-world folk art forms—the painted chests, old ballads, ships' figureheads, and the rest—were modified to a greater or less extent by American circumstances. But there is something quite misleading about the notion, fathered in the early thirties by the now-famous exhibitions of folk art at the Newark Museum and the Museum of Modern Art, that such forms are "evidence of the enduring vitality of the American tradition." It is more accurate to think of them as evidence of the enduring vitality of peasant craft traditions in a civilization which typically has nothing to do with either peasants or handicraft. For American civilization, from anything but an antiquarian point of view, is essentially the product of democracy and the machine.

This is not to say that America has no folk art of its own. It has. But its folk art has nothing in common with the balladry of the Kentucky mountaineers or the decorative crafts of the Pennsylvania Dutch. It is not, as these are, the product of people cut off from the main current of American life. Nor was it inspired, as those were, by ancient craft traditions.

On the contrary, the forms and techniques of American folk art were created by sovereign, even if uncultivated, people, and were evolved empirically from the requirements of new materials and new circumstances. They were, in fact, as I have said elsewhere, "the folk arts of the first people in history who, disinherited of a great cultural tradition, found themselves living under democratic institutions in an expanding machine economy."

The forms and techniques of this vernacular art are sensitive to the technological environment and in harmony with democratic social institutions. Its products, as distinguished from those of the folk arts which have their roots in racial or class tradition, are marked by simplicity, lightness, linear clarity, adaptability, and mechanical ingenuity. And they carry in themselves the seeds of the future, rather than memories of a nostalgic past.

The greatest single collection of vernacular objects was in the United States Patent Office up until 1926, when the original models of thousands of gadgets, machines, and devices were dispersed at public auction. There can never be such a collection again. But the Patent Office's annual reports provide a storehouse of illustrations which are themselves a significant vernacular form. And the vernacular still flourishes, in the "souped-up" cars which young Californians call "hot rods," for instance; in amateur movies and home recordings; and in the creations of innumerable household and backyard mechanics and inventors.

In the American folk arts, as conventionally defined, we can trace the alienated remnants of great cultural traditions in charming survivals. In the vernacular, often crude but always vigorous, we can discover the sources of artistic forms which belong to our own time and place.

—JOHN A. KOUWENHOVEN
Author of Made in America: The Arts in Modern Civilization

AMERICAN FOLK ART—the art of the common man—represents the most purely native and the most independent and democratic tradition in early American art. Folk painting and sculpture were produced by talented amateurs and craftsmen ignorant of cosmopolitan styles and untrained according to academic standards, who were therefore free to pioneer, to emphasize original design rather than finished techniques. This home-grown art, finding its inspiration in the robust American people and the unromanticized American scene, based only on a first-hand knowledge of craftsmanship and on the assumption that anyone who wanted could learn to paint or carve, was American to the core. It was indeed a free artistic expression of the very spirit of the flowering American democracy.

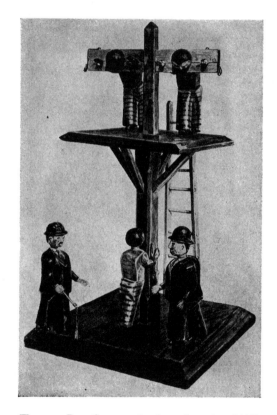

WHIPPING POST GROUP, painted wood carving (1875).

The period—the late eighteenth and the nineteenth century—was that in which America came into its own as a nation, when its national life, and so its native art, expressed the realization of American independence won in the Revolution.

In the field of painting, folk art includes portraits, landscapes, ship pictures, genre, historical and Biblical scenes, memorials, still-lifes, and decorative pieces of various kinds—painted in oil, water color, and pastel on canvas, paper, wood, cloth, leather, metal, glass, and plaster. The chief species of folk sculpture are ship figureheads and ornaments, weathervanes, cigar-store figures and other trade signs, toys, circus and carrousel carvings, decoys, portraits, and ornamental sculpture for the house and garden—made of wood, metal, stone, plaster, and whalebone.

The artists comprised thousands of common folk who painted and carved for pleasure or profit—housewives, young ladies in seminaries, house painters, itinerant artists, carpenters, sailors, blacksmiths, professional carvers and amateur whittlers, metalworkers and stonecutters. A large proportion remain anonymous today, but hundreds are known by name.

Folk art is radically different from the more conventional

and fashionable American arts, and in order to judge it on its own merits several critical pitfalls may be mentioned:

Folk art is not significant in proportion to its early date. The most noteworthy body of folk art was produced around the middle of the nineteenth century.

The size of a folk painting or carving is unimportant, for the primitive artists were modest in their intentions and methods and characteristically worked best in small scale.

A named piece is not necessarily superior to a piece by that great master of folk art, "Anonymous."

It is a mistake to look for "schools" of folk painting or carving. The single piece is of interest in proportion to its individuality.

In the field of painting, water colors are not of secondary importance, for the folk artists excelled in the water-color medium which more perfectly than oil recorded the crisp linear design and flat color that distinguish the primitive vision.

The vitality of design rather than technical proficiency determines the esthetic validity of an example of folk art, for the artist worked from insight rather than eyesight, creating from within rather than recording the surface appearance of what he saw. The basic characteristic of American folk art is original, stylized design rather than illusionistic realism, an inevitable and unselfconscious result of the personal, unacademic approach of the folk artist.

—JEAN LIPMAN
Author of American Primitive Paintings *and other books*

AMERICAN FOLK ART is, to me, essentially the expression of the individual. Even in such well-defined categories as cigar-store Indians, weathervanes, and figureheads, each subject exhibits many original elements. One of its outstanding characteristics is spontaneity. As opposed to formal art, American folk art is utterly unselfconscious. The artist's lack of ability to paint a flat rug or a horizontal table did not deter him from attempting the picture, nor did it apparently prevent others from enjoying it.

For an example of folk *craft* to be also considered as folk *art* it should, I believe, have been made with a conscious attempt on the part of its creator to enhance it above the purely utilitarian, either by adornment or refinement. I do not think that unintentional refinement in a primarily utilitarian object makes it other than a more esthetically pleasing utensil.

In the field of non-academic pictorial art it is hard for me to accept the term "folk." I cannot, for instance, consider a painter such as Winthrop Chandler (who was a member of a prominent Connecticut family) as "folk," nor his rugged likenesses as "folk art." I think the word "provincial" more truly applies

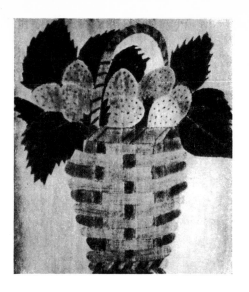

PAINTING ON VELVET, strawberries in basket.

to him, and to the work of Richard Jennys and many others of their type. In the same way I feel that "primitive" and "unschooled" also have their rightful place as descriptive adjectives. In my opinion, the study and classification of non-academic American painting has now progressed beyond the point where one heading can satisfactorily be used to cover the whole subject. And I like the generic term "folk art" rather less than some of the others because to me the word "folk" connotes a European class which had no counterpart in rural America.

—NINA FLETCHER LITTLE
Collector and writer

A WORK OF AMERICAN FOLK ART is an esthetically satisfying creation produced in either the craft or domestic tradition, rather than in the tradition of the professional artists. It may be the work of a trained craftsman who goes beyond the strict demands of the product he is creating to give it an individualized and satisfying quality; it may be the work of a gifted but untutored creator, working in an established artistic medium but unaware of the more sophisticated traditions of that medium.

To a large extent our folk art is the product of the working class, both rural and urban, living before the era of mechanization. It was created by fireside whittlers and master carvers of wood and stone, by itinerant painters on wood and canvas, by humble potters and blacksmiths, by housewives with their needles, at their looms and at their quilting frames. Much of the time they followed well-established traditions; most of these traditions were European in origin but modified considerably by the native environment and cultural climate.

The motivations of the folk artist may differ somewhat from those of the professional artist who seeks wide recognition, acclaim, and reward. The folk artist is sometimes, of course, a craftsman creating a product for sale, but in this instance a product imbued with esthetically satisfying qualities. Much folk art is created with a very limited and intimate audience in view, the members of the artist's family and his immediate circle. It is created out of the emotional needs of the artist and for his personal pleasure; it is compared, in his own sphere, not with the great world of art, but with those other examples of the type known to his neighbors.

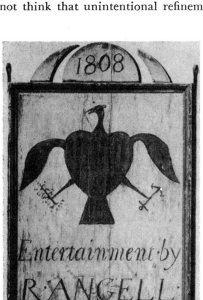

TAVERN SIGN, Providence (1808).

Folk art in America is characterized by its vigor, color, individuality, and especially by its reflection of the artist's lack of selfconsciousness.

We would like to suggest three classifications which take into primary consideration the purposes of the artist.

Classification I: Those utilitarian objects which have an esthetic appeal for us deriving from their basic design. Those unadorned tools or utensils recommend themselves to us because the designer-artist combined perfectly the necessities of function with the grace of form. We are thinking here, for example, of such things as barley forks or grain cradles which were so flowing and uninterrupted in their design that we can be stimulated by them in much the same way that we can be moved by good examples of non-objective art. It is probably safe to assume that the creator never thought of these objects in any terms other than those of good, well-made tools, but we see in them a satisfying symmetry of line and movement.

Classification II also involves utilitarian objects, but in this instance those which the maker has deliberately decorated, to please himself and the eye of the beholder. He has carved his buttermold with carefully incised decoration, or, with humor and taste, made his weathervane into a running horse or a crowing cock. Whatever is both useful and decorated falls within this group. Under Classification III fall all types of folk art which are simply decorative and have no ulterior function: the paintings on paper, glass, foil, and cloth, the decorative carvings, silhouettes, samplers, shadow boxes.

Our concept of folk art must be broad enough to include not only those pieces which we now recognize, but also those which a growing awareness of our folk culture may call to our attention as time goes on. At this relatively early point in our understanding of this national asset we should be prepared to search through the entire range of our early artifacts for a continuing extension of this category. The early products of needle, knife, brush, kiln, chisel, and forge should be examined so that we may judiciously select from the multitude those pieces which are deserving of being included among our listings of American folk art. The greatest mistake we can make is to close our minds as to what constitutes our artistic heritage at a folk level.

—Janet R. MacFarlane and Louis C. Jones
Curator and Director, New York State Historical Association

The values which American folk art has contributed to American life have been confused by an unfortunate choice of terms. The terms "folk art" and "primitive art" have been used almost indiscriminately to describe any kind of painting, sculpture, or handcraft work which falls out of the ordinary field of academic exhibition material. Both terms are borrowed from other fields of art in which they have exact and well-recognized meanings. Their application to the American material has hindered rather than helped the revelation of its real values.

Primitive means the art at the beginning of a long development, *e. g.*, primitive Greek sculpture. (There is no development in much of the so-called primitive painting, which remains at a constant level.) It also applies to the arts of savages or "primitive" men. (American primitive art is the work of unsophisticated members of a people in a high state of civilization.)

Folk art is an unselfconscious, highly developed, traditional craft. Whereas a primitive artist is untrained, a folk artist is the product of an ancient and traditional sense of design. The element of continuity is important in folk art. So is the element of being *made for use*. Folk art is a skilled handicraft product done for everyday use, for the general enjoyment rather than the selfconscious public of amateurs. It is an enrichment of objects for everyday use by the skilled craftsmen who produce them. The art of the Navajo potter is a genuine folk art, the art of the natives of Bali, or the peasants of Brittany. In the United States the Pennsylvania German crafts are an example of genuine folk art, or the cowboy's saddlery.

Confused under the indiscriminate use of these two terms are:

1) Naïve *amateur* work, the product of the child within us. Untrained adults who try their hand at copying nature or another work of art begin at the childish level. It is incorrect to call this primitive art because there is no germ of great future development in it.

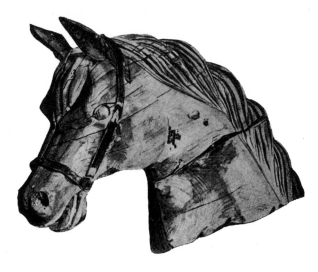

Carrousel Horse's Head, wood carving *(c. 1890)*.

2) The work of the *untrained professional*. This is a distinctive feature of American art, arising from the influence of the frontier. As the population of America moved into the wild continent and was detached from the established institutions of western society, people with the natural gifts to become artists were born in a frontier society in which there were no established arts. If these men and women had been born in a settled society, as Copley or Benjamin West were, they would have had opportunity to develop professional skills and make their contributions to the organized professional life of the arts. They had the natural equipment of the artist, a sensitive eye, an intuitive sense of design, sensitive feelings. But they remained partially or inadequately trained in the skills of their craft. The best of the so-called primitive painters are really not primitive but *untrained professionals*. Naturally this category shades off into professional art at its extreme limit but it is a distinct category in American art, with its own values.

3) *Folk art.* There are genuine forms of trained traditional crafts in American life which can be properly called **folk art**. Ship's figureheads, cigar-store Indians, Pennsylvania German handcrafts, cowboy saddlery, are called folk art because they fall outside the ordinary academic exhibit material. But the makers of these things were highly skilled craftsmen. They thought of themselves as professionals. Their work shows the elements of being made for use, of continuity, of being done for the general untrained enjoyment

20

rather than for the connoisseur's enjoyment, of being attached to one's home or part of the articles of daily living, that characterize a true folk art.

This may seem very dry and pedantic. But only when American folk art is clearly defined, and separated from other types of art, can we see what it is and begin to study its values seriously. What are the constants in it, constants of material, of the impression of milieu, of use, even of climate, which it shares, perhaps, with folk art of similar climates and cultures elsewhere? What are the fresh contributions, of form and imagination, made by American craftsmen? What are the traditional forms it has inherited, from Europe, from Mexico, perhaps even from the Indian? (Are there any elements derived from the Indian? is an important question in itself.) Exactly what is that poetry of feeling—so fresh, so light-hearted, so objective, so uncomplicated, so vital— that captivates and delights us in it? I do not believe the frequently repeated explanation that its charm comes from the fact that American folk art was made by free and hardy native Americans who were ignorant of Old World customs and conventions. That is not altogether true, in the first place, and it is usually irrelevant, in the second. American folk art is not Americana. It is art.

—E. P. RICHARDSON
Director, Detroit Institute of Arts

THE GUSHING PROPRIETRESS of the antique shop cooed that it was "quaint" when she sold it to the dealer searching for "American primitives." Observing it in the dealer's gallery a critic described it as a piece of "pioneer art" to his friend, a collector of "provincial painting." The collector gave it to a museum where the curator put it on exhibit along with other examples of "American folk art." There it was admired by visitors including some who spoke knowingly of "untutored art" by an "anonymous" "selftaught" artist. Finally it was seen by a suburban matron doing the museums on her day in town. "Isn't it quaint?" she remarked, while the long-dead artist made one last revolution in his grave and then lay still.

Pity the poor writer in a plight like this! What is the proper word or phrase to adopt in referring to the work of our early non-academic American artists? The weathervane of fashion has veered now for 25 years from one to another of the terms mentioned above. To this innocent bystander the Babel of tongues indicates chiefly that although everybody knows what the other person is talking about, no one term has been coined that will satisfy all as being the acceptable and indisputably appropriate characterization.

The word *folk* conjures up for many a vision of peasants clad in colorful national costume dancing gaily on the village green. It is difficult for these people to associate the nineteenth - century American, turned artist, with the traditional folk art found in peasant cultures of European countries. *Folk*, these objectors to the term complain, implies a homogene-

PAINTED TIN CANTEEN
from Pennsylvania.

ous long-standing local tradition. Our American artist emerged in widely separated parts of the country, from varying national backgrounds, and from different periods spanning most of a century. Furthermore, they were rarely seen cavorting on the green.

Primitive has its detractors too. They point out that the adjective has long since been preempted by art historians to describe the work of pre-Renaissance Italian painters. More recently, certain French artists have been labeled primitive and, to add to the confusion, archaic African sculpture has received the same designation. "Why get mixed up in that?" is their objection.

In some circles *provincial* is used to avoid the complication involved in *folk* or *primitive*. But art is not a matter of geography, the dissenters argue. Whenever an artist is discovered who did not come from the hinterland, the term becomes misleading.

Similar geographical obstacles face *pioneer*. In spite of spatial definition, the word still brings thoughts of a frontiersman furiously hacking forest into farm land, moving slowly across the continent—1750, New England; 1800, Ohio; 1850, California. The mid-nineteenth-century Yankee itinerant, painting the portrait of a Massachusetts farmer whose acres have been under cultivation for 150 years, scarcely fits the idea of a pioneer.

The art biographer turns thumbs down on *untutored, selftaught* and *anonymous*. The more we learn about the careers of these artists, the less accurate the words become.

What to do? This innocent bystander has fallen back upon an admittedly unsatisfactory negative approach, to characterize—for himself at least—the quality distinctive of work known by these various names. This term is *non-academic*. It tells that the artist and his work did not stem from the fashionable art world of the period. It pictures the artist pursuing his own individual creative career, out of touch and uninfluenced by prevailing academic concepts. It implies that he lacked technical skills comparable to those of his studio-trained contemporaries. It suggests that the artists knew little of esthetic theory and not much of traditional practice. "Primitive" he was indeed—in respect to starting from the beginning. He was a "pioneer"—in the sense that almost always he worked alone, not as part of an art circle. He was "folk" also—although a most uncommon Common Man.

But until somebody finds or invents the one positive term that carries all these meanings, this confused layman will rely upon *non-academic*, negative and unsatisfactory as it is.

—FRANK O. SPINNEY
Director, Manchester, New Hampshire, Historical Society

WEATHERVANE, cut out of sheet metal *(late 1700's)*.

ARTISAN AND AMATEUR

In American Folk Art

By HOLGER CAHILL

Mr. Cahill, distinguished authority and writer on folk art, was formerly director of the Federal Art Project, which included the Index of American Design.

VIRGIL BARKER in his *American Painting*, the soundest book on this subject which has appeared in our generation, devotes a number of chapters to our "continuous and strong tradition of common art." These chapters contribute to his history firm and close texture, a continuity, and articulation which would not be as clear if he had confined himself to recognized masters and their followers, that is, to the professional artists. The "tradition of common art" is, of course, what has been called folk art, primitive, provincial, pioneer, and Sunday painter art. Mr. Barker's study of it in relation to a general history of painting yields new insights into the development of American creative energy, particularly in the eighteenth century. It is my guess that from this time forward no history of American painting will neglect this phase of its story as it has in the past.

It is interesting to note that Mr. Barker nowhere uses the term *folk art,* nor any of the other terms which have been used in recent years in endeavors to define the subject more closely. He finds *artisan* and *amateur* adequate. This might be one way of solving the differences about terminology which have been evident in previous discussions of the subject, in the ANTIQUES symposium of May 1950, for instance. In my early catalogues (1930-32) I separated folk art into these two categories: the work of the artisan who inherited an immemorial tradition of shop practice; and the amateur whose simple self-training might include the study of the work of others, and in some instances a little training in shop or school. It is sometimes difficult to keep these categories clearly separate, and even to keep them clear of professional art, for the Jack-at-a-Pinch who could turn his hand to anything, a necessary and ubiquitous phenomenon of colonial and pioneering days, often developed high talent and skill. A magnificent example is that of Charles Willson Peale.

Up to the middle of the nineteenth century it was the artisan who made the greatest contribution. The portraits so ably discussed by Louisa Dresser and Alan Burroughs in the Worcester Museum catalogue, *17th Century Painting in New England,* and now again by Mr. Barker in his history, are the work of artisans. Their roots lie in medieval craftsmanship. Their branches reach into the eighteenth and nineteenth centuries. Without their example a great talent like Robert Feke's could not have developed here as early as the 1740's. Their influence may be found in innumerable portraits by anonymous itinerants working here up to the third quarter of the nineteenth century. They speak across nearly two hundred years in the *Noah's Ark* on the Frontispiece and the *Peaceable Kingdoms* of Edward Hicks. It is probable that Hicks never saw them, and that he did see Benjamin West's *Penn's Treaty,* and paintings by Charles Willson Peale, and by his own contemporary John A. Woodside, as well as prints of farm animals. He seems to have used these as subject sources, and in certain ways also to modify his technical procedure. However, the backbone and connective tissue of his painting is the artisan tradition, the "mystery and craft" of the wagonmaker and painter in which he served a full apprenticeship. This shop training included the design and execution of heraldic devices, decorative figures, conventionalized landscapes, and portraits. Through it Edward Hicks reached the same springs of tradition as the portrait painters of the seventeenth century. His training would differ very little from theirs.

The seventeenth-century portraits had their sources in provincial England, Flanders, and Holland. In their linearism they are related to Tudor painting. Their methods of suggesting interior space go back to Italo-Byzantine ideas. Little of all this has been lost in the art of Edward Hicks, and not too much conceded to painters whose work helped him with subject matter: West, Peale, Woodside, *et al.* One sees his shop training in the linear style, the way he handled drapery, the lambs and wolves with their backs folding into each other, the heavy feet of leopards inscribed within a curve of tail, the rhythmic sweep of white line in the horns, back, brisket, and tail, and the star spotting in the foreheads of his innocent and surprised bulls. All this conventional calligraphy is the stock-in-trade of the shop-trained carriage painter.

The artisan tradition in which Hicks was trained was conservative almost beyond belief. One finds this not only in painting but also in sculpture, for example in the carvings called Schimmel, and the great eagle tavern sign formerly in the collection of the Museum of Modern Art, now in the Metropolitan Museum. Stylistically these by-pass Renaissance and Gothic periods for the Romanesque, though they were carved in the United States in the nineteenth century. In Edward Hicks' time this carvers' art flourished in Pennsylvania and there was another mode of expression which Hicks might have found among his neighbors in Bucks County. This was the art of fractur, which reminds us at times of something out of the ancient Near East, and has its ancestors in medieval illuminated missals and books of

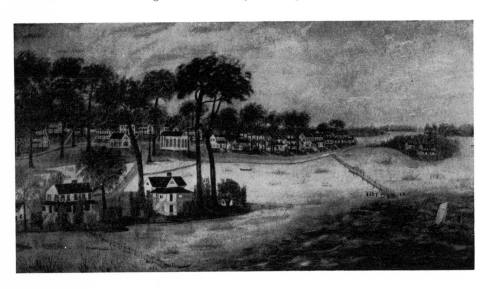

LEGARÉVILLE, by Portia Trenholm. *Colonial Williamsburg, Inc.*

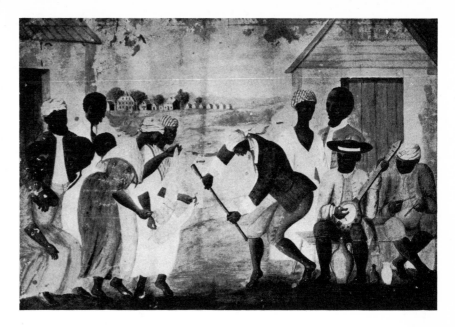

THE OLD PLANTATION, by an unknown artist. *Colonial Williamsburg, Inc.*

hours. Many Pennsylvania writing masters worked familiarly in an iconographic tradition of great antiquity, some elements of which had disappeared from European professional art for five hundred years. It is hard to say whether they were artisans or amateurs.

Since the time of the Civil War, which marked our turning point from a rural to an urban civilization and from handicraft to machine production, the artisan contribution to American art diminished sharply and the contribution of the amateur increased in relative importance. The amateur, of course, has been with us from the beginning. Virgil Barker mentions one who came to Boston from Dublin in 1684 with a letter to the Reverend Increase Mather explaining that Allen could not "thrive at buying and selling, but . . . hath acquired good skill at . . . graving and limning & that by his owne ingenuity and industry chiefly for he served an apprenticeship faythfully to another trade." This trade was that of an ironmonger. Joseph Allen was probably not the first amateur painter working in this country and he was certainly not the last. More than two hundred years later we find another Joseph, Joseph Pickett of New Hope, Pennsylvania, achieving museum stature with such paintings as *Manchester Valley* (Museum of Modern Art), *Coryell's Ferry, Washington Taking Views* (Whitney Museum), and *Washington Under the Council Tree* (Newark Museum). Between the two Josephs we have scores of gifted amateurs who gave up their amateur standing to join the ranks of the professionals, like Charles Willson Peale and Chester Harding, all of them filled, as Mr. Barker says, "with that love of practical processes which is so important a motive in amateurs everywhere." The much greater number remained amateurs, like the young ladies who made watercolors and velvet pictures from patterns and gave us some of our finest early still-life paintings; as well as the makers of votive and occasional paintings and sculpture, in which categories one would include the New Mexican santeros and the painters of *The Old Plantation* and *Legaréville*, illustrated here.

The anonymous painter of *The Old Plantation* may have been an officer who fought with or against the Revolutionary armies in South Carolina. He was a gifted amateur and may have been a military mapmaker. This is suggested by his feeling for scale and panorama. He shows familiarity with the Carolina low country and with a type of eighteenth-century plantation architecture not unlike that of Williamsburg, and he knew the look and bearing of the Carolina Gullah Negroes.

The painter of *Legaréville* was a Charleston lady, Miss Portia Trenholm. She is the pure amateur with no artisan training. If she had school instruction in art it must have been very slight. Her landscape, though childlike, is not without a charm and a real feeling for locality. It is a personal view of a subject not otherwise recorded, so far as I have been able to determine. Legaréville, named for one of the most distinguished families of South Carolina, was a summer resort on one of the sea islands near Charleston. It was much favored by Southern planters in the 1840's and 1850's. Nothing remains of it now. The painting was owned by the Legaré (pronounced Legree) family until it came to Williamsburg.

Most important of the amateur painters mentioned in these paragraphs is Joseph Pickett. He was born in Miss Trenholm's day, 1848, but did not begin to paint until a few years before his death in 1918. His work has been so much written about that there is no need to go into it here except to say again that it is at the very summit of American amateur expression. Pickett, like the seventeenth-century amateur, Joseph Allen, was apprenticed in another trade, that of the carpenter and canal-boat builder but his last and true love was painting.

Since his time the amateur painter has waxed mightily in the land. Some idea of this may be gleaned from the *Art News'* national amateur show held at the National Academy last December. This show of 150 pictures was selected from 1430 entries. But the circle of the amateur artist spreads much wider than this, and we may expect more revelations about it when the Karolik and Garbisch collections are published. What has been called folk art is the most ancient and pervasive form of art expression, and its earliest representatives must have been amateurs. The extraordinary efflorescence of the amateur artist in this country today has come about for a variety of reasons. Not the least of these is that something in man which even in an age of machine production will not relinquish the idea of himself as maker, searching out the forms of the unknown with the most primitive of techniques and instruments, even with his bare hands. But not all amateurs are folk artists.

This returns us to the discussion with which we began, whether the terms *artisan* and *amateur* take the full measure of folk art. From the point of view of a general history such as Mr. Barker's, no doubt they are adequate, but the historian of folk art as such probably must plumb deeper dimensions. The folklorists, who have considered this matter from the point of view of literature, have a word, *Volksgedanke*, folk thought, which would suggest that this depth is to be sought in a people's sense of community. The most profound thinking on this subject has been done by religious philosophers, men like Nicholas Berdyaev and Martin Buber, whose work has been found valuable by art critics. From them one gets the idea that utterance is a function not so much of the genius or the rare individual giving his vision to the community as it is of the community or congregation itself. This is a profoundly democratic thought. Another dimension of the greatest folk art is the artist's sense that the reality which he seeks to create lies pre-eminently within his medium and that it needs no reference beyond, though this reference is not excluded. Hicks, the artisan, had this sense. Pickett, the amateur, had it in supreme degree, and that is why his work has always interested the artists of the *avant-garde*.

PRINT TO PRIMITIVE

By JEAN LIPMAN

AMERICAN PRIMITIVE PAINTING should not be judged by the criteria accepted for academic art, for verisimilitude was neither the aim nor within the range of possibility of the primitive painter. He did not attempt to imitate, nor was he technically able to do so. What he saw was merely a point of departure for his design. Whether he derived his inspiration from an incident in nature, or in a painting or print, he always recreated rather than imitated his model. This is why primitive "copies" of well-known prints seem just as fresh and original as the primitives that were inspired by direct observation of a scene. The work of art derived from the mind of the artist, more than from the external source. The copies of art works by talented primitive painters are not inferior primitives, any more than some of Shakespeare's plays are inferior because the plots were borrowed. The print-inspired primitives are indeed no more stylistically derivative than is a Dali copy of an old-master Madonna. Because gifted primitive painters always reinterpreted conventional themes in terms of heightened design, a number of print-model primitives can rank among our outstanding examples of folk art.

These paintings are the very ones in which the essentials of primitive style are most strikingly apparent. The differential between the copy and its academic model is the distilled essence of primitive style, clearly isolated for our critical scrutiny. A basic critical definition of primitive style might well be formulated by examining the juxtaposed examples here reproduced. Each of these pairs shows how a primitive artist reconstructed a literally rendered scene in terms of formalized design — of heightened color, rhythmicized line, bolder juxtaposition of forms, and sharpened tonal contrasts. The seemingly slight changes in design represent, in each of the selected examples, the evolution from an academic print to an outstanding primitive painting.

Every one of the primitive examples chosen has altered the pattern, color, line, tone, and the forms of its model in some degree. In order to abbreviate, however, we will discuss the differential of just one aspect of design in each of the five selections of print and primitive.

The aquatint of Mount Vernon (*Fig. 1*) — drawn by Alexander Robertson, engraved by Francis Jukes, and published by Robertson and Jukes in London in 1800 — was a popular model for young-lady amateurs throughout the first half of the nineteenth century in America. Of these the water color captioned *Painted by Susan Whitcomb at the Lit. Sci. Institution Brandon Vt. 1842* is one of the most delightful examples (*Fig. 2*). Let us see how Miss Whitcomb transformed her realistic model into a scheme which suggests a stylized embroidery pattern rather than an illusionistic landscape. The large trees have become richly elaborated featherstitch and crewelwork designs, while the plants and shrubs are simplified into ornamental accents of lines and spots. The foreground is arbitrarily divided rather than shaded into receding planes. The ground and distant islands are evenly speckled with what, executed in embroidery, would have been French knots. All the other details in the two pictures — clouds, building, sailboats — reveal the same transformation from reality to decorative pattern. It is significant to notice that the shadows, an important element of realism in the aquatint, have been entirely omitted in the primitive water color.

The hand-colored Currier and Ives lithograph of *The Evacuation of Richmond Va.* was copied by one John H. Smith of Thomaston, Maine, in 1878. This painting in thin oils changes the detailed Currier version into a simplified abstraction of the scene. The print is entirely conventional in every detail, including the color scheme. It is colored with washes of mauve pink and dull blue for the water, a neutral shade of green for

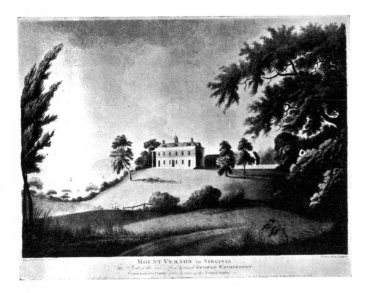

FIG. 1 — "MOUNT VERNON IN VIRGINIA" drawn by Alexander Robertson, engraved by Francis Jukes, published by Robertson and Jukes, London, 1800.

FIG. 2 (*below*) — "THE RESIDENCE OF GEN. WASHINGTON Mt. Vernon Vir. Painted by Susan Whitcomb at the Lit. Sci. Institution Brandon Vt. 1842." Water color on paper. *Rockefeller Collection, Ludwell-Paradise House, Colonial Williamsburg, Inc.*

FIG. 3

FIG. 4

the trees, pink for sky, pink and gray for the houses. Even the yellow, red, and orange of the fire are muted, and the whole gives a hazy effect not entirely appropriate to the dramatic incident. In the painting Mr. Smith sharpened and dramatized the design, and heightened the excitement with a robust scheme of rich, odd colors. The fire spurting from the buildings is vivid red and yellow and smoky black. The shrubbery is an unusual yellow-green, the water opaque pink and gray, the bridge sharply accented in black. The houses are crisp gray and black blocks, with an occasional one a strong pink that echoes the water. The entire color composition is as unconventional as that of a Picasso.

Hunting Buffaloe, engraved for *Graham's Magazine* from an original drawing by Darley *(Fig. 5)*, was closely followed in the magnificent painting by an anonymous primitive reproduced as Figure 6. Here the background detail and incident have been simplified to focus interest on the hunter, horse, and

buffalo. But the most significant change lies in the subordination of everything to linear contour, and in the vitality of the line itself which, tense and yet supple, endows the painted forms with bold and finely coördinated rhythms. The "original" is an animated piece of genre engraving; the "copy" a great romantic painting, considered by a number of critics the outstanding canvas in the Museum of Modern Art's recent exhibition devoted to *Romantic Painting in America.*

In the two versions of *Perry's Victory on Lake Erie (Figs. 7 and 8)*, seemingly minor alterations in the scale and placing of the forms change the representation from an interesting academic naval scene to a masterpiece of design. The changed relationship between forms and space in the painting, the new economy of detail, and the sharpening of tone to create bold patterns of line and form, scarcely need comment. The artist has revitalized a pictorial theme in terms of abstract design.

Trumbull's painting of the *Declaration of Independence* was undoubtedly copied by Edward Hicks *via* Asher B. Durand's popular engraving *(Fig. 9)*. Durand, incidentally, was an original member of the National Academy of Design. The outstanding quality of Hick's version — which in my opinion far surpasses not only Durand's engraving but Trumbull's original painting — is the lucid tonal design which bears no relationship whatsoever to the engraving which Hick's "copied." We may truly say that the academic print was a point of departure rather than a model for Hicks. Although

FIG. 7—"PERRY'S VICTORY ON LAKE ERIE." Engraved by A. Lawson after the painting by Thomas Birch. Published by Joseph Delaplaine.

FIG. 8 — PERRY'S VICTORY ON LAKE ERIE. Oil on canvas, early nineteenth century. Anonymous. *Collection of the author.*

Photographs of Figures 1, 7 and 9, courtesy of the Old Print Shop.

Photograph of Figure 3, courtesy of Kennedy & Co.

the poses of the figures and their arrangement are strictly followed, the Quaker artist reorganized the composition on a new tonal basis that shifts the emphasis from representation to design.

Some time ago James T. Flexner asked me why I considered the Hicks copy of the *Declaration of Independence* a greater painting than Trumbull's original version. This question was the point of departure for the article here published. The simplest answer to the specific question seemed to be that if one reversed the two photographs, Hick's painting remained a masterpiece of design while Trumbull's became just a lot of people standing on their heads. In order to clarify the complete stylistic divergence between each of the other prints and its primitive copy, we might reverse these pages and then reappraise the pictures. With this trick we minimize their representational content and isolate the design as such. It is clear to see that the prints lose largely, the primitives relatively little, in the process.

In a recently published article I discussed the basic "points" by which masterpiece primitives may be recognized. All of these points have a common denominator which might be described, in its most general terms, as fine stylized design. This depends on the uniform clarity and quality of balanced design created in terms of sharp simple forms and bold distinct line, color, and tone. Subject matter and verisimilitude are definitely secondary — exactly reversing the emphasis of the typically academic painting or print. This basic difference between the academic prints and their primitive copies is more significant than the obvious superficial likeness.

The primitive paintings we have reproduced, falling far short of academic standards and lacking completely any aura of continental elegance, are free, original, vigorous expressions of an important native tradition in American art. They express the very spirit of the flowering democracy of nineteenth-century America, and as such are highly significant in the history of American art.

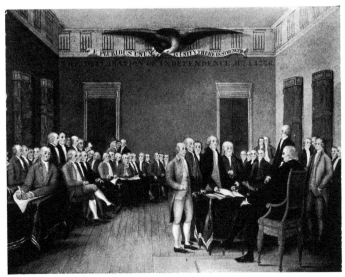

FIG. 9 (*right, above*) — "THE DECLARATION OF INDEPENDENCE of the United States of America." Engraved by Asher B. Durand after the painting by John Trumbull.

FIG. 10 — "THE DECLARATION OF INDEPENDENCE" by Edward Hicks. Oil on canvas, c. 1840. *Collection of Richard A. Loeb, Hampton, New Jersey.*

Engraved sources for American overmantel panels

BY NINA FLETCHER LITTLE

Fig. 1. Overmantel panel in the Alexander King house, Suffield, Connecticut. This panoramic view was for years believed to be a local scene bordering the Connecticut River until its English prototype was recognized. *Suffield Historical Society; photograph from the Index of American Design.*

ONE OF THE MOST ABSORBING aspects of the study of early American paintings is the search for the engravings from which some of them were copied, and still others derived. Such sources have been discovered for a number of landscapes painted on the raised panels above fireplaces which were fashionable during the second half of the eighteenth century. These paintings usually fall into one of three categories: a few actual views which were composed on the spot "from nature"; those decorative scenes which were certainly combinations of topographical elements familiar to the artist; and many others that were inspired more or less directly by recognizable sources of design.

It is the third group which will concern us here, not only for the obvious satisfaction of discovery and the fun of comparison, but also because this type of investigation sheds light on the many kinds of pictorial material which found their way to colonial America and were ingeniously

adapted by our provincial artisan-decorators.

During the eighteenth century countless imported mezzotints and engravings found a ready market in our coastal cities, and formed a rich backlog of potential inspiration for local artists. Among others, the work of François Vivarès (1709-1780), a Frenchman resident in England and an eminent landscape engraver of his day, was advertised by Minshull's Looking Glass Store on March 16, 1775, in the *New-York Journal or the General Advertiser*. It is of particular interest, therefore, to record an overmantel in the Alexander King house in Suffield, Connecticut, that derives from one of his engravings which must have been seen by a local artist (Fig. 1). Although the original composition has been naïvely simplified, endowing it with a distinctly local flavor, the derivation was unmistakably from *A View from Richmond Hill up the River* (near London). This Vivarès himself had based

upon an original painting by Antonio Jolli (1700-1777), a pupil of Pannini, painter of scenery for the London opera and a topographical artist of considerable merit (Fig. 2).

In England one of the major eighteenth-century pastimes was riding to hounds over the fertile rolling countryside. Because the opportunities for indulging in any leisure-time sport were not so great in America as abroad it comes as something of a surprise to find that a number of New England walls were decorated with traditional hunting scenes. Close scrutiny, however, reveals that these animated compositions do not depict local gatherings of huntsmen and hounds, as we should like to believe, but are in fact differing versions of imported engravings which in turn were based on original paintings by well-known English sporting artists.

An upper chamber in the 1763 Moffatt-Ladd house in Portsmouth, New Hampshire, was at one time hung with imported yellow paper handsomely patterned with Gothic designs intended to suggest stucco molded strapwork. Forming a decorative frieze around the top of the room was a sequence of hunting scenes printed on individual sheets of the background paper (Fig. 3). Some of these

bore on the reverse a printed cipher with the initials *G R* interlaced and surmounted by a crown. This mark, which appears on other importations of the period, proves that the required tax for each square yard of printed, painted, or stained paper had been paid at the source by the manufacturer before exportation. The Moffatt-Ladd hunting pieces were copies of four well-known engravings after James Seymour (1702-1752), who lived and painted in the south of England, while his famous contemporary John Wootton recorded episodes in the Midlands and the North.

At the same time traveling artists began to encounter among their clientele an interest in oil paintings of conventional English sporting subjects. Two of a group of three wall panels from Franklin, Massachusetts, depict ladies and gentlemen engaging in riding, shooting, and other country pursuits, while the third panel is decorated with a lively scene of hunters and hounds streaming over the hills (Fig. 4). With interesting variations, this is based on what was perhaps Seymour's most popular engraving, *In Full Chace*, which incidentally was one of the four subjects printed on the Moffatt-Ladd wallpaper. A second version, quite different in interpretation and by

Fig. 2. English engraving, *A View from Richmond Hill up the River*, c. 1749; source of design for the overmantel in Fig. 1. While most of the same basic elements can be discerned in both pictures, the topography of the Suffield view has been simplified and the larger buildings modified in scale, subtly changing the character of the entire composition. *Except as noted, illustrations are from the author's collection.*

Fig. 3. Hunting scene printed on the original wallpaper in the Moffatt-Ladd house, Portsmouth, New Hampshire, c. 1763; after one of James Seymour's most popular sporting subjects, *In Full Chace*. Fragments of the background paper may be seen surrounding the print, which has been cut out. *Society for the Preservation of New England Antiquities.*

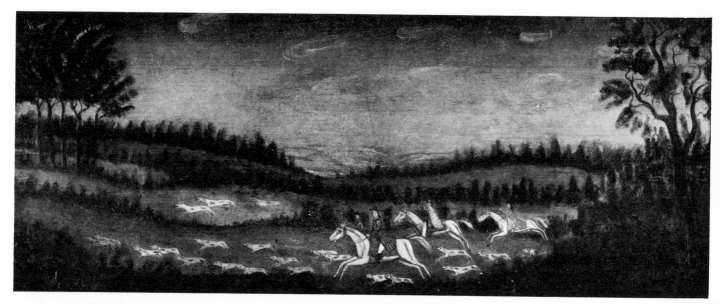

Fig. 4. Overmantel painting from Franklin, Massachusetts, based on Seymour's engraving in Fig. 3. Here again the American artist has simplified the background, but the four riders and several groups of hounds correspond to those in Seymour's *In Full Chace*. The fox is at far left center.

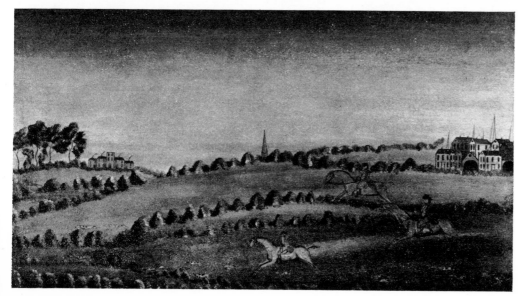

Fig. 5. Overmantel from East Douglas, Massachusetts, another variant by a second unknown artist of Seymour's *In Full Chace*. The source is less readily recognized but the distant buildings omitted in Fig. 4 have been included here, while a new group of brightly painted wooden houses has been added at the far right. The fox is just below the trees at the far left.

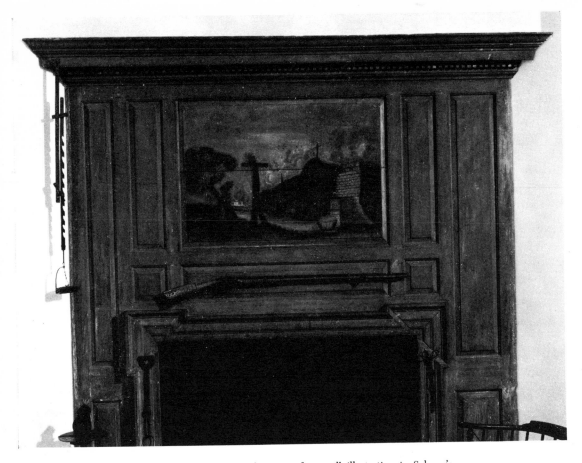

Fig. 6. Pennsylvania overmantel, c. 1761, a careful copy of a small illustration in Salmon's *Polygraphice*. The text of the book includes directions "to Extend or Contract a Picture" by means of laying out the pattern in corresponding large and small squares. This method was probably followed when the original print was enlarged to overmantel size. *Metropolitan Museum of Art; photograph by Taylor and Dull.*

Fig. 7. Plate XXI from the fifth edition of William Salmon's treatise on the pictorial arts, *Polygraphice*, London, 1685.

another hand, came from East Douglas, Massachusetts (Fig. 5).

One of John Wootton's compositions, *The Going Out in the Morning*, formed the basis for a handsome overmantel now in the collection of the Marblehead (Massachusetts) Historical Society. In this case, as in the previous instances, the American artist utilized certain groups and figures while rearranging or omitting others. Such ingenuous juxtaposition often prevents the recognition of otherwise obvious background sources.

A very different kind of prototype has been discovered for the strange overmantel *Landscape With Wayside Crosses*, which came from an unidentified house near Morgantown, Pennsylvania (Fig. 6). This fantastic concept is actually a careful copy (many times enlarged) of a small illustration in William Salmon's *Polygraphice or the Arts of Drawing, Engraving* . . . published in London in 1685 (Fig. 7). Here is proof that at least

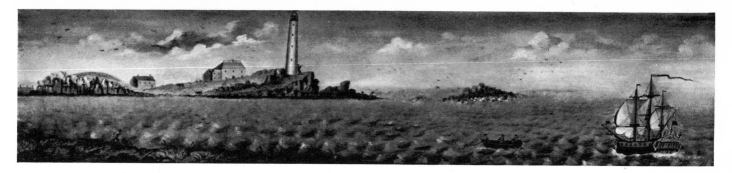

Fig. 8. Overmantel from Waltham, Massachusetts,
depicting *Boston Light* with a pilot being rowed out to an incoming vessel.
Signed *Jona. W. Edes. pinct. 1789.*

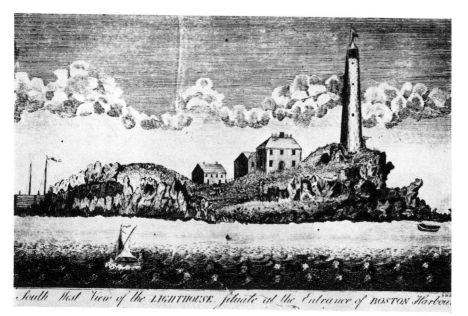

Fig. 9. *A South West View of the Lighthouse. Situate at the Entrance of Boston Harbour,* from the *Massachusetts Magazine* of February 1789, engraved by S. Hill after J. Edes. The *Massachusetts Magazine,* unlike some of its contemporaries, announced the intention of supplying its readers with "copperplate delineations on domestick subjects as being more agreeable to the citizens of this new Empire, than copying sketches from European masters."

one copy of this rare seventeenth-century instructor had found its way across the Atlantic and been put to unexpectedly practical use in Pennsylvania, probably at least seventy-five years after its appearance in London.

Occasionally it is difficult to decide which came first, the hen or the egg. A long panel picture of *Boston Light* from the old Josiah Sanderson house at Piety Corner, Waltham, Massachusetts, is signed and dated *Jona. W. Edes. pinct. 1789* (Fig. 8). In February of that same year an engraving, also bearing Edes' name as painter, appeared in the *Massachusetts Magazine* (Fig. 9). Only the

left half of the scene was reproduced, but the printed illustration differs little from the corresponding part of the painting. Whether the magazine sketch was Edes' first rendition of this theme, or whether the large oil was painted first, it is now impossible to say. There is in existence a third very similar picture painted by one Captain Matthew Parke, also in 1789, and now in the collection of the Truxtun-Decatur Naval Museum in Washington, D. C. This small oil on wood is said to show the frigate *Alliance,* on which Captain Parke was an officer, returning from a tour of duty under the command of Commodore John Barry in 1781. The

sequence and inspiration of these three versions of the same view make for interesting speculation.

The subjects of some landscapes may be recognized as derivations while their exact source can remain tantalizingly obscure. Such is the case with a handsome Pennsylvania overmantel which exhibits many elements in common with another example from central Massachusetts, though the latter is much less accomplished and obviously by an inexperienced hand (Figs. 10, 11). The right side of each composition includes a river or lake widening out at the right, a pedimented building among the trees, swans in the foreground, and several figures, three of them in corresponding attitudes. There the similarity ends. Although the old gentleman on the carrying bench can be seen clearly in the Pennsylvania scene and dimly in the Massachusetts one as well, the center distance and left banks have no pictorial connection. Nevertheless, there was obviously a basic source which each artist adapted to his own taste. Complicating the issue still further is a small engraved copperplate that has come down to collateral descendants of the family of the Boston-born artist Mather Brown (1761-1831), who departed for Europe about 1780 and never returned to America (Fig. 12). One immediately perceives an unmistakable affinity among the three compositions, yet apparently neither panel derived directly from the copperplate, from which no contemporary proofs appear to have ever been struck. It seems likely, therefore, that all three widely separated artists saw the same engraving (which may have been French), although no one to whom these photo-

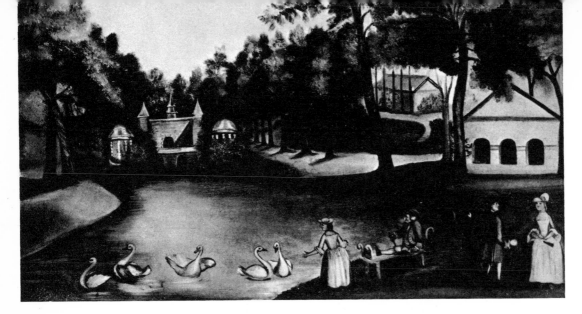

Fig. 10. Pennsylvania overmantel with eighteenth-century figures feeding swans, which may derive from a Continental engraving. Note the old gentleman with one leg supported on an interesting type of bench that has two sets of handles for carrying.

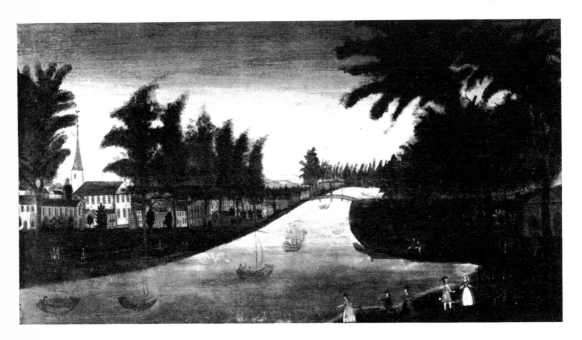

Fig. 11. Overmantel from central Massachusetts. Close comparison reveals that the right side of this scene exhibits many features in common with Fig. 10 although the manner of painting is more primitive. The unknown artist chose to include boats and a bridge, and to add a delightful group of typically American buildings on the opposite shore. *Worcester Art Museum.*

Fig. 12. Engraving made from a three-inch-square copperplate which descended in the family of the Reverend Mather Byles, presumably through his grandson the Boston-born painter Mather Brown, who took up permanent residence in England in 1781. While the picture is reversed in this impression, it still retains several recognizable elements common to the paintings in Figs. 10 and 11, and further suggests the same inspiration for the three compositions. *Collection of S. W. A. Almon.*

Fig. 13. Overmantel in the Seth Wetmore house, Middletown, Connecticut, a classical landscape typical of the romantic mood of the mid-eighteenth century. An almost identical panel may be seen in the Burbank-Phelps-Hatheway-Fuller house in Suffield. Both were probably inspired by imported engravings adapted by a local New England artist. *Collection of Samuel M. Green.*

Fig. 14. Overmantel from the Colonel Josiah Pitkin house, East Hartford, Connecticut. One of a large group of wall panels by the same artist which includes examples in Middletown, Connecticut, and Hingham, Massachusetts. Castles, ruins, and European country scenes form the subject matter of this notable series. While individual derivations are still obscure, the painter's competent technique is unmistakable whenever new examples come to light. *Wadsworth Atheneum.*

Fig. 15. Imported scenic wallpapers simulating engraved Italian landscapes framed in graceful rococo moldings should not be overlooked as prime sources of inspiration for American panel painters. Many picturesque details in examples such as this in the Jeremiah Lee Mansion reappeared in simplified form over New England country fireplaces and provided a touch of Old World elegance in colonial homes. *Marblehead Historical Society; photograph by courtesy of the Society for the Preservation of New England Antiquities.*

graphs have been shown has as yet been able to pinpoint the original.

A last significant group of American panels relies heavily on southern European motifs which are as picturesque as they were remote from the everyday experience of the journeymen artists by whom they were borrowed (Figs. 13, 14). Individual sources are still unidentified but their inspiration, based on eighteenth-century neoclassicism, is not far to seek. These variations on themes of classical antiquity were no doubt also inspired, at least in part, by European importations. *The Boston News-Letter* for July 8, 1773, advertised: "A set of very handsome Prints, neatly framed and glazed, engraved from original Paintings by Claud Lorrain." Surely the fashionable English wallpapers, such as those ordered in the 1760's for the Lee Mansion in Marblehead (Fig. 15) and the Van Rensselaer Manor House in Albany, must have played their part in acquainting the average citizen with the flavor of Italy and the romantic glamour of the Grand Tour, which was soon to become a "must" for sophisticated young Americans.

Untrained though they may have been in the tenets of formal art, our indigenous painters were not afraid to adapt almost any variety of available source material, and in so doing produced a large group of landscapes which had style, individuality, and above all appropriateness for the decorative purposes they were intended to fulfill.

Liberty and considerable license

BY LOUIS C. JONES, Director, New York State Historical Association

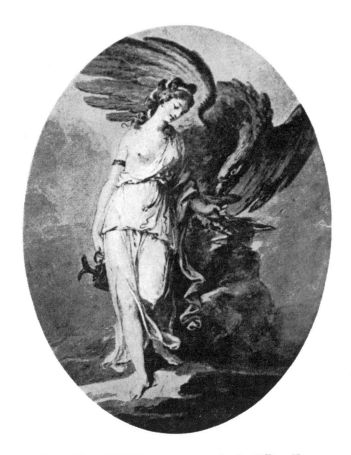

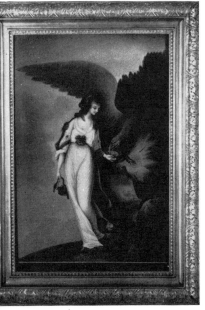

Fig. 1. *Hebe*, by William Hamilton, R.A. (1751-1801); oval water color 11¾ by 9 inches; c. 1791. Homer Eaton Keyes was undoubtedly correct in suggesting (ANTIQUES, November 1935, p. 187) that Hamilton's *Hebe, Goddess of Youth* inspired Savage's *Liberty. In the form of the Goddess of Youth*. It probably also inspired Benjamin West's *Psyche on a Rock*, c. 1805.

Fig. 2. *Hebe*, by a Chinese artist, painted on glass. Based upon a lost engraving of Figure 1. A family heirloom owned by Mrs. Francis B. Crowninshield.

I was also told of a gentleman of High Cincinnati ton and critical in his taste for the fine arts, who, having a drawing put into his hands, representing Hebe and the bird, umquhile sacred to Jupiter, demanded in a satirical tone, "What is this?" "Hebe," replied the alarmed collector. "Hebe," sneered the man of taste, "What the devil has Hebe to do with the American eagle?" (Frances Trollope, Domestic Manners of the Americans.)

IN 1796, IN PHILADELPHIA, Edward Savage published an engraving of his painting entitled *Liberty. In the form of the Goddess of Youth; giving Support to the Bald Eagle*. The remarkable impact of this engraving on non-academic artists over the following quarter century provides us with a tantalizing series of footnotes on the iconography of our national symbolism and the variety of folk expression stemming from a common source.

Savage began his career as a goldsmith in Princeton, Massachusetts, but by 1785, when he was twenty-four years old, he was already a competent painter, producing expert copies after Copley. He went to London in 1791, presumably to study under Benjamin West. We may hazard the guess that during the three years he was there he became aware of a painting of Hebe by William Hamilton (Fig. 1) which is the discoverable genesis of the theme we are considering.

Hebe is a water color of a young woman with a ewer in her right hand, chalice in her left, offering a drink to her father, Zeus, in the guise of an eagle. Here are the elements to appear and reappear: the dominant figure of a maiden in classical garb holding a cup from which she quenches the thirst of an eagle. Scores of details will change but these elements provide the thread which runs through the pictures under consideration. Apparently an engraving made from this painting found its way to Canton where a skilled Chinese artist painted it on glass (Fig. 2). The position of the eagle in his copy is slightly different from that in the Hamilton original, the face of Hebe is sharpened and refined, her gown is tidied up and made more contemporaneous, but the indebtedness is unmistakable.

Savage returned to Boston in 1794, married, and by 1796, when *Liberty. In the form of the Goddess of Youth* (Fig. 3) was engraved, was living in Philadelphia. So far as can be determined the history of his original painting, which was life size, is unknown beyond the fact that it was exhibited in 1802 in the Columbian Gallery, South Greenwich Street, New York City. The artist's description in the exhibition catalogue clarifies some of the detail: ". . . in the Back-ground is a monument supporting a Flag-staff on which is suspended the Cap of Liberty and the union of the United States; in the offscape appears a view of Boston harbor representing the Evacuation of

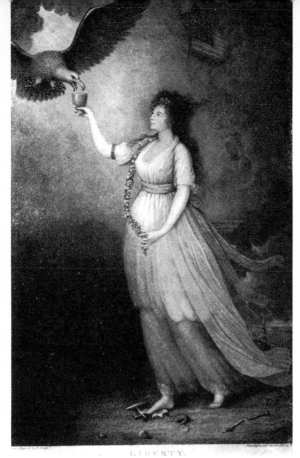

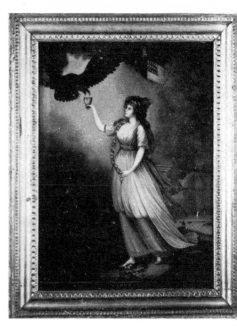

Fig. 3. *Liberty. In the form of the Goddess of Youth; giving Support to the Bald Eagle,* painted and engraved by Edward Savage (1761-1817), Philadelphia, and published by him June 11, 1796; 23 by 14¾ inches. Details are fully explained by Savage, but the dark lower left was the area needleworkers and velvet painters later put to their own imaginative use. *This and Figures 7 and 8, Harry Shaw Newman, The Old Print Shop.*

Fig. 4. *Liberty.* Chinese painting on glass, 22½ by 16½ inches, is a typically meticulous Chinese copy of Savage's work but it differs from the original in two minute details: there are only five ships in Boston Harbor and there are fifteen stars in the flag. *Henry Francis du Pont Winterthur Museum.*

the British fleet; the Goddess of Liberty is supposed to be on Beacon-hill, where she tramples under foot the Key of the Bastile, as the Key of Tyranny Connected with the different orders of Hereditary Nobility." The "Key of Tyranny" is, of course, the key to the Bastille which had been sent to Washington in 1790 by Lafayette and is still to be seen at Mount Vernon.

In the late eighteenth and early nineteenth centuries Cantonese artists raised to a delicate and meticulous art the copying of Occidental engravings translated into oil on glass, largely for export back to Europe and America. In China paintings on glass were most frequently to be found in *maisons tolérées*, where American and British sailors may have had the opportunity to broaden their esthetic appreciation. The popularity of painted copies on glass of Savage's engraving is to be judged by the fact that no less than five are known to exist in this country a century and a half later: two in the Metropolitan Museum of Art, one at the Winterthur Museum (Fig. 4), one in the possession of Arthur Edwin Bye of Philadelphia, and one owned by Mrs. Francis B. Crowninshield which is framed identically with her *Hebe* (Fig. 2) and is a companion to it.

Each of these Chinese paintings is a most exact copy of Savage, the only deviation being in the number of stars in the flag and the number of ships in Boston Harbor. There were thirteen stars in Savage's flag; most of the Chinese copies show fifteen, the actual number of stars between 1792 and 1796.

We now turn to the American copies of this engraving and the variety of media used. The first of these is a water color found in an attic in Alexandria, Virginia (Fig. 5).

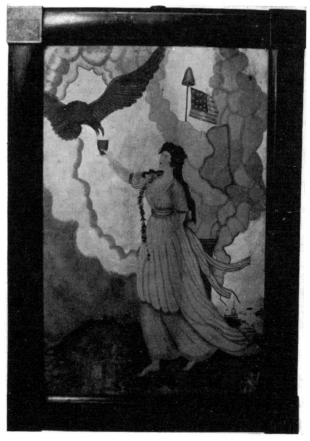

Fig. 5. *Liberty.* Water color, 22 by 15 inches. The only water color close to Savage's engraving. Homer Eaton Keyes suggested cautiously (ANTIQUES, June 1932, p. 257) that this, too, might be Oriental but nothing except the slanting eyes supports this conjecture. *Collection of Charles R. Hooff.*

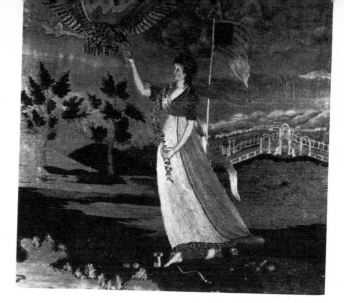

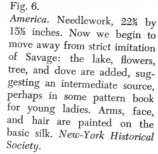

Fig. 6.
America. Needlework, 22¾ by 15½ inches. Now we begin to move away from strict imitation of Savage: the lake, flowers, tree, and dove are added, suggesting an intermediate source, perhaps in some pattern book for young ladies. Arms, face, and hair are painted on the basic silk. *New-York Historical Society.*

Fig. 7.
Liberty at Trenton. Needlework. Here a creative artist takes over with notable results: in place of Boston is Trenton, New Jersey, and the arch the ladies of that town made for General Washington; trees and landscape are invented, the flowing scarf and chirpy face are substituted.

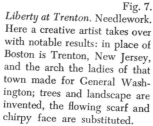

Fig. 8.
Liberty. Painting on velvet. 22 by 16 inches. Boston is gone, the lake lies lower left. Stripes in the flag are blue.

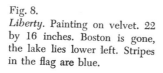

Fig. 9. *Liberty and the Bald Eagle.* Painting on velvet, 22 by 18 inches, in original painted frame. There must have existed a common source in which the urn, the lake, boats, trees were added, for this is similar to an example found in Kentucky (ANTIQUES, November 1947, p. 352). The liberty cap has shriveled to indistinctness; the basket of fruit is unique. *Collection of Nina Fletcher Little.*

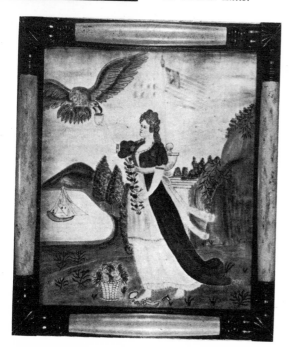

Interesting liberties were taken with the original by the two ladies whose needlework examples survive. In Figure 6 Boston Harbor still appears in the right "offscape," but one ship and a rowboat are all that is left of the fleet, while on the left, below the eagle, is a curiously shaped tree with a dove peering at Liberty. More imaginative and more successful is *Liberty at Trenton* (Fig. 7), which retains the basic elements but has substituted for Boston a scene from Trenton, New Jersey, a pair of trees and mountains on the left. Liberty, here, has a winsomeness lacking in all but the Chinese *Hebe.*

Three executions on velvet are known (ANTIQUES, November 1947, p. 352; and Figs. 8, 9) and there is evidence that they may derive not directly from the Savage engraving but from a still undiscovered pattern book which blithely suggested certain changes in the original. Boston Harbor is replaced by landscape with trees. The lower left now shows a lake, in two instances with a boat on it. There is a freedom to add and subtract which the Chinese glass painters did not feel and there is a grossness about the figures. I regret to observe that when girls gave up needlework for painting on velvet, some evil influences had begun to permeate life in America.

Finally, there are two oil paintings, a needlework piece, and two water colors which indicate that the folk memory retained certain elements of Savage's work long after it had ceased to have a direct effect. Each of these has details in common with and is derivative from the engraving. In most of these Liberty (or her successor) now holds the flag in her left hand, her costume has undergone complete change, the eagle has assumed far less importance; in none of them is the liberty cap on the flag pole; the symbols of monarchical tyranny have been changed or eliminated and three memorialize Washington. Essentially these represent a girl with a flag rather than a girl giving nourishment to an eagle, but in Figure 10, the two groups find a perfect meeting place, for here girl, eagle, and flag receive equal emphasis.

Around this theme gather the artists of England, China, and our young republic. The English and English influence on Savage provided the academic models; the Chinese, responding to a market, imitated precisely; while Americans, careless of the academic tradition, rang such changes of detail, of mood, and of media that the derivation becomes almost unrecognizable.

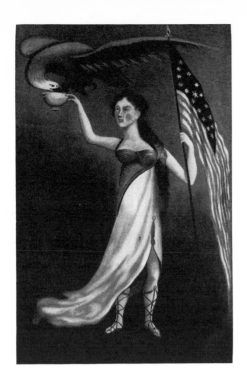

Fig. 10. *Columbia.* Oil on canvas, 29⅞ by 20 inches. The girl (Liberty?), eagle, cup, and flag are still present but the eagle has changed the direction of his flight, the girl's costume is new, she now holds the flagpole. I suspect another undiscovered source, influenced by Savage but fresh in approach. *National Gallery of Art (collection of Edgar William and Bernice Chrysler Garbisch).*

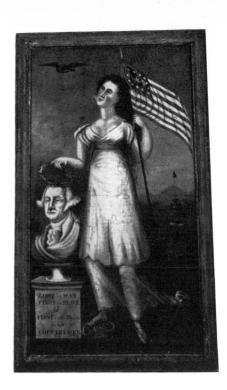

Fig. 11. *Liberty and Washington.* Oil on canvas, 67 by 34¼ inches. From Savage: Liberty, eagle, liberty cap, symbol of tyranny. In common with Figure 10: direction of eagle, laced sandals, flagpole in left hand. New elements: Washington, laurel wreath, liberty pole, pine tree, mountains, crown. The eagle recedes into insignificance. *New York State Historical Association, Cooperstown.*

Fig. 12. *Mourning Picture — George Washington.* Needlework and water color on silk, 20⅞ by 17⅛ inches. This is Fame, not Liberty, but the liberty cap, her standing on the British flag, the British fleet, the posture of the main figure suggest a valid descent from Savage. *Abby Aldrich Rockefeller Folk Art Collection.*

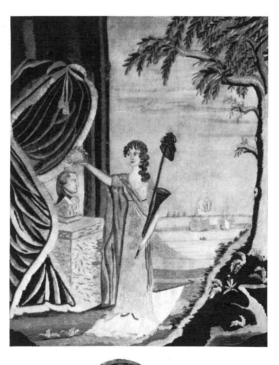

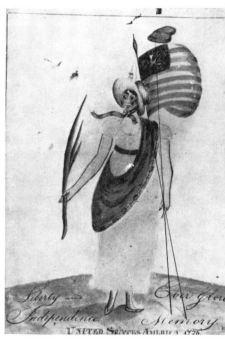

Fig. 13. *Miss Liberty.* Water color on paper, signed *F*; 10 by 8 inches. Here and in the frontispiece the eagle appears on the flag and the liberty cap on a second pole. The palm leaf and palm tree provide a new element, accentuated in the frontispiece by the title *Emblem of Peace.* Note the clocks in Miss Liberty's stockings and the contemporary (c. 1815) costume. *Abby Aldrich Rockefeller Folk Art Collection.*

Fig. 14. Trade sign painted on canvas, c. 1860. Back where we started with a girl, a cup, and an eagle. *Connecticut Historical Society.*

Emblem of Peace. 1823. Water color on paper, 14 by 11½ inches.
Collection of Dr. and Mrs. Louis C. Jones.

How pictures were used in New England houses, 1825-1850

BY BEATRIX T. RUMFORD, *Director, Abby Aldrich Rockefeller Folk Art Collection*

CONTEMPORARY PORTRAITS and genre scenes are probably the best sources of information about the popular taste in pictures and how they were framed and hung in middle-class New England homes during the second quarter of the nineteenth century.

During this period, portraits were the most popular kind of picture, followed by landscapes, decorative prints and fancy pieces, including theorem paintings, memorials, and family records. Proof of this can be found in the many inventory references to portraits, in the great number of portraits which have survived, and in the preponderance of portraits shown in views of contemporary interiors—views that themselves very often form the background in

portraits. Written accounts also emphasize the importance of painted likenesses, for example Edward Everett Hale's description of a Boston interior of 1825:

A handsome parlor then, differed from a handsome parlor now, mostly in the minor matters of decoration. The pictures on the walls were few, and were mostly portraits. For the rest, mirrors were large and handsome. You would see some copies from well-known paintings in European galleries, and any one who had an Allston would be glad to show it. But I mean that most walls were bare.[1]

In the portrait of Mr. and Mrs. Charles Henry Augustus Carter (Fig. 1) painted about 1845, three portraits in ornate frames of gilded plaster and wood are placed high on the

Fig. 1. *Mr. and Mrs. Charles Henry Augustus Carter*, attributed to Nicholas Biddle Kittell (1822-1894), c. 1845. Oil on canvas, 23½ by 21½ inches. *Museum of the City of New York.*

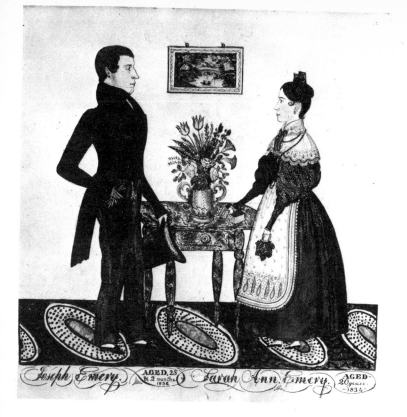

walls. They are suspended on exposed cords from nails driven into the wall just below the ceiling molding. Until the early 1900's pictures were hung considerably higher than the five and one-half foot center line advocated by decorators today. In 1841 Catharine Esther Beecher wrote: "In hanging up pictures around a room, they should be placed so that the lower parts are not above the eye of an observer. It prevents defacing a wall, if there are many pictures, to have long brass rods at the top of the wall, from which the pictures can be suspended, by cords or ribands, which should all be of a color."[2] Miss Beecher suggests hanging pictures from brass picture rods, but probably the most common method was to attach rigid screw eyes to the top of the frame and drive nails or decorative pins through them into the wall (Figs. 2, 3). This was the continuation of an eighteenth-century practice. Illustrations of nineteenth-century interiors also show pictures attached by a variety of ribbons and cords to nails, cast-brass pins, pressed-glass knobs, or South Staffordshire enamel knobs (see Fig. 4).

Fig. 2. *The Emery Family,* by Joseph H. Davis (w. 1832-1838), 1834. The pastoral landscape may represent a watercolor executed by Sarah Ann when she was a school-girl. Its decorative frame could be the result of Joseph H. Davis' fanciful brushwork rather than an actual frame. Even so, the design relates to colorful freehand motifs found on some frames of about 1835. Watercolor on paper, 14½ by 14½ inches. *New York State Historical Association.*

Fig. 3. *Sportsman with Dog,* artist unknown, c. 1835. The severe beveled, veneered frame with half-round moldings shown in the picture is typical of the period. A similar frame surrounds the actual portrait. Oil on canvas, 72 by 47½ inches. *Abby Aldrich Rockefeller Folk Art Collection.*

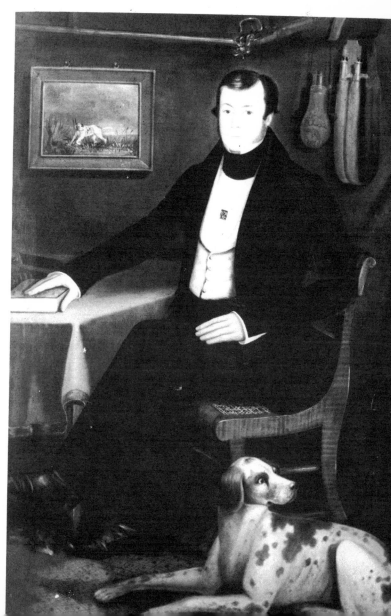

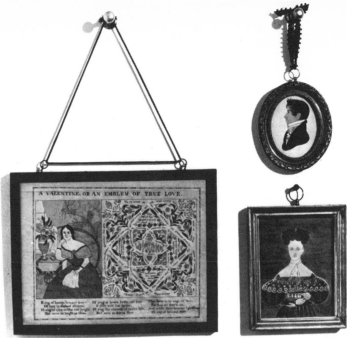

Fig. 4. Three small watercolors in their original frames arranged to illustrate hanging methods popular between 1825 and 1850. *Left:* Labyrinth valentine derived from a print, c. 1835. The reed-molded frame, stained to resemble mahogany, is hung on braided cord which passes through rings attached to screw eyes on top of the frame. The hanging pin is cast brass. Watercolor on paper, 8 by 10⅝ inches. *Upper right:* Miniature of an unknown subject by an unknown artist, c. 1825. The molded brass frame is hung from a picot ribbon knotted around the hanging ring and tied to a cast-brass hanging pin. Watercolor on paper, 4 by 3⅜ inches. *Bottom right: Lady in Blue,* attributed to R.W. Shute and S.A. Shute, c. 1832. The cove-molded and gilded frame is hung from a nail by means of a brass ring hanger. Watercolor on paper, 5⅞ by 4⅝ inches. *Abby Aldrich Rockefeller Folk Art Collection.*

Fig. 5. *A Greek Revival Interior,* artist unknown, c. 1835. Oil on canvas. *Photograph by courtesy of Hirschl and Adler Galleries.*

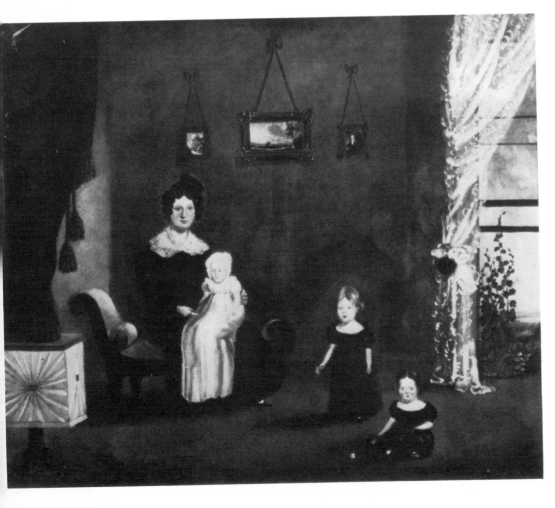

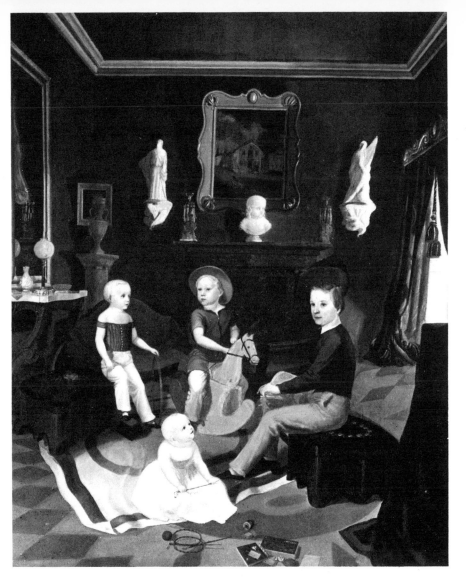

Fig. 6. *The Carryl Children of Salisbury Center, New York,* artist unknown, c. 1850. The frame on this portrait duplicates the frame on what appears to be the depiction of a warehouse which hangs over the mantel. During the first half of the nineteenth century owners would commission paintings of their house, farm, ship, or business premises. This type of picture was essentially an extension of portraiture. Oil on canvas, 47¼ by 38 inches. *Fruitlands Museums.*

Fig. 7. *Yankee Pete Tavern,* artist unknown, c. 1850. The name of Philip Snyder, proprietor of this Schoharie, New York, tavern, is inscribed at upper right. His father, known as "Yankee Pete" Snyder, built the tavern about 1819. Oil on canvas, 24⁵⁄₁₆ by 36⅛ inches. *Abby Aldrich Rockefeller Folk Art Collection.*

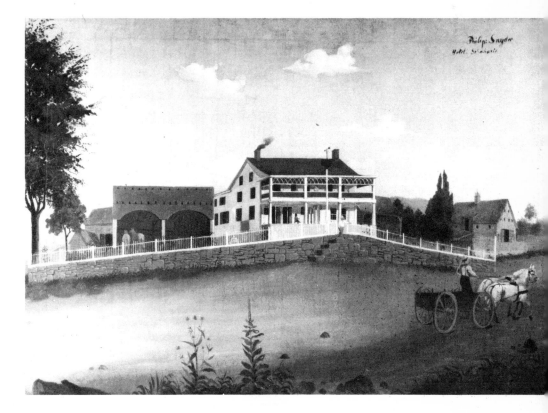

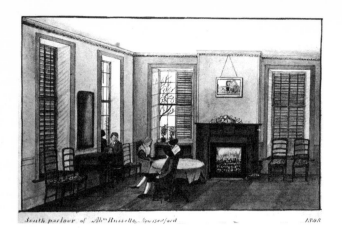

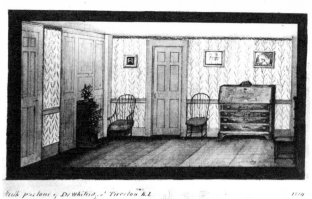

Fig. 8. *South Parlor of Abm Russell Esq. New Bedford*, by Joseph Shoemaker Russell (b. 1795), 1848. The bare branches of the tree outside and the coal fire burning briskly in the grate suggest that the sketch was done in winter. A looking glass with a plain veneered frame hangs just above the chair rail so it could be used by shorter members of the family. By contrast, the painting above the mantel is hung quite high. Watercolor on paper, 5½ by 8⅞ inches. *Whaling Museum, New Bedford.*

Fig. 9. *North Parlor of Dr. Whitridge's Tiverton, R.I.*, by Russell, c. 1840. The picture was presumably painted thirty years after the 1814 date inscribed. It was perhaps based on an earlier sketch. The presence of flowers in and on the iron warming stove indicates summertime. Besides the pictures on the wall, other interesting details include a skirted slipcover on the windsor armchair and the wallpaper, especially the contrasting border at the ceiling line. Watercolor on paper, 4⅝ by 8⅝ inches. *Whaling Museum.*

Fig. 10. *The Rev. John Atwood Family*, by Henry F. Darby (b. c. 1831), 1845. The same severe kind of gilded moldings frame the pictures on the back wall and the looking glass resting on the mantel. Oil on canvas, 72 by 96¼ inches. *Museum of Fine Arts, Boston.*

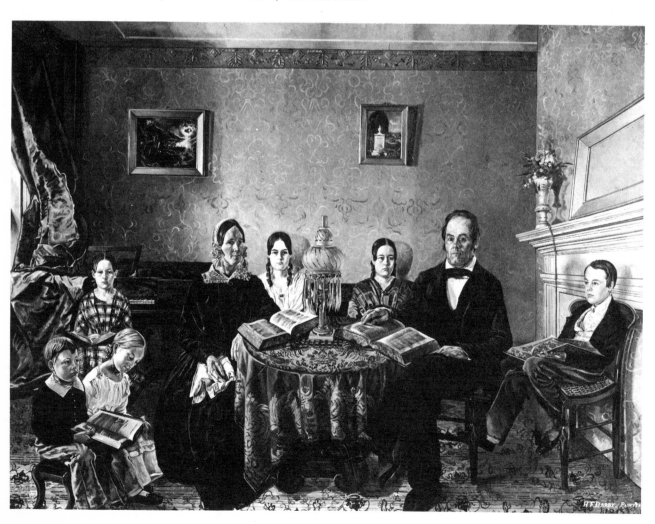

44

Fig. 11. Frontispiece from *The Well Bred Boy* (Boston, 1839). This rather idealized view of a schoolboy's bedroom documents the practice of tacking unframed pictures to the wall. Wood engraving. *Society for the Preservation of New England Antiquities.*

Neither the artist nor the subjects of *A Greek Revival Interior* (Fig. 5) have been identified, but the scene nicely documents the appearance of a fashionable parlor of the 1830's. Except for the baby, everyone wears mourning. The painting probably commemorates the father's recent death; presumably it is his portrait that hangs on the back wall together with a pair of romantic landscapes. The three pictures are framed in matching gilded frames with cast-plaster classical motifs applied in the corners. Each painting is suspended on long black ribbons tied in a bow around a brass hanging pin.

In the portrait of the Carryl children (Fig. 6) the peculiar cater-corner position of the small painting with the beveled, gilded frame behind the two-handled vase indicates that the arrangement and grouping of pictures was as much a matter of personal taste in the second quarter of the nineteenth century as it is today. The subject matter of the picture above the mantel seems oddly informal in the overdecorated Carryl parlor. Perhaps like *Yankee Pete Tavern* (Fig. 7), which was painted for the tavern's proprietor, the painting in the Carryl portrait was commissioned by the children's father and represents his business premises. Pictures of houses, business establishments, and shops were frequently ordered by their owners and displayed as prominently as family portraits. A scene of this type is shown hanging high over the mantel in Joseph Shoemaker Russell's 1848 watercolor of the south parlor of his father's house in New Bedford, Massachusetts (Fig. 8). The painting has a simple gilded frame and hangs on a twisted cord from a nail driven into the wallpaper border.

Fig. 12. *Eagle Mill,* attributed to Thomas Wilson, c. 1845. The town of Eagle Mills, in which the mill was situated, is a few miles east of Troy, New York. The mill was later converted to a hoe factory and burned in 1911. The grapevine painted on the canvas takes the place of a frame. Oil on canvas, 36 by 40 inches. *Abby Aldrich Rockefeller Folk Art Collection.*

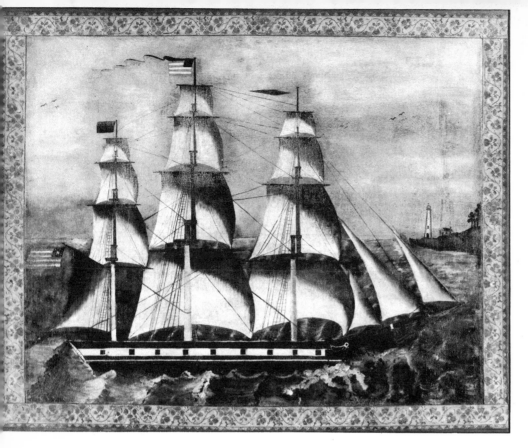

Fig. 13. Picture of a ship, with a wallpaper border, artist unknown, c. 1825. This is thought to be an imaginative representation of a type of frigate used by the American navy in the first quarter of the nineteenth century. The unusual applied border of contemporary wallpaper acts as a frame. Oil on canvas, 36½ by 45 inches. *Abby Aldrich Rockefeller Folk Art Collection.*

Russell seems to have been meticulous about recording his surroundings. In his view of the north parlor of Dr. Whitridge's house in Tiverton, Rhode Island (Fig. 9), the three small pictures nicely document several popular genres of painting. The portrait of a man on the left is probably executed in watercolor or pastel. The subject of the picture in the center seems to be an artist at his easel. It could be a wash drawing, or perhaps it represents one of many prints and engravings listed in inventories which were used as wall decorations and collected in the portfolios found on parlor tables. At the right is a mourning picture perhaps executed as a classroom exercise in a girls' seminary. It would not be unusual if the memorial honored someone who had died before the young artist was born. All three pictures have gilded frames and black borders reverse-painted on the glass.

The Rev. John Atwood Family (Fig. 10) of 1845 is a splendid record of the taste of a middle-class New England clergyman. The parlor is not the usual hodgepodge of old and new. The simple but stylish furnishings are in the latest fashion, including the pictures in gilded frames, which are hung high and off-center from ring hangers. The tombstone in the memorial is inscribed *John,* for two sons who died as infants. Appropriately, the other scene has been identified as a Biblical one, *Samson Carrying Off the Gates of Gaza.* It represents or is derived from a mezzotint by the English engraver James S. Lucas.[3]

The eighteenth-century habit of tacking inexpensive prints to the wall continued in this period (Fig. 11). Household receipt books, including the 1828 Boston edition of *The House Servants Directory* and Rufus Porter's invaluable *Curious Arts,* published in 1826, explain how to back maps and prints with linen and varnish their faces so that they would continue to look fresh without the more costly protection of glass and frame. Paintings too were

Fig. 14. *Profile of a Boy,* by Ruth Henshaw Miles Bascom (1772-1848), c. 1835. The frame was supplied by the artist. Pastel on paper, 16 by 12 inches. *Abby Aldrich Rockefeller Folk Art Collection.*

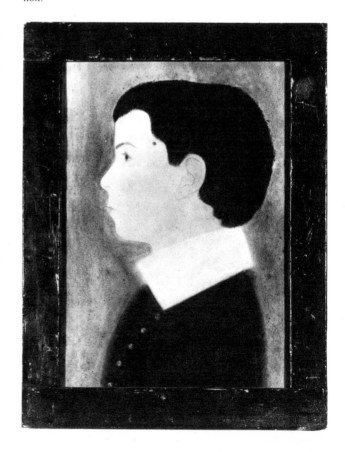

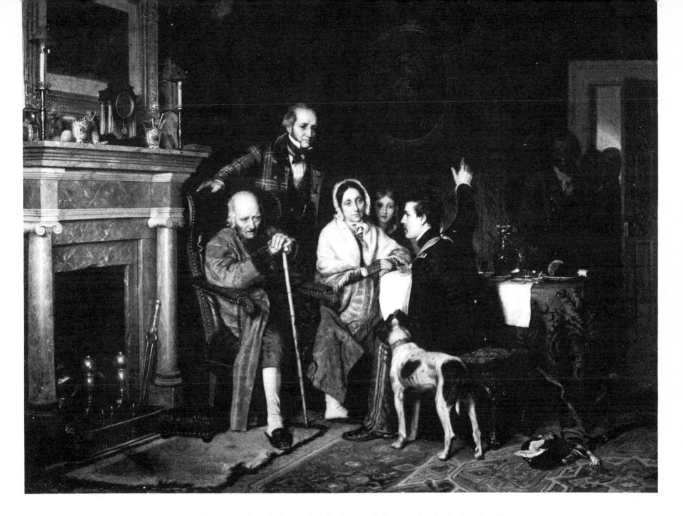

Fig. 15. *Old '76 and Young '48*, by Richard Caton Woodville (1825-1855), 1849. The historical engraving above the mantel has an ornate frame complete with reeded inner members and foliate cartouches of cast plaster applied in each corner. The more restrained frame surrounding the oval portrait of a Revolutionary hero has a decorative outer border incorporating classical motifs. Oil on canvas. *Walters Art Gallery.*

hung without frames. A number of portraits from this period still have brass hanging rings attached to their top stretchers and no surface wear along the edges of the canvas to suggest that they ever had frames. In the view of Eagle Mill a painted grapevine takes the place of a frame (Fig. 12); in a ship painting in Williamsburg's collection, a border of wallpaper strips applied to the canvas serves the same purpose (Fig. 13).

Frames could be purchased from local carpenters and cabinetmakers or from certain artists. In an 1842 entry in his journal Joseph Whiting Stock writes, ''finished Mrs. Fitch's portrait and sold a frame with it.''[4] Sometimes the use of identical frames on different pictures can be a clue to the work of a particular painter. Many of the life-size pastel profile portraits signed by Ruth Henshaw Miles Bascom have survived in simple board frames usually composed of four flat strips of white pine stained to simulate cherry or mahogany (see Fig. 14). In her diaries, now at the American Antiquarian Society, Mrs. Bascom records that she supplied the glass and framed her own pictures.

The gilded frames popular in the second quarter of the nineteenth century tend to be either overloaded with orna-

ment or quite severe. Less sophisticated than the gilded wood-and-plaster confections used on academic pictures and more suitable for straightforward likenesses painted by itinerant artists were frames modeled on architectural moldings. That surrounding *Vermont Family* (Fig. 16) closely resembles the trim used on doors and windows in simple Greek revival houses.

Many of the techniques popular with furniture decorators—marbleizing, graining, stenciling, and freehand painting—were also used on picture frames. The portrait of David Hall Hilliard attributed to Asahel L. Powers (Fig. 17) has a rather elaborate architectural frame composed of split balusters with blocked corners. The surface has been stained to resemble mahogany, with floral motifs stenciled on it in bronze paint and cast-brass mounts applied to each block.

A few artistic liberties are inevitable but, viewed with discretion, paintings of nineteenth-century interiors generally provide more information about the use of pictures in rooms than any written documents. In addition, many of these scenes suggest something about the artists' values and the attitudes and interests of their patrons.

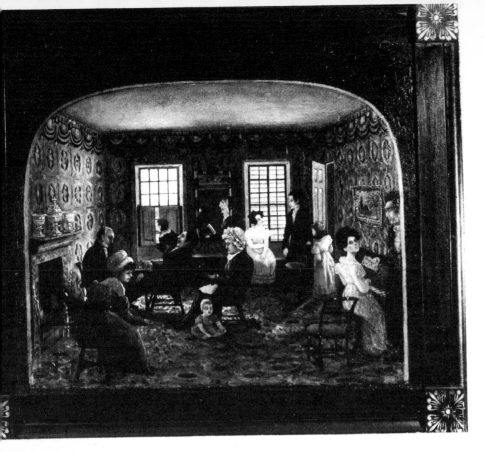

Fig. 16. *Vermont Family*, artist unknown, c. 1830. A simple architectural molding is combined with stenciled blocks to frame this delightfully cluttered parlor scene, which nicely documents leisure-time activities and details of interior decoration in the 1830's. More elaborate frames appear on the Empire pier glass between the windows and the landscape shown hanging over the piano in a room where the design in the wall-to-wall carpet competes with boldly patterned geometric wallpaper and its swag border. Despite some rather obvious technical problems, the artist managed to include a dozen people in his animated composition. Oil on canvas. *Private collection; photograph by courtesy of Childs Gallery.*

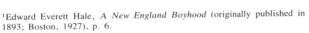

[1]Edward Everett Hale, *A New England Boyhood* (originally published in 1893; Boston, 1927), p. 6.

[2]Catharine E. Beecher, *A Treatise on Domestic Economy for the Use of Young Ladies at Home and at School* (Boston, 1841), p. 342.

[3]Inge Hacker, "Discovery of a Prodigy," *Museum of Fine Arts* [Boston] *Bulletin*, Vol. 61, No. 323, pp. 25, 26.

[4]Journal of Joseph Whiting Stock, unpublished manuscript in the collection of the Connecticut Valley Historical Museum, Springfield, Massachusetts, p. 48.

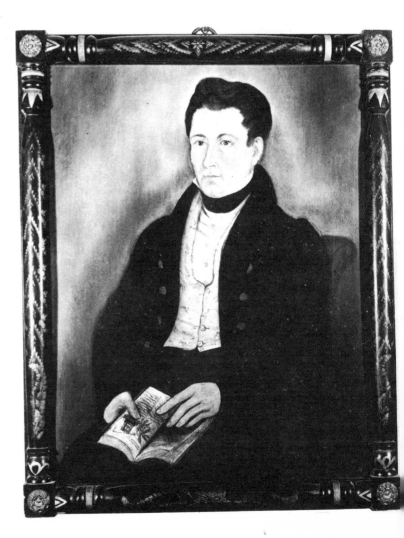

Fig. 17. *David Hall Hilliard*, attributed to Asahel L. Powers (1813-1843), 1833. Although he holds a book opened to a section on coining, Hilliard was a Vermont gunsmith. The handsome frame is thought to be original and may be a product of the Hitchcock factory. Oil on canvas. *Photograph by courtesy of Kennedy Galleries.*

II Painting

The great heyday of American folk art production was the first half of the nineteenth century, or roughly 1790-1860. The reasons for its popularity are varied. Growth and prosperity followed the turbulent Revolutionary years and the disruptive War of 1812. Peace and economic stability were kind to the arts. As restless pioneers pushed westward, increasingly affluent and educated Easterners became more interested in supporting the arts. Nationalism and populist democratic urges blossomed as well in the early nineteenth century. Andrew Jackson ushered in the age of the "common man." This ubiquitous symbol of the Jacksonian Era represented a fervent belief in democracy, a feeling which eventually permeated the arts. Amateurs tried their hand at painting and sculpture. Newly-affluent farmers and merchants wanted to see their own likenesses, just as the wealthy gentry of the Hudson Valley had in the eighteenth century. These new art patrons were unaware of European academic traditions and uncritically accepted what was created for them. They eagerly encouraged the work of equally untutored local painters and portraitists. The range of price, size, and medium of portraits was so broad that most could afford a likeness or, at least, a silhouette.

As the new art of photography developed in the late 1840's and 1850's, the demand for likenesses declined. In addition, because of improved public education, the increasing number of public libraries, and the popularity of illustrated magazines and prints, the general public became more aware of what constituted academic art. This increasing sophistication sounded the death-knell for folk art. Naive art was produced for the remainder of the century and into the twentieth century, but on a smaller scale and with overtones of super-sophistication. Today, one must try hard to be naive.

Who were the folk artists? By far the largest number of paintings were produced by artists who did not sign their work and are now anonymous. Most of them were amateurs such as children, housewives, retired persons, or eccentric individuals. Students who attended young ladies' seminaries also produced a prodigious amount of naive art. Some were commercial artisans or craftsmen, such as decorators or sign painters like Edward Hicks, who produced folk art in their spare time. They were not trying to produce "works of art" in the academic sense, but were simply attempting to depict some inspiring subject from everyday life, from traditional lore, or from spiritual revelations. These amateurs, or what we would call "Sunday painters" today, had only to satisfy themselves.

In contrast to the amateurs were the professional artists, the most prominent of whom were Ammi Phillips, Erastus Salisbury Field, Isaac Sheffield, Joseph Goodhue Chandler, Sheldon Peck, Joseph S. Blunt, and the Prior-Hamblen school. They were sometimes lucky enough to have a studio.

Often, they had another principal occupation and only painted portraits in good weather, when they could travel from town to town. Frequently, they would paint landscapes and historical subjects during inclement weather and sell them during their travels.

The professionals usually had more skill and dexterity than the amateurs, although they were also self-taught and were, no doubt, often instructed by another artist. Their general lack of training and knowledge of traditional academics led to the creation of non-academic or naive paintings which met with approval from an unsophisticated public. Their relative ignorance reinforces the contention that they were not executing unskilled imitations of academic art.

What are some of the characteristics of this naive art? Technically, there is a tendency toward flatness and a deficient understanding of the use of light and shadow. The artist had great difficulty with perspective and spatial relationships. Often, an object was outlined and then the color was filled in. Countless distorted hands and ears testify to a problem with draughtsmanship. Much use was made of bold, colorful decorative design, particularly by professionals who also served as ornamental painters. Linear composition is an oft-repeated technique. Many paintings contain, for example, rows of trees or marching soldiers. This perspective leads to a characteristic repetitive quality of objects, forms, and designs.

What did these amateur/professional non-academic artists portray? At times they reached a simplification and directness—an abstraction—that omitted unnecessary detail, but which allowed for a piercing characterization and candor that a society portraitist could not afford to employ. There was a greater emphasis on what the artist had to say, than on how he said it. In other words, content over style. Folk artists often reveal a rollicking sense of humor and a wonderful use of imagination. Fantasy also enters into the scene in what is painted and how it is presented. These conservative, non-sexual, and non-hostile paintings may come closer to illustrating life as it is fantasized rather than how it is lived. The gap between the ideal and the real can be exemplified by a comparison of Seifert's idyllic Wisconsin farmscapes with the photographs and text in Michael Lesy's *Wisconsin Death Trip* (1973). Flights of fancy can also be seen in derivative folk art, or paintings which are based on prints. For the folk artist the print was merely a stopping-off place for the artist's imagination.

This look at the character of naive art is necessarily brief. It is just as difficult to describe the contents of folk art as it is to define its scope. The specialists will continue to struggle with meanings, while an interested public will continue to enjoy the art.

BENJAMIN GREENLEAF

New England Limner

By JEAN LIPMAN

THE NAME of Benjamin Greenleaf (*1786–1864*) is still well known to educators and mathematicians, and his achievements in these fields are fully recorded in the *Dictionary of American Biography*. This biography does not, however, mention that Greenleaf was a portrait painter. Mantle Fielding merely lists him as "a painter of portraits who was working in New England about 1817." Surely his remarkable group of portraits on glass merits as much attention today as does his series of arithmetic textbooks published in the 1800's, which the *Dictionary* article features as his chief gift to posterity.

Benjamin Greenleaf was born in Haverhill, Massachusetts, in 1786. He was a descendant of Edmund Greenleaf, who came from England in 1635 and settled in Newburyport, Massachusetts. Benjamin worked on his father's farm as a boy, and had so little schooling that at the age of fourteen he didn't know the multiplication table. But he was eager for learning and in his late teens he began, on his own initiative, to prepare for a higher education. He started his portrait painting at this time, presumably to help pay his way through college. In 1804, at the age of eighteen, he painted his first recorded portrait, of the Honorable Doctor Colton Tufts, president of the Medical Society in Boston. This portrait, now in the collection of the Boston Medical Library, represents the tall, august Doctor Tufts in a black suit, short curled wig and white stock, sitting at a round table, his right hand on a book. It seems extraordinary to find a boy of eighteen executing so important a portrait commission in such a dignified manner. This is the only discovered portrait by Greenleaf that is painted on canvas. All the others are on glass.

All but one of the portraits found to date were painted before 1820. The exception is the portrait of a child attributed to him which, judging by the costume, was probably painted about 1825.

Portrait painting was evidently an important moneymaking activity in Greenleaf's youth. We know that before entering the sophomore class of Dartmouth College in 1810, he had also taught elementary school. A small income from teaching and portrait painting seems to have paid his way through college.

In 1810, the year he entered college, he painted the portrait of Lydia Warterman (*Fig. 3*), probably his most remarkable glass portrait. The manner in which the severely profiled black-and-white figure is silhouetted against the dark olive ground creates a striking and perfectly balanced design. The characterization of the old lady is as acute as the linear contours and the tonal contrasts. The combination of bold design and intense character study creates a portrait which seems like an American version of a Holbein, an amazing portrait indeed for a Dartmouth sophomore to have produced. Technically the portrait is extraordinarily advanced for the student-painter who created it.

It is interesting to remember that

in executing these portraits, painted in reverse on the under side of the glass, the artist began with the details closest to the surface. In the Lydia Warterman portrait, for instance, the pin fastening the black ribbon on the cap was painted first, then the ribbon, then the cap. In the face, the highlights and shadows had to be detailed before the flesh was painted in. The need for precise technical calculation at every stage must have appealed to Greenleaf's mathematical mind. However, one is unaware of the tricks of the difficult trade of glass painting in the finished portrait, an impressive example of native American portraiture at its best.

It seems probable that the portraits of the unidentified divine and his wife (*Figs. 4 and 5*), clearly attributable to Greenleaf, were painted at approximately the same time, and nothing could be less sophomoric than the style of these early likenesses. In this pair of portraits Greenleaf's instinct for the perfect placing of a figure within the rectangular picture space is again apparent. Here too the crisp details of the lady's white cap and ruff and the clergyman's neckpiece against the black clothing create interesting designs in black and white. The vivid facial characterizations, however, hold our interest fully as much as do the all-over patterns.

At Dartmouth young Greenleaf distinguished himself in mathematics, and when he graduated in 1813 he became the principal of a grammar school in Haverhill. The next year he was made preceptor of Bradford Academy in Bradford, Massachusetts. When he accepted this academic post there were only ten pupils, but within three years a hundred and forty-seven students were enrolled, and the Academy flourished under his charge. He resigned in 1836, to become a member of the Massachusetts legislature.

The majority of the portraits were painted while he was at Bradford Academy, a number of them in Maine. The portrait of

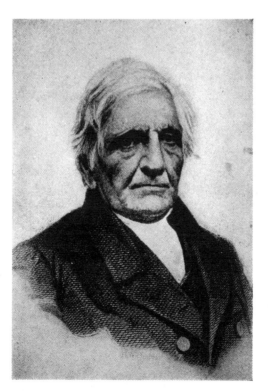

Dummer Sewall (*Fig. 7*) was painted at Bath in 1817, and that of Mark Langdon Hill (*Fig. 6*) at Phippsburg in 1818. These portraits are witness to the robust manner in which a self-taught provincial limner simply and directly described the basic characteristics of his sitters. All superficial detail is omitted, there is no flattering soft light or elegant environment. But one feels the essence of the New England character much more forcefully than in the highly finished academic portraits of the time.

The portrait of Dolly Smith Ripley (*Fig. 8*), who was born in Hallowell in 1801 and died in Portland in 1823, was probably painted in Maine around 1820. Major Jones and his wife were probably painted in Massachusetts, also about 1820. The portrait of Mrs. Ripley is a bit less striking than the others we have discussed. The subject may have had something to do with this, for Greenleaf was not at his best

FIG. 1 — BENJAMIN GREENLEAF. From "A Jubilee Sketch," in *New England Magazine* for May 1903.

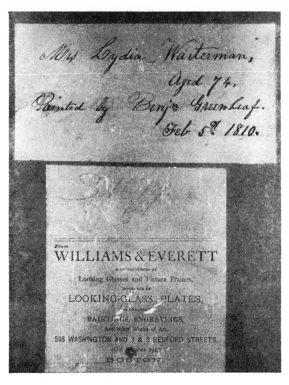

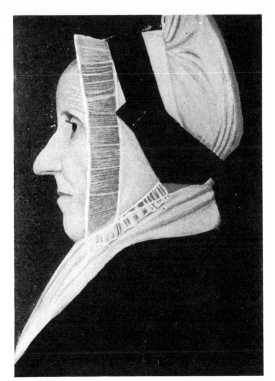

guages, and was used as far abroad as India and Greece. In 1837, 1838, and 1839, Greenleaf was a member of the Massachusetts legislature. In 1839 he founded and became the head of Bradford Teachers' Seminary, which position he held until 1848. His later years he spent on his textbooks and in educational activities, and there is no evidence that he painted after 1825.

An examination of Greenleaf's surviving portraits, painted during the first quarter of the nineteenth century, reveals unusual stability of quality — especially when one considers the fact that the earliest portrait was done when the artist was a boy of eighteen, the latest when he was a man of about forty. Comparing the earnest, somber oil portrait of the Honorable Tufts with the gay little girl painted two decades later, one finds a somewhat surprising evolution. The schoolboy painted with stiff conventionality; the schoolmaster enjoyed a free, independent approach to the art of limning. While the early canvas seems to derive from the academic, English-style portraiture most highly respected in the late eighteenth century, the glass portraits developed a purely native American style.

Benjamin Greenleaf deserves to be known as one of the outstanding provincial limners of nineteenth-century New England.

when portraying smoothly pretty features. The Jones couple are more mature and somewhat more interesting as portraits. They are entirely characteristic of Greenleaf's style, and so are here attributed to him.

In the portrait of the little girl (*Fig. 9*), also attributed to Greenleaf on the basis of stylistic evidence, the artist manages to portray, without any mawkish prettifying, the innocence of the very young. This portrait is not quite such a naïve, primitive affair as one might suppose at a glance. The technique of modeling the flesh is highly developed and the silhouette is deliberately planned for effective variety. Notice the manner in which the branch of peaches, the little butterfly bow of the dress, the zigzag ruching at the back of the neck, and the curl on the forehead, give movement to the plump silhouette of the child.

Benjamin Greenleaf was known as a man of original and progressive tendencies, and also of marked nervousness and eccentricity. He was often impolite, overly dramatic in his utterances, and careless and extremely unconventional in his dress. He is said to have worn his hair braided in a long queue, though the portrait reproduced from a historical account of Bradford Academy (*Fig. 1*) does not show this original hair-do. It is too bad that Greenleaf never painted a self-portrait! During his years of teaching he wrote a series of popular textbooks on arithmetic, algebra, geometry, and trigonometry. *Greenleaf's Arithmetic* was translated into many lan-

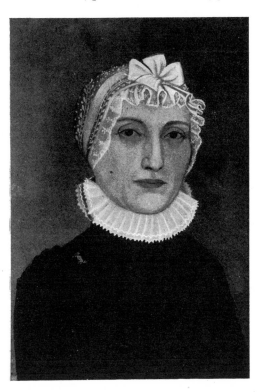

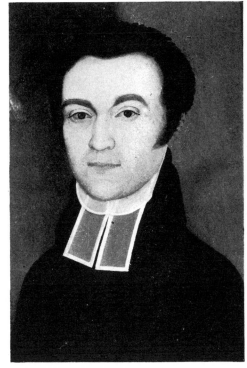

FIGS. 4 AND 5 — UNIDENTIFIED DIVINE AND WIFE. Glass portraits attributed to Benjamin Greenleaf (*c. 1810*). *Collection of Walter P. Chrysler, Jr.*

FIG. 6 — GOVERNOR MARK LANGDON HILL. Painted on glass by Benjamin Greenleaf at Phippsburg, Maine in 1818. Portrait destroyed. *Formerly collection of Bowdoin Museum of Fine Arts.*

FIG. 7 — DUMMER SEWALL. Painted on glass by Benjamin Greenleaf at Bath, Maine in 1817. *Collection of Arthur Sewall.*

Undoubtedly he painted many more portraits on glass in Massachusetts and Maine than those here listed, and I should be greatly interested to hear of additional portraits, so that a complete check list of Greenleaf's portraits may eventually be published.

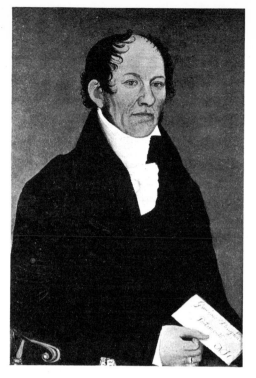
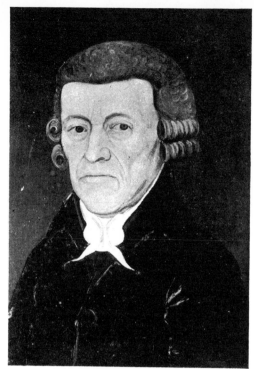

PORTRAITS LABELED BY AND ATTRIBUTED TO BENJAMIN GREENLEAF

Greenleaf apparently made a practice of attaching a label with his signature and information about the sitter on the backing of the portraits he painted. In the case of those listed here as attributed to Greenleaf the labels were probably lost when the portraits were rebacked or reframed.

1. HONORABLE COLTON TUFTS (*1731–1815*). President of the Medical Society, Boston. Oil on canvas, mounted on board. Greenleaf s label, written in ink and pasted on backing of picture reads: *Hon. Colton Tufts M.D. A.A.L. — M.M.S. Drawn in the 73rd year of his life 1804 — By Benjamin Greenleaf. Died Dec. 8th 1815 in the 84th year of his age. Collection of the Massachusetts Medical Library, Boston.*

2. LYDIA WARTERMAN (*Fig. 3*). Oil under glass. Greenleaf's label, written in ink on backing of picture, reads: *Mrs. Lydia Warterman, Aged 74, Painted by Benjn Greenleaf Feb. 5th 1810.* Framer's label is of Williams and Everett of Boston. *Collection of Jean Lipman, Cannondale, Connecticut.*

3 and 4. UNIDENTIFIED DIVINE AND HIS WIFE (*Figs. 4 and 5*). Oil under glass. Attributed to Greenleaf (*c. 1810*). *Collection of W. P. Chrysler, Jr., N.Y.C.*

5. DUMMER SEWALL (*1737–1832*) (*Fig. 7*). Oil under glass. Greenleaf's label, attached to back of frame, reads: *Dummer Sewall Esq./ aet. 80/ painted by Benj. Greenleaf/ at Bath Dec. 30, 1817. Sewall collection, Bath, Me.*

6. HONORABLE MARK LANGDON HILL of Portsmouth (*1772–1842*) (*Fig. 6*). Governor of New Hampshire and later member of Congress. Oil under glass. Penciled label on backing of portrait reads: *The portrait of Mark Langdon Hill, Esq. AE 46 Painted by Benjamin Greenleaf at Phippsburg April, 1818.* Letter sitter holds addressed to "Governor Langdon Portsmouth N. H."; word "free" written in upper right corner where stamp would have been affixed. This portrait smashed and completely destroyed. *Formerly in the collection of the Bowdoin Museum of Fine Arts, Brunswick, Maine.*

7. MRS. THOMAS B. RIPLEY (Dolly Smith) (*1801–1823*) (*Fig. 8*). Oil under glass. Inscription on old backing covered and cannot be restored. Subject born and died in Maine. Old information gives provenance as Maine (*c. 1820*). *Collection of Mary Ballou Stafford, Bath, Maine.*

8 and 9. MAJOR JONES AND HIS WIFE of Weymouth, Massachusetts. Oil under glass. Attributed to Benjamin Greenleaf (*c. 1820*). *Collection of Fred W. Fuessenich, Torrington, Connecticut.*

10. UNIDENTIFIED LITTLE GIRL (*Fig. 9*). Oil under glass. Attributed to Benjamin Greenleaf (*c. 1825*). Boston provenance. *Formerly in the collection of Harry Stone, New York City.*

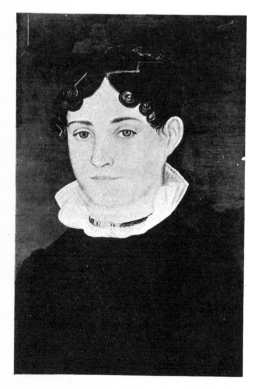
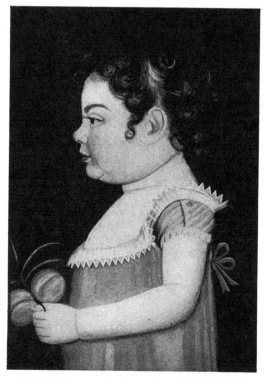

(*Far left*) FIG. 8 — DOLLY SMITH RIPLEY. Painted on glass by Benjamin Greenleaf about 1820, in Maine. *Collection of Mary Ballou Stafford.*

FIG. 9 — LITTLE GIRL FROM BOSTON. Glass portrait attributed to Benjamin Greenleaf (*c. 1825*). *Formerly in the collection of Harry Stone.*

Photographs of Figures 1, 6, 7, 8, courtesy the Frick Art Reference Library; photographs of Figures 4, 5, 9, courtesy the Primitives Gallery of Harry Stone.

Isaac Sheffield, Connecticut limner

BY EDGAR deN. MAYHEW, *Associate director, Lyman Allyn Museum*

Isaac Sheffield was painting portraits in New London when that Connecticut town was the second largest whaling port on the east coast, surpassed only by New Bedford, and his works reflect that setting. Only a small group of them is known, however, and recorded information about the artist is sparse and inconsistent.

Sheffield was mentioned as early as 1879 by H. W. French in his *Art and Artists in Connecticut* (p. 60). He quoted a letter from the artist which said, "I came here [to New London] from my home in Guilford when thirty-five," and on the strength of this statement and of dated Sheffield pictures French concluded that the artist was born in Guilford in 1798. This date has been repeated in the few later published references to Sheffield.

However, in *The People's Advocate* of New London for Wednesday, January 22, 1845, the following terse item appears under the death notices: "In this city on the 14th inst. Mr. Isaac Sheffield, aged 38 years." That puts his birth date not in 1798 but in 1807 (or 1806 if his birthday came later in the year than January 14). And it means that he moved to New London in 1841 or 1842 and was there only about three years, if we accept his statement that he came when he was thirty-five years old. Nevertheless, as we shall see, he signed and dated at least two of his pictures in New London in 1840. Local records have been of little help in supporting or adding to these meager and contradictory vital statistics. Sheffield's name appears in New London papers only in the death notice cited. It can be added that he lived on Main Street at the corner of Shapley Street, which was at the time in the heart of New London's whaling district. At least one of his portraits was done in nearby Stonington, and it seems safe to assume that he did some painting in Guilford. Quite probably he worked as an itinerant along the Connecticut shore.

Ten examples of Sheffield's work have been identified with certainty, and they fall into three categories: full-length portraits of children, half-length portraits of adults, and miniatures.

There are two of the first type, a girl and a boy. The girl is Mary Ann Wheeler of Stonington (Fig. 1). The daughter of Homer Wheeler and his wife, Mary Ann Roberts, she was born January 22, 1833, and died January 24, 1835, at the age of only two years and two days. Sheffield painted her picture posthumously, in March 1835. He made her appear perhaps rather older than she was, with her leghorn bonnet and large reticule, though in the foreground he put some of her toys and pet possessions—a wooden horse and dog, a pewter porringer, and a cup and saucer. The face looks blurry, less clearly

defined than those of Sheffield's other portraits, and he may have worked over it considerably in the attempt to achieve a likeness of the dead child that would satisfy her parents. A distinguishing feature of Mary Ann as she is portrayed here is that she had two right thumbs.

The second full-length portrait (Fig. 2) is identified by an inscription in the lower right corner: *James f Smith. born decr 19th 1831/this represents him in the dress*

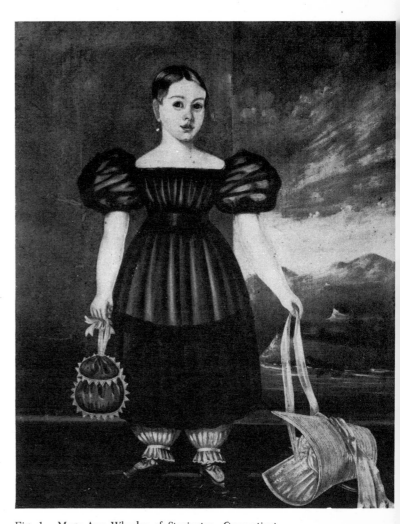

Fig. 1. Mary Ann Wheeler of Stonington, Connecticut. Signed on back *Isaac Sheffield Pinxt, March 1835.* Oil on wood panel, 30 by 24 inches. Owned by a descendant of the subject. *Collection of Marion Clarke.*

he wore when he landed/from a voyage in the Ship-Chelsea-from the/South Seas-island of desolation. Oct 12th 1837/aged at that time 5 years and 10 months. The boy is shown dressed in a penguin-skin coat and standing on the shore as if he has just landed from the ship in the background. He was the son of Captain Franklin F. Smith of the whaling ship *Chelsea,* who made nine voyages to the south Atlantic between 1830 and 1841, returning with sixteen thousand barrels of whale oil and eleven hundred of sperm. Such successful trips made history in

the port of New London. Son James was obviously introduced early to the sea and continued to follow it, becoming captain of the schooner *Columbia* and later of the steamer *Manhasset* which plied Long Island Sound between New London and Fisher's Island. He died in 1904.

Five Sheffield portraits of adults are known, of which four are of sea captains. French may have known more: he says, "The portraits are all red-faced, and most of them sea-captains, with one single telescope in the hand of every one, while they all stand before a red curtain." The ones I have seen do indeed conform to a pattern. The man wears a black frock coat, a starched shirt, and a wide stock of white linen or black silk, and he grasps a telescope—not very firmly, for Sheffield had difficulty with the hands, which always appear two-dimensional. His concentration was on the head of the subject, which is treated with care and portrayed with a solemn expression. Behind the figure a red or green curtain is draped, always in the same fashion, with a large double loop, and beyond it is a marine view. Sheffield has a characteristic treatment of sky and water; the sky sweeps away in dark stormy strokes to the upper right of the painting, and the waves are short and choppy with the wind blowing from the left. In some pictures there is a suggestion of a distant hilly coast.

The earliest known dated portrait by Sheffield is of April 1833 (Fig. 3) and is one of a pair. The undated companion (Fig. 4) is the only woman's portrait by Sheffield so far discovered. Another painting of a sea captain, signed and dated in May 1833, is owned by M. Augusta O'Sullivan in Waterford, Connecticut.

The two portraits dated in New London in 1840 are of sea captains. One is identified as that of Captain John Bolles (Fig. 5), a member of a seafaring and shipbuilding family associated with New London history from the seventeenth century on. John Bolles lived on Main Street, almost next door to Sheffield. The marine view in his picture shows a sloop of the type used all along the New England shore and it flies only an American flag and a pennant from the topmast.

The other 1840 portrait, owned in West Hollywood, Florida, by Alfred Friedland, shows a view from the window similar in all details to that in one of Sheffield's miniatures (Fig. 6), in which a harpooned whale is pursued by a whaleboat. The subject of this miniature has been identified as Captain Elisha Buchanan of New London, who was to become commodore of both the *USS Merrimac* and the *USS Tennessee* during the Civil War. The miniature follows Sheffield's formula in the pose and costume of the sitter (though he lacks a telescope), with red drapery behind him and the marine view beyond.

Two earlier miniatures are recorded by Frederic F. Sherman (*Art in America,* December 1933, p. 27, and April 1936, p. 77). They are dated 1836 and 1837, and the latter is illustrated, with the comment, "Though not really good in technic, it is considerably better than his oil portraits and presents indications of being a really excellent likeness." I have been unable to trace the present whereabouts of either of these miniatures.

Sheffield's style is stiff but it is individual enough to be recognizable, his subjects are interesting, and his curtained-window glimpses of seas and ships evoke a historic era. It is to be hoped that more may be learned about him and that more of his work may come to light.

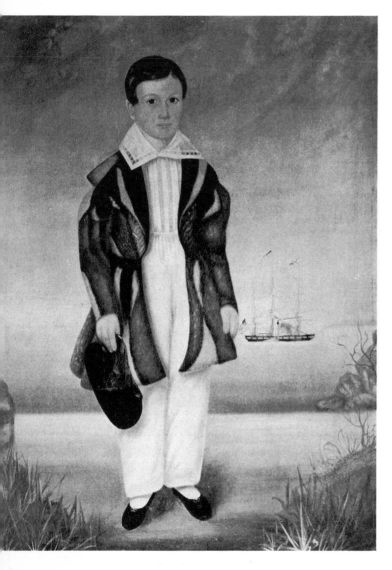

Fig. 2. James Francis Smith.
Dated 1837. Oil on canvas, 48 by 35½ inches.
Lyman Allyn Museum, New London, Connecticut.

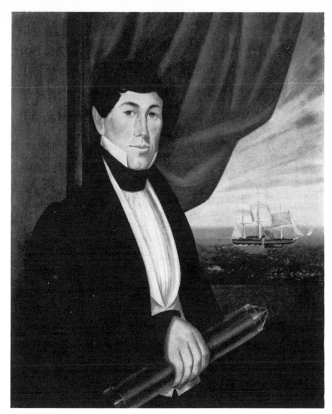

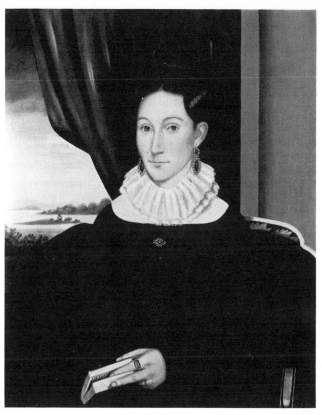

Fig. 3. *Connecticut Sea Captain.*
Signed on back: *I. Sheffield Pinxt. April 1833.*
Oil on canvas, 30 by 24½ inches.
National Gallery of Art, collection
of Edgar William and Bernice Chrysler Garbisch.

Fig. 4. *Connecticut Sea Captain's Wife.*
Probably 1833. Oil on canvas, 30 by 24½ inches.
National Gallery of Art, Garbisch collection.

Fig. 5. Captain John Bolles.
Inscribed on back of canvas:
Painted by Isaac Sheffield, Aug 1840, New London.
Oil on canvas, 33 by 27 inches.
Lyman Allyn Museum.

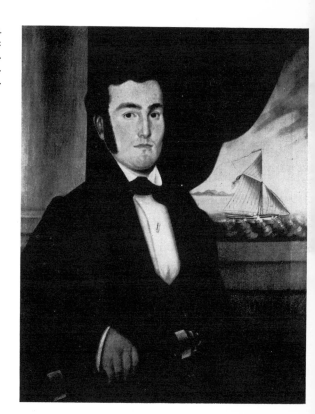

Fig. 6. Captain Elisha Buchanan. Dated 1840.
Miniature on ivory, 2¾ by 2 inches.
Right, the signature on the back.
Lyman Allyn Museum.

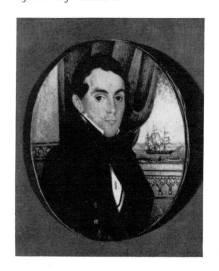

The conversation piece in American folk art

BY NINA FLETCHER LITTLE

THE CONVERSATION PIECE in pictorial art may be broadly defined as a representation of two or more persons, either a family or a related group of individuals, portrayed informally amid their own surroundings. The subjects are usually painted full length, and although they may not appear to be actively engaged in conversation they are always shown either visibly sharing a mutual interest or jointly participating in some polite social pastime. They may be indulging in parlor games or musical parties, drawing from nature, taking tea, looking at books, displaying family possessions, playing with children and pets, or merely enjoying one another's company in the open air. Compositions that include stylized characters rather than actual individuals, episodes deriving from literature or history, and scenes depicting genre or satire are not properly a part of this specialized subject. Conversation pieces are essentially intimate portrayals of family life before the day of the candid camera.

In English paintings of this type, outdoor activities frequently take place on lawns or river banks of large country estates, and include such fashionable pursuits as fishing, boating, picnicking, or feeding swans as they glide by on picturesque streams. Artless games occupy the children—tree climbing, kite flying, or archery—while their elders gracefully relax and meditate on the beauties of nature. American folk artists used the same approach, but understandably expressed the result in much less conventional terms. Since their acquaintance with society was necessarily limited to their own environment, their compositions tend to be spontaneously naïve, in contrast to the studied affectation inherent in much academic art of the period. Outdoors for the average American signified not landscaped parks but woods to be cleared or fields to be plowed and cultivated. A few American painters did specialize in representations of "gentlemen's country seats," and during the second and third quarters of the eighteenth century offered for sale to gentlemen in Maryland and South Carolina "Views of their own Houses and Estates" and "Draughts of their houses in Colours or Indian Ink." And in Charleston in 1773 one J. Stevenson, limner, announced in the *South Carolina Gazette and Country Journal:* "Family and Conversation Pieces, either the size of Nature, or small whole lengths, in the Stile of Zoffani . . ." But these Southern artists were probably English-trained, and not working in the folk tradition.

An amusing conversation piece by a folk artist identified only as "Dupue" appears in Figure 1. This traditional pose clearly derives from the English style which places master and mistress close to the viewer while their an-

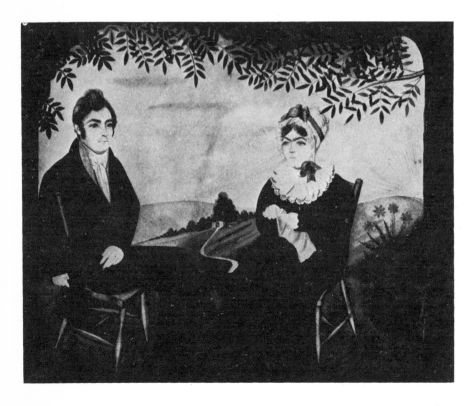

Fig. 1. *Mr. James Raglen and Wife,* inscribed on reverse, *Taken August 1820 in Clark Co. Kentucky by Dupue.* The winding drive leading to the entrance of a large house intentionally diverts the observer's eye and subtly suggests wealth and prosperity. Water color on paper, 12 by 14½ inches. *Author's collection.*

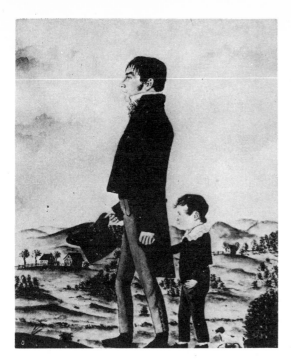

Fig. 2. *Joseph Gardner and Tempest Tucker Gardner,* 1814-1815, attributed to Dr. Jacob Maentel, German-born farmer-painter who worked from c. 1800 to the 1840's in Pennsylvania and New Harmony, Indiana. Water color on paper, 11⅜ by 9⅞ inches. *Abby Aldrich Rockefeller Folk Art Collection, Williamsburg.*

Fig. 3. *Mr. and Mrs. Sherman Griswold,* c. 1830, attributed to "Mr. Johnson," active 1825-1837. The Griswold family, with several neighbors, went from Saybrook, Connecticut, to settle in Columbia County, New York, where this fertile farm land was purchased by Sherman Griswold in 1825. Later misfortunes deprived him of this happy home. Oil on canvas, 84 by 48 inches. *Collection of Mrs. Frank Rundell Sr.*

cestral acres stretch impressively in the background. No matter that she is a plain homebody knitting a sock, or that he sits a bit self-consciously in his painted country chair; for the moment (and for posterity) they are landed gentry. A less formal concept, but one in which local surroundings are also a feature, is the extremely effective portrait of Joseph Gardner and son walking hand in hand amid the rolling Pennsylvania hills (Fig. 2). Again, in the charming double portrait of Mr. and Mrs. Sherman Griswold we see owners surveying their own estate, where the substantial house, capacious barns, and favorite sheep provide tangible evidence of prosperity in New York's Columbia County in the early 1830's (Fig. 3). This composition invites comparison with Gainsborough's fine portrait of Robert Andrews and his wife painted on their Suffolk estate about 1755.

Quite possibly the earliest recorded American conversation piece is the sharply defined rendition of the Martin Van Bergen farm near Leeds, Greene County, New York, painted about 1735 on an overmantel panel which formed part of the woodwork in the farmhouse (Fig. 4). Various country activities are in progress while the owners and their relatives, in unbelievably formal attire, survey the whole. Their traditional poses, and other aspects of the lively scene, derive from the European sources which so directly influenced eighteenth-century American painting. Approximately one hundred years later Cornelius Pering, an unassuming English artist, painted himself and his family among the modest dwellings of Bloomington, Indiana, where his proudest achievement was the founding of a successful female academy in 1832 (Fig. 5).

It was, however, life indoors which the folk artist was

Fig. 4. *Van Bergen Overmantel*, c. 1735; artist unknown. This house, built in 1729, stood near Leeds, Greene County, New York, until demolished in 1862. At that time the panel was removed and installed in the family's new home nearby. Pictured in the center are Martin Van Bergen with his wife and family. At the right is his brother Gerritt followed by his two sons. Oil on wood, 18 by 87 inches. *New York State Historical Association.*

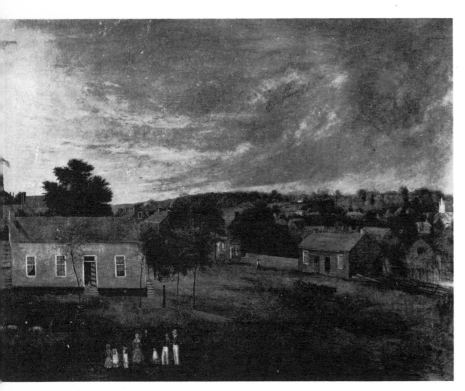

Fig. 5. *Early Bloomington*, c. 1840, by Cornelius Pering, who lived in Bloomington between 1830 and 1846. None of the buildings pictured here is now standing. The spire at the right was that of the Methodist church; the building with cupola at extreme left was the courthouse; the houses in foreground were dwellings. Oil on canvas, 34¼ by 44¼ inches. *Indiana University.*

Fig. 6. *The Schuyler Family*, dated 1824, by Ambrose Andrews, who was an active itinerant portrait, miniature, and landscape painter traveling widely in New England, New York State, Michigan, and Louisiana between 1824 and 1859. This family group was painted in Schuylersville, New York, and includes Philip and Grace Schuyler with their children Ruth, Grace, Elizabeth, Catherine, and Harriet. The handsome little piano with its adjustable stool is the focal point of this conversation piece. Water color on paper, 9½ by 12⅛ inches. *New-York Historical Society.*

most frequently called upon to record, and the variations on this theme run from spirited parlor gatherings to rigidly posed family groups. Music and games added to the gaiety of many social occasions and formed an integral part of everyday life. Although a piano is the focal point of many happy scenes (see Figs. 6, 7), wind instruments and fiddles were also played at musical parties. Shuttlecock and battledore and roll-the-hoop are being enjoyed by the children of Nathan Starr in Figure 8. In more serious mood, a geography lesson is being given to Samuel F. B. Morse and his brothers by their father, the eminent geographer, in his study in Charlestown, Massachusetts, about 1810 (Fig. 9).

The picture of Mr. and Mrs. Nathan Hawley (Fig. 10), with its glimpse of informal family life, is an excellent example of the spirit of the traditional conversation piece, as is the study of the Sargent family which shows two little girls, with paired bird cages and Hepplewhite chairs (Fig. 11). A conversational, although less spontaneous, group comprises the guests in Mrs. Smith's Philadelphia

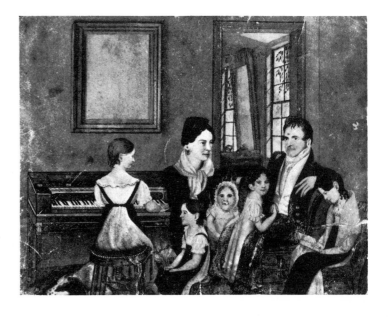

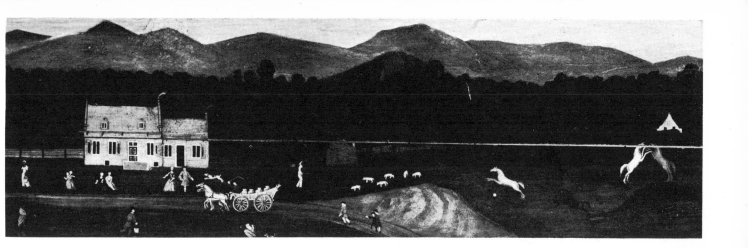

boardinghouse, painted in 1853 (Fig. 12). It is noteworthy that card- and tea-party scenes, so typical of conventional English pictures, were seldom portrayed by American artists. One eighteenth-century example is painted on a wood panel and depicts the family of John Potter, the Rhode Island counterfeiter, taking tea from a silver pot (Fig. 13).

A well-documented interior is presented in the picture of the Reverend John Atwood and family painted in 1845 (Fig. 14). Despite the conventionally draped table about which the Atwoods are gathered, this is not at all a static composition. Each member is painted as a specific individual, only momentarily excused from the Bible reading in which all are dutifully engaged.

Unlike the examples illustrated here, many family portraits were stiffly posed, and such rigid likenesses of the mid-nineteenth century often betray the influence of the newly popular daguerreotype. Such pictures lack the basic attribute of mutual participation which distinguishes the true conversation piece.

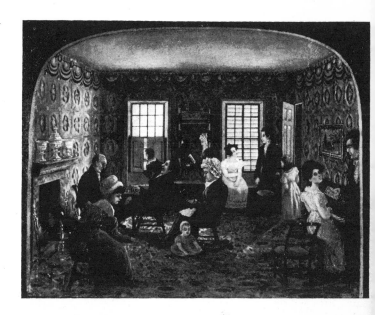

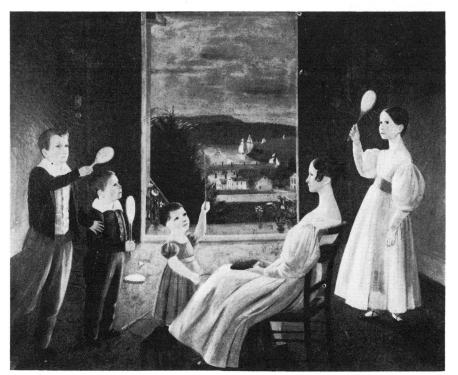

Fig. 7. *Vermont Family*, c. 1830; artist unknown. All ages are represented in this animated scene where the decoration and furnishings play an important part in re-creating a New England home of the period. Visible at the extreme left is the head of a little black boy blowing up the fire. Oil on canvas, 23¼ by 29½ inches. *Privately owned.*

Fig. 8. *The Children of Nathan Starr*, dated 1834, painted by Ambrose Andrews in Middletown, Connecticut. During the ten years between his portraits of the Schuyler and Starr families, Andrews' technique had improved noticeably and had begun to give promise of the recognition to be accorded him in mid-nineteenth-century art exhibitions. The children shown here range from three to fifteen years of age. Beyond the garden may be seen the eighteenth-century buildings of the family's munition works in Middletown. Oil on canvas, 28⅝ by 36⅝ inches. *Collection of Mr. and Mrs. Nathan Comfort Starr.*

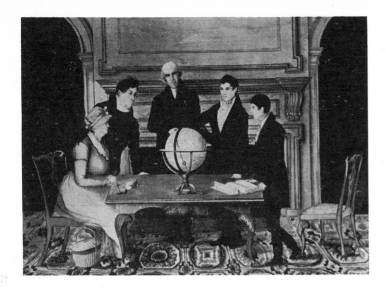

Fig. 9. *The Family of Jedidiah Morse*, c. 1810, by Samuel F. B. Morse, artist and inventor or the telegraph. Painted in the study of the family's home in Charlestown, Massachusetts, the group includes Mrs. Morse with her sewing; Samuel, the artist, at the age of nineteen; Jedidiah Morse, the well-known geographer; and younger sons, Sidney and Richard. All are intent on the globe which rests on a Chippendale table covered with green baize. Water color on paper, 19 by 23 inches. *Smithsonian Institution.*

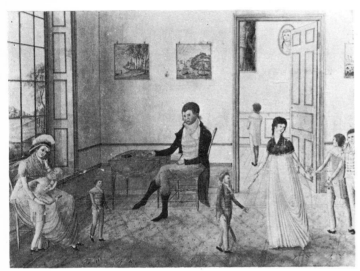

Fig. 10. *Nathan Hawley and Family*, dated November 3, 1801; signed *William Wilkie*. The artist is presently known through only one other picture, a view of Albany painted in 1800. This shows the interior of Hawley's house next to the Albany jail, of which he was the sheriff. Water color on paper, 14 by 18⅝ inches. *Albany Institute of History and Art.*

Fig. 11. *The Sargent Family*, dated 1800; artist unknown. The meticulously drawn floor covering, drapery, and furniture create an excellent documentary setting for this lively family scene. Oil on canvas, 37½ by 50½ inches. *National Gallery of Art, Edgar William and Bernice Chrysler Garbisch Collection.*

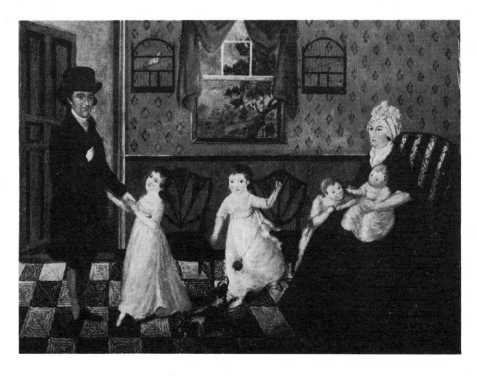

Fig. 12. *Mrs. A. W. Smith's Parlor*, dated 1853, by Joseph Shoemaker Russell. The artist, at right, is gathered with other guests at Mrs. Smith's boardinghouse, Broad and Spruce Streets, Philadelphia. Two couples by the windows appear to be actually engaged in conversation. Water color on paper, 8¼ by 10¼ inches. *Author's collection.*

Fig. 13. *John Potter of Matunuck and His Family at Tea*, c. 1740; artist unknown. John Potter began the construction of his large house in Matunuck, Rhode Island, in 1740. This panel was painted for the dining room. About that time he also initiated the counterfeiting of twenty-shilling bills for which he was apprehended in January 1742. The center figures are believed to be Potter and his second wife, the other women possibly his sister and daughter. All are taking tea from delft cups; the pot is silver and has a black finial. Oil on wood, 31½ by 64½ inches. *Newport Historical Society.*

Fig. 14. *Reverend John Atwood and His Family*, dated 1845, signed *H. F. Darby, Painter* (Henry F. Darby). The artist was only sixteen years old when he undertook this life-size Victorian conversation group. Although motion is temporarily suspended in the parsonage parlor, each member is shown with his book, while the Reverend Atwood's forefinger marks the passage at which the family reading will soon resume. Oil on canvas, 72 by 96¼ inches. *Museum of Fine Arts, Boston, M. & M. Karolik Collection.*

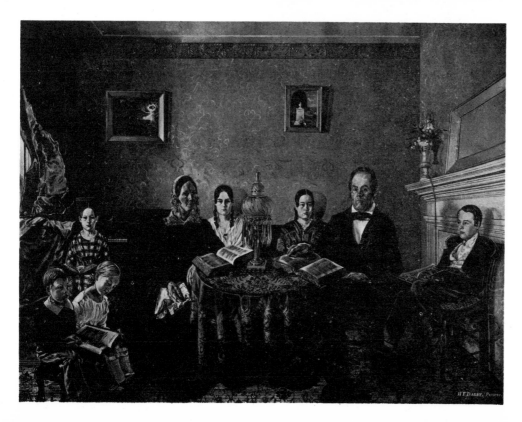

New light on Joseph H. Davis, "Left Hand Painter"

BY NINA FLETCHER LITTLE

IT IS ALMOST thirty years since Frank O. Spinney gathered the first definitive information concerning the artist Joseph H. Davis and his water-color portraits. Mr. Spinney's findings were published in ANTIQUES for October 1943 (p. 177) and August 1944 (p. 73), and in 1950 were amplified by him in Jean Lipman and Alice Winchester's *Primitive Painters in America*. Since then similar examples from Davis' brush have appeared but they have contributed little new information about the painter or his work.

Joseph Davis traveled and painted in a relatively small area of southern New Hampshire and adjacent Maine. From the inscriptions on his pictures it has fortunately been possible to identify most of his sitters, and to determine where and when they were painted between the years 1832 and 1838.

Davis' distinctive style is characterized by his profile figures, often standing erect on brightly patterned floor coverings or seated in pairs at stylishly grained tables in fancy-painted side chairs. Features and profiles are strengthened by delicate use of a pencil and the draftsmanship is competent and apparently assured.

In addition to his sitters, there are many eye-catching accessories which add interest to Davis' interiors and prove that he was adept at portraying—in miniature—landscapes, mourning pictures, books, and fruit and flower arrangements. Is it not probable, therefore, that on occasion he may have painted these same subjects in full size, as did many of the itinerants of his period? This speculation gains support from a related group of four pictures which descended together in one family from the time they were painted in Barrington, New Hampshire, between February 1836 and July 1838.

The earliest dated example depicts a young schoolmaster, John F. Demeritt, who sits in characteristic pose (Fig. 1). A table is spread with the accouterments of his profession and above it hangs, appropriately, a map of the two hemi-

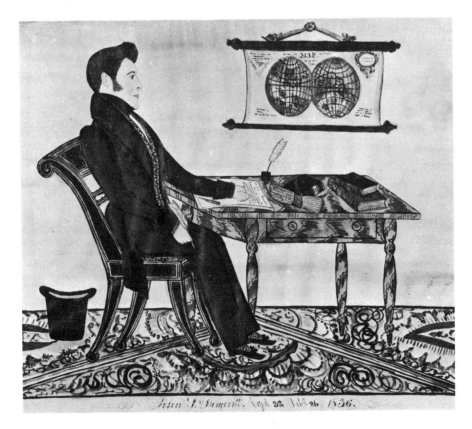

Fig. 1. Portrait of John F. Demeritt, schoolmaster of Barrington, New Hampshire, painted February 26, 1836. Attributed to Joseph H. Davis. Water color on paper, 10 by 12 inches. A small knife on the table suggests the interruption of the sitter's sharpening of quill pens in the bundle. Illustrated in ANTIQUES, July 1964, p. 65. *Except as noted, all illustrations are from the author's collection.*

spheres. In the lower margin of the picture, in the decorative calligraphy associated with Davis, appears the subject's name, his age, and the date of the painting. To the back of the frame is attached a circumspect love letter from John Demeritt to his future bride, Miss Eliza Davis, of nearby Durham, New Hampshire. Their marriage is recorded in the Vital Records of Barrington as having taken place on February 20, 1845. It is, of course, tempting to surmise that Eliza Davis Demeritt was a close relative of Joseph H. Davis, but Davis was a common surname in that part of New Hampshire, and at present there is no proof that the two were related.

In any event, four months later, in June 1836, the single standing figure of John's younger brother (Fig. 2) was painted. Samuel Demeritt, aged twenty-five years, with tall hat, gloves, and cane, must have cut a dashing figure although he evidently suffered from a shortening of one leg as a small supporting platform is clearly visible beneath the heel of his left shoe. Both these profile portraits have all the characteristics of Davis' work and were confidently attributed to him by Mr. Spinney in 1943.

The latest date given by Mr. Spinney for Davis' activity was 1837, but the period can now be extended, for in July 1838 Davis painted a second likeness of Samuel (Fig. 3). This naive fullface sketch lacks the assurance of Davis' usual work; perhaps it was requested, for variety, by the sitter. Faulty anatomy and hesitant draftsmanship replace the crisp outlines of the familiar silhouettes, but Davis always had difficulty painting hands and feet, and most of

his figures are noticeably less competent than his profile faces. Profiles were easily traced by means of shadows thrown by candlelight (that is the way Ruth Henshaw Bascom worked), while fullfaces required freehand drawing "from nature" which presented a problem for an untrained hand. An ink inscription on the reverse (Fig. 4) identifies both sitter and painter, and adds the interesting information that the little portrait was two days in the making. Such pertinent observations were dear to the hearts of traveling artists. The inscription appears to be contempo-

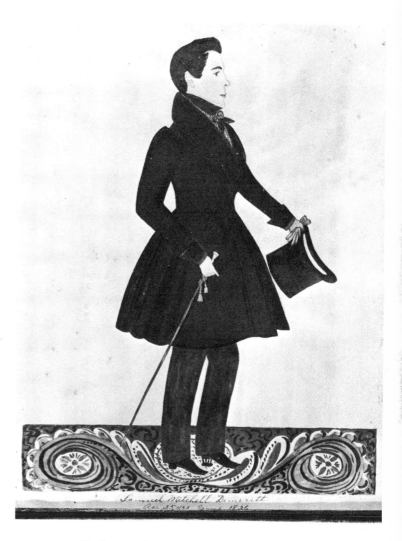

Fig. 2. Portrait of Samuel Mitchell Demeritt, younger brother of John, painted in June 1836. Attributed to Joseph H. Davis. Water color on paper, 10 by 8½ inches. Note the small platform beneath his left heel. The identifying inscription was probably added by a member of the family.

Fig. 3. Portrait of Samuel M. Demeritt, painted by Joseph H. Davis in July 1838 (see detail). Water color on paper, 4¾ by 4⅛ inches. The attenuated figure and naively drawn features suggest that Davis felt more at home with his conventional profile portraits.

Fig. 4. Pen-and-ink signature on the reverse of the portrait of Samuel Demeritt (Fig. 3). The inscription reads *Samuel M. Demeritt Aet. 27 yrs. 2 mo. 17 d./ By J. H. Davis/ July 23 & 24 1838*. Detailed information of this sort was more often recorded by artists than by sitters.

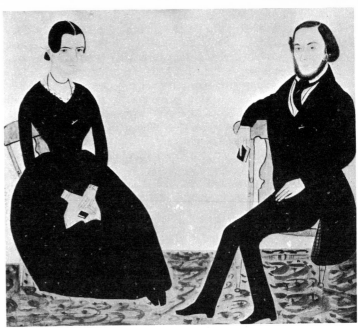

Fig. 6. *John A. Barber Taken Aug 7th 1844,* attributed to Eben P. Davis. Water color, 8⅜ by 7 inches. The penmanship is in the same tradition as that used by Joseph H. Davis, although less elaborate. *Old Sturbridge Village.*

rary, and may well be in Davis' personal handwriting, as differentiated from his calligraphy.

One of the distinguishing characteristics of most Davis pictures is a detailed legend in the lower margin, executed in decorative penmanship which sometimes includes as many as three different styles of meticulous lettering. None of these represents the personal handwriting of the signer: they were recognized forms of nineteenth-century calligraphy taught to children by their writing masters and endlessly practiced in penmanship books. Some of these books survive to illustrate styles of lettering variously known as *Italic alphabet, Roman print, German script,* and others.

In connection with Davis' fullface portrait of Samuel Demeritt, it should be recalled that during the second

quarter of the nineteenth century there were other New England water-colorists painting in a similar manner, among whom was Eben P. Davis of Byfield, Massachusetts—not related, apparently, to Joseph H. Davis. Sometimes Eben, like Joseph, identified his subjects with calligraphic inscriptions, and it is interesting to note that his grandchildren now remember him not as an artist, but as an expert penman. Eben was an amateur and not an itinerant, but a number of unsigned pictures have been attributed to him on the basis of two inscribed examples in the Abby Aldrich Rockefeller Collection in Williamsburg, one of which is shown in Figure 5. Among these is the full length of John A. Barber (Fig. 6), which, with likenesses of his mother and brother, is owned by Old Sturbridge Village. Similarities in technique between this portrait attributed to Eben Davis and the fullface by Joseph H. Davis are obvious, but differences are also discernible. Of the two Davises, Joseph appears to have been the more versatile.

The fourth picture in the group that has come down in the Demeritt family and is said by the descendants to have been painted by Joseph H. Davis is the unsigned still life illustrated in Figure 7. Davis' favorite apples, peaches, and pears are piled lightly in a porcelain compote, the decoration of whose fluted base repeats the familiar scrolls and S-like curves which appear in so many of the Davis floor coverings (Figs. 1, 2, and 8). The album beside the compote is very like the Bibles and other volumes in his portraits. Moreover, this large fruit piece reveals the same oddly pronounced high lights and the characteristic range of colors that are such distinctive elements of the miniature still-life compositions in his portraits (Figs. 8 and 9). Here, however, the artist has introduced shadows which contribute a three-dimensional quality that is lacking in his miniatures.

Joseph H. Davis' individual style has long been studied and admired. Now fullface portraiture and still-life painting may be added to the profile portraiture for which he is well known. Perhaps further examples in these and other styles may eventually be recognized, and increase appreciation of the artist and the variety of his work.

Fig. 7. Still life attributed to Joseph H. Davis. Water color on paper, 12 by 15½ inches. The stemmed fruits exhibit the same strong, unblended high lights that appear in miniature arrangements in Davis' portraits. Scrolls on the footed compote echo those used in his floor coverings, and the decorated backstrip of the book is reminiscent of others seen on his grained tables.

Fig. 8. Portrait of John and Abigail Montgomery, water color painted on May 22, 1836. Attributed to Joseph H. Davis. Typical Davis details are the arrangement of fruit and the book on the table, and the well-drawn landscape in a carefully delineated frame, above. *National Gallery of Art; gift of Edgar William and Bernice Chrysler Garbisch.*

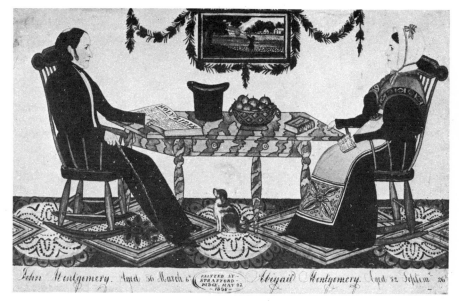

Fig. 9. Detail from a portrait of Thomas and Betsy Thompson of Durham, New Hampshire, painted by Joseph H. Davis in 1837. Water color, 10½ by 15 inches. On the table rest books and a basket of fruit with the artist's unmistakable high lights.

J. Evans, Painter

BY NORBERT AND GAIL SAVAGE

THE WORK THAT is now attributable to the painter J. Evans has, through the years, received recognition from many of the leading folk art collectors and museums; his name, however, is almost unknown. Now, due to the discovery of a second signed example and further research, J. Evans can be placed high on the list of New England water-colorists.

Apparently active around Portsmouth, New Hampshire, and Boston from about 1827 to around 1855, J. Evans left us only two known signed examples: *Woman in a Garden* (Fig. 6) and *Family of Four* (Fig. 7), which is dated 1832. Both are boldly signed *J. Evans, Painter*—the woman in script, the family group in roman capital letters and script in a modified rectangle, trade-sign fashion.

These two signed examples have enabled us to attribute nineteen more portraits to J. Evans, a surprisingly small number considering the search that has been made. All are water colors on paper—usually the English paper watermarked *J. Whatman.* A number of these have inscriptions on the back which give names and dates of the subjects and which provided us with the basis for assigning approximate dates to the paintings.

The faces of all the subjects are shown in profile with bodies in profile, three-quarter, or full view. Only the earliest in the group, *Sarah Jane Pennell* (Fig. 1), is not shown at full length. The artist apparently started painting miniatures, then progressed to the more involved full-length paintings. Certainly he learned to paint faces and heads with beautiful detail before he was able to handle perspective. This can be seen in *The Christian Children* (Fig. 4), where his subjects perch on the edge of the floor as if they were on top of a wall. This painting seems less technically advanced, so is probably earlier, than the *Family of Four,* which is dated 1832. Research into the birth dates of the Christian family of Amesbury, Massachusetts, suggests that the painting of the two children was done about 1831. As the paintings progress chronologically the handling of perspective improves until in the latest examples the problem has been mastered: the perspective in *Man with Chair and Table* (Fig. 10) seems to be fairly accurate.

Throughout these paintings the treatment of faces remains remarkably constant and quite distinctive. The most characteristic feature is a slightly projecting upper lip. Noses also seem to follow an identifiable pattern. Most of the women display a slight double chin. Delineation of faces is done with great care, with coloring and shading in red, blue, and white. Attention to detail, even to the subject's hair, is characteristic. There is frequent use of blue, for draperies, floors, table covers, and clothes; even men's trousers are sometimes shown in a deep royal blue. Throughout the group the clothes appear elegant and stylish for rural New England.

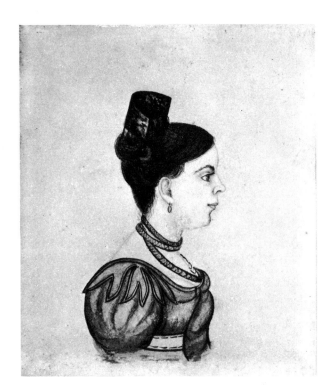

Fig. 1. *Sarah Jane Pennell, 1827. 5 by 4⅛ inches. Sarah Jane Pennell from N. H. Painted Nov. 16, 1827 when Age 16* inscribed in ink on backboard. This earliest example in the group of water colors attributed to J. Evans shows the nose, protruding upper lip, slight double chin, and well-defined hair that are characteristic of the artist's depictions of women. The dress is light blue. *Collection of Edgar William and Bernice Chrysler Garbisch.*

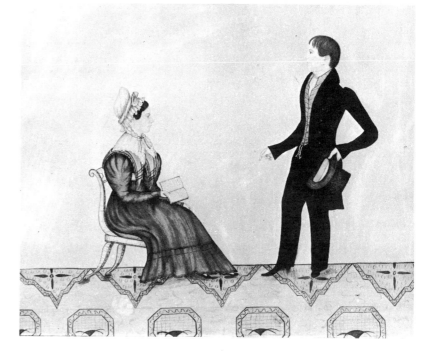

Fig. 2. *Man with Seated Woman*, c. 1831. 13¾ by 17¾ inches. Watermark *J. Whatman 182*[?]. Said to have been found in Georgetown, Massachusetts. The man's vivid deep-royal-blue suit and the woman's light-blue dress make this one of the artist's most colorful paintings known. The floor covering is in shades of gray. The painter's early difficulty with the problem of perspective is seen in this picture and in Figs. 3 and 4. *Collection of Charles E. Buckley.*

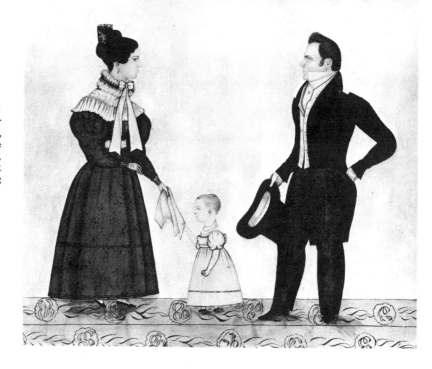

Fig. 3. *Family of Three*, c. 1831. 12 by 14⅛ inches. Pencil inscription on back of paper appears to read *Jane Water, Berwick* [Maine], though only the word *Berwick* is clear. The woman is in a striking deep-rust-color dress, the baby in white, and the man in a black tail coat with gray trousers. The floor covering is in shades of gray. *Fruitlands Museums.*

While so much remains constant, the floors depicted in these paintings show a remarkable variety, ranging from a plain gray wash to wildly colorful floors in the Thompson paintings (supplementary list C, D). These last are reminiscent of those pictured by Joseph H. Davis, who painted water-color portraits in rural New Hampshire and Maine in the 1830's (see ANTIQUES, October 1943, p. 177; August 1944, p. 73; November 1970, p. 754). There are many similarities between Davis and Evans besides their depiction of floors: both were water-color profilists, working in the same region about the same time, and only a very few signed examples of their work have been found. Compositions are similar, with accessories playing an important part.

Paintings by Davis have a decidedly provincial look, while this artist, probably painting people of similar social standing, tried for more elegance and sophistication. Unfortunately he almost never saw fit to identify his subjects or to give their locales and dates, as Davis so often did. This and the apparent rarity of his work have certainly delayed his recognition.

It is in the handling of faces and heads that J. Evans and Davis are least alike. Davis' paintings are usually outlined in pencil, without coloring, while those signed by and

Fig. 4. *The Christian Children*, c. 1831. 10 by 12 inches. Watermark *J. Whatman, Turkey Mill*. This probably portrays Mary Moody Christian (1829-1832) and Edwin John Christian (b. 1830), both born in Amesbury, Massachusetts. The larger child is dressed in shades of light blue, the baby in white with a coral necklace. The floor covering here too is painted in shades of gray. The blue-gray cat is the only animal known to have been painted by this artist. *Privately owned.*

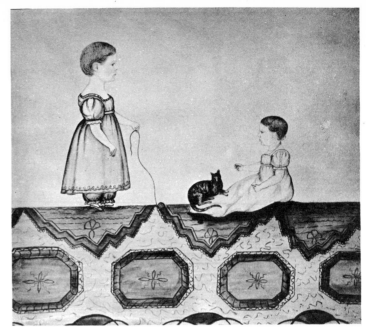

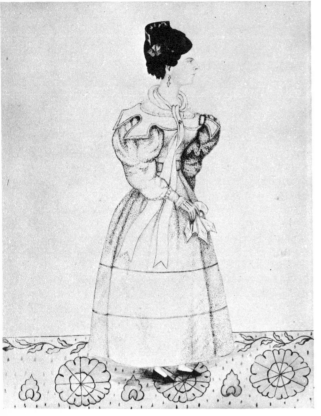

Fig. 5. *Gertrude Jacobs in a White Dress*, c. 1832. 12 by 8½ inches. Watermark *J* (probably for J. Whatman). Pencil inscription on back of paper, *Gertrude Jacobs*, believed to be contemporary. The woman's white dress has interesting brush dots, which give an effect of shading. The floor covering is painted in several muted colors. Here the similarity to the work of Joseph H. Davis is evident. *Privately owned.*

Fig. 6. *Woman in a Garden*, c. 1832. Signed on front *J Evans/Painter*. 12 by 8½ inches. Said to have been found near Portsmouth, New Hampshire. The woman wears a black dress with a blue scarf and belt. The ground is done in a green-gray wash. One other example attributed to this artist shows part of a marble balustrade (supplementary list E). This is the only known painting by him with shrubbery. *Privately owned.*

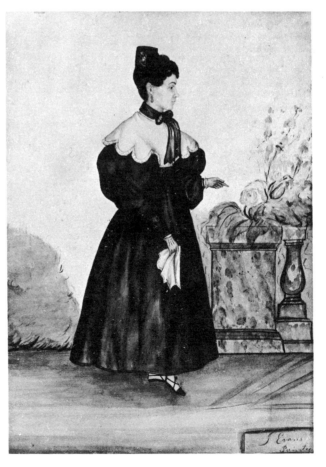

68

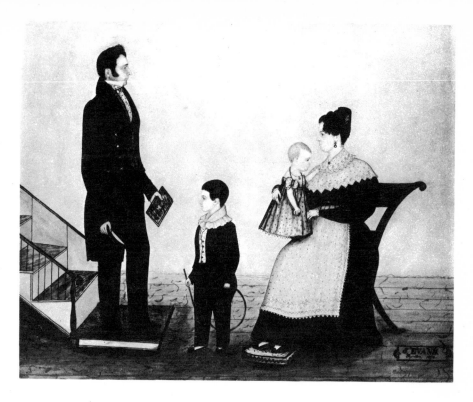

Fig. 7. *Family of Four*, signed and dated on front, *J, Evans./Painter, 1832.* 14 by 17¾ inches. Reproduced in the catalogue of an exhibition in 1966, *101 American Primitive Water Colors and Pastels from the Collection of Edgar William and Bernice Chrysler Garbisch*, p. 105. Found in New Hampshire. The clothes, in rather high style for 1832, are painted in varying shades of blue, and the floor in shades of gray. The stairs add unusual interest, and here the artist has begun to solve the problem of perspective. *National Gallery of Art, gift of Edgar William and Bernice Chrysler Garbisch.*

attributed to Evans are most detailed, appearing almost to be miniatures on ivory. Davis was also less proficient in his rendering of hands and feet.

Since Sarah Jane Pennell was painted in New Hampshire in 1827 and the Christian children of Amesbury about 1831, it seems probable that our artist was traveling through that section of New England shortly before Joseph H. Davis started painting there. Evans could, therefore, easily have had an influence on Davis' work. Perhaps they were in direct contact, or Davis may have been merely aware of the other's work.

Time after time in our search for the works of J. Evans we have been told by museum curators, collectors, and dealers that the painting or paintings in question were now, or were at one time, thought to be by Joseph H. Davis. In fact, the comment "very much like Joe Davis but more refined" has led us to many of the paintings we here attribute to J. Evans. The similarity is greatest in Evans' earlier works.

From a study of the paintings illustrated or listed here it can be noted that seventeen were done between about 1827 and 1834 and four between approximately 1845 and 1855. Fairly accurate documentation for dating works in the early group exists; but there is none for the later examples, which have been assigned dates with the help of students of costume. During the second period, in which there are no known signed paintings, a great change in the artist's work takes place: an improvement from a technical standpoint if not an aesthetic one. The later work shows the influence of, perhaps training by, English or Continental profilists.

Genealogical research on the subjects has confirmed, at least in part, the histories that are associated with eight of the paintings. The four earliest identified subjects (Figs. 1, 4, and supplementary list A, B) are from the extreme southeastern part of New Hampshire and the adjacent section of Massachusetts. The latest paintings with identified subjects portray people from Roxbury (now part of Boston), Massachusetts. These are the Carpenters (supplementary list F, G), who were married there in 1833, and Daniel D. Chaffee (Fig. 9), whose intention to marry was recorded there in the same year. About the same time, perhaps a bit earlier, the Thompsons (supplementary list C, D) were painted. Records exist of Eliza Burt Thompson's confirmation in 1808 and marriage in 1826, both in Portsmouth, New Hampshire. The two Thompson paintings are by far the best documented in the group. Portsmouth directories from the mid-1820's to the 1850's list Zara Thompson as a tailor. The January 1, 1831, issue of the Portsmouth *Journal* contains on the first page a rather impressive advertisement by Z. Thompson, tailor and ready-made-clothing merchant. Thompson's occupation offers an obvious explanation of the subjects' fashionable attire.

A search of the records and town histories in the localities associated with the paintings has turned up many men with the name J. Evans, one of whom might be the painter. Several are indeed listed as painters (probably house painters), but at this time it is impossible to ascertain which, if any, is our water-colorist.

Of all the J. Evanses listed in the standard reference works only James G. Evans seems to have a chance of being the artist in question here, unless the elusive J. Evans is one of those for whom so little information is given that it is impossible to identify him. Anna Wells Rutledge's *Artists in the Life of Charleston* (South Carolina; Philadelphia, 1949) lists on page 195 a James Evans advertising that he has "A MACHINE for taking . . . A PROFILE, or LIKENESSES" (*Charleston Courier,* October 25, 1803). This seems to be early for the New England water-colorist. Groce and Wallace, in their *Dictionary of Artists in America 1564-1860,* list a John T. Evans, water-color portrait and landscape painter in Philadelphia about 1809, and Theodore Bolton, in his *Early American Portrait Painters*

Fig. 8. *Unidentified Gentleman*, c. 1833. 10 by 8 inches. Watermark *J. Whatman*. Found near Boston, but with a Portsmouth, New Hampshire, history. The man's coat is dark brown, his trousers black. This example and items F and H in the supplementary list are very similar and are the only known examples attributed to this artist in which a particular composition is repeated. *New York State Historical Association*.

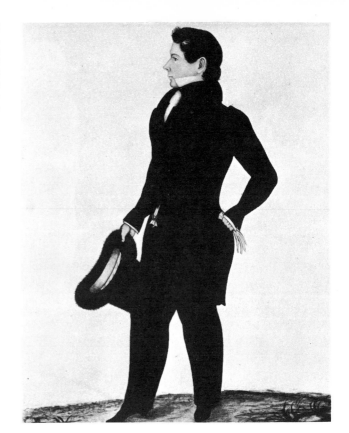

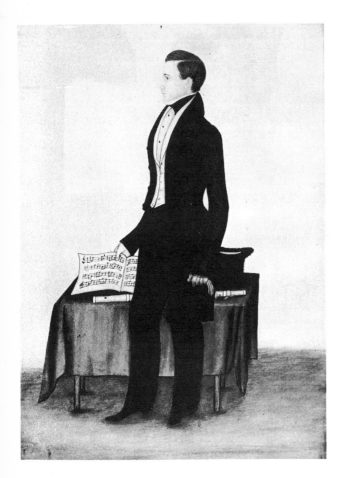

Fig. 9. *Daniel D. Chaffee*, 1834. 12 by 8⅝ inches. *Picture of D. D. Chaffer* [sic], *painted Boston 1834, taken in Freedom Suit at 21 years of age*, inscribed in pencil on back of paper. Chaffee wears a brown coat over black trousers. The table cover is blue and the floor is done in a gray wash. Perspective is handled with increasing skill. *Garbisch collection*.

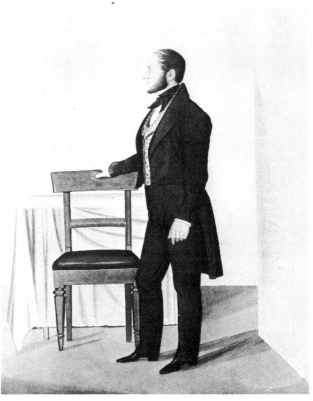

Fig. 10. *Man with Chair and Table*, c. 1845. 11½ by 9½ inches. Found in Maine with item I in supplementary list. The man's suit is black. The strong colors of the artist's earlier paintings are gone and a more academic picture results. *Garbisch collection*.

70

in Miniature (New York, 1921), gives the following information on this man: "Flourished 1809 in Philadelphia, landscape and miniature painter in water color. He exhibited at the Pennsylvania Academy both miniatures and scenes in watercolor made during visits to Ireland and England. . . ." Three of the paintings illustrated or listed here had previously been attributed to this Evans, but it is hardly likely that a man who exhibited at the Pennsylvania Academy, painted on visits to England and Ireland, and, according to William Dunlap's *History of the Rise and Progress of the Arts of Design in the United States* (Vol. III, Boston, 1918), taught water-color drawing—all about 1809—could be the New England folk artist who was struggling with the problem of perspective twenty-two years later.

The J. (James) G. Evans listed in Groce and Wallace as a ship painter is possibly the man for whom we are searching. About twenty-five signed ship paintings by this artist are known. These are signed in many ways, *Evans, J. Evans, J. G. Evans,* and *Ja. Evans.* The earliest ones, dating about 1835, are in water color, while the later examples, dating well into the 1850's, are in oil on canvas. Comparison of the signatures on the two water-color portraits signed *J. Evans* (Figs. 6, 7) with those on some of the ship paintings does reveal a similarity. James Cheevers, curator of the museum at the United States Naval Academy, who is doing research on the ship painter, has informed us of the existence of a James Evans "who enlisted in the U. S. Marine Corps 29 July, 1830, served aboard USS *Delaware* 1833-1836, and was discharged at Norfolk 4 March, 1836 . . . returned to Norfolk early 1836, and may have found passage back to the Mediterranean Squadron aboard USS *United States* . . . could have transferred to USS *Constitution.* . . ." It is not yet known whether this James Evans is the ship painter listed in Groce and Wallace as J. G. Evans, but the USS *Delaware* and the USS *Constitution* were favorite subjects for James G. Evans and he painted many pictures of these vessels in and near Malta in the mid- to late 1830's. This is the period for which we can not find any portraits attributable to the artist who signed the water colors illustrated in Figures 6 and 7. If these two J. Evanses should be the same man, an enlistment and extended foreign cruise on a United States ship could explain both the lack of portraits during the period and the style change noted between the first seventeen paintings and the later four (Fig. 10 and supplementary list I, J, K). It would be interesting to know if any water-color portraits similar to the two signed *J. Evans* exist in and around New Orleans, for James G. Evans is known to have lived and worked there about 1846 to 1853. At this point we can only speculate as to the possibility that these two painters are one, but as Mr. Cheevers' documentation on the ship painter and ours on the portrait painter accumulate, the answer should come.

Much more still has to be done before J. Evans, New England water-colorist, can be fully identified. Perhaps a diary or a contemporary newspaper reference will be found which will amplify what is so far known. We hope additional examples of his work may be brought to light so that a more complete story of J. Evans and his paintings can be told.

In addition to the water colors illustrated here, we list below eleven others which we attribute to the same painter, J. Evans.

A. *Abigail Courier* [or *Couvier*] *Fellows* (Mrs. Moses Wood), c. 1830. 10⅛ by 8⅛ inches. Watermark *J. Whatman, Turkey Mill, 1829.* Post-1890 inscription on back of paper states that Abigail was born in Wiscasset, Maine, in 1804 and was married in 1835; it states further that the portrait was *painted in Boston, Mass. 1832.* Reproduced in the Newark Museum's bulletin, *The Museum,* No. 26, Summer-Fall 1967, p. 32. *Newark Museum.*

B. *Mother and Daughter of the Chase Family,* c. 1831. Approximately 10 by 14 inches. Found in the Deerfield, New Hampshire, home of the Chase family. Reproduced (in its stenciled frame) in ANTIQUES, September 1969, p. 276. *Collection of Mrs. Cyril A. Nelson.*

C. *Eliza Burt Thompson and Daughter Caroline,* c. 1833. 11¼ by 8½ inches. Watermark *J. W.* (for J. Whatman). *Eliza Burt Thompson wife of Zara Thompson and daughter Caroline born Christmas day in 1831, died Portsmouth Sept. 26, 18(?)8,* inscribed in pencil on backboard. *Privately owned.*

D. *Zara Thompson and Daughter Elizabeth,* c. 1833. 11½ by 8¾ inches. Watermark *J. Whatman, Turkey Mill, 1829.* Inscribed *Zara Thompson and wife Eliza Burt Thompson their eldest child Elizabeth Greenough Thompson born Sept. 22, 1826. Married James Morland and died in Chicago Jan. 8, 1916,* in pencil on backboard. *Privately owned.*

E. *Woman with a Vase of Flowers,* c. 1833. 12⅛ by 8½ inches. Found in Massachusetts. *Collection of Edgar William and Bernice Chrysler Garbisch.*

F. *Sullivan Lucion Carpenter,* painted the year of his marriage, 1833. 12⅞ by 9⅛ inches. Watermark *J Whatman, Turkey Mill, 1829.* Reproduced in the M. & M. Karolik Collection of American Water Colors & Drawings 1800-1875, catalogue No. 1117. *Museum of Fine Arts, Boston.*

G. *Lucinda Warren Goddard Carpenter* (wife of Sullivan Lucion Carpenter), 1833. 12½ by 9 inches. Watermark *J Whatman, Turkey Mill, 1829.* Reproduced in the Karolik catalogue, No. 1118. *Museum of Fine Arts, Boston.*

H. *Man with Whip,* c. 1833. 11¾ by 8½ inches. Pencil inscription on back of paper, *Leonard,* preceded by what appears to be a *P.* Reproduced in the Colby College publication *American Heritage Collection,* catalogue No. 60. *Colby College.*

I. *Mother and Baby,* c. 1845. 11½ by 9½ inches. Found in Maine with Fig. 10. *Garbisch collection.*

J. *Two Little Girls in Blue,* c. 1850. 8¾ by 11⅞ inches. *Garbisch collection.*

K. *Father and Daughter,* c. 1850. Size and owner unknown. Reproduced on the cover of ANTIQUES, January 1935.

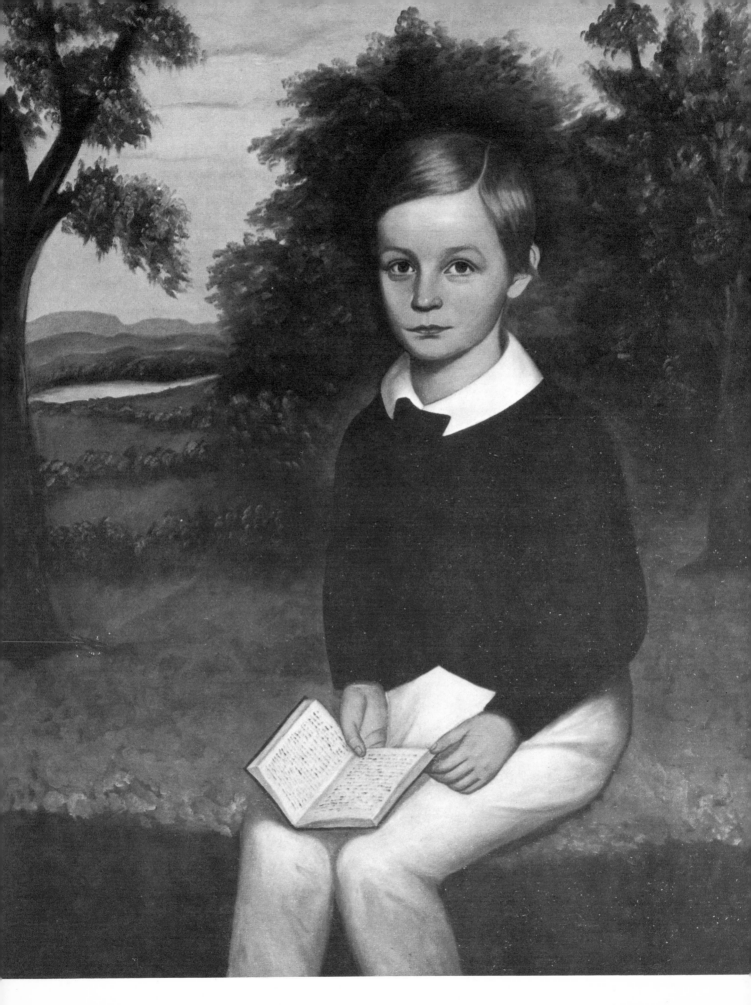

Joseph Goodhue Chandler (1813-1884)

Itinerant painter of the Connecticut River Valley

BY JOHN W. KEEFE, *Assistant curator, European decorative arts, Art Institute of Chicago*

JOSEPH GOODHUE CHANDLER's career is typical of that of many nineteenth-century itinerant painters. Some of his works are of lasting quality, but toward the end of his prolific career academic taste and photography began to encroach upon his style. In this sense his stylistic progress mirrors much of the history of American folk art in the middle of the last century.

Born on October 8, 1813, according to local records, Joseph Chandler was the second child and first son of Captain David (1770-1838) and Clarissa Goodhue Chandler. His father was a respected citizen of South Hadley, Massachusetts, where he owned a farm, acted as postmaster, operated a tavern, and was a successful land speculator.

Little is known about Joseph Chandler's youth except that he was trained early as a cabinetmaker and worked in that trade for several years. His desire to become a professional painter must have been strong, however, for his family permitted him to travel to Albany, New York, to study painting with William Collins (1787-1847). Collins appeared in the Albany city directories from 1827 until 1832, which would indicate that Chandler was between fourteen and nineteen when he worked with him. Just before 1827 an artist named Collins was working in the South Hadley region. It is possible that this was the same William Collins, and that the Chandler family first became acquainted with him there and subsequently sent their son with him to Albany.

Changes of focus, such as Chandler's from cabinet-making to painting, were not unusual in the lives of itinerant folk painters: Joseph Badger (1708-1765), Erastus Salisbury Field (1805-1900), and Jeremiah Harding (active c. 1820-1830 in Lowell, Massachusetts) were also portraitists who practiced sign, carriage, and other ornamental painting. Chandler's first known portraits were done in 1837. Except for the Russell likenesses (see Fig. 1) his early paintings are of members of his immediate family.

It can only be assumed that after he left Collins' studio and before he began to paint, Chandler was learning farming and the land speculation business from his father. In 1838 Captain David Chandler died, leaving his two sons a small farm. Joseph bought his brother's share, added to the inheritance, and prospered at land management. That he pursued this business throughout his life may indicate that a sufficient living could not be made from painting alone.

Sometime during the 1830's Chandler met Lucretia Ann Waite (1820-1868) of Hubbardston, Massachusetts, who was already locally established as a painter. On October 14, 1840, they were married. Shortly thereafter Chandler began a decade's work as an itinerant painter. The majority of his known paintings were executed during this time, most of them commissioned by clients in northwestern Massachusetts.

In 1852, however, Chandler moved to Boston and established a studio at 69 Bedford Street, which he maintained for eight years. Boston at this time was the artistic center of New England and many painters had studios along Tremont Street.

According to a descendant, the couple flourished in Boston, where it was known that Mrs. Chandler frequently "finished up" the paintings of her husband; the two also apparently worked together on some portraits. Eventually Lucretia Ann Chandler became better known in Boston than her husband, and in 1856 an exhibition of her work was held at the Boston Athenaeum. Late in 1860 the couple returned to Hubbardston where Chandler purchased a farm on which they lived for the rest of their lives.

The paintings Chandler made between 1837 and 1852 embody much of the best in American folk art. Even his earliest portraits (Figs. 1, 2, 3) have the vigorous candor characteristic of this type of American painting. The same quality was still apparent ten years later (Fig. 8).

Like that of many talented folk painters, Chandler's work is an odd juxtaposition of the skilled and the naïve. In the portrait of Charles Parsons Jr. (Pl. I), the seated pose and the sunset are convincing, whereas the hand holding the open book is anatomically incorrect and awkwardly proportioned. In the ambitious double portrait of Whiting and Joseph Griswold (Fig. 5), the well-conceived figures are clothed in most unconvincing trousers.

Although Chandler followed the rare practice of signing and dating most of his work, his portraits of adults follow the conventions of the period: somber backgrounds, sitters wearing dark clothes, occasionally a red curtain placed behind the figure to relieve the heaviness of the composition (Figs. 7, 8). Equally conventionally, his young adults wear costumes of lighter tone and sometimes pose against brighter backgrounds, as in the portrait of eighteen-year-old Luthera Barnard Lee (Fig. 6). In spite of these widely followed conventions, the adult portraits retained a freshness of vision and expression that has given them an important place in nineteenth-century folk art.

It was in his portraits of children that Chandler excelled.

Pl. I. *Charles Parsons Jr.* (b. 1839), by Joseph Goodhue Chandler (1813-1884). Inscribed on back *Painted for Charles Parsons, jr., aged 8. by J. G. Chandler, Oct. 1847.* Charles Parsons Jr. was the son of the subject of Fig. 7. He was later to become a breeder of horses well known around Conway, Massachusetts, where he lived. This portrait is typical of the artist's warm and direct depiction of youthful subjects. In his portraits of children he frequently used what is presumably an imagined sunset for a background. Oil on canvas, 35⅞ by 28⅞ inches. *Private collection; photograph by Howard Kraywinkel.*

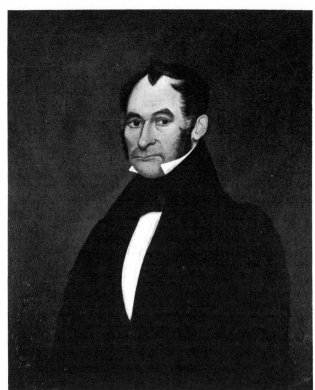

Fig. 1. *Dr. J. Russell.* Inscribed on back *Painted by J. G. Chandler, Feb. 1837 for Dr. J. Russell, Northampton, Mass.* This is the earliest portrait presently known by Chandler. It is traditionally associated with a portrait of a woman painted in the same month and thought to be of Mrs. J. Russell. Both are closely related to the portraits in Figs. 2 and 3 painted five months later. Oil on canvas, 29 by 24½ inches. *Collection of Dr. and Mrs. C. Keith Wilbur; photograph by H. Edelstein.*

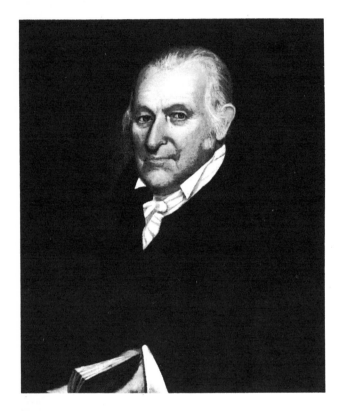

Fig. 2. *Dr. Joseph Goodhue* (1764-1849). Inscribed on back *Painted by J. G. Chandler for Dr. Joseph Goodhue, aged 75,* [sic], *Deerfield, Massachusetts, July 1837.* Goodhue was Chandler's maternal grandfather and for many years a surgeon in the United States Army. He lived in Fort Constitution, New Hampshire, and died in Deerfield. Chandler painted a larger portrait of Goodhue in May 1844. Oil on canvas, 26 by 22 inches. *Historic Deerfield; Edelstein photograph.*

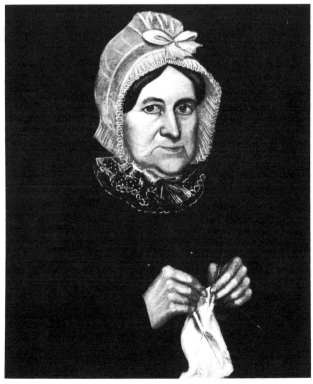

Fig. 3. *Mindwell Taylor Goodhue* (1759-1837). Inscribed on back *Mrs. Mindwell Goodhue, aged 77, painted by J. G. Chandler, July 1837.* She was the wife of Joseph Goodhue. Although one of the earliest Chandler portraits, it is one of his most direct and appealing depictions of an intelligent and aged subject. Oil on canvas, 25¾ by 21¾ inches. *Historic Deerfield; Edelstein photograph.*

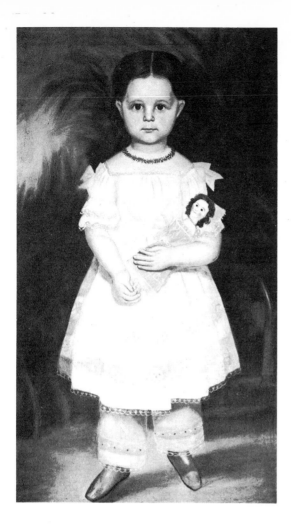

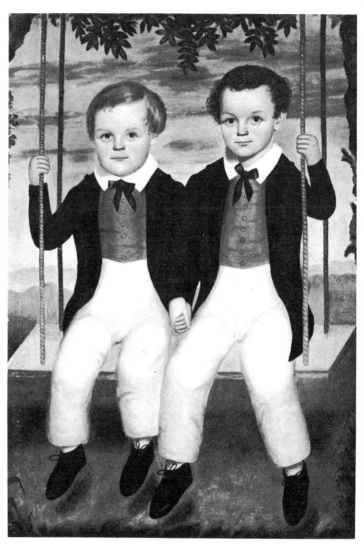

Fig. 4. *Ann G. Tibbals* (b. 1838). Inscribed on back *Painted for Ann G. Tibbals, aged 3 years and 4 months, J. G. Chandler, Painter, July 1841*. This large-scale portrait is the earliest known child's portrait in Chandler's mature, fully developed style. The vaguely palmlike trees in the background are typical of the imaginative and sometimes exotic settings Chandler chose for his portraits of children. Oil on canvas, 40¼ by 24½ inches. *Wilbur collection; Edelstein photograph*.

Fig. 5. *Whiting and Joseph Griswold*. Inscribed on back *Painted for Whiting Griswold, aged 5 years, and Joseph Griswold, aged 4 years, J. G. Chandler, Painter. August 1844*. This portrait is one of the largest, most ambitious, and most charming known by Chandler, although the costumes reveal the artist's difficulty in handling fabric realistically. The Griswold family owned large cotton mills in Colrain, Massachusetts. Oil on canvas, 45 by 32 inches. *Griswold Memorial Library; Edelstein photograph*.

He appears to have had a lively empathy and warmth toward his youthful sitters, particularly for the small Frederick Eugene Bennett whose (now unlocated) portrait he painted in 1848; in it the subject is impishly tugging at the ear of a large dog. The painter's sympathy is evident too in the solemn yet engaging portrait of three-year-old Ann Tibbals and her doll (Fig. 4). There is no evidence that Chandler followed the earlier practice of traveling with nearly completed portraits and filling in only the face from life. In the surviving portraits of children the background and pose are distinctive (Figs. 4, 5, 9, Pl. I). Indeed, the house in the portrait of Nora Davison (Fig. 9) is the one in which the child lived, as no doubt was specified by the client. The settings devised by Chandler for his portraits

of children were among the most original—and frequently most exotic—of the nineteenth century.

Following his exposure to the more academic art world of Boston, Chandler's style became more sophisticated and less spontaneous. He began to use heavy shadows and a darker palette, and the vigorous flatness of image of his earlier work became less apparent (Fig. 10).

After his wife's death Chandler's style changed again, perhaps indicating that Lucretia Ann had collaborated on some of his portraits. Characteristic of this new style were muted, more refined colors and a more academic approach to his subjects (Fig. 12). During these later years, Chandler was obviously influenced by the photograph; he is thought to have painted several portraits of celebrities, such as the

75

Fig. 6. *Luthera Barnard Lee* (b. 1829). Inscribed on back *Painted for Mrs. Luthera Lee, aged 18, J. G. Chandler, April 1847.* The Barnard family was prominent in Deerfield, Massachusetts. In 1846 Luthera Barnard married Charles Lee of Connecticut, whose portrait and whose mother's portrait Chandler also painted in April 1847. Light-color costumes and comparatively bright backgrounds were conventional for portraits of young adults. Oil on canvas, 35 by 28 inches. *Pocumtuck Valley Memorial Association; Edelstein photograph.*

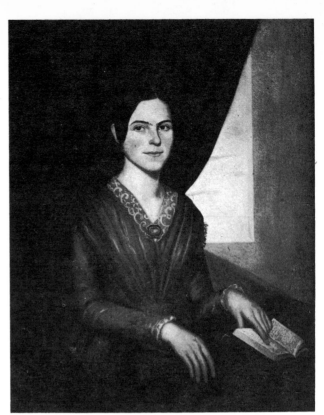

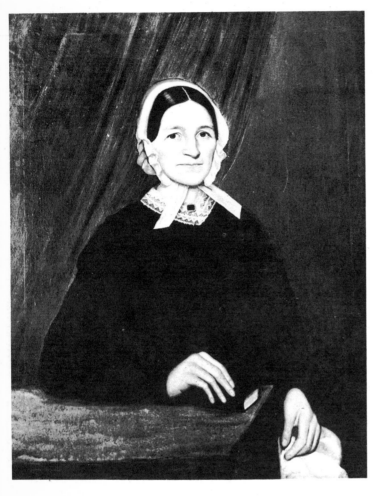

Fig. 7. *Mrs. Charles Parsons* (b. 1801). Inscribed on back *Painted for Mrs. Sylvia B. Parsons, aged 46, by J. G. Chandler, June 1847.* Like its pendant of her husband, Charles Parson Sr., this is one of the best portraits of adults from Chandler's mature period. Oil on canvas, 35 by 29 inches. *Collection of Mr. and Mrs. William L. Hubbard.*

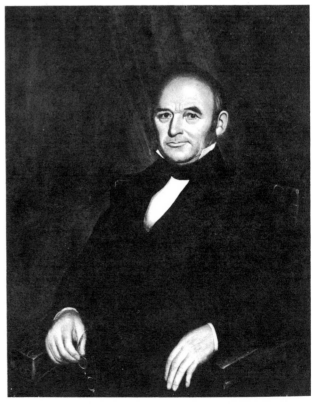

Fig. 8. *Joel Bardwell* (b. 1780). Inscribed on back *Painted for Mr. Joel Bardwell, aged 67, by J. G. Chandler, Aug 1847.* Joel Bardwell was a prosperous farmer of Shelburne Falls, Massachusetts, and the owner of the Bardwell Ferry of that community. His portrait and that of his wife, Lydia, are among Chandler's best mature works. Both illustrate the vigorous representation obtained by literal shadowing, outlining of volumes, and restriction of movement. Oil on canvas, 35½ by 29 inches. *Collection of Leila Bardwell; Edelstein photograph.*

explorer General John Charles Frémont (1813-1890), after photographs. (A privately held unsigned portrait of General Frémont has been attributed to Chandler by Professor Charles Morgan of the Amherst College art department.) Technically these late portraits are more sophisticated than those of the 1840's. Aesthetically, however, Chandler's early folk style is more appealing and significant.

Chandler occasionally executed still lifes and landscapes in his ''primitive'' style (Figs. 11, 13). The still lifes, of which only two are presently known, were probably based upon fashionable works by New York and Philadelphia artists like John F. Francis (1808-1886). In Figure 11 the curious tiered arrangement, the bold graining of the shelves, and the stylized grape tendrils are characteristic of the American folk style. The landscape of 1882 (Fig. 13) is Chandler's last known painting. He died on October 27, 1884.

Although prolonged exposure to academic painting and to photography had caused his style to disintegrate, Chandler's late works are valuable in assessing the aesthetic merit of his earlier paintings. His early interest in observed detail and his direct, sympathetic portrayal of his sitters reflect some of the best elements of the American folk-art tradition.

The paper and *catalogue raisonné* from which this article is drawn were originally prepared for Historic Deerfield. Both the author and Historic Deerfield would welcome any additional information regarding the work of J. G. Chandler.

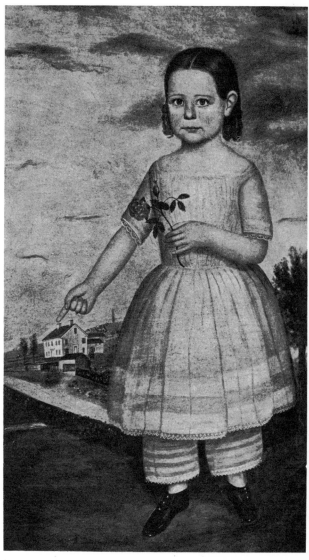

Fig. 9. *Nora Isabella Davison* (b. 1847). Inscribed on back *Painted for Miss Nora Isabella Davison, aged 3 years and 4 months. by J. G. Chandler, Jan. 1851.* The painting is one of the few with an identifiable location as a background. The house at which the girl points was her childhood home in Leesville, Connecticut. It has since been destroyed by fire. Oil on canvas, 46 by 27½ inches. *Private collection.*

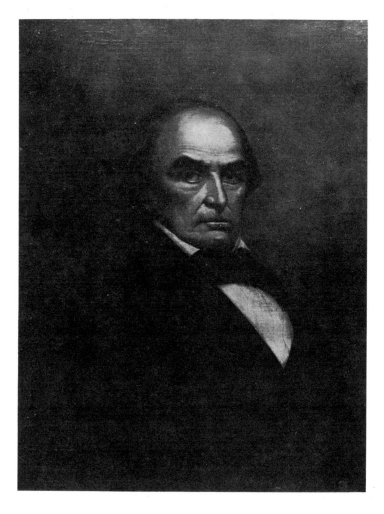

Fig. 10. *Daniel Webster.* Signed and dated *Joseph Goodhue Chandler, 1852.* Daniel Webster died on October 24, 1852, in Marshfield, Massachusetts. It is not known if Chandler painted the portrait from life or from a photograph. He made thirty copies of this portrait, which became his most famous work. This is the original from which the copies were made. Oil on canvas, 36 by 26 inches. *Dartmouth College.*

Fig. 11. *Still Life—Variety of Fruit*, c. 1866. Signed *J. G. Chandler*. This still life has been dated on the basis of a similar signed and dated example in the Shelburne Museum. The subject is based upon fashionable New York and Philadelphia types, but the curious tiered arrangement is a variation devised by Chandler. Still lifes are rare among Chandler's surviving works. Oil on canvas, 25 by 30 inches. *Museum of Fine Arts, Boston; M. and M. Karolik Collection.*

Fig. 12. *Man with a Cravat*. Signed and dated *J. G. Chandler, 1880*. The naïve strength of the artist's earlier style has been diluted by his exposure to academic painting and the photograph. Oil on canvas, 30 by 25⅛ inches. *Old Sturbridge Village.*

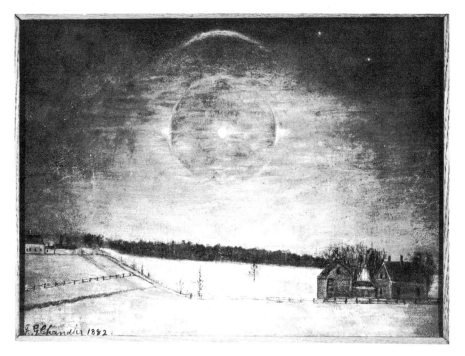

Fig. 13. *The Moon as seen February 2, 1882 at Baldwinsville, Massachusetts*. Signed and dated *J. G. Chandler 1882*. Inscribed on back *The Moon as seen Feb. 2, 1882 at Baldwinsville, Mass. J. G. Chandler, Artist*. This rare landscape is the last known work by Chandler. His wife's family owned the Waite Chair Company in Baldwinsville, and Chandler was a frequent visitor to the town. Oil on canvas, 11 by 15⅛ inches. *Mead Gallery, Amherst College; Edelstein photograph.*

J. A. Davis

BY NORBERT AND GAIL SAVAGE

FOR YEARS MANY nineteenth-century watercolor portraits have been attributed to Eben P. Davis in art shows and museum catalogues, by collectors, dealers, ourselves, and this magazine.[1] Now, after finding four, perhaps five, paintings signed or initialed by J. A. Davis, and having found no portrait indisputably signed by Eben P. Davis,[2] we feel that the group traditionally attributed to Eben P. Davis should be reattributed to J. A. Davis. We have also found portraits attributed to Joseph H. Davis and Alexander H. Emmons which we feel should be given to J. A. Davis.

The sole basis for the Eben P. Davis attributions has been the watercolor shown in Figure 4. This is inscribed on the back of the paper: *Eben Davis, he and wife* and along the side of the frame *Mr. and Mrs. Eben Davis of Byfield, Mass. Painted by Mr. Davis before their marriage*

about 1860. There seems no reason to doubt that this is a portrait of Eben and his wife; but the second inscription, on the edge of the frame, is not contemporary. It was obviously written after 1860 and it errs on the marriage date, which was not in 1860, but 1844. The painting probably was done about the time of the Davises' marriage. This later inscription containing such a large discrepancy in dates should not be accepted as fact. Even if one does accept it, it does not tell us which "Mr. Davis" did the painting. We feel that this portrait is not by Eben P. Davis but by J. A. Davis because its style closely resembles that of the signed portraits illustrated in Figures 1 and 2.

J. A. Davis' technique is quite consistent. All the paintings are in watercolor on paper, often an English paper watermarked *J. Whatman*. Except for one profile portrait in a private collection, faces are shown in three-quarter view, almost always facing slightly to the sitter's left. Pencil is used for outlines and sometimes for shading. Both white and blue paint are used on faces. Hands, which are certainly less competently done than faces or clothes, have very long fingers. The clothes are usually painted in mat black with the details picked out in somewhat glossier black. The paper is sometimes painted at the edges, perhaps to simulate a frame. Differences in facial expression indicate that the artist did attempt to portray the character of his sitters. However, to judge by these portraits it appears that the artist had little if any formal training.

In addition to the double portrait of Mr. and Mrs. Eben Davis we have found more than forty portraits attributable to J. A. Davis. Of these, three are signed (see Figs. 1, 2); in a group of five one is initialed (Fig. 5) and four are closely related to it (see Figs. 6, 7); three others were once attributed to Alexander H. Emmons; and one, showing Samuel Demeritt,[3] is perhaps signed. The inscription on the back of the Demeritt portrait is difficult to read in places, particularly the second initial of the painter's name. Nina Fletcher Little felt that that initial was *H* and that the portrait was painted by Joseph H. Davis, the well-known painter from Maine and New Hampshire.[4] We feel that the inscription reads not J. H. Davis but J. A. Davis. Stylistically the portrait of Samuel Demeritt is far more similar to the signed works of J. A. Davis than to works signed by or attributed to Joseph H. Davis, but until the second initial can be made out, the painting cannot be given with certainty to either artist.

Fig. 1. *Mr. Stephen N* [Nelson] *Tingley*, signed and dated *By J. A. Davis/1839*. Tingley, the son of Benjamin and Polly Tingley of Cumberland, Rhode Island, was born in 1816 and died in 1861. Another, almost identical, portrait of Tingley, also dated and signed *J. A. Davis*, is shown in *The Old Print Shop Portfolio* for May 1960, p. 214. Watercolor on paper, 7½ by 5¾ inches. *Authors' collection.*

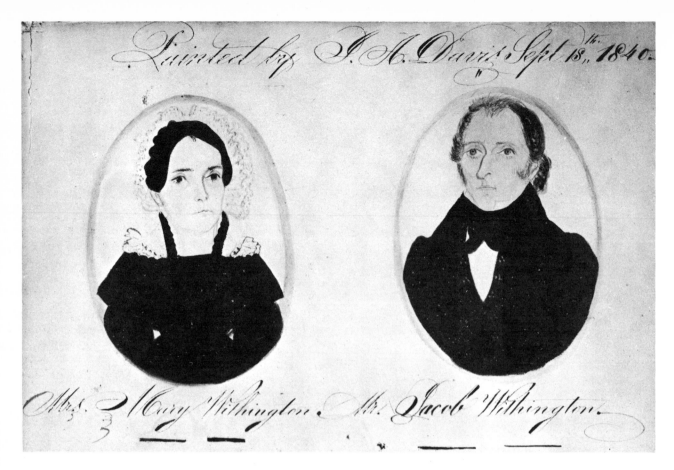

Fig. 2. *Mary and Jacob Withington,* signed *Painted by J. A. Davis* and dated September 18, 1840. A Jacob (b. 1785) and Mary Withington are listed as having lived in Henniker or in Manchester, New Hampshire, in 1840 (Leander W. Cogswell, *History of Henniker, New Hampshire, 1735-1880,* Concord, 1880, p. 792). Watercolor on paper, 5 by 7⅝ inches. *Collection of Mr. and Mrs. Peter H. Tillou.*

It does seem possible that J. A. Davis and Joseph H. Davis were related or were at least acquaintances, for they both appear to have painted Samuel Demeritt. A full-length watercolor of Demeritt dated 1836 has been attributed to Joseph H. Davis by Mrs. Little.[5] Perhaps the relationship between the two Davises will become clearer in time.

The portrait of Emma L. Arnold (Fig. 5) in the Garbisches' collection is initialed *J.A.D.* on the front. It is dated within one day of portraits of her parents (Figs. 6 and 7), which are done in the same manner. Similar portraits of Emma's sister Ellen and of James Arnold are also in the Garbisches' collection. The acquisition card for all but the portrait of Mrs. Arnold (which was bought two years later) says "signed by Joseph A. Davis on back of paper." As the watercolors have now been pasted onto Oriental rice paper and mounted on white rag board it is impossible to say how many are so signed. But since all five portraits bear a stylistic resemblance we feel safe in attributing them all to J. A. Davis, whose initials appear on the portrait of Emma Arnold.

The colors used in some of these five pictures are much brighter than those usually found on paintings we can attribute to J. A. Davis. Emma's dress is green; her sister's is true red; Mrs. Arnold has a green collar, a red pin, and a red book, while her chair and the border around

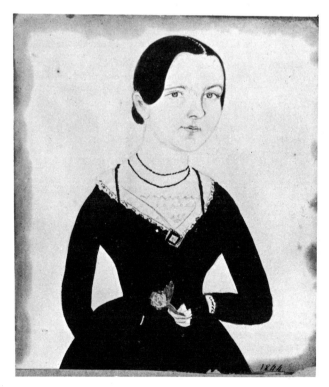

Fig. 3. *Woman of the Arnold Family,* attributed to J. A. Davis, dated 1844. A twentieth-century inscription on the original backing reads *Arnold Family, A . . . , near Narragansett, R.I.* There is a striking similarity between the sitter and Mrs. Eben Davis in Fig. 4. Watercolor on paper, 5¾ by 4¾ inches. *Authors' collection.*

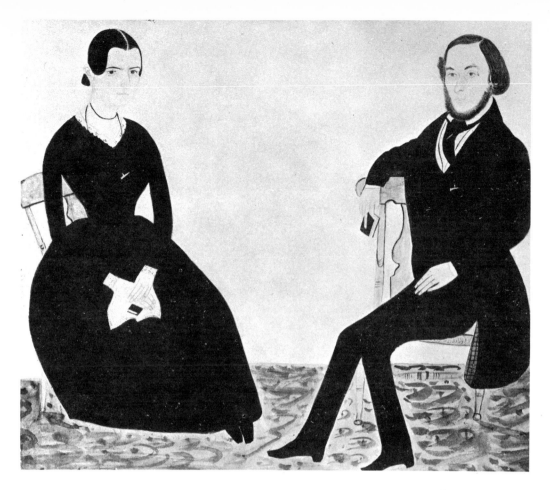

Fig. 4. *Mr. and Mrs. Eben P. Davis*, attributed to J. A. Davis, c. 1844. Inscribed on the back is *Eben Davis, he and wife,* and along the side of the frame *Mr. and Mrs. Eben Davis of Byfield, Mass. Painted by Mr. Davis before their marriage about 1860.* Watercolor on paper, 13¼ by 15⅝ inches. *Abby Aldrich Rockefeller Folk Art Collection.*

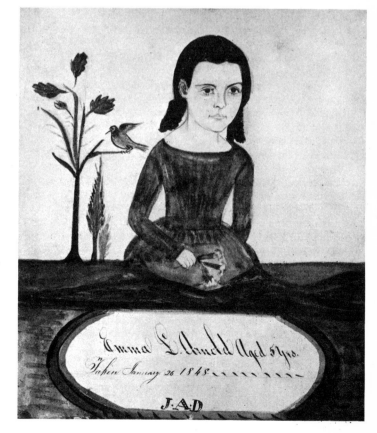

Fig. 5. *Emma L.* [Louise] *Arnold*, signed *J.A.D.* and dated January 26, 1848. The sitter was born in Woodstock, Connecticut, on February 11, 1842, and died on October 9, 1870. Her parents are shown in Figs. 6 and 7. Watercolor on paper, 7½ by 6½ inches. *Collection of Edgar William and Bernice Chrysler Garbisch.*

the inscription are yellow and red. The captain's coat and vest are a deep navy blue and his tie is a muted plaid.

The dates on portraits signed by or attributed to J. A. Davis are 1837, 1838, 1839, 1840, 1844, 1848, and 1851. The known sitters appear to have lived, at some time during their lives, in the towns of Barrington, New Hampshire (Samuel Demeritt); Cumberland, Rhode Island (Fig. 1); Henniker or Manchester, New Hampshire (Fig. 2); Woodstock, Connecticut (Figs. 5, 6, and 7); Lowell, Massachusetts; and Providence and Warren, Rhode Island.

Many years ago in this magazine Frederic Fairchild Sherman attributed three portraits found in Norwich, Connecticut, to Alexander H. Emmons,[6] but we feel that they too are the work of J. A. Davis, for they are very much in his style.

J. A. Davis appears to have worked in south-central New Hampshire, northeastern Massachusetts, eastern Connecticut, and particularly Rhode Island. Several of the known subjects are from Rhode Island, and many portraits of the unknown subjects have Rhode Island histories.

It is possible that J. A. Davis is the Joshua A. Davis listed as a portrait painter in Providence, Rhode Island, directories for 1854, 1855, and 1856, a few years after J. A. Davis's latest datable picture. In the 1852-1853 directory a Joshua N. Davis is listed as a portrait painter. Perhaps the N is incorrect and should be an A, as this is the only listing for that name.

[1] ANTIQUES, November 1970, pp. 754-757.

[2] There is, of course, the watercolor *Eben Davis' Horse* in the Abby Aldrich Rockefeller Folk Art Collection inscribed at the lower left *By E. P. Davis*, but that is not strictly speaking a portrait.

[3] ANTIQUES, November 1970, p. 755, Figs. 3, 4.

[4] ANTIQUES, November 1970, p. 755, Figs. 3, 4. For more on Joseph H. Davis see ANTIQUES, October 1943, p. 177; August 1944, p. 73; and July 1945, p. 40.

[5] ANTIQUES, November 1970, p. 755, Fig. 2.

[6] ANTIQUES, December 1923, p. 275.

Fig. 6. *Mrs Almariah Arnold*, attributed to J. A. Davis, dated January 25, 1848. The sitter was the wife of Captain Edward Greene Arnold (Fig. 7) and the mother of Emma L. Arnold (Fig. 5). Watercolor on paper, 7½ by 6¼ inches. *Garbisch collection.*

Fig. 7. *Capt. Edward G. [Greene] Arnold*, attributed to J. A. Davis, dated January 25 or 26, 1848. The sitter was born September 13, 1814, married Almariah (Fig. 6) on August 30, 1835, and died on January 26, 1899. Watercolor on paper, 7½ by 6¼ inches. *Garbisch collection.*

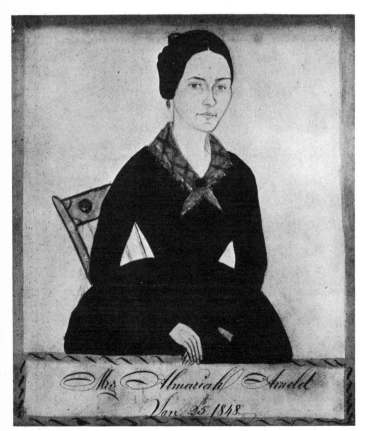

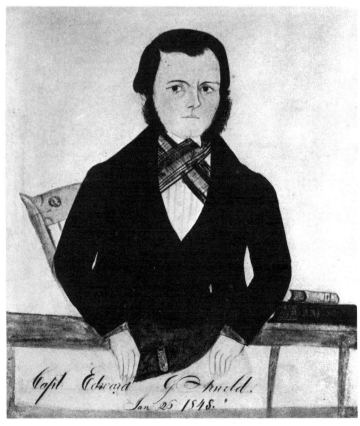

Sheldon Peck

BY MARIANNE E. BALAZS

The exhibition *Sheldon Peck* will be shown at the Whitney Museum of American Art, New York, August 8 to October 5, 1975; Abby Aldrich Rockefeller Folk Art Collection, Williamsburg, Virginia, October 12 to December 1, 1975; Munson-Williams-Proctor Institute, Utica, New York, December 14, 1975 to February 8, 1976; Flint Institute of Arts, Flint, Michigan, February 26 to April 4, 1976; Illinois State Museum, Springfield, April 25 to May 30, 1976. A Youthgrant from the National Endowment for the Humanities supported much of Marianne Balazs' research.

THE LIFE OF Sheldon Peck (Fig. 1) was typical of nineteenth-century itinerant portraitists. His ancestors settled in America in 1635 and were among the founders of New Haven Colony. His father, Jacob Peck, a farmer and blacksmith who had fought in the Revolution, was one of the first settlers in Cornwall, Vermont, to which he and his wife, Elizabeth, moved from Litchfield, Connecticut, in the winter of 1787. Sheldon Peck was born in Cornwall on August 26, 1797, the ninth of eleven children. He was probably a self-taught artist, for no record exists of his

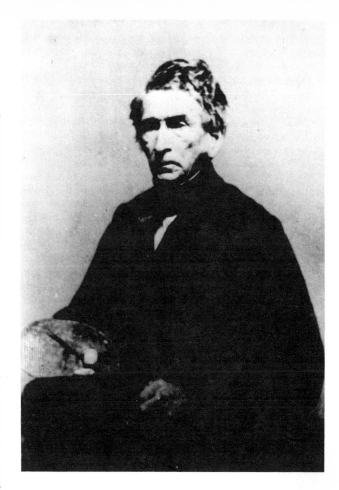

Fig. 1. Sheldon Peck. *Photograph by courtesy of Allen F. Mertz.*

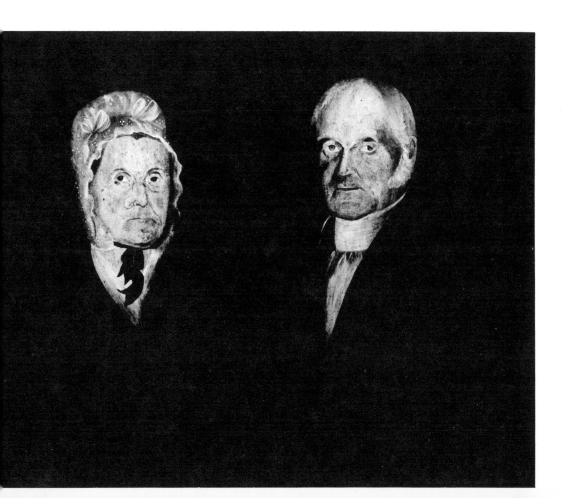

Fig. 2. Portrait of Elizabeth (nee Gibbs; 1760-1843) and Jacob Peck (1756-1838), c. 1820. Oil on wood panel, 25 by 30 inches. The sitters, the parents of the painter, were married on January 18, 1781, in Litchfield, Connecticut. *Collection of Mr. and Mrs. Sanford S. Witherell.*

August, 1975

having studied with an established artist. He may, however, have had access to books in the library of the Cornwall Young Gentleman's Society, a cultural and educational institution founded in 1804.

Peck did not sign his paintings, most of which lay largely unnoticed in attics and cellars for nearly a century. However, from works attributed to him and other paintings still owned by descendants one can discern his distinctive style and three stages of his development as an artist. These coincide with his early years in Vermont, his sojourn in New York State, and his final years in Illinois.

Peck's earliest known portraits, of members of his family, appear to have been painted about 1820. In the double portrait of his parents (Fig. 2) he has reversed the usual placement of the man on the woman's right, perhaps because he was unaware of that convention. The brushwork is painterly, quite unlike that in Peck's later work, but the dark, somber colors and plain backgrounds are typical of his first period.

Peck is believed to have painted the waist-length portraits of his brother and sister-in-law Alanson and Mary Parker

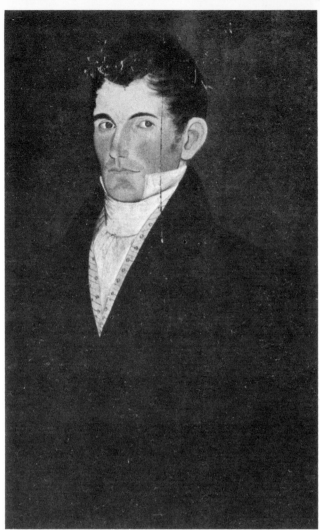

Pl. I. *Captain Alanson Peck* (1800-1897), c. 1824. Oil on wood panel, 29½ by 18¼ inches. The sitter, a younger brother of the artist, was a captain of militia in the Civil War, a gentleman farmer, and heir to the Peck farm in Cornwall, Vermont. *Witherell collection.*

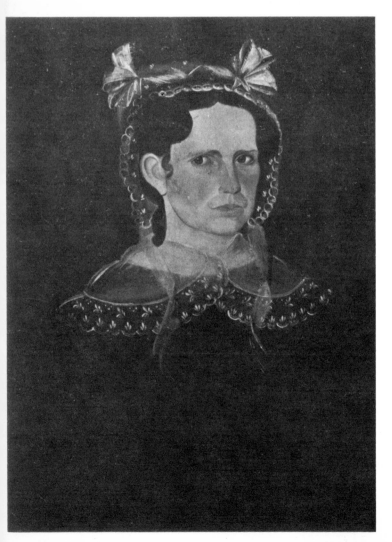

Pl. II. *Mary Parker Peck* (1801-1876), c. 1824. Oil on wood panel, 28¾ by 20 inches. Born in Bethel, Vermont, the sitter married Alanson Peck on January 27, 1824. *Witherell collection.*

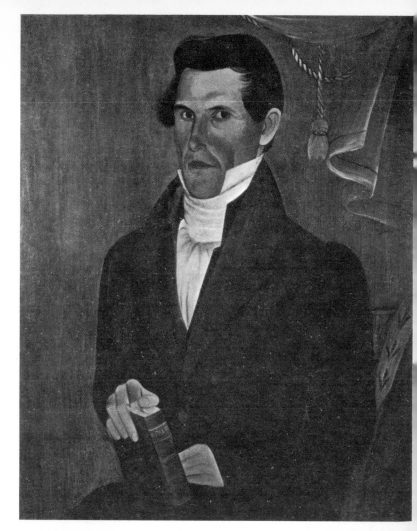

Pl. III. *Man Holding Bible*, c. 1830. Oil on wood panel, 31½ by 25½ inches. *Munson-Williams-Proctor Institute.*

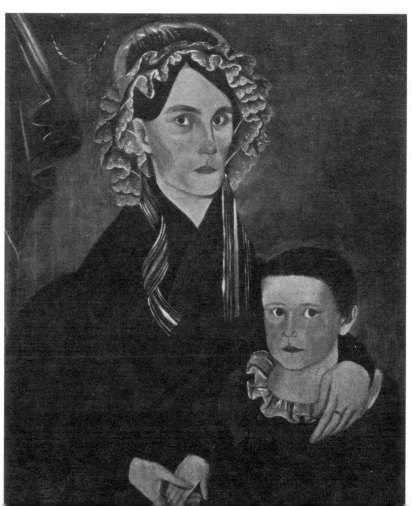

Pl. IV. *Mother and Son*, c. 1830. Oil on wood panel, 31½ by 25¼ inches. *Munson-Williams-Proctor Institute.*

Peck (Pls. I, II) about the time of his own marriage to Harriet Corey (1806-1887) of Bridport, Vermont, on September 15, 1824. Here his distinctive style begins to show in the sculptural quality of the sitters' features—the piercing eyes, prominent brow, and immobile expression. The collar on Mary Peck's dress introduces a decorative motif that reappears throughout the artist's work in one form or another—a long stroke flanked by two shorter ones, like the print of a rabbit's foot. The frequent recurrence of the motif on clothes and furniture indicates that Peck may have thought of it as a sort of trade mark. In portraits done about this time Peck elaborated on his sitters' coiffures and costumes by painting in curls, lace-trimmed collars and bonnets, and gold buttons. In the portraits of a Mr. and Mrs. Murray (Figs. 3, 4), he included drapery in the background, and in the slightly later portrait of a woman (Fig. 5), he added a chair to his repertory of props.

Sheldon and Harriet Peck were in Burlington, Vermont, in 1827 when their second child, Charles, was born.[1] He later became a landscape painter, photographer, and founding member of the Chicago Academy of Design. There are no records to indicate that Peck bought property in Burlington, which would suggest that the family did not intend to stay there long. From Vermont they probably traveled down Lake Champlain and the Hudson River and west along the Mohawk River and the Erie Canal. The canal had opened in 1825 and made westward travel by boat cheaper than overland travel along the toll roads.

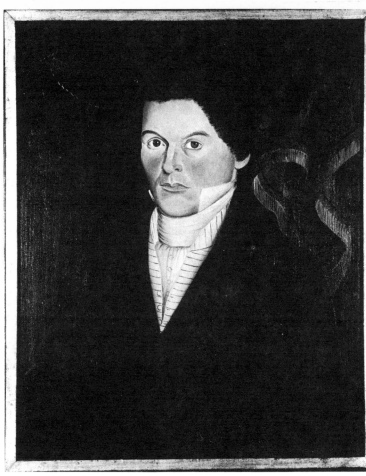

Fig. 3. *Mr. Murray*, c. 1825. Oil on wood panel, 27 by 21¾ inches. *Flint Institute of Arts, Flint, Michigan; gift of Edgar William and Bernice Chrysler Garbisch.*

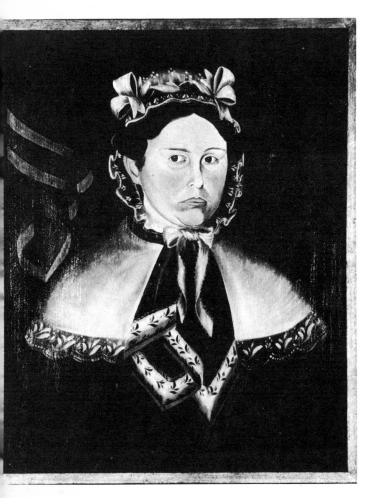

Fig. 4. *Mrs. Murray*, c. 1825. Oil on wood panel, 27 by 21¾ inches. *Flint Institute of Arts; Garbisch gift.*

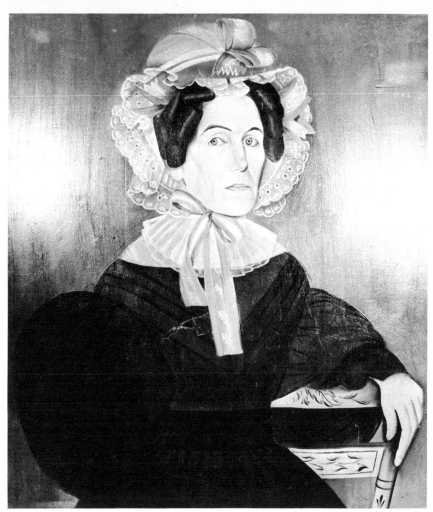

Fig. 5. *Woman in a Chair*, c. 1827. Oil on wood panel, 29½ by 24½ inches. *Sheldon Art Museum, Middlebury, Vermont.*

Fig. 6. *Portrait of a Boy*, c. 1828. Oil on wood panel, 22⅝ by 17⅞ inches. *Collection of Mr. and Mrs. Richard Bury.*

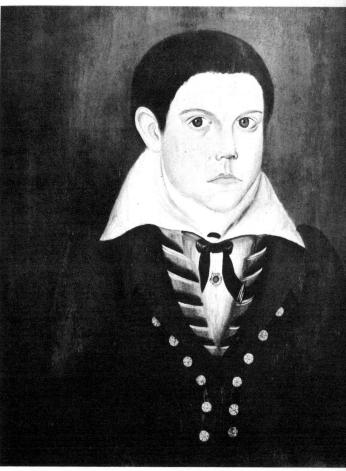

By 1828 the Pecks had settled in a booming canal town called Jordan in Onondaga County, New York.[2] Census records for Jordan and nearby towns suggest that Vermont relatives of the Pecks may also have settled in the area about the same time. Judge William Cooper of Cooperstown, New York, described the western counties of New York as "chiefly peopled from the New England states, where the people are civil, well informed, and very sagacious. . . ."[3] By the time the Pecks arrived, Onondaga County was fairly well settled and prosperous, with its own local government already established.

During his New York period Peck continued to paint half- and three-quarter-length portraits on wooden panels, but sometimes in brighter colors and with settings which are generally more detailed than they are in the Vermont paintings. There are often swags of drapery at the corners, painted furniture (Pls. III, IV), Bibles (Pl. III) and other books, bowls of fruit, and a landscape in the background (Fig. 7). The Bible and drapery at the corners were particularly popular artistic conventions at the time. Peck's use of them suggests that he had observed the work of other artists.

Four of the five half-length portraits of members of one family Peck painted in New York (see Figs. 6, 7) have the plain dark backgrounds of the Vermont-period portraits. The familiar rabbit's-foot motif appears in three of the series and the buttons on the boy's jacket (Fig. 6) bear a starlike design that reappears in later portraits on buttons

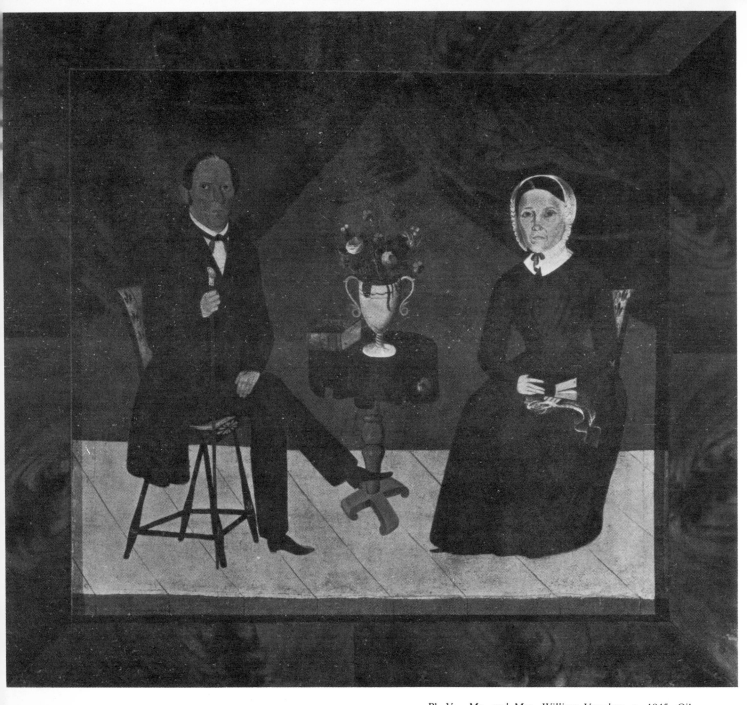

Pl. V. *Mr. and Mrs. William Vaughan*, c. 1845. Oil on canvas, 30 by 34 inches. The sitters were residents of Aurora, Illinois (see also Fig. 13). The frame is the original one, painted to simulate mahogany veneer. *Collection of Bernard M. Barenholtz.*

and on the knobs of drawers. The portrait of the little girl (Fig. 7) is the most ambitious of the group, since for the first time Peck suggests a landscape background by his inclusion of stylized trees, hills, and water. The rose, with its peculiar circular brush strokes and dots in the center, also appears for the first time in Peck's surviving work. He employed the rose often during his Illinois period.

Peck prospered while in New York State. By 1835 he was able to buy a fifty-acre parcel of land outside the village of Jordan for $1,500. Then in August 1836, Peck sold his house and all his land and left Jordan. An announcement by the town physician dated October 1, 1836, in the *Onondaga Standard* of November 9, 1836, may explain the family's abrupt departure:

Be it known to all people, that one Sheldon Peck, and Harriet his wife, not having the fear of God before their eyes, being instigated by the devil, have with malice aforethought most wickedly and maliciously hired, flattered, bribed or persuaded my wife Emeline, to leave me without just cause or provocation. It is supposed that said Peck has carried her to some part of the state of Illinois. This is therefore to forbid all persons harboring or trusting my wife Emeline, for I will pay no debts of her contracting.

Hezekiah Gunn

The wording of the newspaper entry and the alleged responsibility of both Pecks brings to mind the possible influence of the Mormon practice of polygamy. Joseph Smith had founded the Church of Jesus Christ of Latter-day Saints in Onondaga County, near Jordan, in 1830. How-

Pl. VI. *David Crane* [1806-1849] *and Catharine Stolp Crane* [1814-1889], c. 1845. Oil on canvas, 35¾ by 43¾ inches. The couple were married on February 23, 1832, and in 1834 moved from Poultneyville, New York, to settle in Aurora, Illinois. The trompe l'oeil frame is painted on the canvas. *Private collection*.

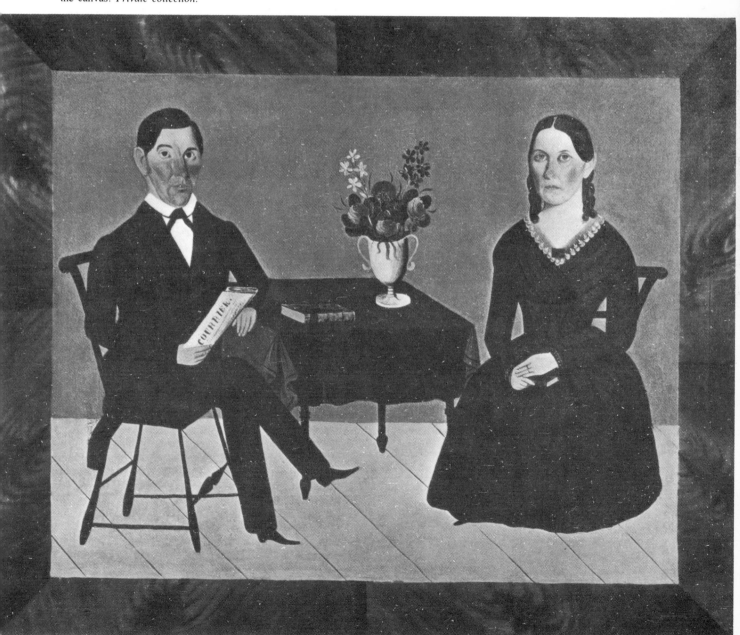

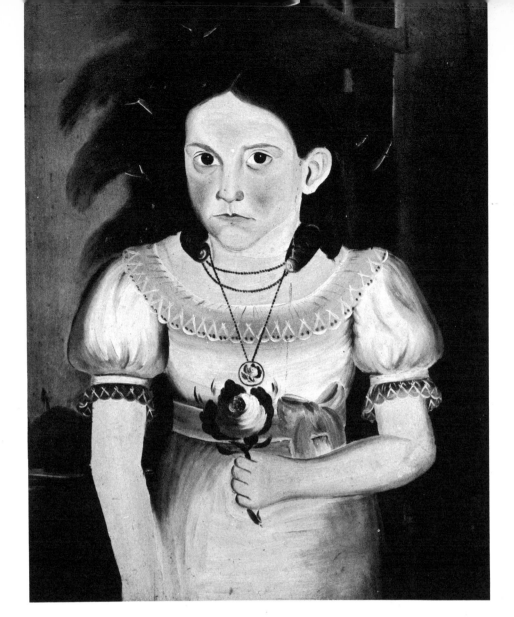

Fig. 7. *Girl with Rose and Landscape*, c. 1828. Oil on wood panel, 22⅝ by 17¹³/₁₆ inches. *Bury collection.*

ever, neither family tradition nor church records indicate that the Pecks were Mormons, and as Emeline Gunn is not listed in any Illinois census entries for the Pecks, it seems she did not join their household permanently.

The Pecks traveled to Chicago but apparently did not stay very long. According to family tradition Sheldon Peck bought property near Washington and State streets in what was by then a bustling and growing city. However, with the Panic of 1837, largely resulting from wild land speculation, there was probably little demand for portraits in Chicago. In the portraits in Figures 8, 9, and 10, which may date from this time, Peck reverted to his plainer Vermont style, perhaps so that in simplifying he could minimize his prices to attract customers. These three portraits, like the others done in Illinois, are painted on canvas, not on wooden panels as the Vermont and New York pictures are.

The portraits shown in Figures 11 and 12 include many elements Peck had used singly in earlier works, plus a newspaper dated 1838 which bears part of the motto of Chicago's first paper, the *Chicago Democrat:* "Where Liberty dwells, there is my Country—Franklin." Newspapers recur frequently in Peck's later portraits.

According to family tradition Peck traded his land in Chicago for a team of horses to move his family and

furnishings to the part of Babcock's Grove that is now known as Lombard, twenty miles west of Chicago. Here the Pecks are said to have lived in a covered wagon for two years while Peck built the house in which his descendants still live today.

Sheldon Peck was a farmer and a community leader in Babcock's Grove. He started the first school in his house and paid the teacher's salary himself. In the 1840 census he was listed as "employed in agriculture" and it was not until the 1850 census that he gave his profession as portrait painter. That census, too, shows that he was one of the wealthiest landowners in the region. According to family accounts he was an abolitionist and his house was a stop on the Underground Railroad used by escaping slaves.

After the summer farming season, Peck traveled and painted. On trips to Aurora he painted, among others, members of the Crane (Fig. 14, Pl. VI), Vaughan (Fig. 13, Pl. V), and Wagner (Fig. 15) families in what can be clearly identified as his Illinois style. He painted full-length figures, often in groups, using bright colors such as red and yellow. Sometimes he attempted to give the settings three-dimensionality by painting in the floor boards, and he frequently painted a trompe l'oeil grained frame directly on the canvas.

By using brighter colors, larger canvases, and trompe

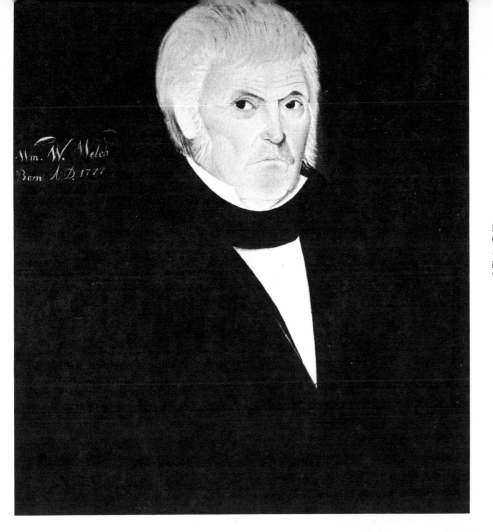

Fig. 8. *William W. Welch,* c. 1837. Oil on canvas, 25½ by 21⅞ inches. According to the inscription on the painting, the sitter was born in 1777. *Collection of William F. Carr.*

Fig. 9. *Phebe Welch,* c. 1837. Oil on canvas, 25½ by 21⅞ inches. According to the inscription on the painting, the sitter was born in 1793. *Carr collection.*

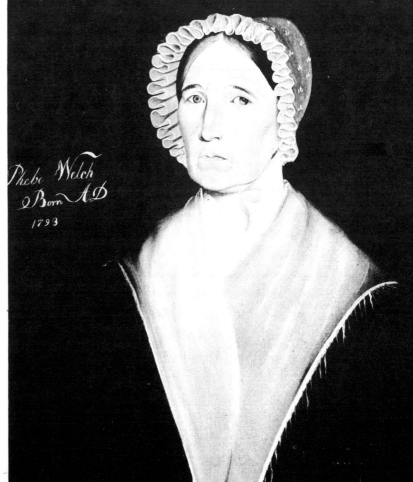

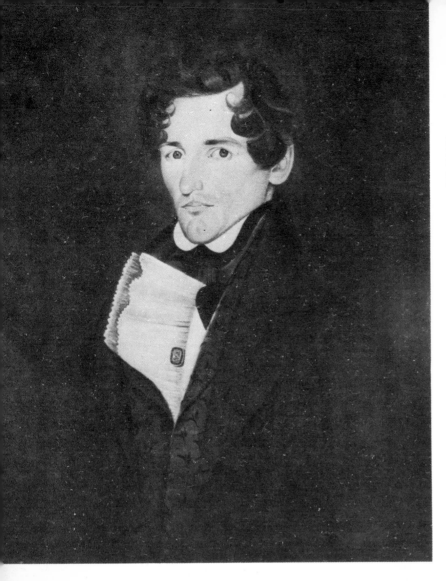

Fig. 10. *Elmer Tyler*, c. 1837. Oil on canvas, 30 by 25 inches. One of the first tailors in Chicago, he is listed at 101 Lake Street in the 1839 city directory. *Chicago Historical Society, gift of Mrs. W. H. Flagg.*

Fig. 11. *Man with Newspaper and Landscape*, c. 1838. Oil on canvas, 28½ by 27½ inches. The newspaper is dated 1838 and bears part of the motto of Chicago's first newspaper, the *Chicago Democrat*. John Calhoun, founder and editor of that paper, has been suggested as the subject of this painting; however, he had sold the paper in 1836. *Photograph by courtesy of John Gordon.*

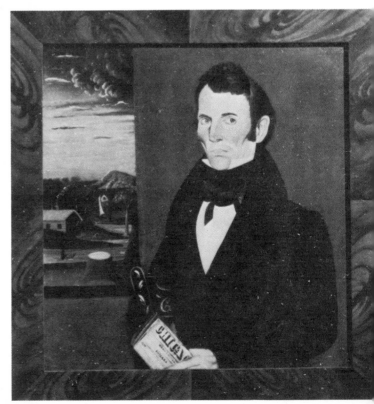

l'oeil frames Peck was clearly offering effects that his patrons could not get in the quick, accurate, and inexpensive daguerreotypes which had been introduced to America in 1839. By the 1850's the competition proved too much, however, and Peck, like countless other itinerant portrait painters, was obliged to explore new avenues for his painting.

In 1854 and 1855, Peck had a studio at 71 Lake Street in Chicago, where he advertised himself as "decorative painter," perhaps painting chairs and other furniture. In the 1860 census for Lombard, Peck, then sixty-three years old, gave his profession simply as "artist." Family tradition relates that he traveled to St. Louis to do medical drawings for colleges there, but research has failed to substantiate this. His son Charles, however, was an artist and photographer listed in the St. Louis directories between 1860 and 1866. Peck died of pneumonia on March 19, 1868. His estate in Lombard comprised 175 acres of land valued at $9,000, including a large farm well stocked with seventy-seven sheep, two horses, three cows, five hogs, and farming tools.

Peck's portrait of his parents (Fig. 2) indicates that he had the potential to work in the academic tradition, emphasizing brush stroke and careful modeling. Instead he appears to have consciously chosen to paint in a simple

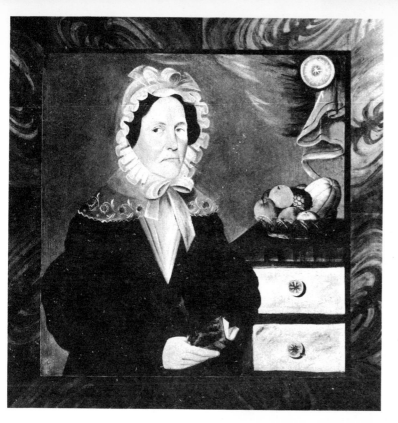

style that would appeal to relatively unworldly patrons. Facial features are treated as simple planes rendered by flat areas of color. Unlike most artists, who flocked to the cities to compete for the patronage of wealthier merchants and manufacturers, Peck chose his style and went to the frontier where he would find people to appreciate it.

[1] The Pecks had twelve children: John (1825-1884), Charles (1827-1900), George (b. 1829), Abigail (b. 1831), Alanson (b. 1833), Watson (1835-1889), Martha (b. 1837), Henry (1839-1914), Susan Elizabeth (1843-1919), Abigail Corey (1846-1909), Sanford (b. 1848), and Frank Hale (1853-1944). Abigail and Alanson died in infancy.

[2] On September 24, 1828, after his arrival in Jordan, Peck paid $90 for a quarter acre of land near the center of town on a road leading south from the canal.

[3] William Cooper, *A Guide in the Wilderness; or the History of the First Settlement in the Western Counties of New York, with useful Instructions to Future Settlers* (Dublin, 1810; reprinted Cooperstown, New York, 1965), p. 50.

Fig. 12. *Woman Holding Book with Chest and Bowl of Fruit,* c. 1838. Oil on canvas, 28½ by 27½ inches. This is a companion to the painting shown in Fig. 11. *Gordon photograph.*

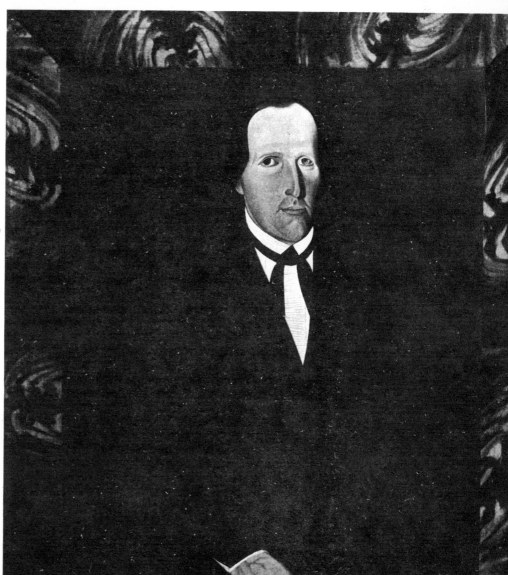

Fig. 13. *Mr. S. Vaughan,* c. 1845. Oil on canvas, 34¾ by 31 inches. The sitter was a resident of Aurora, Illinois (see also Pl. V). The trompe l'oeil frame is painted on the canvas. *Illinois State Museum.*

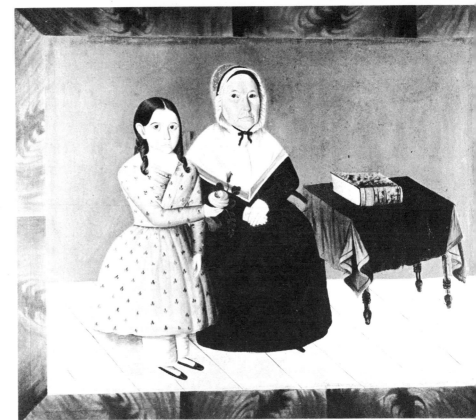

Fig. 14. *Anna Gould Crane and Granddaughter Jennette*, c. 1845. Oil on canvas, 35½ by 45½ inches. Anna Gould Crane was the mother of David Crane (see Pl. VI), who was Jennette Crane's father. The trompe l'oeil frame is painted on the canvas. *Collection of Mr. and Mrs. Peter H. Tillou.*

Fig. 15. *John J. Wagner Family* (detail), 1846 or 1847. Oil on canvas, 33¼ by 41½ inches. The ages of Mr. and Mrs. Wagner (respectively 53 and 41) are inscribed beside them on the canvas. These and their listings in the 1850 census make it possible to date the portrait. Four-year-old Martha sits on her mother's lap, covering both a sister's finished arm and hand and her mother's right hand. This placement may have been dictated by the imminent arrival of the Wagners' seventh child, Laura, who is listed as being four years old in the 1850 census. Mr. Wagner holds a copy of the *Liberty Citizen*. A trompe l'oeil frame (not shown) is painted on the canvas. *Aurora Historical Museum, Aurora, Illinois.*

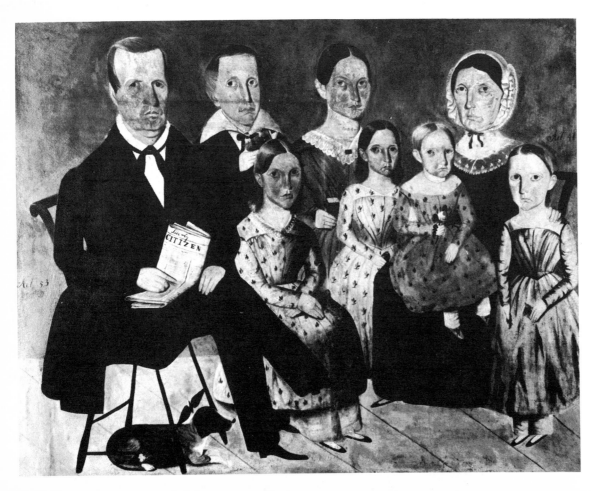

The landscape of change: *Views of rural New England, 1790-1865*

BY JAY E. CANTOR, *Special exhibition curator, Old Sturbridge Village*

Fig. 1. *Taunton Common*, artist unknown, c. 1830. Watercolor on paper, 14³/₁₆ by 19⁵/₁₆ inches. *Old Colony Historical Society, Taunton, Massachusetts; photograph by the author.*

IN THOSE DYNAMIC years between the American Revolution and the Civil War, what did New England look like and how did the surge of commercial expansion, technological advance, and industrial development affect the physical and cultural landscape of the region? *The Landscape of Change: Views of Rural New England, 1790-1865,* an exhibition on view at Old Sturbridge Village until May 16, attempts to answer these questions by providing visual evidence of the impact of New Englanders' presence on, and their use of, their surroundings. The show is the product of a year-long search I conducted in local historical societies, museums, libraries, and private collections for paintings, drawings, watercolors, and prints which document a changing New England.

Old Sturbridge Village presents a localized portrait of a rural New England agricultural community through its re-creation of domestic environments, craft techniques, and work processes based on extensive study of period materials and the selection of appropriate historical models. This exhibition of landscapes is an extension of the picture that the Village presents, encompassing a wide range of community types and geographical situations as well as adding to the available body of documentation for a correct image of the New England village. Moreover, the exhibition demonstrates how this rural world was viewed during the period by residents and outside observers.

The landscape record left by painters in the romantic tradition, loosely associated as the Hudson River school, concentrated on wilderness situations, dramatic natural manifestations, and poetic reveries; these painters sought to depict an undefiled landscape which would awaken the sensibilities of the viewer to the inherent beauty of the American scene as well as to the spiritual and philosophical values of life as a means of counteracting the overt materialism of the age. The clearing and cultivation of the land with the removal of timber and other raw materials posed a continual threat to the spectacle of the untouched American wilderness, which artists and writers committed to romantic democracy felt was the embodiment of the American national identity.

By contrast, the pictures shown here from the exhibition celebrate the man-made world and, in fact, document the very ways and means that the landscape was altered: they demonstrate the extensive clearing associated with timber consumption and land tillage, the division of land into lots, the construction of earthworks, walls, dams, bridges, and mill runs—all diverting and subduing nature to human purpose. This disregard for the natural amenities of the landscape was an expression of the reordering of the environment for personal, communal, or economic reasons—a reordering of nature which has been subsequently masked from view in large part by the regrowth of forests and in some cases by conscious efforts to beautify the surrounding countryside.

Before the Civil War, New England was experiencing dramatic changes influenced by social mobility, territorial expansion, immigration, and an increasing sense of separateness as the sectional conflict approached. Each of these exerted strong pressures for change on local values and institutions. These pictures—images of local identity—not only record but also memorialize the local scene in New England: as products of a number of widely shared values and experiences, they record the traditional symbols of rural identity and suggest the emergence of new ones during the era of the industrial revolution. They attest to the significance of agriculture and to its gradual displacement as the principal economic activity. They reveal the impact of improved inland transportation—the estab-

Fig. 2. *View of the Great Curve Near Newton Lower Falls on the Boston and Worcester Railroad,* by Samuel Adams Hudson (1813-after 1894), 1852. Oil on canvas, 25 by 30 inches. *Photograph by Herbert P. Vose, by courtesy of Robert C. Vose, Jr.*

Pl. I. *View of Williamstown looking East from West College,* artist unknown, c. 1847. Oil on canvas, 24 by 30 inches. *Williams College Museum of Art. Except as noted, photographs are by Bruce Fenton.*

Pl. II. *View of Northampton, Massachusetts,* artist unknown, 1850-1860. Oil on canvas, 29⅛ by 36⅛ inches. *Smith College Museum of Art.*

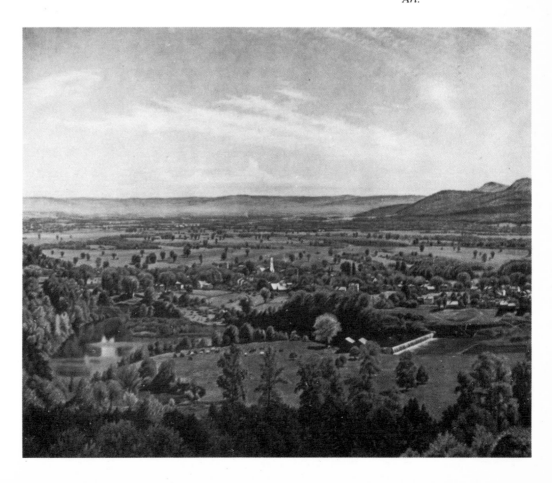

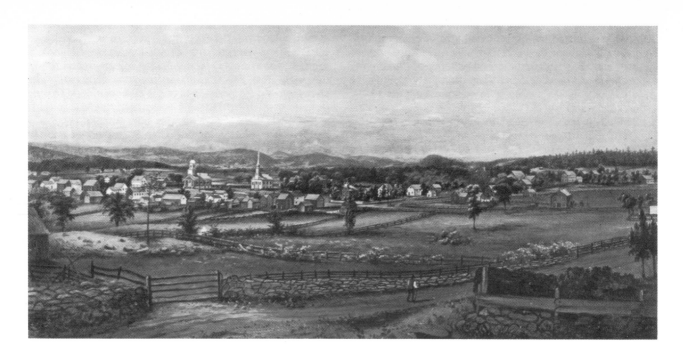

Pl. III. *Orwell, Vermont*, by Jenny Royce, c. 1860.
Oil on canvas, 14⁵/₁₆ by 29⁵/₁₆ inches. *Wright Memorial Library, Orwell, Vermont.*

Pl. IV. *View of Arlington, Vermont*, attributed to Charles Louis Heyde (1822?-1892), c. 1852. Oil on canvas, 17 by 25½ inches. *Canfield Memorial Library, Arlington, Vermont, Russell Vermontiana collection.*

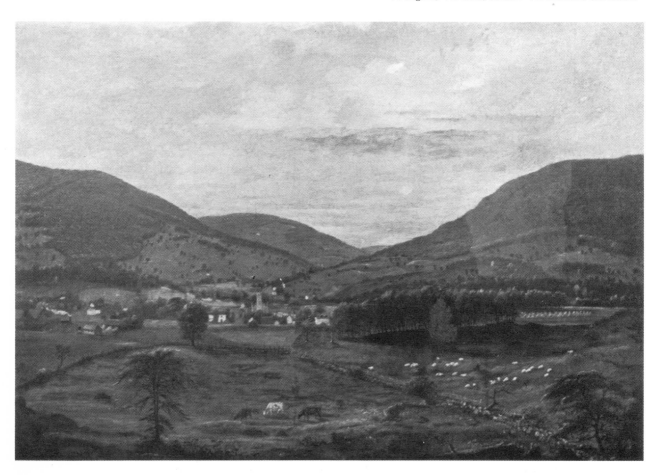

lishment of roads, turnpikes, and ultimately the railroad—all of which affected the location and size of communities. They also document the early and widespread presence of industry and show its alteration of patterns of community organization and development. They ultimately identify the industrial city as it developed in striking contrast to the surrounding rural world.

Included in the exhibition are house portraits (see Pls. IX-XIII), mill-village scenes (see cover, Pl. V, and ANTIQUES for December 1970, pp. 910-915), agricultural landscapes (see Fig. 2, Pls. II, IV, XIV), town views (see Pls. I-V, VIII), pictures of town centers and commons (see Fig. 1, Pls. XV, XVIII), and illustrations of colleges and academies (see Pls. I, XVI, XVII). All of these landscapes had special significance for their contemporaries, but for a variety of reasons: some were intentional expressions of community—showing a newly improved town common or the buildings surrounding that space—while others were inspirational in content, intended to instill and reinforce particular sentiments; some were advertisements or records of accomplishments; all were, to varying degrees, colored by cultural intentions and by artistic considerations of composition and style.

While providing a detailed view of many facets of the New England rural scene, these pictures are nonetheless selective and interpretative in what is shown. They concentrate, for example, on the man-made environment with the result that the natural landscape is frequently only shown around the perimeters of the composition. Clearings and stump-cluttered hillsides occasionally appear in larger scenes, but these visual insights into outdoor occupation and land use are more random than intentional in purpose. These views are formal portraits of places, not intimate scenes of country life and rural occupations: activity is relegated to occasional figures existing primarily as compositional motifs and not as story-telling devices. Indications of real work are minimal and are usually associated with some form of harvesting in agricultural scenes or hauling in commercial and industrial views. The expansiveness of American society—flourishing farms and thriving commerce, an abundant well-being that reached deep into the rural interior, a confident optimism that seemed almost idyllic in the clearness of its limited goals and the excitement of its occasional glimpses of a wider world—saturates these New England landscapes. Faith in constant improvement and belief in the indefinite progress of man-

Pl. V. *Boston Manufacturing Company, Waltham, Massachusetts*, artist unknown, 1826-1830. Oil on canvas, 27 by 39¾ inches. *Lowell Historical Society, on long-term loan to Old Sturbridge Village.*

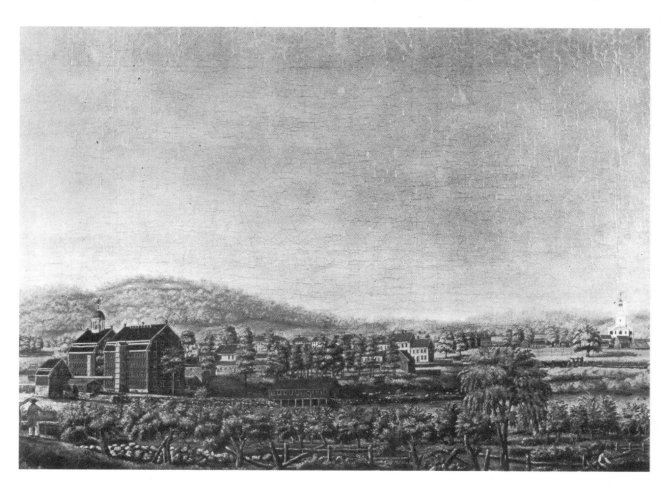

Pl. VI. *Sutherland Falls*, by Ambrose Andrews (w. 1824-1859), 1851. Oil on canvas, 29⅝ by 23¾ inches. *Vermont Historical Society.*

kind were repeatedly reinforced in these views. As a result, the more remote, backward regions of New England—with their humble farmers in distressing circumstances and acquiescent artisans whose positions in the community were deteriorating as radical changes in manufacturing pre-empted the scene—went largely undepicted in the major compositions of this type of painting. After 1820, however, some less ambitious pictures inspired by an emerging interest in local history and family genealogy provide useful insights into this other New England. The pictorial record became more complete by mid-century with the appearance of photography, the changing scope of the Hudson River school of painting, the growth of illustrated periodicals, and the spread of genre painting.

Each landscape illustrated here should be viewed as representing a single place at one moment in history—a solitary document of the dynamic changes and massive shifts in the life and times of New England which shaped the region into a landscape of change.

The author is preparing a monograph on New England landscape paintings, which is to be published in 1977. He welcomes information from readers about such landscape views that are presently unknown to him.

Pl. VII. *Ktaadn*, by Charles Thomas Jackson (1805-1880), c. 1836. Watercolor on paper, 7⅜ by 9⅜ inches. *Maine State Library.*

Pl. VIII. *Clarendon Springs*, by James Hope (1818 or 1819-1892), 1853. Oil on canvas, 26 by 36 inches. *Currier Gallery of Art.*

Pls. IX and X. Views of the Elizur Wright House, Medford, Massachusetts, artist unknown, c. 1810. Watercolor on paper. Front view, 8¼ by 11½ inches; rear view, 8¼ by 12¼ inches. *Society for the Preservation of New England Antiquities.*

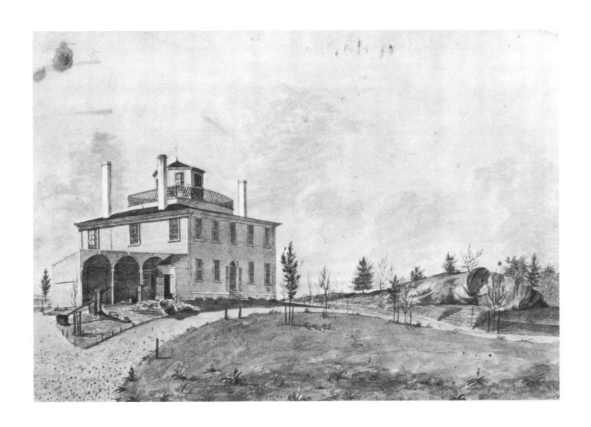

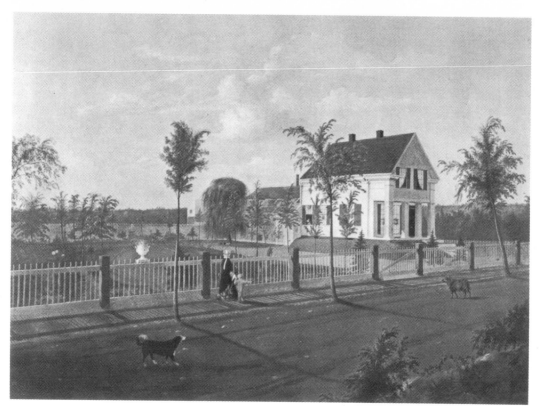

Pl. XI. *Home of Capt. George P. Burnham as it appeared at 94 Cottage Street, North Malden, Massachusetts in 1845,* artist unknown. Oil on canvas, 22 by 30 inches. *Collection of Mr. and Mrs. Richard Merrill; photograph by Richard Merrill.*

Pl. XII. *The House with the Red Door,* by Samuel Lancaster Gerry (1813-1891), c. 1850. Oil on canvas, 20¼ by 26 inches. *Private collection.*

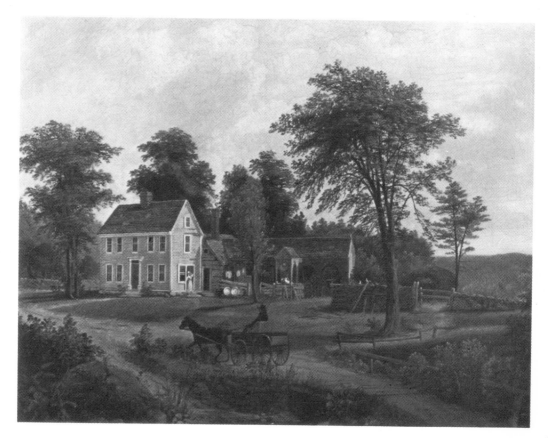

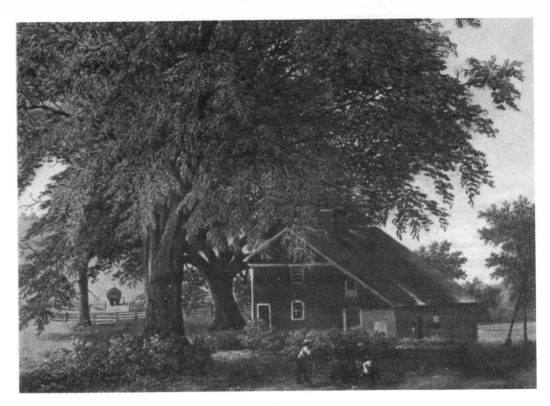

Pl. XIII. *Hartford Scene*, by Nelson Augustus Moore (1824-1902), 1862. Oil on canvas, 13 by 18 inches. *Connecticut Historical Society.*

Pl. XIV. *Country Landscape with a Red Farmhouse*, artist unknown, c. 1850. Oil on canvas, 22$\frac{1}{16}$ by 36 inches. *Collection of Mr. and Mrs. Robert Skinner.*

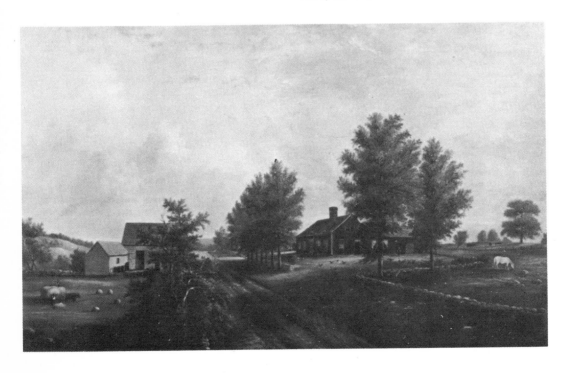

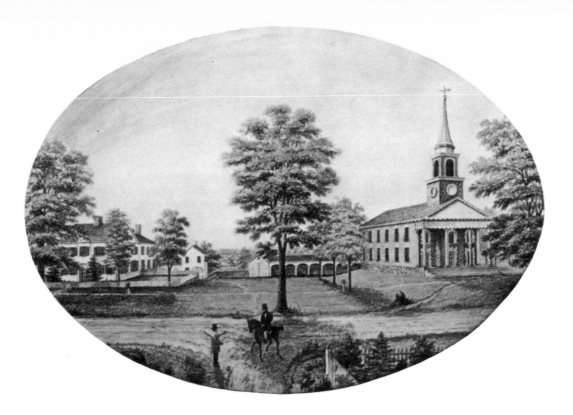

Pl. XV. *Church and Parsonage, Plainfield, Connecticut,* by John H. Raser, 1850. Oil on prepared ground, 13 by 19 inches. *Connecticut Historical Society.*

Pl. XVI. *Old Mill, University of Vermont,* by Augusta Stevens, 1840. Watercolor on paper, 10 by 13¼ inches. *Robert Hull Fleming Museum, University of Vermont.*

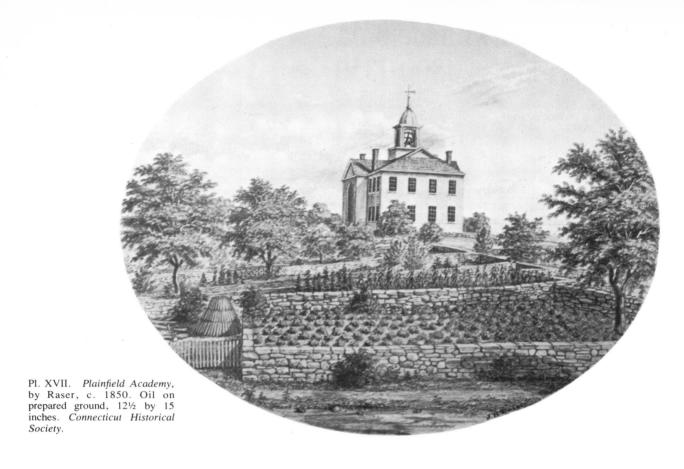

Pl. XVII. *Plainfield Academy*, by Raser, c. 1850. Oil on prepared ground, 12½ by 15 inches. *Connecticut Historical Society*.

Pl. XVIII. *View of the Common, Lebanon, New Hampshire*, by Ulysses Dow Tenney (1826-after 1904), 1852. Oil on canvas, 19^{15}/$_{16}$ by 27⅛ inches. *Lebanon Public Library*.

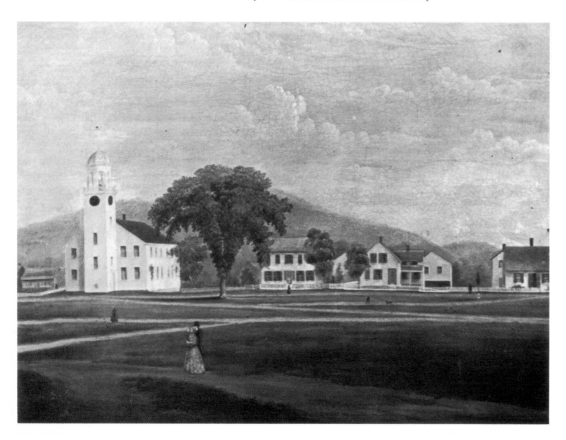

Mary Ann Willson

BY N. F. KARLINS

MARY ANN WILLSON (or Wilson) was one of the large number of American watercolorists who painted between 1800 and 1825. In this century, however, her work was not seen until the 1940's, when the Harry Stone Gallery of New York City acquired twenty of her watercolors and a letter of comment signed "An Admirer of Art."[1] The unidentified author of the four-page letter claimed to have visited the artist in Greenville, Greene County, New York. The letter itself appears to have been written about 1850, since it refers to Thomas Cole, Asher B. Durand, and Daniel Huntington as "modern" painters.

At the time the Stone gallery procured the paintings an appreciation for American primitive art was growing. In the 1920's the Whitney Studio Club of New York City (later the Whitney Museum of American Art) and several galleries began to exhibit it; in the 1930's there were a number of major museum shows of American folk art; and in the 1940's the first books to deal extensively with the subject began to appear. Although twentieth-century painters and sculptors responded to the powerful linear rhythms and abstract designs of these early American works, Mary Ann Willson's paintings were undoubtedly startling in 1944. They were among the crudest nineteenth-century American watercolors that had yet come to light. Their subject matter includes Biblical scenes, portraits, genre scenes, birds, and flowers. The rich, unmixed colors are principally oranges, blues, greens, russet, and black. Large, flat areas of color surprisingly balanced with areas of tiny, repetitive patterns are characteristic of Mary Ann Willson's watercolors.[2] Occasionally she incorporated riotous patterns within the figures, as in the body of the mermaid shown in Figure 1. At other times she used patterns to form the backdrop for a painting.

Mary Ann Willson followed her own rules of distortion and color to create exciting works of art which have a twentieth-century sense of abstract design. In fact, there has been speculation that the paintings and accompanying document were concocted in this century in order to benefit from the growing market for folk art. However, this is not the case, for Mary Ann Willson is documented in R. Lionel De Lisser's *Picturesque Catskills, Greene County,* which first appeared in 1894.[3] At that time local legends and recollections about Mary Ann Willson still lingered in Greene County, and were duly recorded in *Picturesque Catskills.* Illustrated were two of her watercolors (Figs. 2, 3) which belonged to Theodore Cole, a local resident, who was the oldest son of Thomas Cole the painter. Even from black and white reproductions it is apparent that these pictures are stylistically related to the twenty watercolors exhibited at the Harry Stone Gallery in 1944.

It seems likely that *Sallyann* (Fig. 2) was painted from life. The sharply upturned nose, small bow mouth, elabo-

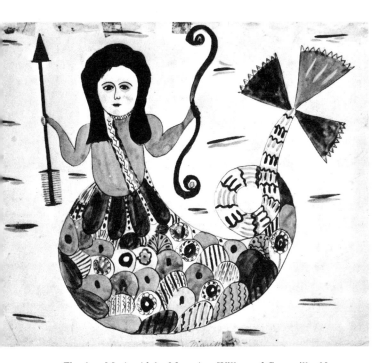

Fig. 1. *Marimaid,* by Mary Ann Willson of Greenville, New York (w. 1800-1825). Ink and watercolor on paper, 13 by 16 inches. *New York State Historical Association.*

Fig. 2. *Sallyann,* by Willson. Whereabouts unknown; photograph from R. Lionel De Lisser, *Picturesque Catskills, Greene County* (Northampton, Massachusetts, 1894), p. 107.

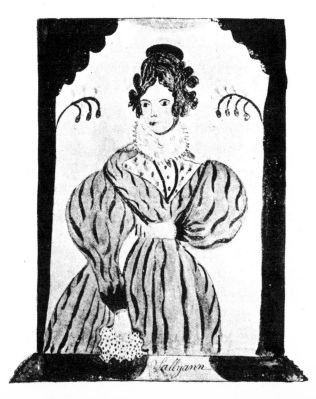

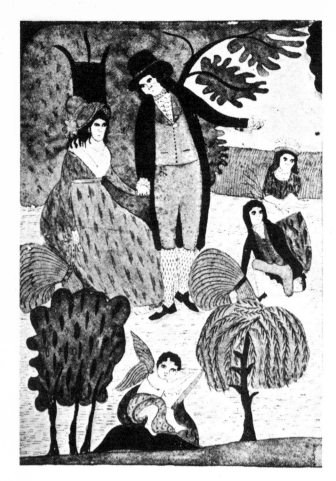

Fig. 3. *Ruth and Boaz*, by Willson. Whereabouts unknown; photograph from De Lisser, *Picturesque Catskills*, p. 106.

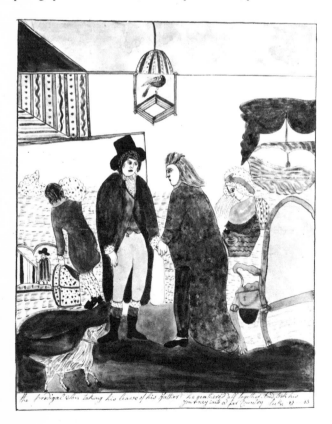

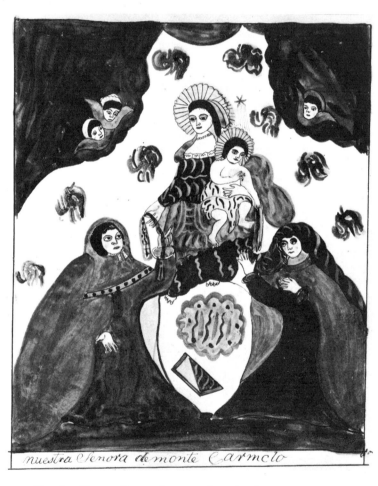

rate hairdo, repetitive patterns in the collar and dress, and free handling of the paint all relate this to the other watercolors of Mary Ann Willson. The method of framing the central figure was used in other Willson works, such as the drapery which frames *Nuestra Senora de monte Carmelo* (Fig. 4).

The handwriting of the inscription on *Sallyann* matches the script found on a number of other Willson watercolors (see Figs. 4, 5, 8, 10, 12; Pls. I, II). In all the artist's works on which handwriting appears (eleven of twenty-two recorded watercolors) the inscription is an integral part of the composition.

Ruth and Boaz (Fig. 3) is a Biblical subject painted by many folk artists. Although Biblical folk paintings often shared a common source, frequently a print, Willson's *Ruth and Boaz* is not related in composition to any other folk

Fig. 4. *Nuestra Senora de monte Carmelo* (Our Lady of Mount Carmel), by Willson. Ink and watercolor on paper, 12⅛ by 9¹¹⁄₁₆ inches. *Museum of Fine Arts, Boston, M. and M. Karolik Collection.*

Fig. 5. *The prodigal Son taking his leave of his Father,* by Willson. Inscribed across the bottom: *The prodigal Son taking his leave of his Father he geathered all together And took his Journey into a far country luke 15-13.* Ink and watercolor on paper, 10⅛ by 12⅞ inches. *National Gallery of Art, Edgar William and Bernice Chrysler Garbisch Collection.*

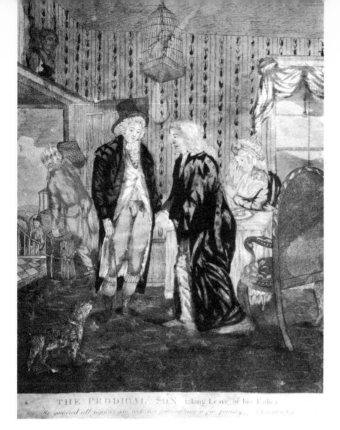

THE PRODIGAL SON taking Leave of his Father

Fig. 6. *The Prodigal Son taking Leave of his Father,* attributed to Cornelius Tiebout, 1790-1795. Hand-colored engraving and etching, 13¾ by 10¾ inches. *Colonial Williamsburg; photograph by courtesy of Childs Gallery.*

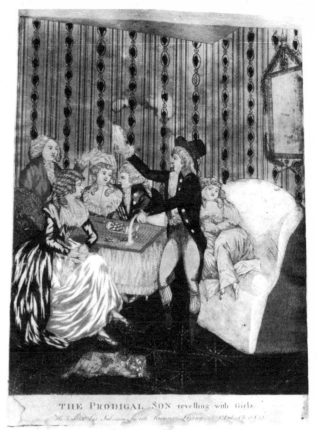

THE PRODIGAL SON revelling with Girls.

Fig. 8. *The prodigal Son in Misery,* by Willson. Inscribed across the bottom: *The prodigal Son in Misery he would Fain have filled his belly with the husks that the Swine Did Eat luke 16.* Ink and watercolor on paper, 10⅛ by 12½ inches. *National Gallery of Art, Garbisch Collection.*

Fig. 7. *The Prodigal Son revelling with Girls,* attributed to Tiebout, 1790-1795. Hand-colored engraving and etching, 13¾ by 10¾ inches. *Colonial Williamsburg; Childs Gallery photograph.*

Fig. 9. *The Prodigal Son in Misery,* attributed to Tiebout, 1790-1795. Hand-colored engraving and etching, 13¾ by 10¾ inches. *Colonial Williamsburg; Childs Gallery photograph.*

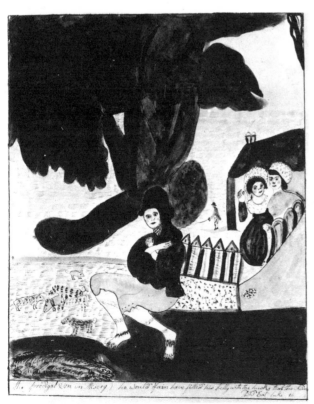

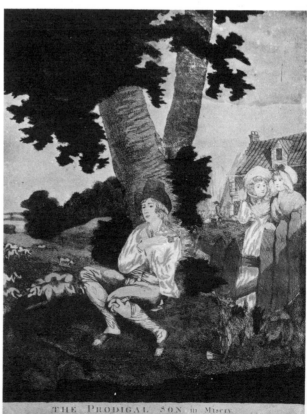

THE PRODIGAL SON in Misery.

painting that I have seen, and its print source, if it has one, has not been identified. A surprising feature of *Ruth and Boaz* is the cupid in the foreground, clearly identified by the inscription *Cupit* on the tablet or lyre he holds. Although it is rare to find a pagan figure in a Christian story, bodiless angels resembling the cupid appear in *Nuestra Senora de monte Carmelo* (Fig. 4), and a cupid fountain can be seen in *The prodigal Son Reclaimed* (Fig. 10).

The present whereabouts of *Sallyann* and *Ruth and Boaz* is unknown, and I have been able to locate only seventeen of the twenty watercolors exhibited by the Harry Stone Gallery. Although Mary Ann Willson is only known for twenty-two paintings (see check list, p. 1045), she is said to have sold her works ''from Canada to Mobile.''[4]

What little we know of Willson's life and work is contained in *Picturesque Catskills*, the letter from the Admirer of Art, and a second letter (unsigned) that came to light in 1967 among the papers of Theodore L. Prevost.[5] The tone, style, and handwriting of the two letters are the same. In all three sources Mary Ann Willson is depicted as living in a log house on a few acres of land with a Miss Brundage, who farmed while Mary Ann painted. According to the Admirer of Art, they had ''a romantic attachment for each other.'' Despite the suggestion of lesbianism, they were apparently accepted by Greene County society, and their long stay there was marked by the sale of a great many paintings. The account in *Picturesque Catskills* says that

They were supposed to be sisters, but in fact were not related by the ties of blood in any way. They had both of them, in their younger days, experienced a romance that had broken their hearts, and the bond of sorrow between them had drawn the two close to each other in womanly sympathy. Together they had

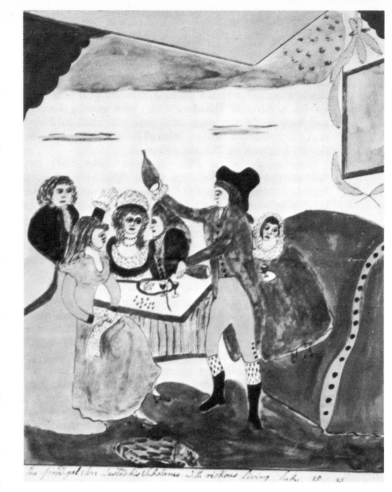

Pl. I. *The prodigal Son wasted his Substance,* by Willson. Inscribed across the bottom: *The prodigal Son wasted his Substance With riotous living luke 15-13.* Ink and watercolor on paper, 12⅝ by 10 inches. *National Gallery of Art, Garbisch Collection.*

come from the old country to Connecticut, and from there to this place, seeking peace and forgetfulness in the wilderness. They never told their story or anything in fact, relating to themselves, that could serve as a clue to their identity or past life.[6]

Since neither woman is listed in the land records at the Catskill courthouse or in any census of Greene County, it is possible that they were squatters. Several Brundages do appear in early Greene County records, but none can be identified as the Miss Brundage under discussion. Perhaps she and Mary Ann Willson came to Greene County because a relative of hers was already living there.

Assuming that both letters were written by the same person, and given the fact that the information and some of the phrases contained in the letters also appear in *Picturesque Catskills*, it is possible that the same person was the source for all three. Mabel Parker Smith, the historian of Greene County, has argued that Theodore L. Prevost was the Admirer of Art, and De Lisser affirms that Prevost was the discoverer[7] of Mary Ann Willson. This is possible, since Prevost came from a family which had helped found Greenville and continued to support its

Pl. II. *Henry On his pet goat,* by Willson. Ink and watercolor on paper, 7⅞ by 6½ inches. *Museum of Fine Arts, Boston, Karolik Collection.*

development.[8] On the other hand, samples of Prevost's handwriting fail to match the admirer's. Another possibility for the admirer is Theodore Cole, who owned *Sallyann* and *Ruth and Boaz* when they were published in *Picturesque Catskills* and whose father, Thomas Cole, was married to a cousin of Theodore Prevost.

Notwithstanding the little we know about Mary Ann Willson and her admirer, her works stand as a tribute to her individuality as a painter. Her paintings bear no stylistic kinship to those of other Greene County artists but, like many nineteenth-century painters, she was at least occasionally inspired by prints. A series of paintings based on the parable of the Prodigal Son, a popular theme in the late eighteenth and nineteenth centuries, was done after the etched and engraved edition of the subject illustrated in Figures 6, 7, 9, and 11.[9]

In *The prodigal Son taking his leave of his Father* (Fig. 5) Miss Willson apparently began to copy the wallpaper in the print (Fig. 6), but stopped after completing only a corner. Even that corner, however, has a boldness far exceeding that of the original. She has accentuated the outline of the bird cage by enlivening the top and base with simple patterns, and she has ignored the wire mesh of the cage in favor of a silhouette of the bird. She also ignored the carpet design, although the minute patterns that appear in other areas are reminiscent of the etched and engraved lines.

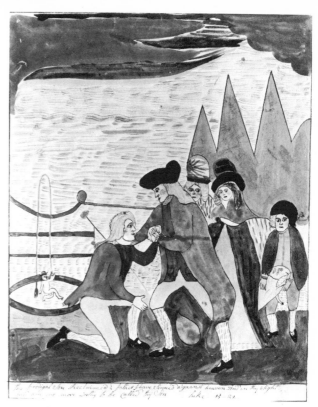

Fig. 10. *The prodigal Son Reclaimed*, by Willson. Inscribed across the bottom: *The prodigal Son Reclaimed father I have Sinned against heaven And in thy Sight And am no more worthy to be called thy Son—Luke-15-21*. Ink and watercolor on paper, 10 by 12⅝ inches. *National Gallery of Art, Garbisch Collection.*

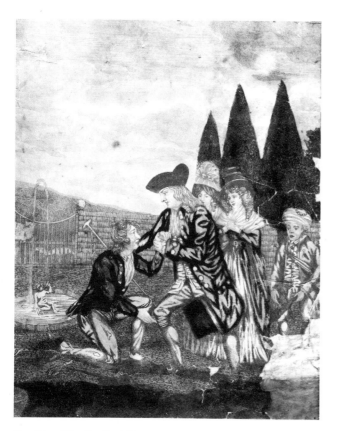

Fig. 11. *The Prodigal Son returned Home Reclaimed*, attributed to Tiebout, 1790-1795. Hand-colored engraving and etching, 13¾ by 10¾ inches. *Colonial Williamsburg; Childs Gallery photograph.*

In *The prodigal Son wasted his Substance* (Pl. I) the modeling of the headdress on the central female figure consists simply of dashes. The figured carpet of the print (Fig. 7) has been replaced by a wash of blue, and the couch and bolster by a sweep of orange. The folds of the napkin on the lap of the woman seated in the foreground are dots in the watercolor, and the elaborate background has been severely simplified. The white edges that outline areas of color resemble those in the watercolors of Henri Matisse. Miss Willson's painting is a new work of art, totally different in feeling from the one that inspired her. Its affinity to twentieth-century abstraction is evident in all the watercolors of Mary Ann Willson, including the others in the Prodigal Son series. *The prodigal Son in Misery* (Fig. 8) sits amid spotted pigs, his bare feet and legs scraped and bloodied in neat lines. Two ladies gossip behind a fence whose pickets are outlined by thick bands of color and decorated with stripes. The receding row of trees in the print (Fig. 9) has been replaced by a wash of watercolor. In *The prodigal Son Reclaimed* (Fig. 10) spiked trees appear as flat areas of color, while wall and gate (Fig. 11) have been reduced to a few simple lines.

There are many questions still to be answered about the origins of and influences on Mary Ann Willson's works, but one thing is certain—they are not twentieth-century fakes. They are the product of one of the most original early nineteenth-century folk watercolorists yet discovered.

111

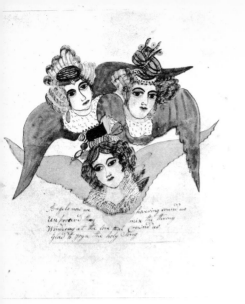

Fig. 12. *Three Angel Heads*, by Willson. Inscribed at lower center: *Angels now are hovering round us/ Unprocevd thay mix the throng/ Wondering at the love that crownd us/ Glad to joyn the holy Song.* Ink and watercolor on paper, 16 by 13 inches. *Museum of Fine Arts, Boston, Karolik Collection.*

Fig. 13. *Young Woman Pointing to a Flight of Birds*, by Willson. Watercolor on paper, 7¹⁵/₁₆ by 6½ inches. *Museum of Fine Arts, Boston, Karolik Collection.*

Fig. 14. *Floral Fantasy*, by Willson. Watercolor on paper, 7⅞ by 6½ inches. *Museum of Fine Arts, Boston, Karolik Collection.*

[1] The letter is in the M. and M. Karolik Collection of the Museum of Fine Arts, Boston.

[2] Tiny patterns similar to those used by Willson appear in *William and Mary*, an oil painting on wood done by the Greene County artist J. N. Eaton about 1845. It is in the Abby Aldrich Rockefeller Folk Art Collection and is illustrated in Jean Lipman and Alice Winchester, *The Flowering of American Folk Art* (New York, 1974), p. 42.

[3] First published in Northampton, Massachusetts, the book contains more than eight hundred photographs and illustrations that De Lisser collected all over Greene County in 1893. In 1967 Charles E. Dornbusch reissued it, adding a foreword by Alf Evers and an index.

[4] De Lisser, *Picturesque Catskills*, p. 136. The same information is given in the letter from the Admirer of Art.

[5] This letter is in the Vedder Library, Bronck House Museum, Coxsackie, New York. After his death in 1895 Prevost's papers were taken to the estate of the painter Thomas Cole (who had been married to a cousin of Prevost)

by Prevost's two daughters, who lived there with Cole's granddaughter Florence Cole Vincent. On the death of Florence Vincent, the estate passed to her niece Edith Cole Hill, who put it up for auction. According to Raymond Beecher, curator of the Bronck House Museum, and Mabel Parker Smith, historian of Greene County, Edith Cole Hill found the letter while searching through old papers before the auction.

[6] De Lisser, *Picturesque Catskills*, p. 134.

[7] *Ibid.*, p. 136.

[8] Theodore Prevost's great-grandfather Augustine Prevost was one of the original settlers of Greenville, and his grandfather Augustine Prevost (1744-1821) donated land for a park and a church in the town.

[9] This American edition of the series has been attributed by D. Roger Howlett of Childs Gallery in Boston to Cornelius Tiebout, 1790-1795. The prints are the mirror image of those in a 1794 edition published by Laurie and Whittle in England. Willson's watercolors combine elements found only in the Laurie and Whittle prints with others found only in those attributed to Tiebout.

Check list of Mary Ann Willson's known watercolors

Floral Fantasy; see Fig. 14

Floral Spray, 1800-1825. Watercolor on paper, 6⁷/₁₆ by 8¹⁵/₁₆ inches. Museum of Fine Arts, Boston

General Washington on Horse, 1800-1825. Ink and watercolor on paper, 12⅞ by 15¹⁵/₁₆ inches. Museum of Art, Rhode Island School of Design

Henry On his pet goat; see Pl. II

The Leave Taking, 1800-1825. Watercolor on paper, 10¹¹/₁₆ by 13¹¹/₁₆ inches. The painting is another version of *The prodigal Son taking his leave of his Father* (Fig. 5). Museum of Fine Arts, Boston

Lovers, 1800-1825. Watercolor on paper, 6¼ by 7¹⁵/₁₆ inches. Museum of Fine Arts, Boston

Marimaid; see Fig. 1

Nuestra Senora de monte Carmelo; see Fig. 4

Parrot, 1800-1825. Watercolor on paper, 6½ by 7¹⁵/₁₆ inches. Museum of Fine Arts, Boston

Pelican, 1800-1825. Ink and watercolor on paper, 12⅞ by 16 inches. Museum of Art, Rhode Island School of Design

The prodigal Son in Misery; see Fig. 8

The prodigal Son Reclaimed; see Fig. 10

The prodigal Son taking his leave of his Father; see Fig. 5

The prodigal Son wasted his Substance; see Pl. I

Queen of Sheba, 1800-1825. Watercolor on paper, approximately 13 by 16 inches. Whereabouts unknown

Ruth and Boaz; see Fig. 3

Sallyann; see Fig. 2

Summer, 1800-1825. Inscribed in lower margin: *I neither want your ring nor money/ I want a lad will call me honey/ There's a ring cost many a shilling/ That you may have, if you are willing.* Watercolor on paper, approximately 13 by 16 inches. Whereabouts unknown

Three Angel Heads; see Fig. 12

A Tree of Life, 1800-1825. Ink and watercolor on paper, approximately 13 by 16 inches. Whereabouts unknown

Young Woman Pointing to Flight of Birds; see Fig. 13

Young Woman Wearing a Turban, 1800-1825. Watercolor on paper, 7⅞ by 6½ inches. Museum of Fine Arts, Boston

Noah North (1809-1880)

BY NANCY C. MULLER, *Assistant to the director, Shelburne Museum*
AND JACQUELYN OAK, *Research associate, Museum of our National Heritage*

NOAH NORTH, a portrait painter, worked in upstate New York, Ohio, and perhaps in Kentucky before the middle of the nineteenth century. His contemporaries rarely commented on his artistic abilities, and his work has not attracted much more attention in recent years.[1] North's precise, if solemn, portraits depict his neighbors: the small-town bankers, judges, businessmen, and farmers of western New York State. They are painted with the confidence and strong sense of design that characterize the best of American folk painting and deserve further attention.

Rooted in the strong traditions of western New England, his family, like so many others, carried their cultural baggage westward to New York. The migration both helps to explain the heritage that shaped his work and obscures the specific associations that influenced the young painter. Noah North's grandfather Martin North (1734-1806), a wheelwright in Litchfield, Connecticut,[2] fathered four children by his first wife. Noah Sr., the painter's father, was the only child by his second wife, Mary Agard, to survive infancy.[3] In 1808 Noah Sr. and his wife, Olive Hungerford, left Connecticut with their two children, Thetis and Launcelot (Lot), for western New York, where they settled in the wilderness near Batavia in what became the village of Alexander.[4]

Noah, born on June 27, 1809, was the third of eight children.[5] The elder North, a farmer actively involved in the community, earned the reputation of a "man of superior attainments who personally attended to the education of his children, fitting several of them to be teachers."[6] Noah Sr.'s participation in the establishment of a public library in Alexander in 1811, the first in Genesee County, suggests an interest in cultural affairs. He served in the War of 1812 and maintained his farm until his death on September 28, 1824. He had "engaged in so many cases of public trust that on his death a special town meeting was called" in memorial.[7] The family probably remained in Alexander after this date, as Mary Agard North, the painter's grandmother, died there in 1825.

While information about the Norths' life during the following years is scanty, one major local event affected them directly. In August 1826 the impoverished William Morgan conspired with David C. Miller, publisher of the Batavia newspaper *Republican Advocate,* to expose the secrets of Freemasonry[8] by reissuing an English pamphlet on the subject under the new title *Morgan's Illustrations of Masonry.* During the course of publication Morgan was charged with a trifling criminal offense, arrested, and jailed in Canandaigua, fifty miles east of Batavia. Within twenty-four hours "unknown benefactors" paid Morgan's bail and obtained his release. Soon afterward Morgan disappeared, prompting Miller to charge the Masons with his abduction and murder. Despite the lack of evidence, several Masons were tried for the alleged murder and were convicted of being parties to the conspiracy.[9] Feelings of resentment against the Masons intensified, the issue soon became a political one, and the "excitement" persisted until the 1840's.

In 1832 Noah North was a delegate and special committee member from Alexander to a convention of "Democratic, Anti-Masonic Young Men of the County of Genesee."[10] The convention "enthusiastically" supported the anti-Masonic candidates for president, vice-president, and governor. Although only twenty-three, North was not only continuing the tradition of civic involvement established by his father, but had already attained a measure of local recognition that might prove useful to an aspiring painter. What prompted North to begin painting is not known, but one account suggests that at least one person, Van Rensselaer Hawkins, gave art lessons in Alexander.[11]

Assuming accurate and consistent numbering, North had already executed ten paintings when he depicted his neighbor Dewit Clinton Fargo in a death portrait dated July 7, 1833, and inscribed *No. 11 By Noah North* (Pl. I). In the

Fig. 1. *Mrs. Sally Fargo* (b. 1794), by Noah North (1809-1880), 1833. Oil on canvas, 27 by 24 inches. Inscribed on the back, *No. 18 By N. North/Mrs. Sally Fargo/AE 39 years 1833,* and on the stretcher, *Dec. 25, 1833.* The sitter's husband, Orange T. Fargo, was a farmer and keeper of the Fargo Tavern between Batavia and Alexander. The tavern was "a favorite place for balls and parties" (F. W. Beers, *Gazeteer and Biographical Record of Genesee County 1788-1890,* Syracuse, 1890, p. 148). The painting turned up in California in 1951 (see ANTIQUES for December 1951, p. 547). *Private collection.*

same year he painted a death portrait of Oliver Ide Vaughan of Darien, another neighbor. That portrait is now in the Holland Land Office Museum, Batavia, New York. In 1833 he also painted the Reverend Hugh Wallis, probably of Bennington Center, Wyoming County, New York.[12] He inscribed this straightforward painting *No. 15 By Noah North 1833/Rev. Hugh Wallis/AE 66 years.* In all probability, North's imposing double portrait *Aphia Salisbury Rich and Baby Edward* also dates from 1833.[13] The portrait of Sally Fargo (Fig. 1) and those entitled *Man in Black Coat* and *Woman in Lace Collar and Cap with Ribbons*[14] complete the group of known paintings assigned to 1833.

The charming portrait attributed to North of Gracie Beardsley Jefferson Jackman and her daughter of Alexander (Fig. 2) illustrates a more assured stylistic technique and growing artistic maturity. A companion portrait of her husband, Major James R. Jackman, attributed to North probably dates from the mid-1830's as well. It is now in the Flint Institute of Arts.

By 1834 the market for North's work had spread beyond Alexander. In Holley, New York, a village well to the north by the Erie Canal in neighboring Orleans County, he painted Eunice Eggleston Darrow Spafford (Pl. II). The same year he painted her daughter-in-law Sarah Angelina Sweet Darrow (Fig. 3). Perhaps North's sister, Olive, who died in Holley the next year, introduced him to the village. Also dated 1834 is a portrait attributed to the artist of Agnes Frazee and child, about whom no information has been unearthed. It is a stock North composition of a woman with a child who holds a cluster of flowers.[15]

Pl. I. *Dewit Clinton Fargo* (1821-1833), by North, 1833. Oil on wood panel, 26 by 21 inches. Inscribed in red on the back, *No. 11 By Noah North/Mr. Dewit Clinton Fargo/Who died July 7th, 1833/AE 12 years.* It is likely that the sitter was the son of Orange T. and Sally Fargo (Fig. 1) of Alexander. Note the Hitchcock chair, a prop commonly used by the artist. *Collection of Mr. and Mrs. William E. Wiltshire III.*

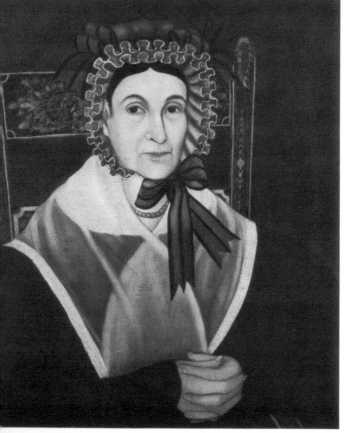

Pl. II. *Eunice Eggleston Darrow Spafford* (1778-1860), by North, 1834. Oil on wood panel, 27⅜ by 23⅝ inches. Inscribed in red on the back, *No. 40 by N. North/Mrs. Eunice Spafford/AE 55 years/Holley./1834.* Born in Dutchess County, New York, Eunice Eggleston became the third wife of John Darrow of Chatham, New York, in 1798 or 1799. She reared his younger children, plus seven of their own. He died in 1813 and two years later she moved the family to Clarendon, New York. There she married Bradstreet Spafford, a widower with a young daughter, and had two more children. After Spafford's death in 1828, Eunice remained in Clarendon, managing the farms. She is buried in Holley, New York. The decoration of the chair has been stenciled with gold powders onto the panel. *Shelburne Museum.*

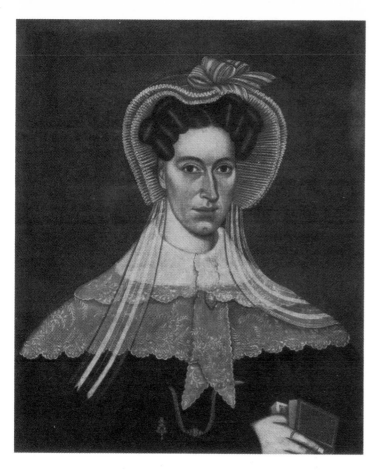

similar portraits in which the sitter is depicted with an object. These include *Girl with Flower Basket* (Pl. V), an almost identical *Girl with Bible, Woman with Hymnal* (the latter two are in the Munson-Williams-Proctor Institute), *Girl with Cat* (in a private collection), and *Boy Holding Dog* (Pl. VI). Despite the repetitious format, North has instilled each work with vigorous individuality which reveals his greater stylistic assurance.

In 1837 North painted a portrait of an unknown man holding an issue of the *Missionary Herald* for January of that year (Fig. 6). It must have been later in 1837 that he left for Ohio, for he is listed as a portrait painter in the 1837-1838 directory for Cleveland and Ohio City.[16] His residence is given as the Ohio City Exchange, a hotel that has been described as "the finest building west of Albany, a magnificent brick building of five stories, crowned with a noble dome and having splendid balconies in front, supported by pillars of the Ionic Order."[17] Ohio City was incorporated on March 3, 1836, on the west bank of the Cuyahoga River across from (and now part of) Cleveland. The area, claimed by Connecticut and controlled by the Connecticut Land Company, was first settled in the late eighteenth century by men who like North's father had left the rocky New England soil for better prospects. With the completion of the Ohio and Erie Canal in 1832, linking the Ohio River with Lake Erie, the importance of the two cities escalated rapidly. In 1839 alone the canal carried 19,962 passengers to Cleveland and Ohio City.[18] Quite probably, the attraction of grand new opportunities in these booming

Pl. III. *Ann Gennett Pixley Lacey* (1809-1841), attributed to North, c. 1837. Oil on canvas, 30 by 25 inches. Ann Pixley was born in Kirkland, Oneida County, New York, the eldest child of William and Abbey Lewis Pixley, and moved with them about 1818 to Chili, New York. There she married Allen T. Lacey, a farmer who was active in anti-Masonic and Whig politics. She is buried in the Fellows Burying Ground in Chili. *Private collection, on loan to the Memorial Art Gallery of the University of Rochester, Rochester, New York.*

The portraits of Elijah Talcott Miller and his wife, Ruth (Figs. 4, 5), attributed to North, also date from about 1835. The sitters lived in Chili (now part of Scottsville), northeast of Alexander. In these panels two strongly defined personalities are portrayed with great clarity. It is presumably at this time too that North painted three other Chili residents, Ann Gennett Pixley Lacey (Pl. III) and her children, Eliza (Pl. IV) and Pierrepont. Those three portraits are now on loan to the Memorial Art Gallery of the University of Rochester, Rochester, New York. The portraits of Mr. and Mrs. Samuel Church, founders of Churchville, near Rochester, which are owned by the Rochester Historical Society, were undoubtedly painted in the mid-1830's as were portraits of the Reverend Z. Case and his wife (in a private collection). Probably also from the period are a group of

Pl. IV. *Eliza Pixley Lacey* (1834-1839), attributed to North, c. 1837. Oil on canvas, 30 by 25 inches. She was the daughter of Ann (Pl. III) and Allen T. Lacey. It is believed that this portrait and those of her mother and her brother Pierrepont were painted while they lived in what is now number 9 Scottsville-Chili Road, Scottsville. *Private collection, on loan to the Memorial Art Gallery of the University of Rochester.*

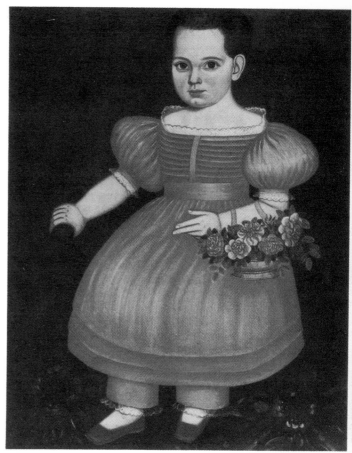

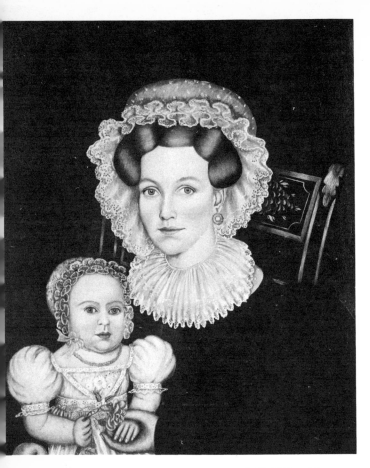

Fig. 2. *Gracie Beardsley Jefferson Jackman* (1803-1887) *and her Daughter,* attributed to North, c. 1834. Oil on wood panel, 27⅞ by 23½ inches. Gracie (or Gracia as her name appears on her tombstone) Jefferson was born on April 28, 1803, in a town called (on her tombstone) Hungersfield, New York, and married Major James R. Jackman from Vershire, Vermont, an early settler of Alexander, in 1816. Major Jackman "started life poor but by hard work became well-off. He was justice for several years and was made judge of the County Court by Governor Seward" (Beers, *Gazeteer,* p. 148). The child in the portrait is either Louise, born in 1832, or Sarah, born in 1833, two of the seven children the Jackmans are known to have had. Gracie and James Jackman are buried in the Alexander town cemetery. *Flint Institute of Arts, Flint, Michigan; gift of Edgar William and Bernice Chrysler Garbisch.*

towns lured North to Ohio, but nothing is known about his activities there.[19] He presumably left Ohio City on the canal and headed south, for his advertisements are said to have appeared in Cincinnati and Kentucky newspapers in the 1830's.[20] However, no portraits which can conclusively be attributed to North have emerged from this sojourn in the Midwest.

By 1841 North had returned to New York State where, in Darien, he married his neighbor Ann C. Williams, the daughter of Thorp and Clarissa Williams. Possibly at this time, North painted Adah Crowell Salisbury and her granddaughter Martha Sophronia Rich (Fig. 7). By April 1842 the Norths had moved to Mount Morris, Livingston County, New York, when they had their first child, Mary Ann. Three years later, on March 14, 1845, their only son, Volney, was born. North's interest in politics surfaced again in Mount Morris when, in January 1844, he signed a petition inviting the Whigs of Livingston County to a meeting to organize the County Clay Club.[21] The 1850 census listed North as a portrait painter living in Mount Morris with his wife, two children, and his wife's fifteen-

year-old niece, Caroline G. Williams, who was "attending school." While no signed portraits have been found corresponding to this period in North's life, *Girl with Coral Necklace* (Fig. 8), *Boy with Tall Hat,* and *Boy with Apple* (locations of all unknown) were probably painted in Mount Morris. Possibly because he could not support his family by painting portraits he engaged in other pursuits. The *Western New York State Business Directory 1850-51,* for example, lists a "North and M'Lane" under "Painters—House, Sign, and Fancy."[22] Sometime in the late 1850's the Norths returned to Darien, where Noah served as a justice of the peace for ten years. The family apparently lived with Ann's father on Bennett Road and turned to farming. With them lived Clarissa North, born in 1855, the illegitimate daughter of Caroline Williams whom the Norths presumably adopted.[23]

In February 1869 Thorp Williams died at the age of eighty-nine and in May the Norths sold the Darien property

Fig. 3. *Sarah Angelina Sweet Darrow* (1812-1889), by North, 1834. Oil on wood panel, 28 by 24 inches. Inscribed on the back, *Mrs. Sarah A. Darrow, N. 39/By N. North 1834/was born April 29, 1812.* The sitter married Nicholas Eggleston Darrow (1806-1896) of Clarendon, New York, on December 30, 1830. Sarah was reputedly one of Clarendon's "most beautiful women, both in countenance and character" (quoted in Irene M. Gibson, *Descendants of John Darrow and Eunice Eggleston,* privately printed, n.d., p. 21). An invalid during the last four or five years of her life, Sarah reared seven daughters and two sons. Nicholas Darrow, a farmer, schoolteacher, postmaster, justice of the peace, and state assemblyman, commissioned North to do this portrait and the one of Eunice Spafford, his mother, shown in Pl. II. Darrow's house, in which both paintings once hung, still stands. *Private collection.*

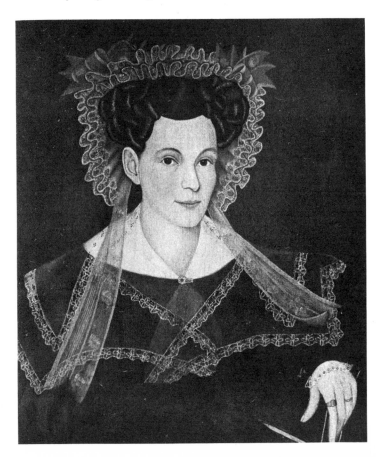

and moved to nearby Attica, where they bought land for $7,000. The 1870 United States census listed North living in Attica with his wife, Ann, two children, and Clarissa. In 1872 Ann North died[24] and was buried in the Williams family plot in Maple Hill Cemetery in Darien. The following year twenty-eight-old Volney North died and was buried near his mother. Possibly needing money, Noah North sold two pieces of his Attica land in 1872 and 1874. In March 1875 his daughter Mary Ann died at the age of thirty-two and, like her mother and brother, was buried in Darien.

The last four years of North's life were financially troubled. Records indicate that he sold most of his remaining Attica property in small parcels. If North still painted, no work from this period has been discovered. He served on the Attica board of education in 1878 and 1879 and at the time of his death in Attica on June 15, 1880, he was vice-president of the Genesee County Pioneer Association. A history of Wyoming County published in 1880 calls North a "farmer, manufacturer of lumber, painter, and teacher who served on the board of education."[25] *The Batavia Daily News* of June 15, 1880, stated:

Mr. Noah North, of Attica, died very suddenly this morning at his home in that village. He was born in the town of Alexander in June, 1809, and was therefore 70 years of age. Mr. North has always been a resident of Genesee County, with the exception of a few years residence at Mt. Morris and 10 years in Attica. Deceased was a brother of J. A. North, of Alexander, and uncle to S. E. North of this village.

While relying on the formulas that typify mid-nineteenth-century American portraiture, North nevertheless

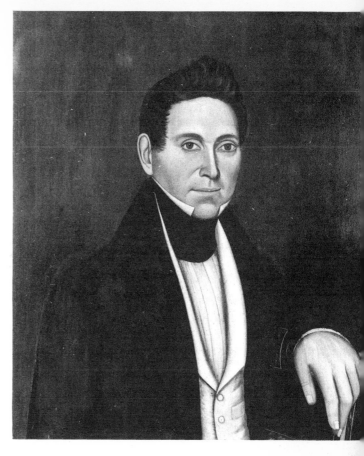

Fig. 4. *Elijah Talcott Miller* (1800-1854), attributed to North, c. 1835. Oil on wood panel, 27 by 23 inches. A trader, merchant, and farmer, Elijah Miller was born in Farmington, Connecticut, the son of Elijah and Chloe Allyn Miller. About 1825 he moved to Chili (now part of Scottsville), New York, and two years later to neighboring Scottsville. Miller married Ruth Tillotson (Fig. 5) in Farmington on September 16, 1824. *Memorial Art Gallery of the University of Rochester; photograph by Richard Margolis.*

developed an assured and distinctive style that makes his work readily identifiable. The features of his sitters are sharply delineated and facial modeling is accomplished through the use of grayish flesh tones. Ears are distinctly oversize with prominent C-shape inner curves; fingers are long and narrow with blunt nails; bits of lace, ribbon, and jewelry are minutely detailed; bright touches of color in faces and clothing contrast with the muted gray and brown backgrounds.

North's portraits are related visually to the work of other artists, notably to that of Ammi Phillips, who painted in Connecticut and New York. One of the most obvious similarities in the two painters' work is their frequent use of a Hitchcock-type stenciled chair as a prop. In many of their paintings the sitter's arm rests on the top rail, exposing only a small portion of the chair's decoration. The two may perhaps have known each other, for Phillips' parents and North's mother, Olive Hungerford North, all came from Colebrook, Connecticut, and were in Colebrook, Ohio, in the 1840's. Ammi Phillips' brother Halsey married Sally Hungerford, Olive's sister, and in 1842 Ammi Phillips painted Nancy Hungerford, a cousin of Sally and Olive.

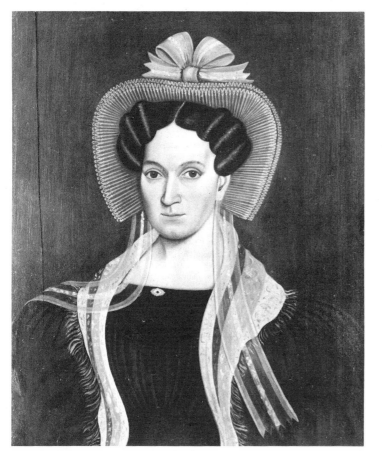

Fig. 5. *Ruth Tillotson Miller* (1803-1863), attributed to North, c. 1835. Oil on wood panel, 27 by 23 inches. The daughter of Elias and Experience Hosford Tillotson, the sitter was born in Farmington, Connecticut, and died in Scottsville, New York. She and her husband, Elijah Talcott Miller (Fig. 4), had eight children. *Memorial Art Gallery of the University of Rochester; Margolis photograph.*

As no paintings dated by North after the 1840's have yet been found, it appears that the demand for his work diminished. Most of his patrons seem to have commissioned their portraits during the 1830's, when North had relatively little competition and no family responsibilities, making travel to the neighboring counties easy. The coming of other portraitists and the advent of photography must have cut into his market, and the diversity of his jobs and frequent sales of land in later years may indicate new interests and difficult times. Neither his obituary nor the family history written by his nephew Safford[26] makes much of his career as a portraitist. Nevertheless, Noah North's insightful depictions of the newly prosperous citizens of western New York State bespeak a talent that has too long gone unnoticed.

[1]See ANTIQUES for March 1932, p. 152, and December 1951, p. 547.

[2]Dexter North, *John North of Farmington, Connecticut and His Descendants* (Washington, D.C., 1921), p. 33.

[3]Martin and Mary Agard North's first born, also named Noah, died in infancy in 1783. The name Noah recurs frequently in the North family; the most notable Connecticut member was Deacon Noah North, the owner of a rifle illustrated in ANTIQUES for July 1943, pp. 18-19.

[4]The Norths bought land on the Dodgeson Road from the Holland Land Company, which had begun extensive sales in 1800 from offices in Batavia. Although the town records of Alexander were destroyed by fire, Noah Sr.'s grandson Safford noted that both he and his father were born on the farm in Alexander on which Noah Sr. settled in 1808 (Safford E. North, ed., *Our Country and Its People, A Descriptive and Biographical Record of Genesee County, New York,* Boston, 1899, pp. 513-514).

[5]The other children were Thetis (1806-1870), Launcelot M. (1807-1865), Alcimeda (1811-1833), James Agard (1813-1893), Olive F. (1814-1835), Aurelia N. (1816-1896), and Zaxie C. (1817-1891). See Dexter North, *John North,* p. 61.

[6]Safford North, *Our Country,* p. 514.

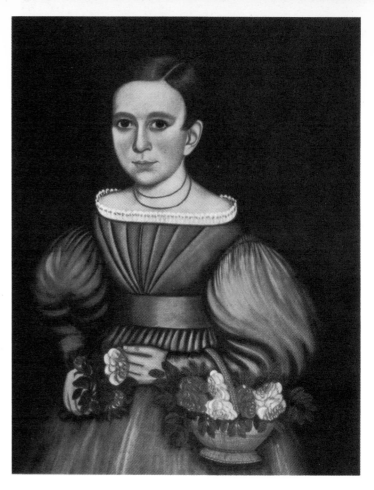

Pl. V. *Girl with Flower Basket,* attributed to North, c. 1835. Oil on panel, 27 by 21 inches. This is one of three similar paintings attributed to North. In *Girl with Bible* (at the Munson-Williams-Proctor Institute) the hair style, necklace, and dress are identical but the girl holds a Bible. In *Girl with Cat* (in a private collection) the sitter wears the same dress in another color and carries the basket of flowers, but she has no necklace, her hair is long and curly, and a cat perches on a window sill in the background. *Abby Aldrich Rockefeller Folk Art Center.*

[7]F. W. Beers, *Gazeteer and Biographical Record of Genesee County 1788-1890* (Syracuse, 1890), p. 162.

[8]See Charles McCarthy, "The Antimasonic Party: A Study of Political Anti-Masonry in the United States, 1827-1840," *Annual Report of the American Historical Association for the Year 1902* (Washington, D.C., 1903), vol. 1, p. 371.

[9]In October 1826, a few weeks after the "kidnapping," a body was found near Albion, twenty-five miles from Batavia. It was at first thought to be Morgan's although later examination proved that to be incorrect. It is widely believed today that Morgan escaped to Canada.

[10]See the report about the convention in the *Republican Advocate,* October 30, 1832.

[11]William Lawrence Utley, "Ancestors of William Lawrence Utley, Son of Hamilton and Polly (Squires) Utley" (1924), n.p. Although Utley claims in this typescript that Hawkins, "a celebrated artist," taught him painting in Alexander for three or four years, Hawkins is mentioned in the *Republican Advocate* of August 10, 1841, and listed in Beers, *Gazeteer,* as a merchant and postmaster, but not as an artist. Hawkins' art instruction was probably informal.

[12]That portrait is in a private collection. The Reverend Wallis may have been the father-in-law of Noah's sister Alcimeda, who married a Hugh Wallis (or Wallace) Jr.

[13]The painting is in the National Gallery of Art, Washington, D. C.

[14]The latter two paintings are in the collection of Mr. and Mrs. Peter Tillou.

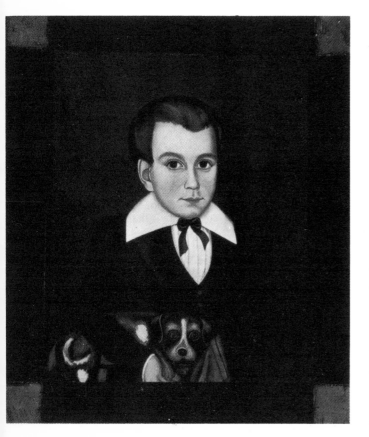

Pl. VI. *Boy Holding Dog,* attributed to North, c. 1835. Oil on wood panel, 20¾ by 17½ inches. *Abby Aldrich Rockefeller Folk Art Center.*

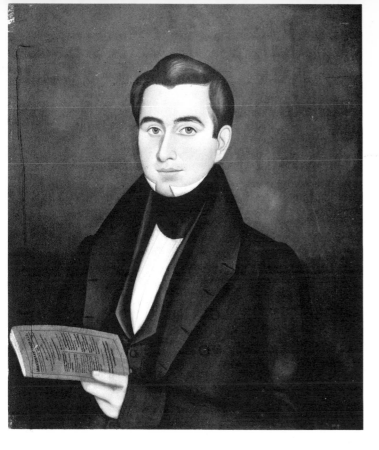

Fig. 6. *Man with the* Missionary Herald, attributed to North, 1837. Oil on wood panel, 28 by 23½ inches. The sitter holds a copy of the *Missionary Herald* for January 1837, which was published in Boston. *Collection of Dr. and Mrs. Ralph Katz.*

Fig. 8. *Girl with Coral Necklace,* attributed to North, c. 1850. Oil on canvas, 20 by 16 inches. *Present whereabouts unknown.*

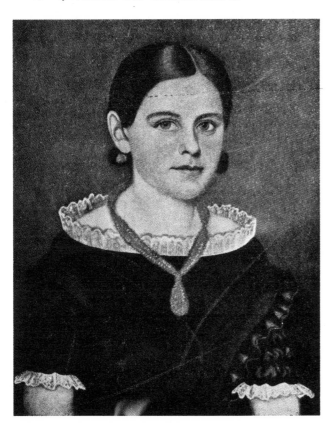

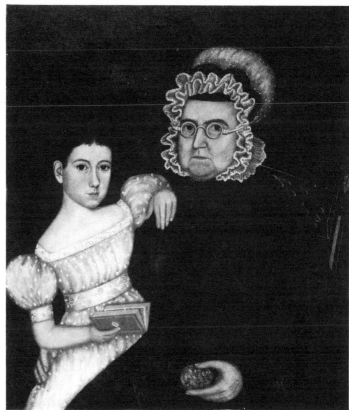

Fig. 7. *Adah Crowell Salisbury* (1762-1850) *and Martha Sophronia Rich* (b. 1836), attributed to North, c. 1841. Oil on canvas, 33 by 29 inches. Adah Crowell married Edward S. Salisbury (1765-1832) of Western (now Westernville), New York. Her granddaughter Martha Sophronia Rich, daughter of Aphia Salisbury Rich and Gaius B. Rich, married Charles Townsend of Buffalo. *Private collection.*

[15]The painting is in the collection of Edgar William and Bernice Chrysler Garbisch.

[16]*Directory of Cleveland and Ohio City 1837-38* (Cleveland, 1837), p. 131.

[17]Richard N. Campen, "The Story of Ohio City" (unpublished manuscript in the Western Reserve Historical Society, 1968), p. 9.

[18]*Ibid.*

[19]A portrait thought to be of Francis Drake Parrish, a prominent lawyer from Sandusky, Ohio, that is in the Oberlin College collection can be attributed to North on stylistic grounds. However, the portrait depicts a much older person than Parrish would have been when North was in Ohio. It is possible that the portrait depicts Francis Drake's father, Elijah Parrish, a resident of Naples, New York. In that case the portrait could have been done before North left for Ohio.

[20]This is affirmed, but not documented, by Rhea Mansfield Knittle in ANTIQUES for March 1932, p. 152. Mrs. Knittle's notes have been destroyed.

[21]*Livingston Republican* (Geneseo, New York), January 9, 1844.

[22]P. 6295.

[23]The presence of Clarissa North is noted in North's will, written November 4, 1875, and now in the surrogate's office, Wyoming County Courthouse, Attica, New York.

[24]North married his late wife's sister, Caroline Williams Gibson, on January 19, 1876.

[25]F. W. Beers, *Illustrated History of Wyoming County, New York* (New York, 1880), p. 144.

[26]See n. 4.

John S. Blunt

BY ROBERT BISHOP, *Director, Museum of American Folk Art*

THE IDENTIFICATION of the portraits here attributed to John S. Blunt (1798-1835) of Portsmouth, New Hampshire, has required some ten years of research.

I began by attempting to identify the painter of the pair of portraits shown in Figures 1 and 2, which were once in my collection. Mary Black, then director of the Abby Aldrich Rockefeller Folk Art Collection at Colonial Williamsburg, said she felt that they were by the unknown painter of the portraits at Williamsburg shown in Figures 3 and 4. In succeeding years Mrs. Black and I exchanged photographs and compared notes about other canvases we thought to be by the same hand. Eventually I came to refer to the unknown artist as the Borden limner for the portraits of Captain Daniel Borden and his wife, Mary B. Jenney Borden (Figs. 5, 6).

Obvious similarities in some twenty-five portraits indicate that they were executed by a single artist: all are primed with the same red underpaint which is sometimes allowed to show through a thinly painted background. The painter repeatedly used unusual shades of red and sour yellows, blues, and greens. There is consistently a greenish tint to the flesh tones. The willful disregard of perspective and the failure to acknowledge a single source of light often lend an air of abstraction to the background. Among the persistent formulas are the chair back seen over the sitter's shoulder and the positions of the sitter's arms: the left propped on the back of a sofa and the right appearing to rest on an upholstered bolster. It is also clear that a single person made the stretchers to these canvases.

A visit to Strawbery Banke in Portsmouth, New Hampshire, provided the first clue to the identification of the artist. There I saw portraits of Mr. and Mrs. Leonard Cotton (Figs. 7, 8) on exhibit in the Chase house. Correspondence with their owner, Dorothy Vaughan, a local librarian and historian, revealed that the portraits had descended in the Cotton family of Portsmouth along with two fire buckets (Figs. 9-11) that are believed to have been painted by Blunt. Dr. Vaughan felt relatively certain that the portraits were

Fig. 1. *Wife of the Country Squire,* attributed to John S. Blunt (1798-1835), c. 1830. Oil on canvas. An issue of the *Lady's Book* (later *Godey's Lady's Book*) for 1830 indicated that it was fashionable to wear the hair lower than in previous years and to have ringlets at the side of the face. Combs, especially of tortoise shell, were in favor during the 1830's. *Present whereabouts unknown; photograph by Geoffrey Clements.*

Fig. 2. *Country Squire,* attributed to Blunt, c. 1830. Oil on canvas. *Present whereabouts unknown; Clements photograph.*

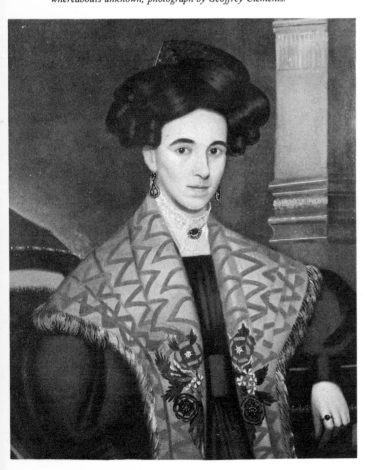

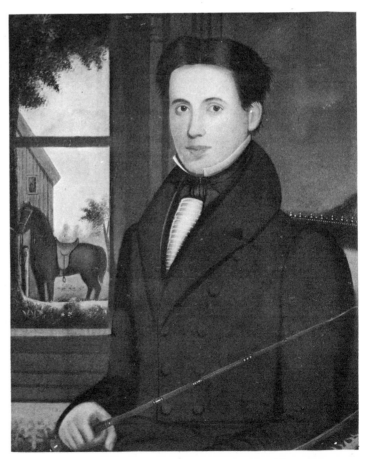

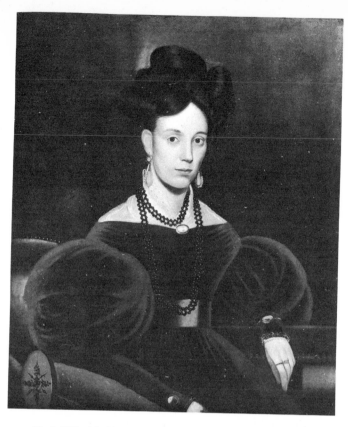

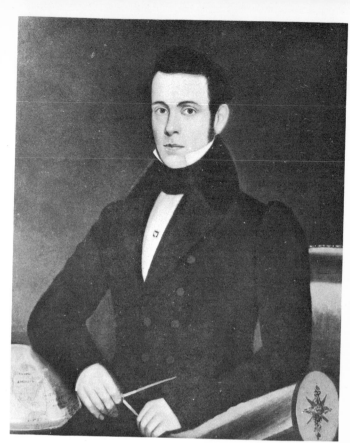

Fig. 3. *Wife of the Navigator*, attributed to Blunt, 1832-1833. Oil on canvas, 33⅜ by 28¼ inches. The June and July 1831 issues of the *Lady's Book* illustrate hair styles nearly identical to the sitter's. Her chemisette is similar to those shown in Fig. 7 and Pl. III in that it has a band running from shoulder to neck. *Abby Aldrich Rockefeller Folk Art Center.*

Fig. 4. *The Navigator,* attributed to Blunt, 1832-1833. Oil on canvas, 33½ by 28¼ inches. Fashion plates indicate that coats of this cut were fashionable about 1832. A black stock became very popular in the early 1830's. *Abby Aldrich Rockefeller Folk Art Center.*

Fig. 5. *Mary B. Jenney Borden* (1812-1891), attributed to Blunt, c. 1834. Oil on canvas, 33 by 27½ inches. The sitter's tight curls are characteristic of the late 1820's and early 1830's. *Whaling Museum, New Bedford.*

Fig. 6. *Captain Daniel C. Borden* (1805-1849), attributed to Blunt, c. 1834. Oil on canvas, 33 by 27½ inches. The sitter was a shipmaster who lived in New Bedford at the time the portrait was painted. In 1841 he was master of a whaling ship out of Hudson, New York. *Whaling Museum.*

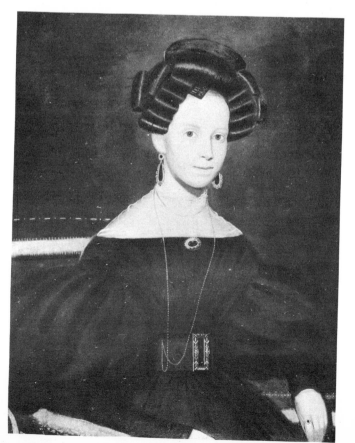

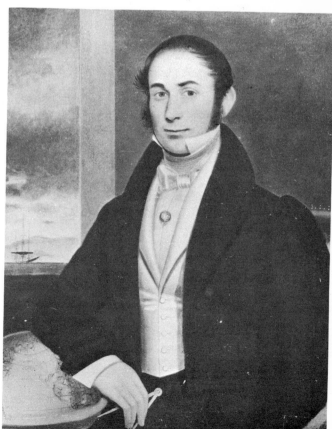

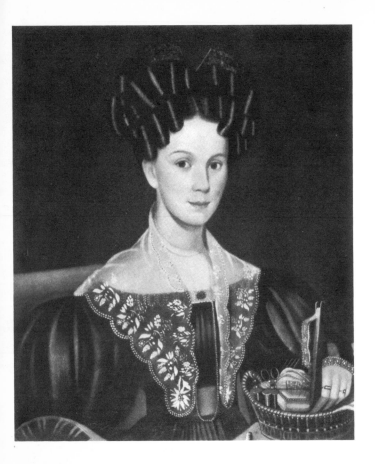

Pl. I. *Pharmacist's Wife, the Lacemaker,* attributed to Blunt, 1830-1832. Oil on canvas. The sitter and her husband (Pl. II) are believed to be members of the Warner-Sherburne family of Portsmouth, New Hampshire. The paintings descended in these families. *Photograph by courtesy of Webster, Incorporated.*

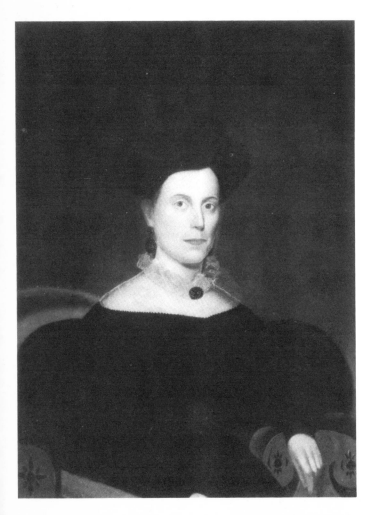

Pl. II. *Pharmacist,* attributed to Blunt, 1830-1832. Oil on canvas. The sitter is so called because of the bottles and mortar and pestle in the background. *Webster photograph.*

Pl. III. *Unidentified Lady from Boston,* attributed to Blunt, c. 1831. Oil on canvas, 36 by 28 inches. The picture retains its original gilded frame, which is identical to the frames on other portraits attributed to Blunt. *University of Michigan Museum of Art; gift of Robert Bishop.*

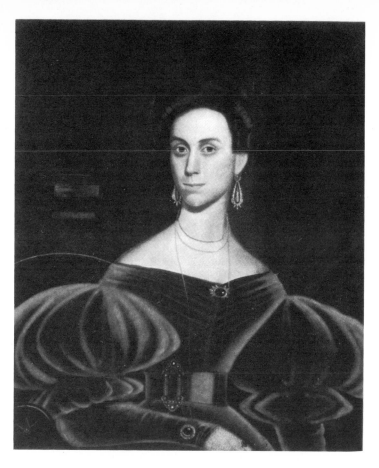

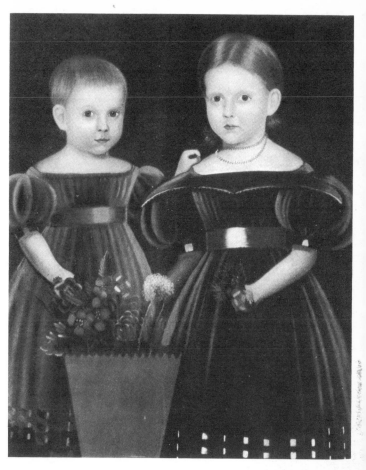

Pl. IV. *Eliza Anthony Brownell,* attributed to Blunt, 1830. Oil on canvas, 32 11/16 by 28 1/8 inches. According to the owner of the painting, Mrs. Brownell had eleven children, some of them born on the New Bedford whaling ships of which her husband was captain. The English publication *Ladies Pocket Magazine* for January 1827 stated, "Velvet dresses, either black or crimson, for married ladies at evening parties, increase in favor. . . . " *Collection of Barbara Johnson.*

Pl. V. *Two Young Children from the Torrey Family, Fitchburg, Massachusetts,* attributed to Blunt, c. 1831. Oil on canvas, 30 1/16 by 24 15/16 inches. A paper label pasted on the back reads, "From Judge Torrey/House, Fitchburg, Mass./about 30 years ago/history unknown/recently acquired/F. G. Lawton/Shirley, Mass. 1924." *Greenfield Village and Henry Ford Museum.*

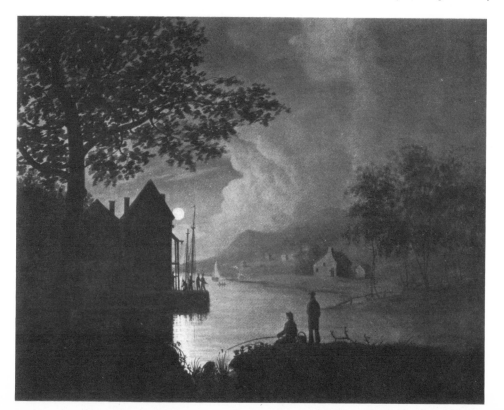

Pl. VI. *Moonlit Landscape,* by Blunt, 1825-1835. Oil on canvas. Signed. *Webster photograph.*

123

also by Blunt. She put me in touch with collectors in Cooperstown, New York, who had recently spent considerable time researching Blunt and who owned a diary/account book kept by him. The pages of the book are filled on one side with accounts dated from 1819 through 1826, and on the other with undated diary entries. The pages were evidently torn from an account book and then rebound. The account book entry for August 22, 1826, records that Blunt charged Leonard Cotton $3 for painting three fire buckets (see Fig. 9). The background of the fire buckets in Dr. Vaughan's collection is painted the same red as the underpaint on the portraits, and the lettering on the fire buckets matches the lettering on the cover of Blunt's diary/account book. The fireman's bag stored inside one of the fire buckets appears to have been lettered by the same hand (Fig. 13).

The lettering on the cover of the diary/account book also matches that on the globes that appear in the portraits shown in Figures 4 and 6 and the printed inscriptions and signatures on some of Blunt's landscapes, seascapes, ship portraits, and genre paintings. Although Blunt advertised portrait painting, as we shall see, and although his accounts record portraits he made in December 1822 and February 1823, no signed portrait by him is yet known.

My theory that the Borden limner and John S. Blunt are the same person has been supported by Nina Fletcher Little. She kindly compared photographs of examples of Blunt's printing and writing with his signature on the painting shown in Figure 14 and wrote to me as follows:

Symmetry is signed on the front, undoubtedly by Blunt. We have examined and compared the letters carefully with the two inscriptions you sent and I feel quite confident that they are by the same hand. My signature is done in capital letters with serifs, as is seen on the photos of the globes, and the sweep of the A's in all is also a noteworthy point. . . . Being an old hand at this type of investigation I always incline to be cautious, but in this case I think you have solved the authorship of the portraits.[1]

I am indebted to Mrs. Little's research for much of the following chronicle of the artist's life.[2] John S. Blunt was the son of Mark Sherburne Blunt, a Portsmouth, New Hampshire, sea captain, and Mary Drown Blunt. He was a member of the seventh generation of Blunts in New England. He is listed in the first Portsmouth directory, published in 1821, as "Ornamental and Portrait Painter," and on December 31, 1822, he advertised in the *New-Hampshire Gazette* "profiles, profile miniature pictures, landscapes and ornamental painting." In the *Portsmouth Journal* of April 2, 1825, he proposed opening a drawing and painting school, and in October 1826 he announced an exhibition of paint-

Fig. 7. *Martha Clarkson Cotton* (1805-1842 or 1847), attributed to Blunt, 1830-1832. Oil on canvas. A similar hair style was mentioned as early as the June 1831 issue of the *Lady's Book*. Leonard Cotton obviously enjoyed seeing his wife elegantly dressed and bejeweled. In the *Portsmouth Journal* for September 26, 1829, he advertised, "Lost—on the 25th inst. between Newburyport and Portsmouth—one small Jewel Box containing one Jet finger ring and four elegant Breast Pins. The finder will be handsomely rewarded by returning them to the owner Leonard Cotton." *Collection of Dorothy Vaughan.*

Fig. 8. *Leonard Cotton* (1800-1872), attributed to Blunt, 1830-1832. Oil on canvas. A cooper by trade, Cotton also owned real estate and operated a ship's store in Portsmouth. He was admitted to the Mechanic Fire Society in March 1831 and was its president in 1840 and 1841 (*Biographical Roster, Members of the Mechanic Fire Society*, Portsmouth, New Hampshire, 1966, p. 27). *Vaughan collection.*

Fig. 10. Detail of the right-hand fire bucket shown in Fig. 9.

Fig. 11. Detail of the left-hand fire bucket shown in Fig. 9.

Fig. 9. Pair of fire buckets, painting attributed to Blunt, 1826. In his diary/account book, Blunt recorded a charge to Leonard Cotton for painting three fire buckets on August 22, 1826 (see Fig. 12). This pair of fire buckets descended in the Cotton family of Portsmouth. *Vaughan collection.*

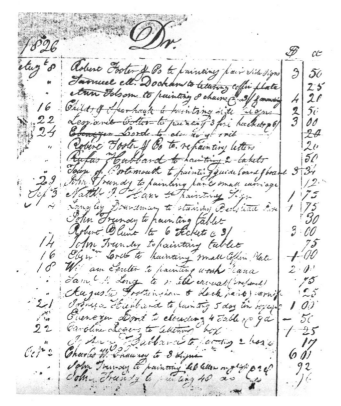

Fig. 12. Page dated 1826 from Blunt's diary/account book. Among the entries is the August 22 charge of $3 to Leonard Cotton for painting three fire buckets. The page amply illustrates the variety of tasks performed by a New England folk artist at the time. Included are charges for painting signs, lettering coffin plates, painting parts of a small carriage, staining a bedstead, and, on September 21, painting five dozen tin boxes for Joshua Hubbard, a Portsmouth druggist. *Private collection.*

ings, including "six views of Niagara Falls, a view of the Notch of the White Mountains, a view of Lake Winnipiseogee, a likeness of Sir William Pepperell. . . ."[3] Pepperell was a collateral relative of Blunt who had died in 1759, so the painting was undoubtedly based on a print—possibly one of the seven framed prints that are valued at $5.25 in the inventory of Blunt's estate. In the 1827 Portsmouth directory Blunt advertised "Portrait and Miniature Painting, Military Standard do. Sign Painting, Plain and Ornamented, Landscape and Marine Painting, Masonic and Fancy do. Ships Ornaments Gilded and Painted, Oil and Burnish Gilding, Bronzing, &c &c."

In 1829 Blunt's *View of Winnipiseogee Lake* was exhibited at the Boston Athenaeum. It was numbered 163 in the catalogue and ascribed to a Joseph Blunt of Portsmouth, New Hampshire, a typographical error for John Blunt.

Blunt exhibited a painting entitled *Winter* at the Athenaeum in 1831, the year he probably moved to Boston. During April and May 1835 the *Portsmouth Journal* carried an advertisement offering Blunt's Portsmouth house for sale. Then, on September 12 of that year, the *Journal* announced in its deaths column, "At sea, on board ship Ohio, on his passage from New-Orleans to Boston, Mr. John S. Blunt, aged 37, painter, of Boston, formerly of this town." A similar notice had appeared in the *Boston Daily Advertiser and Patriot* on September 8.

Blunt's inability to paint figures and establish realistic spatial relationships is open to criticism. He was, however, an extraordinary painter of faces. In nearly every portrait he came very close to creating a masterpiece of folk art which was as valid a work of art for the residents of Portsmouth and the other small New England towns which he visited as the work of John Singleton Copley and Gilbert Stuart was for the residents of the more cosmopolitan cities.

Fig. 13. Fireman's bag, lettering attributed to Blunt. The bag was stored in one of the fire buckets shown in Fig. 9. Volunteer firemen used these bags to carry household goods out of burning houses. *M.F.S.* stands for Mechanic Fire Society, which was founded in 1811. *Vaughan collection.*

Fig. 14. *Portrait of Symmetry,* by Blunt, 1823. Oil on wood panel, 11 by 17½ inches. Signed and dated on the rock at lower left, *J. S. Blunt, 1823* and inscribed on the back in ink, *Portrait of Symmetry, imported in the ship Harmony, Capt. Woodward.* Animal portraits are rare in American art. *Collection of Nina Fletcher Little.*

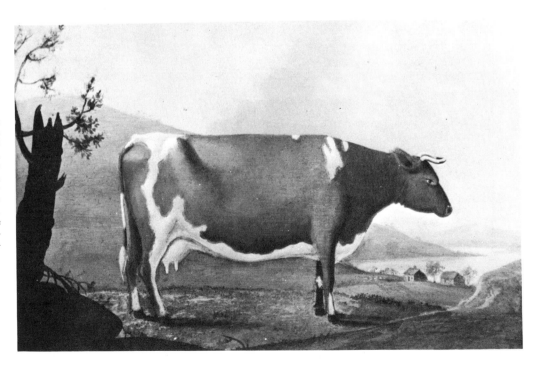

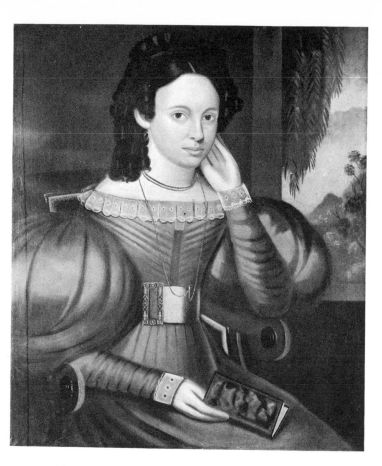

Fig. 15. *Sarah Church,* attributed to Blunt, c. 1835. Oil on canvas, 33 by 28 inches. The sitter was a resident of Bristol, Rhode Island. *Fogg Art Museum, Harvard University; gift of Frank R. Frapie.*

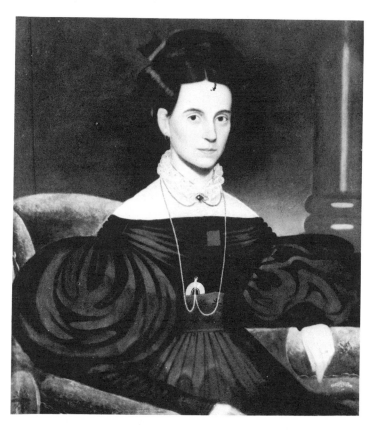

[1]Letter to me from Mrs. Little, July 20, 1975.

[2]See Mrs. Little's article about the painter in ANTIQUES, September 1948, pp. 172-174.

[3]Cited in ANTIQUES, September 1948, p. 174.

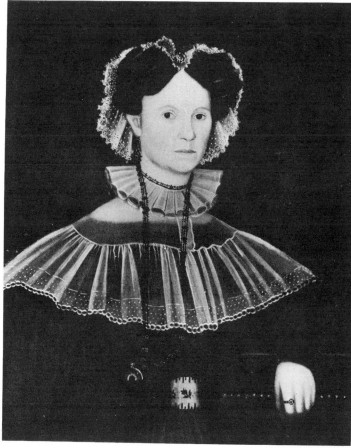

Fig. 16. *Wife of the Unidentified Sea Captain,* attributed to Blunt, 1830-1831. Oil on canvas, 30 by 25 inches. The October 1832 issue of the *Lady's Book* illustrated a hair style and cap quite similar to the sitter's. The diaphanous garment extending from neck to bosom was known as a *canezou. Collection of the International Business Machines Corporation.*

Fig. 17. *Wife of the Unidentified Gentleman from Providence, Rhode Island,* attributed to Blunt, c. 1831. Oil on canvas. Chains securing a watch, locket, cross, or scent bottle continued to be mentioned as a fashionable accessory in popular ladies' magazines throughout 1831. *Collection of Mr. and Mrs. Peter Tillou.*

III Sculpture

From its beginning, *The Magazine* ANTIQUES has printed very few articles dealing with three-dimensional objects made by untrained or non-academic artists. This reflects the general lack of scholarly research in the field of folk art sculpture. Articles included in this anthology discuss carvings in stone and wood, and mass-produced metal weather vanes.

Among the first, and certainly the most profuse and durable sculptural objects produced in the United States, are stone grave markers. From the mid-seventeenth century to the present, grave markers reflect in their size, shape, and surface decoration a direct relationship to prevailing theological, social, intellectual, and economic outlooks. In many respects grave markers are a mirror of over three hundred years of American attitudes toward life, death, and the afterlife.

Grave markers were produced by artisans who received their training primarily through the apprenticeship system. Shapes and sizes of grave markers remained fairly constant for any given time period, while surface decoration was more inclined to change to fit prevailing theological and societal viewpoints. It is most often the surface decoration which attracts the folk art enthusiasts and folklife researchers. It was not until 1927, when Harriette M. Forbes published *Gravestones of Early New England and the Men Who Made Them, 1653-1800,* that interest was aroused in grave markers. Significant recent works include contributions by Preston A. Barba (1954), Allan I. Ludwig (1966), Dickran and Ann Tashjian (1974), and Peter Benes (1977). It is hoped that future scholarly works will include a greater time span and a wider geographical area.

Sculptural folk art objects in wood have also been under-represented in the pages of *Antiques.* The most significant articles are those about John H. Bellamy, Wilhelm Schimmel, Aaron Mountz, and Pierre Joseph Landry, all of which appear in the following section. Wendell Garrett's article on figures and figureheads is also here included.

Wood sculpture is fragile, and no doubt many objects have been destroyed by the elements or an unappreciative public. With the exception of the work of a handful of known wood carvers, most of the objects were produced by anonymous artists or artisans for personal or group enjoyment. As Frederick Fried has so aptly pointed out in *Artists In Wood* (1970), the demise of the great clipper ships forced many skilled carvers to seek employment as producers of advertising figures or circus and carousel carvings. Although each piece, at least through the nineteenth century, was hand-carved by a well-trained and skilled carver, the motifs are highly stylized and approach production on a large scale. In the twentieth century carousel figures were machine produced, which places them in the area of popular art.

It is instructive to compare the celebrated ship carver, John H. Bellamy, with the noted whittler, Wilhelm Schimmel. The productive lives of each artist spanned most of the nineteenth century. Both worked in distinct geographical areas—Bellamy between the port cities of Boston and Portsmouth, New Hampshire, and Schimmel in and around Carlisle, Pennsylvania. Both are remembered for their carved eagles.

Bellamy was an educated man. He had studied art before his apprenticeship to a famed Boston ship carver. He was a cultured, gregarious gentleman of means. For many years he received substantial contracts from the United States Navy for the carving of ships under construction at the Portsmouth and Boston naval yards. Schimmel, by contrast, was an uncouth, quarrelsome German immigrant who arrived in the Carlisle area just after the Civil War. He wandered from farm to farm among the Pennsylvania Germans. He did odd jobs and sold or traded his carvings for lodging, food, and drink. His last years were passed in the Cumberland Country poor farm, where he died in 1890.

As their lifestyles differed, so did their interpretations of the ubiquitous American eagle. Bellamy belonged to a long ship-carving craft tradition that reached back to the sixteenth century. Schimmel produced his eagles and other creatures with a more limited skill and dexterity, but with a directness and strength which greatly appeals to twentieth-century artistic taste. Both men developed a highly stylized patriotic symbol. Bellamy's eagle was consistent with his craft tradition while Schimmel's was more idiosyncratic. Neither artist portrayed the fierceness of the predatory eagle, although Bellamy's work approaches this more nearly than Schimmel's chicken-headed birds. Both men repeated their stylized forms, with variations, for years. Each may have had an equal helping of natural artistic talent, but the experiences and limitations of their respective lives determined what emerged from a block of wood. Each achieved success on his own level.

Weather vanes have received scant mention in *Antiques.* This is no wonder since a competent scholarly monograph on the subject is still awaited. Much of the interest in weather vanes has developed in the last twenty years. Only recently have there been exhibitions and sales of these mass-produced objects which achieved almost universal popularity after the Civil War. To consider these later products of technology as individually created examples of American folk art is to stretch a definition. Weather vanes more properly belong in the category of popular art, along with chalkware and Currier and Ives prints. Even the original wood patterns from which the metal molds were cast were carved by highly trained and skilled carvers. These patterns are too refined to be considered folk art. Perhaps a future work on the subject will clarify some of these observations.

John Haley Bellamy

The Woodcarver of Kittery Point

By Victor Safford

JOHN HALEY BELLAMY, the woodcarver, creator of the well-known and eagerly collected Bellamy eagles, or Portsmouth eagles, as they are sometimes called, was born at Kittery Point, Maine, in the old Sir William Pepperell Mansion, the Bellamy family home, April 16, 1836. He died in Portsmouth, New Hampshire, April 5, 1914. He was the eldest son of the Honorable Charles G. Bellamy and Frances Bellamy, *née* Keene. The latter had previously been married to Charles G.'s older brother, John, who had died leaving her with two daughters.

According to genealogists, the Bellamy tree originally took root and bore distinguished fruit in southwestern France; but John H. Bellamy's American ancestors came from England to America in the seventeenth century. They were early settlers in the region west of Dover, New Hampshire, through which runs the Bellamy River. Prior to their migration thither, they are said to have dwelt for a time in Connecticut. Several of the New Hampshire Bellamys served through the Revolutionary War with creditable records.

Charles G. Bellamy was a contractor and builder. He constructed the first bridge connecting Kittery Point, hitherto virtually an island, with the upper part of the town. Besides executing private contracts he did work for the town and for the state and the federal governments. He also engaged in boat building. For many years he was active in Maine politics and held various public offices including that of state senator. He was likewise appointed by President Pierce as one of the commission representing the United States in the negotiations with Great Britain which resulted in the Ashburton Treaty, whereby, among other matters, the long-standing dispute over the boundary between Maine and New Brunswick was settled. Prosperous, socially and politically prom'nent until past middle life, Charles G. Bellamy ultimately suffered financial reverses and became dependent upon his children. It was the assumption of his debts by one of his sons that saved the elderly man from bankruptcy and kept the Pepperell mansion in Bellamy ownership.

Charles' wife was a descendant of the early English pioneers to the Piscataqua. One of her ancestors was Reginald Fernald, the first physician in this region. Her father, a shipmaster, was lost at sea with his vessel.

The son of this couple, John H. Bellamy, is described by those who knew him when young as an attractive, manly boy. During his early manhood he was companionable, jovial, and popular with men. The girls, too, liked him. In fact,

Introductory Note. Though almost everybody has seen or heard of Bellamy eagles, very few persons know anything concerning the man who carved these widely popular birds. ANTIQUES, therefore, welcomes opportunity to publish the accompanying sympathetic and, it is believed, accurate biographical sketch written by a nephew of John H. Bellamy. The author's fund of information, derived in part from personal experience and observation, has been largely augmented by details supplied by his sister, Mrs. Mary S. Wildes of Kittery, Maine, who for some years past has been collecting data regarding the somewhat capricious but undeniably gifted woodcarver of Kittery Point. — *The Editor.*

to account for this. A grandmother was a French Huguenot. Black curly hair, steady, deep-set dark eyes, a Roman nose, an alert manner, a slight swagger, and withal a heavy, reddish-brown mustache and imperial made John Bellamy a striking figure in any company.

Bellamy never married. When he had reached an age and position that justified matrimony, he courted an estimable, vivacious, and beautiful Kittery girl of about his own age. His rival was a dashing and promising young lawyer much favored by marriageable maidens and their mothers. John was at a disadvantage. Obliged to be away from home for considerable periods of time, he had to conduct most of his wooing by correspondence, while the other man remained on the ground. Furthermore, his beloved had a practical turn of mind, and, it appears, was somewhat bored by the prolixity of the poetical effusions that John enclosed with his letters. So at length she turned down the versifier and bestowed her smiles on the lawyer, whom, after all, she failed to land. None of the participants in this triangular love affair ever married. His inglorious share in the contest probably pricked John's pride more deeply than it wounded his heart. Thereafter, nevertheless, his friends thought that they observed a change in his disposition. He became, it is said, less ambitious and more inclined to recklessness.

Bellamy received his general education in the public schools, by private instruction in Kittery, and by attending the New Hampton Literary Institute in New Hampshire. He then studied art in Boston and New York. In just what institutions he pursued the latter training, of what it consisted, or what was John's original intention in undertaking such a course, I am unable to state.

according to one of his contemporaries, he was very handsome, and any damsel favored with his attentions regarded herself as fortunate. In the prime of his life, his countenance and bearing suggested those of an old French *chevalier*. It is not necessary to go back to the old French Bellamys

However, the outcome was an apprenticeship to a Boston woodcarver, said to be the most famous of the day, and, though I have often heard his name, I cannot now recall it.

Suffice it to say that the selection of both vocation and master was a happy one. Bellamy soon acquired a reputation for originality in design, skill in workmanship, and rapidity in execution. As a woodcarver he found his chief employment with the United States Government, at both the Boston and Portsmouth Navy Yards, though mainly at the latter. He likewise worked

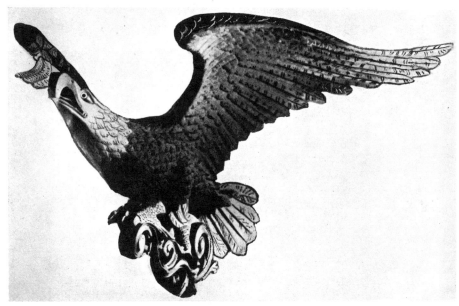

Fig. 1 — EAGLE BY BELLAMY

Figurehead of the U.S.S. *Lancaster* carved when the old vessel, originally built in 1859, was reconditioned at the Portsmouth Navy Yard in the early 1880's. An impressive sculpture. *Wing spread*, 18 feet, 8 inches; *weight*, approximately 3,200 pounds.

From a retouched photograph by courtesy of the Boston "Globe"

for commercial shipbuilders. For a long period of years, beginning prior to the Civil War and continuing until after the opening of the present century, he carved figureheads, ornamental work for sterns, panels for gangways, and sundry decorations for other parts of naval and mercantile craft, large and small. He also executed carvings for public buildings and for private dwellings.

It was frequently essential that his creations should symbolize the authority of the United States Government, and Bellamy had distinctive ways of handling the eagle, the coat of arms of the United States, and the American flag, so as to meet this requirement. Thus, such of his eagles as were destined to adorn the walls of public buildings were usually draped with the American flag. For some Government uses he carved eagles with spread wings, life size, or larger. The figurehead for the U.S.S. *Lancaster* was enormous. He also furnished eagles for municipal and state buildings, clubs, and private estates. Some of these birds were gilded.

When not otherwise occupied, Bellamy turned out flocks of those distinctive small spread eagles, stretching hardly more than two feet from wing tip to wing tip, by which he is most popularly known. A few were of mahogany, but the majority were of pine, painted white. Somewhere in the design he usually managed to introduce a touch of the red and blue of the American flag, the United States shield, and a star or two. Sometimes the bird carried

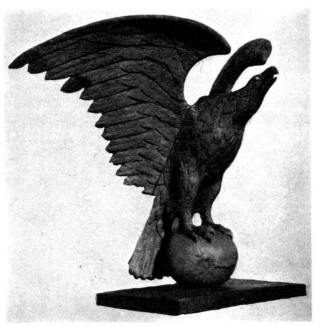

Fig. 2 — EAGLE BY BELLAMY
Like that of the preceding illustration, an uncommonly fine example of the artist's work. Note how the deep concavity at the top of the wing contributes a vivid suggestion of lifting power.
From the Frost collection

in beak or talons a pennant bearing a painted motto, frequently in Latin. Where he found a market for these smartly decorative carvings it is hard to say. I have seen him boxing such wares for shipment; but so many small eagles were presented to friends that their making seems to have been primarily a diversion. He also made and gave away to favored friends larger and more elaborate eagles of a different type. I recall the gift of a life-size eagle with spread wings to Commander Merry of the Navy. Those who saw this ambitious piece of wood sculpture considered it one of the artist's best achievements.

Besides his eagles, Bellamy carved other birds, as well as animals and such devices as family coats of arms. Heraldry was one of his hobbies, and he was an authority on the subject. I have a fox head, nearly life size, presumably carved by Bellamy; but in such unfamiliar productions the man's style and technique are less assured and less certainly identified than in his favorite eagles.

Bellamy was a lifelong student of literature. He continued to be fond of poetry even after the Muse had wrought havoc with his courtship. For years he contributed poems — many of them humorous — to local newspapers; and likewise wrote short articles on historical, political, and other topics, which appeared in Maine and New Hampshire newspapers and in other publications. From time to time, while carving at his bench, he would interrupt his mechanical work to jot down on the paper pad, always near at hand, some thought that had occurred to him and that he wished to preserve for future use.

Bellamy had what is commonly referred to as an artistic temperament. He proclaimed this by his

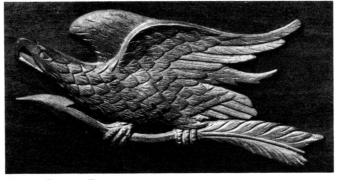

Fig. 3 — EAGLE BY BELLAMY
Of bronze mounted on a panel. The cast was made from a wood model carved by Bellamy. The type is not familiar, but the evidences of Bellamy's handiwork are clearly manifest.
From the collection of Doctor Charles Green

fancy waistcoats when fancy waistcoats were in vogue. Out of working hours he dressed well. The artist in him enabled him to appreciate appetizing cookery and all the other good things of life; and he was willing to put money into circulation to obtain them. He was not one of those fabulous beings who are ready to starve themselves in the service of art. No overmastering ambition was ever permitted to interfere with his comfort. Though at times his sense of duty failed in the presence of disagreeable responsibilities, he was by no means selfish. Sympathy and generosity often swayed him in directions contrary to his own interests. Though he had his human weaknesses, he was, by inheritance and by training, a gentleman. Unlike some artistic geniuses, he cherished strict moral principles to which he adhered. He liked good company. His associates, whether they were local mariners or the actors and writers of the summer colony, were always respected members of their professions. He did not force himself upon them. He was never obtrusive. Others had to come to him; those who proved unwelcome were promptly and bluntly made aware of the fact.

When he so willed, he could assume an imperious dignity. On one occasion he was sent to repair the carvings on the stern of a naval vessel in the harbor. Arriving at the scene of his labors, he found that the apparatus provided to give him access to the carvings consisted of a boatswain's chair and a tackle attached to the spanker boom. The contraption was quite inadequate. Without a word to any of the subordinate officers of the ship, Bellamy went directly to the cabin and demanded interview with the captain. On being admitted to that august presence, he stated his business briefly but emphatically in the following terms: "I am Mr. Bellamy. I have been sent to repair some carving on the stern of your ship. I find that a boatswain's chair has been provided for my use in doing this work. I wanted you to *see* me, because you evidently thought that I was some sort of a damned monkey that could work with his hands and hang on by his tail. If you want me to make the repairs called for you will have to order a suitable platform." The specification was promptly met.

Notwithstanding Bellamy's tendency to indulge himself, he never permitted his fondness for good things to saddle him with debt. His employment by the Government was somewhat intermittent. His reputation brought him orders from other sources. He seems to have made little or no effort to solicit commissions. He derived a small income from his writing. It would appear that, when in need of funds, instead of attempting to stimulate the market for his carvings, he preferred to turn his attention to quite unrelated fields, to the creation of ideas that might be copyrighted for advertising purposes, and to the improvement of mechanical devices and tools. He was gifted with remarkable mechanical ingenuity. Friends helped him to dispose of his inventions and protected his interests. Most of his contrivances he sold outright; for others he was paid small royalties. As he approached the age of sixty, one of his older half-sisters arranged an annuity that assured him a comfortable income for the

rest of his life. Bellamy's artistic genius was never tried by poverty.

Until within a year or two of his death, Bellamy kept bachelor quarters in the old colonial mansion where he was born. His living room was in the southeastern corner on the second floor. It had been the bedroom of the wealthy baronet who once looked out of its windows on his dock, and his vessels, and the harbor beyond. The recessed windows, the paneled walls, and the fireplace still remained as they were then. The desk had been used by somebody in Sir William Pepperell's time; but the paintings, the etchings, the drawings, the books, and the mementoes of foreign countries everywhere scattered about were such as a late nineteenth-century artist might be expected to accumulate. The chairs, too, had evidently been selected with a view to comfort rather than antiquity.

For a time after the Civil War, Bellamy maintained a workshop in Portsmouth. It was here that his Portsmouth eagles gained their first repute. His business card read:

John H. Bellamy,
Figure and Ornamental
CARVER
particular attention paid to
House, Ship, Furniture,
Sign & Frame Carving
GARDEN FIGURES
No. 17 Daniel Street
Portsmouth N. H.

Subsequently, when not occupied at the Navy Yard, he spent most of his days in his workshop at Kittery Point. This shop was a single room in the second story of the building where Bellamy's father had kept his contractor's gear and, with the other sons, had built boats. Its windows opened toward the harbor and the sea to the south. From them at times the eye might catch the looming Cape Ann in the distance. A ship's ladder with a manrope led up to the shop. An iron weight on the end of a rope, which passed through an old clew-line block, closed the door behind the visitor. Along the south side of the shop extended a workbench. Above it hung recent carvings and many patterns and tools used in the woodcarver's craft. The walls were, for the most part, papered with yellowing drawings by Thomas Nast and with brighter-colored political cartoons from *Puck*. Strung about here and there was a varied assortment of prints, carvings, drawings, and curios. A pot-bellied stove standing in a box of sea sand supplied genial warmth during the colder months of the year. Comfortable chairs of diverse styles and ages were placed here and there to accommodate visitors. Nobody ever saw Bellamy sit down in his workshop, except to rest for a few minutes on the high stool that he kept near him at the bench.

The perennial guests who occupied the chairs were usually retired

shipmasters who congregated to swap reminiscences and to discuss with John the affairs of the world. George Wasson, the artist and author, who lived near by, was a habitual caller, as were also some other exotic residents of the village. Now and then an old naval officer would drop in to see Bellamy. With the advent of warm weather in the spring and the arrival of the summer colony, the assemblages took on a more varied aspect. The shop was the rendezvous of all the colonists of artistic or literary tastes. George Wilson, Tom Burns, and Henry Clay Barnabee of the old Boston Tremont Theatre were among the actors to be found there almost any day. One was likely to discover William Dean Howells, or Mark Twain, or some other equally famous writer, ensconced in one of John's easy-chairs. He enjoyed the company of such men. Occasionally he entertained them by relating a humorous anecdote, or by voicing a bit of philosophy that he really believed; but for the most part he worked away at his carving and listened, stopping only to make some debatable statement or to present some query for the sole purpose of quickening a laggard conversation.

His inclination to provoke discussion once caused him considerable embarrassment. He had written several articles for a newspaper regarding a local project that he strongly favored. Failing to awaken the public interest that he thought the matter deserved, he signed a fictitious name to a letter not only opposing the project but personally attacking John Bellamy. Disguised as his own enemy, he characterized himself as erratic, a crank, and even a good-for-nothing, adding references to incidents purporting to justify such charges. The result exceeded expectations, but not in the manner intended. The project in which Bellamy was interested was promptly obscured in the public mind by indignation at the personal attack. So strong became the feeling against a fellow-townsman wrongly suspected of writing the abusive letter that Bellamy was obliged to confess his duplicity.

Occasionally he entertained summer friends by taking them fishing. For this purpose he had acquired an uncouth vessel said to have once been a surf boat somewhere in Central America. Extraordinarily broad for its length, this craft was both staunch and roomy, qualifications that had prompted Bellamy to purchase it. In painting the boat he gave free rein to his imagination, and achieved something that, under way, made a Polynesian war canoe look like a Sunday School picnic launch. On arrival at the fishing grounds, after furling the sail, he would put up an awning as striking in its color effects as the boat itself. Bellamy's

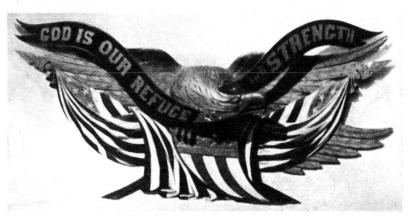

Fig. 4 — EAGLE WITH SHIELD AND FLAGS BY BELLAMY
Polychromed. The plumage of the bird is more broadly summarized than that of the eagles of Figures 1 and 2, but the same characteristic handling of tools is observable in all three

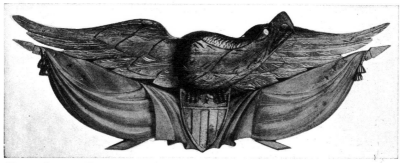

Fig. 5 — BELLAMY EAGLE WITH SHIELD AND FLAGS
The eagle and shield are gilded. Flags are white. Original polychromy probably like that of Figure 4. The lighting here fails to emphasize the hollowing of the wings. While not quite so fine as the immediately preceding example, nevertheless thoroughly characteristic.
From the collection of Doctor Charles Green

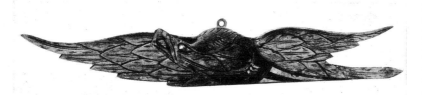

Fig. 6 — SMALL BELLAMY EAGLE
Gilded, with red, white, and blue shield. Of a type infinitely repeated with minor variations by the woodcarver. Note the characteristic square beak with flattened top and front and the extension of the line surrounding the eye socket to summarize the feathering of the upper part of the neck. The linear rhythm of these small eagles and the manner of their decorative conventionalizing deserve no little admiration.
From the collection of Doctor Charles Green

fishing yacht enjoyed the distinction of being the only one with an awning ever seen on the fishing grounds, as well as the only local fishing boat ever known to be equipped with seat cushions.

In his closing years Bellamy led what has been referred to as a "secluded life": "lonely" would be a more appropriate term. He still kept mentally occupied and informed regarding current events. He continued to be interesting company; but he reflected loneliness. With the husband of a dead sister and her unmarried son, he maintained a bachelor ménage in the old home. A housekeeper looked after the trio. John was the last survivor of eleven children. Almost empty of life, the great house was yet crowded with memories: memories of familiar faces that had gone, of the prosperous days when Bellamy's father and mother, famed for their hospitality, had held high entertainment and the mansion had resounded with the voices of his brothers and sisters, and of a jovial company of guests; memories, too, of receding fortunes, of the succession of deaths that had bereft the ageing man of his nearest and dearest kin. Not happy memories, these.

Time had also taken toll of Bellamy's cronies. One after another the ancient mariners had dropped off. Many other friends, including George Wasson, had moved away. The character of the summer colony was changing. The new-comers had not the same interests and diversions as their predecessors. The gatherings at John's shop dwindled, until in winter the only daily visitor was the retired shipmaster, Captain John Lawrence. He and Bellamy had been close friends from boyhood, ever since a local shipmaster had brought Lawrence to Kittery Point as an orphan boy, survivor of an emigrant ship tragedy.

One winter day news came to Bellamy in his shop that Lawrence too was gone. For a time the old woodcarver sat quietly on the high stool by his workbench and let his vision rove over the sea to the meeting line of sky

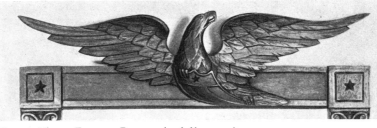

Fig. 7 — MIRROR FRAME BY BELLAMY (*probably c. 1900*)
Revealing the carver in an unusual rôle, in which he was not entirely at home. Not improbably other frames by the same hand are variously hidden away in New England.
From the collection of Mrs. Alfred Mayer-Weismann

and water. Then he arose, left the shop, locked the door, and walked slowly to his room in the old mansion. Never again did he return to the shop. He insisted that he "would go back sometime," but the sometime was postponed. For a year or two he occupied himself with newspapers and periodicals and books in his living room in the mansion. But the love of life had passed from him. At length failing health and the need of personal care led him to accept an invitation to reside with relatives in Portsmouth. And there death presently set him free.

Not long ago the following published poem by Bellamy came into my possession. When it was written, or why, or where, or in what journal it was published, I do not know. Bellamy called it *Tomorrow.*

"Onward I move amid the throng
Who jostle on this rolling sphere,
And feebly murmur this, my song,
We shall all shortly disappear.

"A little month, a passing year,
 And we have reached
 life's journey's end,
 Beyond the font of grief
 and tear,
 The land of promise, home
 and friend.

"Still there will float in
 upper air,
 The storm cloud on its
 trackless way,
 And fawning doves will
 coo and pair
 As fondly as they do
 today.

"There will the unborn millions rear
Their temples high throughout the land,
While crumbling, ours shall disappear
 Beneath Time's all de-
 structive hand.

"Heroes will lead in un-
 known deeds,
 And ships make havoc
 on the deep,
 New kings expound and
 break their creed,
 New babies in their
 cradles sleep.

"Thus runs the busy
 world away

Fig. 9 — FOX HEAD (*date uncertain*)
Presented by Bellamy to Mrs. Victor Safford about 1908. While there is no evidence, beyond the fact of gift, that this well-conceived and capably handled carving is Bellamy's own work, probability seems to favor that assumption. Stylistic evidence in its support appears, however, to be lacking.

Fig. 8 — RAM'S-HEAD GABLE ORNAMENT
The scope of Bellamy's carving appears to have been extremely wide. The ram's head here illustrated was carved to immortalize a famous ram, of which the owner was very proud. Bellamy's authorship is well attested.
From the house of John Thaxter, Cutts Island

Without the breaking of that law
That hath in universal sway
Dealt with our kings as men of straw.

"'Tis well, methinks, there is a power
Beyond the reach of human greed,
That nameth not the day
or hour,
But bids us all alike take
heed."

Not, by any means, a great poem, nor particularly original in either thought or expression, yet none the less a rather touching revelation of the brooding something in Bellamy's soul that distinguished him from the rank and file of men and lifted much of his work above the level of mere craftsmanship to the plane of creative art.

Fig. 10 — EAGLE ON PEPPERELL HOUSE DOORWAY
While attached to Bellamy's own dwelling and ascribed to that carver's hand, this eagle shows not a single feature of style or treatment that would associate it with the master's creations. It may be the work of John Williams of Kittery Foreside

Bellamy's Style and Its Imitators

By THE EDITOR

INEVITABLY the popularity enjoyed by Bellamy's eagles has resulted in various forms of exploitation. On the one hand, imitations of the master's originals have been hacked out and offered either as genuine examples of the old carver's craftsmanship, or as something equally good. On the other, almost any orphan fowls remotely resembling the bird of freedom have been liable to conscription into the Bellamy brood.

As the author of the preceding account points out, John H. Bellamy carved many figures besides eagles. But the latter were his specialty. In the course of a lifetime, spent in chiseling the same contours and shaping the same details of plumage, beak, and claw, he perforce acquired a certain fixity of technique that to the practiced eye is as clearly recognizable in the finished work as would be the peculiarities of letter formation in a written signature. When, however, he was dealing with a more unfamiliar subject, his tool manipulation was necessarily less assured, his treatment of individual features less definitive, or at any rate, less stereotyped. Hence it would seem that while a presumptive Bellamy eagle may be accepted or rejected on the sole basis of its style and technique, animal heads and such other carvings as constitute departures from the artist's accustomed practice must be either accepted or rejected on faith.

Fig. 11 — BRACKET EAGLE ASCRIBED TO PRIDHAM
A perfunctory and childish piece of work that may have been inspired by Bellamy's small eagles, and by comparison serves to emphasize the latter's excellence.
From the collection of Doctor Charles Green

It will be observed that Bellamy by no means confined himself to a single type of eagle. Probably his finest and most important birds are those carved in the round, with wide wings raised and sharp talons grasping a ball, or a ship's billet *(Figs. 1 and 2)*. These figures are endowed with a vitality and an implication of movement that betokens swift, sure workmanship. Though the details are boldly and broadly defined, they are neither slighted nor reduced to purely mechanical terms.

Perhaps next in importance come Bellamy's spread eagles amid flags, such as we encounter in Figure 4. In these arrangements, necessarily somewhat formalized and stylized to meet specific limitations of space, we note a fluid, almost calligraphic linear quality, and therewith various suppressions and elisions of detail. The deft and precise use of carving tools apparent in the more ambitious eagles is equally in evidence, perhaps even more so. But greater economy of effort is manifest. The proportionate size of each element of plumage, for example, is greater — so much so, in fact, that the feathering may be said to be rather suggested than represented.

In the small spread eagles, of which Bellamy carved so many for his friends, the calligraphic quality as well as the previously mentioned suppressions and elisions are carried to a point where the anatomy of the bird is reduced to a kind of decorative shorthand, or to something perhaps between Spencerian penmanship and stenography. Thus wing and tail are merged into a single member. Nothing is left of legs or talons except a row of crisply cut gouges encroaching on the top of a merely embryonic shield. Here we no longer have an eagle, but an eagle symbol, something in the way of a Chesterfieldian gesture, magnificent in swaggering confidence and sweeping grace — and it satisfies.

Different one from another as the types thus briefly enumerated may appear to be, they have certain unmistakable features in common. Of these the most conspicuous is the shape of the beak. The front and top of this member are quite broad and somewhat abruptly flattened. In profile the upper mandible forms an almost rectangular hook whose sharp point just meets or slightly overhangs the stiletto-like end of the lower mandible. In the aperture between is visible a tongue thrusting forward like a weapon. The eyes of Bellamy's eagles are quite as significant as the beaks; their rims marked by a firm line that, starting at the lower corner of the socket, circumscribes the eyeball, and without break or quaver is carried back beneath the flat brow to terminate in a feather or to suggest the entire plumage covering neck and back.

Another almost certain mark of identification in Bellamy eagles is the so-called "shelving" of the wings, by which is meant Bellamy's trick of introducing a fairly deep hollow beneath the upper line of the wing so as to achieve the semblance of an overhang, and by consequence a greater suggestion of lift and power in the spread pinions. This shelving, more than faintly perceptible even in the small carvings, is strikingly manifest in the splendid figurehead of the *Lancaster* and in the vivid portrayal of the first illustration. It would seem that the eagles of no other American woodcarver quite approached Bellamy's, in this respect at least. For lack of a strong shadow, their wings incline to flatness. Bellamy's treatment of feathers is quite as specific both in the long strokes designating the quills and in the crisply cut little half moons and cedillas that mark the direction of the barbs.

And lastly, however beguiling may seem the small eagles carved in emulation or imitation of Bellamy's similar creations, they sink into shameful insignificance when placed beside even the most cursory work of the master. They lack the linear grace, the vitality, the certitude of cutting stroke that proclaim the authorship of their betters and distinguish whittling from true art.

The names of some of the carvers who have approximated Bellamy's style are known along the shores of Maine and New Hampshire. Doctor Charles Green speaks of one John Williams of Kittery Foreside, who was a skilled workman, and, by some persons, is credited with the eagle over the Pepperell Mansion doorway, despite that fine bird's frequent and probably erroneous ascription to Bellamy. Figure 11 pictures, in two positions, a bracketlike eagle, now in Doctor Green's collection, which fairly represents the work of the late John R. Pridham of New Castle, New Hampshire. It is said to have been made about 1895 and to be one of thirty or forty produced by the same man. Pridham was no professional carver except, perhaps, in his capacity as cook at the Wallis Sands life-guard station, where, after active service with the guard, he was retained to operate the kitchen. His crude birds of prey are fitted with sparrowlike heads.

Two imitations of the Bellamy small eagle type are pictured, with brief comment, in Figure 13. The first is inscribed on the under side of the neck *Ivah W. Spinney.* Neither of these fowl should deceive anyone still possessed of a fragment of optic nerve. But it is well to contemplate them if only to obtain thereby a juster appreciation of Bellamy's competence in design as well as in workmanship.

Fig. 12 — SMALL EAGLE BY BELLAMY (*c. 1890*)
Because of its coat of white paint revealing, with unusual clarity, the carver's technique and his sure and facile touch

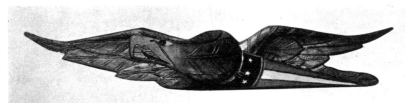

Fig. 13 — IMITATIONS OF BELLAMY EAGLES
The one above, marked *Ivah W. Spinn y*, betrays a fairly painstaking effort to capture Bellamy's free and easy handling. But note the awkward structure of the wings, the laboriously hard lines of gouging, and the absence of the crisp, light-catching accents with which Bellamy enlivened his work. The eagle shown below, from an unknown hand, has not even the merit of a well-poised neck.
From the collection of Doctor Charles Green

SCHIMMEL THE WOODCARVER

By MILTON E. FLOWER

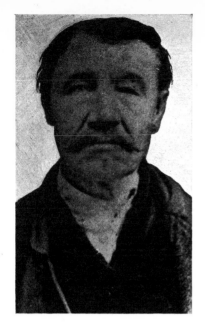

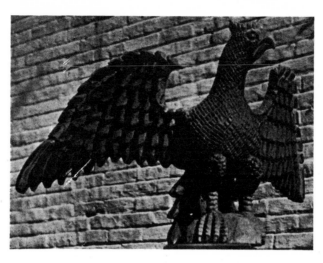

FIG. 1 — WILHELM SCHIMMEL. Photograph of the picturesque Pennsylvania-German woodcarver, made in the 1800's by A. A. Line. *From the collection of Ethel Waggoner Minich.*

FIG. 2 — TWO EAGLES CARVED BY SCHIMMEL. *Left, from the collection of Miss Ellen Penrose. Below, from the American Folk Art collection at Colonial Williamsburg.*

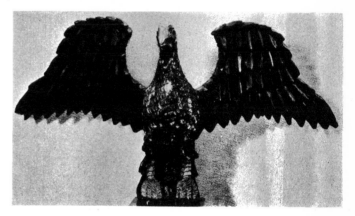

SCHIMMEL WAS THE LAST of the primitive woodcarvers. Though dead for fifty years, he is vividly remembered as a somewhat terrifying old man who sat by the roadside cutting blocks of wood into what seemed useless, if fascinating, objects. No one who had ever seen Schimmel forgot him.

Exact details find little place in such memories. Incredible to old country folk is the thought that their "Old Schimmel" is regarded today as a noteworthy folk artist, whose carvings find a place in every important collection of Americana from the Metropolitan Museum to Greenfield Village.

Wilhelm Schimmel came into the Cumberland Valley near Carlisle, Pennsylvania, shortly after the Civil War. No one knows why this "big, raw-boned, ugly man" settled here. His rough voice, often unintelligible German speech, and peculiarities of manner encouraged many rumors — that he had fled his homeland because he had killed a man, because he was heartbroken at the death of his wife, or because he wished to escape military service — all pure suppositions. No one knew. From the late sixties until 1890 he shuttled from house to house up and down the valley, filling homes hospitable to him with the birds and animals he carved on his way.

When he came into Carlisle with a basket of his birds, he traded handiwork for meals, pennies, or drink. Frequently he passed a splendid carving across the bar in exchange for a pint of whiskey. At one time every tavern, restaurant, and barroom in that town boasted a Schimmel-carved eagle which it displayed conspicuously, often flanked by lesser works. After a few days in town, Schimmel would retrace his way to the countryside he called home, often staggering up the street and roaring like a lion — a condition that terrified timid townspeople.

Greider's Mill, along the winding Conodoguinet Creek some six miles west of Carlisle, was home to Schimmel. John Greider, a miller and farmer, was the friend who trusted Schimmel implicitly, gave him lodging in the loft of his wash house, and recommended him kindly to relatives throughout the valley. Here, by the side of a covered bridge, Schimmel sat for hours on end, intently carving, as he sang loudly in German. The Greiders understood him and often placed their children in his care. And the children of the neighborhood, while fearing his temper, formed an appreciative audience when old Schimmel held up to their view what he called

his "Fogels." They alone did not consider him queer.

Frequently he wandered across the valley to the home of the Waggoner family who lived at the foot of the mountain gap named for them. There, too, he was assured of meals and lodging in return for a helping hand with farm chores. Or again he would follow the western road along the mountain. His favorite tramps were within a twenty-mile area, from Carlisle to Newburg, and from the Conodoguinet Creek to the North Mountain. It was a region as fertile to Schimmel in sales as it has subsequently been to collectors of his work. On occasion he went into adjoining counties — Perry and Franklin, and sometimes as far east as Lancaster — but never for long. He soon returned to Greiders'. That family and their neighbors were the ones he knew best, although he said of an old woman in Newburg, "She makes my shirts, I cut her wood." In Carlisle he found acquaintances and understanding among certain German families, usually of a humble sort. To them he went when the Greiders' home was broken up. It was the Pennsylvania-German element of the valley, rather than the earlier-settled Scotch-Irish, with whom he lived and who knew him most intimately. They cooked meals for him when he was "on tour" and were his best customers, paying him the ten and twenty-five cents he asked for his work. A purposeful wanderer, he was never considered a bum.

Any barn's hayloft was a welcome place at night, and in town the cellar of a German friend, the loft of a livery stable, or customary free lodging in the county jail sufficed. But his

violent temper and his German curses made townsmen wary and countryfolk circumspect in his presence. The latter made sure not to "tant" him, it has been said. Schimmel was always on hand at a barn raising. He could help, and he could reap a big reward in the blocks of wood that remained after the timbers had been cut. Also desirable were the heavy railway ties.

A similar fondness drew him to the place of Samuel Bloser whose farm on Possum Hill had a workshop. Bloser was a local undertaker and cabinetmaker. Such a profession with its good wood made Schimmel call this house his second home. "Don't pick the blocks so close," Bloser would say peevishly, but the carver unheeding would shoulder his bag laden with every available piece. There was easy tolerance in all that region. They laughed at him, feared him, thought him dirty, and dangerous in anger, yet they admired him and fed him. The very aspects which today give his work its characteristic force were the things which made certain contemporaries disdain his carvings as crude. The other cutters of the black-walnut era were precisionists, working with geometrics, while Schimmel's carving was ever individual and full of feeling.

Schimmel carved all manner of birds and animals. Pine was his favorite medium. His only tool was a common pocket-knife which he sharpened assiduously. He made few mistakes. So sure was his eye that every stroke was made to count, a fact reiterated by those who remember watching him whittle. Only when he wished a smooth surface did he use bits of glass to eradicate his knife marks. After carving his bird or beast, Schimmel covered his work with gesso, a plaster wash, to prepare the surface for the final paint coat he always liked to use to brighten his carving.

Most treasured as well as most handsome were Schimmel's eagles, the largest of which had a wing spread of three feet from tip to tip. Smaller ones were regarded as mantel or whatnot ornaments; the larger ones were usually put on top of a pole to ornament the garden. Certain ones were displayed in schoolhouse yards, before a Bloserville boarding house, and in Carlisle on victory poles at election time. Large specimens as well as small had wings carved as if poised for flight. Best examples, such as the one in the Rockefeller collection in Williamsburg and that in Miss Ellen Penrose's home in Carlisle *(Fig. 2)*, present the salient characteristics of all Schimmel eagles. The wings of these birds are gouged out to show each individual feather, and the joint is at a sharp angle. No block was large enough for the largest of these birds, so wings were cut separately and dovetailed into the body, held by a single pin. Bird bodies were carved in sawtooth fashion, as were the backs of the wings, from the head to the claws which grasp a woodblock base. Here again, in the strong, rough work found on the claws we recognize another Schimmel trait, for by observation identity can best be established.

Schimmel eagles had a beak and head often confusingly similar to the small parrots which the carver also made. These latter birds were small and likewise perched on a block. Note, too, that the eagles were more Hapsburgian than of the American bald-eagle genus. Roosters, a favorite subject, were never carved about the wings but had smooth bodies and well-carved tail feathers. In size they varied from a naturalistic, foot-tall fowl to a miniature specimen two inches high. Squirrels had most carving centered on a curving tail lying over the animal's back, while lambs and dogs frequently had on some part the peculiar markings characteristic of good Schimmel work, notably, the sawtooth incising. One who remembers Schimmel working reports than on occasion he

FIG. 3 — SCHIMMEL SOLDIER. This figure bears a resemblance to a German soldier. *This and Figures 4, 5, and 7 from private collections; photographs courtesy of George S. McKearin.*

FIG. 4 — SCHIMMEL SHEPHERD AND HIS FLOCK. The sheep have real wool glued to their wooden hides.

FIG. 5 — TOY ANIMALS AND BIRDS CARVED BY SCHIMMEL.

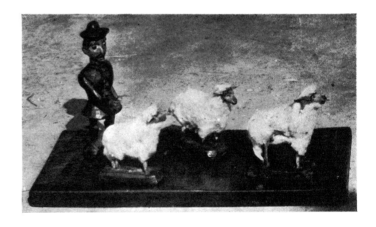

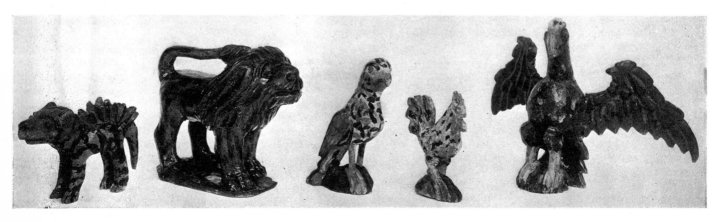

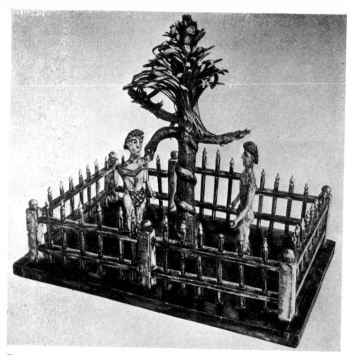

FIG. 6 — THE GARDEN OF EDEN. Carved in pine by Schimmel, each figure separately. Painted in polychrome with heavy oil colors. *From the collection of T. C. Geesey. Water color rendering from Index of American Design, Metropolitan Museum of Art.*

experimented by pasting sheep wool or fur on a finished animal. At times he tried his knife in fashioning stranger beasts, particularly lions, of which a few examples exist.

Schimmel's European background is evident also in the Biblical scenes he fashioned. Particularly impressive was his depiction of Adam and Eve in a realistic garden surrounded by a picket-like fence *(Fig. 6)*. The tree was there with its red apples, the snake, and an enticing Eve. This was the counterpart of what the Bavarian peasants had carved for generations. This model the neighborhood wholeheartedly approved. At least three of these groups were carved by him. Schimmel exhibited one at the Cumberland County Fair in the 1880's. He hurled German curses at the judges who failed to award him a ribbon, despite acclaim from the people who knew him well. In his last months Schimmel carved a miniature of this garden scene and a very small portrayal of the crucifixion. But his fame rests largely on his eagles and animals.

The rather crudely carved blue-uniformed soldier with a sword at his side *(Fig. 3)* has given rise to rumors which have been accepted by authorities as truth. One such legend is that Schimmel was a veteran of the Mexican or Civil War, or of the Franco-Prussian War. No one who remembers Schimmel believes that he ever bore arms for his adopted land. In light of the recollection of those who knew him no foundation for this rumor exists, any more than for the statement that he was affluent enough ever to have possessed better means of transportation than his own feet. The many who remember doubt that he ever turned a hand to "honest work," except for the Greider and Waggoner families.

Schimmel always painted his own carvings, using whatever paints he could acquire. Black, brown, red, and yellow ochre were favorite colors. His large birds were often drab, yet enlivened by red and yellow accents on wings and claws. His

roosters were yellow ochre with black stippling over the bodies, but with careful brushwork on tails and on the smooth sides where he failed to carve wings. Such strokes were often impressionistic daubs. Another characteristic Schimmel addition was the insertion of leaf or bud-like pieces in the base of his eagles and parrots. These additions, designated "nests," were brightly colored and, to a trained eye, are a detracting feature of his work. But for the most part the virile strength of his rude, if forceful, production is both exciting and satisfying. To many, Schimmel's products have more appeal than the neat and realistic work of trained craftsmen such as Samuel McIntire. Schimmel's work exhibits the fundamentals of creative art, and, as with all folk art, "is the expression of the common people, not that of a cultured class." Easily recognizable and related one to the other, each carving has its own merits and demerits, making it individual and good art.

In life Wilhelm Schimmel was known less as a person than as a carver of birds and animals, of ornaments and toys. Suffering from an incurable ailment, he came to Carlisle after the breaking up of the Greider home. In a short time German friends found it necessary to take the sick man to the almshouse. He went, under protest, in mid-May 1890. He died the same year, August 3, aged 73, and was buried in the potter's field. Of three Carlisle newspapers only one made any note of his passing:

"Old Schimmel" the German who for many years tramped through this and adjoining counties, making his headquarters in jails and almshouses, died at the Almshouse on Sunday. His only occupation was carving heads of animals out of soft Pine wood. These he would sell for a few pennies each. He was apparently a man of a very surly disposition.

The weekly edition of the same paper remarked that "Schimmel was known to almost everyone in the country." His creative ability is more truly evaluated in this day than in his own; his work is sought and prized for its inherent artistry.

FIG. 7 — BOWL OF FRUIT. Carved and painted by Schimmel.

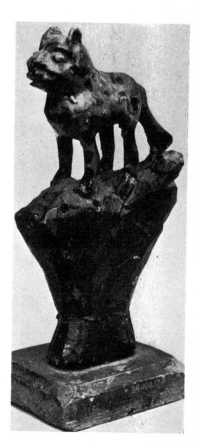

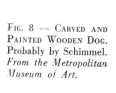

FIG. 8 — CARVED AND PAINTED WOODEN DOG. Probably by Schimmel. *From the Metropolitan Museum of Art.*

137

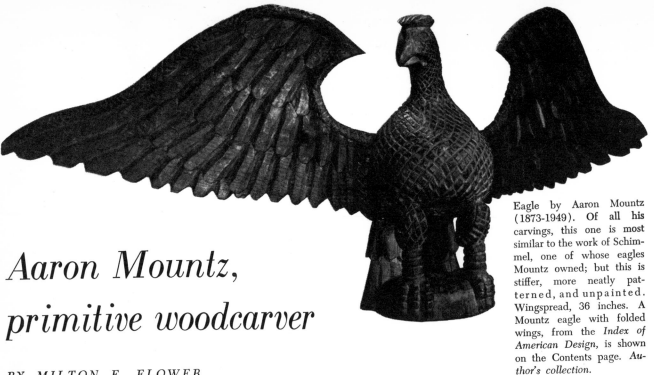

Eagle by Aaron Mountz (1873-1949). Of all his carvings, this one is most similar to the work of Schimmel, one of whose eagles Mountz owned; but this is stiffer, more neatly patterned, and unpainted. Wingspread, 36 inches. A Mountz eagle with folded wings, from the *Index of American Design*, is shown on the Contents page. *Author's collection.*

Aaron Mountz, primitive woodcarver

BY MILTON E. FLOWER

WHEN WILHELM SCHIMMEL, German immigrant from Hesse, entered the Cumberland Valley of Pennsylvania shortly after the Civil War, he made his headquarters along the Conodoguinet Creek not far from Carlisle, where he was befriended by Pennsylvania German farmers who had entered the county a generation before (see ANTIQUES, October 1943, page 164). As he sat on one farm porch or another, or by one of the many covered bridges which spanned the creek, whittling the birds and animals that now delight collectors, the youngsters of the vicinity crowded around him fascinated. One of these was a boy named Aaron Mountz.

The Mountz family occupied a farm less than a mile downstream from Greider's, where Schimmel was most often to be found. The country is rolling, two or three miles from the Blue Mountains which enclose the valley on the north. Though the farmland was not the fertile limestone which lies on the southern side of the Conodoguinet, William Mountz and his wife reared a family of six children. Aaron, the first of four sons, was born in 1873.

With his brothers and neighboring playmates, the boy wandered the banks of the nearby creek and, until the old man's death in 1891, made up part of the ready audience Schimmel could always command. What this gruff German could do with a knife and a piece of wood was wondrous indeed to them all. Inevitably the children tried their own hand at the art. Only Aaron found success.

During his 'teens and twenties Mountz produced much of his best work. Schimmel died when Aaron was seventeen. All the neighbors were delighted by the new talent and encouraged him, saying he was "as good as Schimmel." As he grew older Mountz veered from imitative work to more sophisticated tricks—intricate puzzles and ships which he slipped into bottles. When his brothers and sisters left the farm and his father died,

Aaron stayed home and cared for his aging mother. But he too had an urge to go elsewhere and from time to time left briefly to work with bridge construction companies. Never to be forgotten was a moose-hunting trip he once reputedly made to Canada. John, one brother, later returned and he and Aaron became well-drillers, kept the farm going as best they could, and on free days roamed the rugged hills in search of hare and other game. Aaron was the reflective one and a dreamer. Fishing he loved the most for he could be alone with his thoughts. It was the same, too, when with his knife and odd pieces of wood he sat on winter evenings at the kitchen table and by the light of the oil lamp in total silence patiently carved for hours at a time.

Aaron was also the Mountz with the ideas, ideas which neighbors thought impossibly advanced and impractical. He totally lacked any business sense. In his late fifties, his carvings long forgotten, he became involved in too many farming ventures, from which, simple though they were, he could not extricate himself. He suffered a breakdown and was committed to the state hospital. Some years later he was transferred to the Cumberland County Home where his one-time friend Schimmel had spent his last days—though Mountz by then lacked the capacity to realize that. There this simple old man, his eyes an intense blue but lacking expression, his hair white and his cheeks ruddy, his hands hopelessly idle, quietly lived out his final decade. He died in December 1949.

Aaron Mountz's output of carvings was relatively small, possibly a few dozen compared with Schimmel's hundreds. They are not, actually, "as good as Schimmel's," but they have recognizable characteristics and considerable merit. His style revealed his personality, the mark of any artist. Knowing nothing about Mountz the man, by looking at his work Erwin O. Christensen was able to write with insight, "one imagines him as a delicate, sensitive soul to take good care of each little feather [in

his carvings], forming them into meticulous patterns" (*Popular Art in the United States*, 1948, page 23).

Good care and meticulous work set the carvings of Aaron Mountz apart from those of Schimmel. The rapid spontaneity of the latter betokens the sure touch of the master. The crosshatching in the work of Mountz is so neatly done that it forms unintended patterns; where Schimmel left rough surfaces, Mountz pared smoothly. This labored finish is the primary distinction of all Mountz work. Its difference from his master's lively surfaces is admirably illustrated by a Mountz owl and a Schimmel poodle pictured in Frances Lichten's *Folk Art in Rural Pennsylvania*, 1946 (page 115). It should be emphasized that this carved and painted poodle, though credited to Mountz, is actually the work of Schimmel. Miss Lichten repeated the faulty attribution made in Christensen's *Index of American Design*, 1950 (p. 137).

Eagles by the two carvers show further differences. The wings of every Schimmel eagle are set back on the body and at an angle which gives the bird an effect of being poised for flight. Those of Mountz eagles are set in almost at right angles, so that they seem abstract and lacking in animation. More significantly, Mountz gave little or no angle to the lower line of the wing. He carried over the fine crosshatching of the back of the wing as a rolled edge along the top and side of the feathered front. Here Schimmel had more naturalistic edges.

Finally, whereas Schimmel in practically every case painted his carvings over a gesso filler, Mountz seldom if ever painted his work. The wood used was invariably pine, the simplest and most available wood for both these men.

According to former neighbors and relatives, Mountz had a wider range of subjects than Schimmel. Eagles and owls he carved frequently, and occasionally a parrot, or a poodle in the Schimmel style. Often Mountz's carvings are unintended caricatures. The most successful artistically are those that are the least imitative. One is the muscular Venus in the collection of Mrs. Arthur M. Greenwood, which Carl Drepperd called "Cro-Magnon" (*American Pioneer Arts and Artists*, 1942, page 131). Another, certainly, is the crane or heron, obviously inspired by the birds often seen in summertime by the creek near the Mountz home.

Carvings by Aaron Mountz are found mostly in private collections. Though his work has too often been confused with Schimmel's, his singular characteristics give him independent status as a primitive woodcarver.

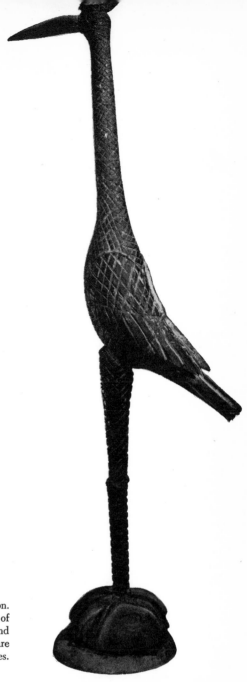

Mountz crane or heron. Carved from one piece of pine except for beak and inch-high base, which are glued on. Height 26 inches. *Author's collection.*

Mountz owl. Of pine, like all Mountz carvings, and unpainted. Height 12⅞ inches. *Index of American Design.*

Mountz parrot. Characteristic crosshatching. The body is painted green, the beak and claws yellow; probably not painted by the carver. Height 8 inches. *Collection of Dr. W. C. Taft; photograph by Ralph Schecter.*

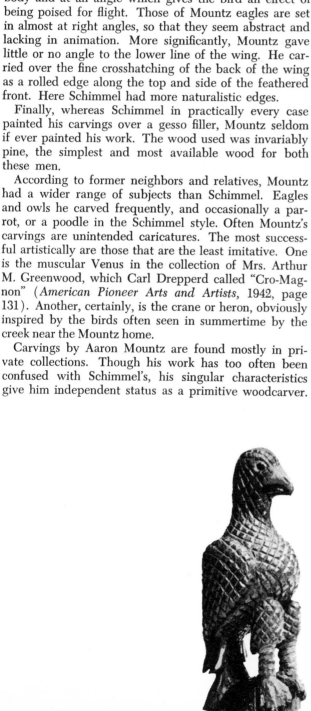

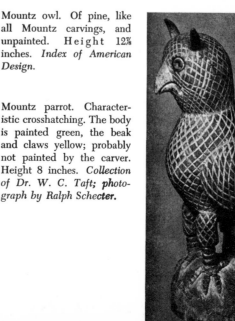

139

BY LESTER BURBANK BRIDAHAM

Museum director, Chicago Historical Society

Pierre Joseph Landry,
Louisiana woodcarver

IN THE YEAR 1834 had you visited a certain Louisiana plantation on the Mississippi above Plaquemine you would probably have found its owner, Captain Pierre Joseph Landry, veteran of the battle of New Orleans, seated at his workbench absorbed in woodcarving. During this year he was producing his most ambitious work, the *Wheel of Life,* an elaborate composition depicting the life of man in nine (instead of Shakespeare's seven) stages. This was his masterpiece, but it is not the only one of his remarkable wood sculptures. Six of them, including the *Wheel of Life,* were presented to the Louisiana State Museum through the efforts of the carver's descendants in New Orleans, headed by Valcour Landry; others are owned in the family, one is at Jackson's Hermitage in Nashville, at least one is in a private collection, and others may remain to be discovered.

Landry was not trained as a sculptor and he did not begin carving until late in life, when a knee injury led to tuberculosis of the bone which confined him to a wheel chair. He was born in 1770 in the French village of St. Servan, which is adjacent to St. Malo on the coast of Brittany and less than fifty miles from Mont St. Michel. He came to Louisiana in 1785, a boy of fifteen, and there he lived until his death in 1843. He became a plantation owner, and a successful one; at his death his estate was valued at over twenty-four thousand dollars. An inventory lists his real property in detail—land, slaves, livestock, cash; a library of 266 volumes including history, science, and literature; even the number of bars of soap and coils of rope—but makes no mention of his sculpture.

One of Landry's carvings is a self portrait in wood, a vigorous work which is easy to believe a close likeness. It is easy, too, to see the man as a strong personality, self-assured, humorous, shrewd; less evident in the face is the romantic, perhaps poetic strain that expressed itself in symbolism in most of his carvings. Sometimes the

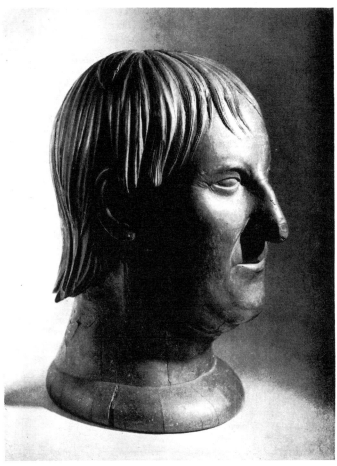

Self portrait. Incised on the base, TETE DE P. J. LANDRY AGE DE 63 ANS FAIT PAR LUI EN 1833. *Except as noted, illustrations from the Louisiana State Museum; photographs by Dan Leyrer.*

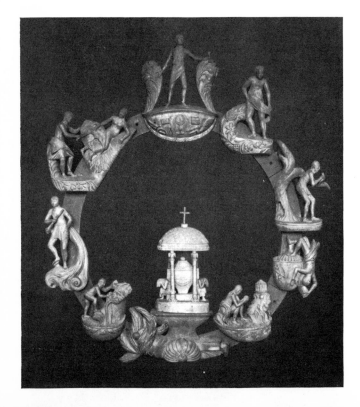

Wheel of Life. Dated 1834.
Clockwise from the bottom, nine stages in the life of man; center, the tomb.

August, 1957

Birth, and the tomb, from the *Wheel of Life*.
The tomb is signed *Sculpter. par. P. J. Landry*.

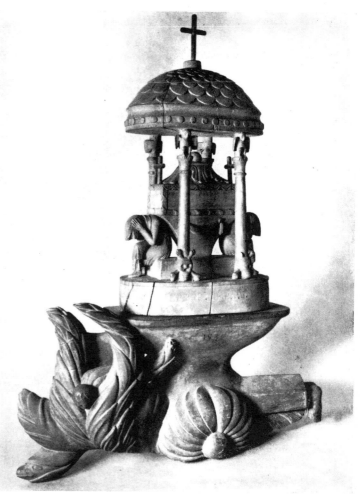

Boyhood, from the *Wheel of Life*.

Success, topmost figure of the *Wheel of Life*.

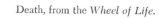

Death, from the *Wheel of Life*.

141

symbolism is quite obscure and has been variously interpreted; sometimes it is no more than stylization. Technically the carving is hardly romantic. It is bold and sure but reveals his lack of training. Landry's rendering of naturalistic details suggests that he retained a vivid recollection of the Gothic carvings he must have seen in Brittany in his childhood, while at the same time he was observant of the lush subtropical growth of Louisiana.

The *Wheel of Life* consists of nine figures or groups mounted on a flat wooden circle. The whole conception is symbolic; besides, each separate carving has details which may be symbolic as well as decorative. Clockwise from the bottom these elements represent: birth (a baby's head emerging from the leaves of a plant with, rather inexplicably, a reptilean head below); boyhood; youth; love; success (perhaps intended as Landry himself in his prime, and with such symbols as hourglass, globe, books, tools, plow, and sheaf of wheat); middle age; old age; death (the fall—quite reminiscent of Gothic carving—with the grim reaper in bas relief); entombment (with devil and mourning figure). On a pedestal within the circle is a canopied tomb with owls, death's heads, and mourning figures. This carving differs in scale and somewhat in character from the rest of the *Wheel* and may not have belonged with it originally.

In the carving *Louisiana*, a symbolic figure wearing a liberty cap and holding a horn of plenty is seated on a cotton bale, with a sugar hogshead nearby. Empty slots in the base indicate that parts of the composition are missing. The umbrella-shape magnolia tree with its neatly carved leaves occurs in other Landry sculptures. In the Andrew Jackson-Louis Philippe group the magnolia is in bloom. This piece is believed to celebrate the gold payment by France to the United States in settlement of the Napoleonic debt in 1836. Bas reliefs around the base show ships plying between the two countries.

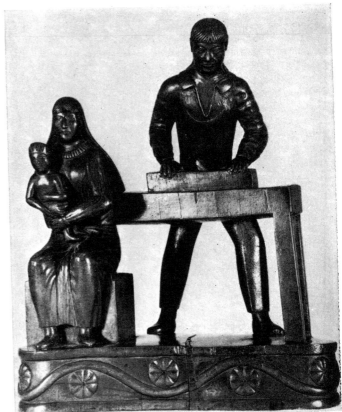

Holy Family. *Owned by Josie Landry Stirling,
descendant of the sculptor.*

Louisiana.

Andrew Jackson and Louis Philippe.
*Ladies' Hermitage Association,
Nashville, Tennessee.*

142

Figures and figureheads:

The maritime collection at the State Street Bank and Trust Company, Boston

BY WENDELL D. GARRETT

IT WAS NOT the intention of the founders of Massachusetts Bay to establish a predominantly maritime community, but stark necessity made mariners of would-be planters and it became a thriving colony of shipbuilders, seamen, merchants, and fishermen. As Samuel Eliot Morison has said: "For two hundred years the Bible was the spiritual, the sea the material sustenance of Massachusetts" (*The Maritime History of Massachusetts, 1783-1860,* 1921). This "material sustenance" from the China trade and other forms of maritime commerce produced the substantial fortunes that have nourished Boston's present-day banking and investment houses. It is thus singularly appropriate that one of Boston's leading financial institutions—the State Street Bank and Trust Company—has collected and exhibits today the most important collection of New England maritime arts outside of the Peabody Museum of Salem. The bank was founded in 1891 and the directors chose the name because of the prominent part State Street had played in the commercial history of the city:

In the first half of the nineteenth century, State Street was the link between the warehouses of the Long Wharf and the heart of the city, the chief entrance to Boston from the sea. In the second half of the century . . . "State Street" had come to denote the financial center of the city, the place from which investors controlled the lines that led into many distant parts of the United States. Banking and investment . . . had superseded maritime commerce as the principal occupation of Boston. (Walter Muir Whitehill, *Boston in the Age of John Fitzgerald Kennedy,* 1966.)

The early maritime history of Massachusetts was a miracle of human imagination and enterprise. Nature had dealt harshly with the Bay Colony: unlike many of the other colonies, she had no great river reaching into the hinterland and no large staple crop with which to trade. But with an abundance of good harbors and tidal rivers, she became an early nursery of seamen. The peninsula upon which Boston was located provided an ideal sheltered deep-water harbor. And with a wealth of excellent timber in her forests to furnish the shipbuilders with

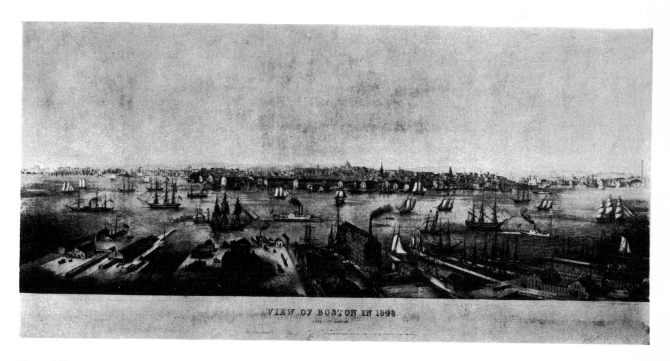

View of Boston in 1848, from East Boston, color lithograph after a drawing by Edwin Whitefield (1816-1892).
All illustrations from the State Street Bank and Trust Company; photographs by Richard Merrill.

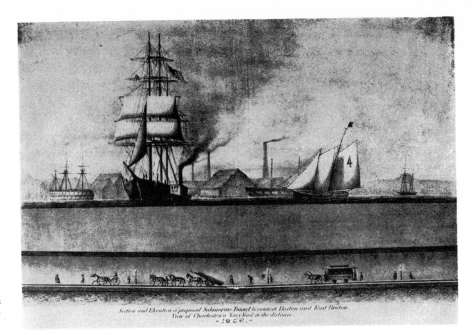

Section and Elevation of proposed Submarine Tunnel to connect Boston and East Boston. View of Charlestown Navy Yard in the distance. Unsigned, dated 1868. Lithograph, thought to be unique, showing clipper ship and pilot boat no. 4. The proposal was not realized until the 1930's with the completion of the Sumner Tunnel.

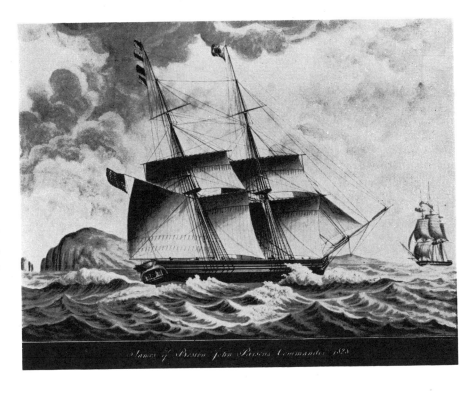

Brig Samos of Boston. John Parsons Commander 1828, water color, signed Edmund Camiletti. The Samos was built at Scituate, Massachusetts, in 1827 for Windsor Fay of Boston and John Parsons Jr. of Gloucester; Parsons was also her master when she was first registered, November 6, 1827. The ship was 243 tons and her measurements were 95 feet, 2 inches, length; 23 feet, 11 inches, breadth; and 11 feet, 11½ inches, depth. Her billethead was carved by William Copeland, master carpenter.

white oak for bottoms, lower sides, knees, and flooring, and pine for upper sides, superstructures, and masts, her shores became an early center of shipbuilding. Tench Coxe in his *View of the United States* described the prospects of the industry in glowing terms in 1794:

Shipbuilding is an art for which the United States are particularly qualified by their skill in the construction and by the materials with which this country abounds: and they are strongly tempted to pursue it by their commercial spirit, by the capital fisheries in their bays and on their coasts, and by the productions of a great and rapidly increasing agriculture.

At the beginning of the eighteenth century, Boston was one of the major maritime centers in the Atlantic world: "Its equivalent was the ancient port of Bristol, second only to London in the British Isles" (Bernard Bailyn, *Massachusetts Shipping, 1697-1714*, 1959). Bailyn has found that one of the most striking characteristics of Boston's colonial maritime community was "the breadth of participation in the ownership of mercantile capital," with approximately one out of three adult males in Boston during the first decade of the eighteenth century part-owner of a seagoing vessel. A ship would be divided into shares, usually sixteenths or a multiple thereof, and numerous families in the town, and even from adjoining towns, would hold shares, sometimes only one-hundred-twentieth part. This form of corporate ownership tended

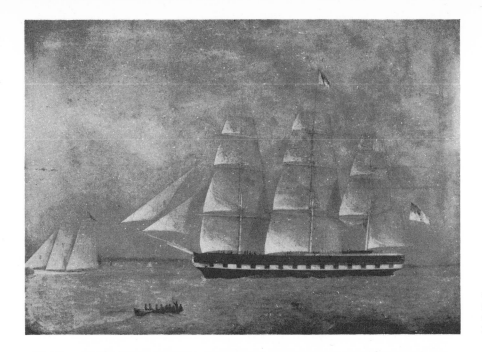

American packet ship off the Battery in New York Harbor with pilot boat no. 7; oil painting attributed to James Fulton Pringle (1788-1847).

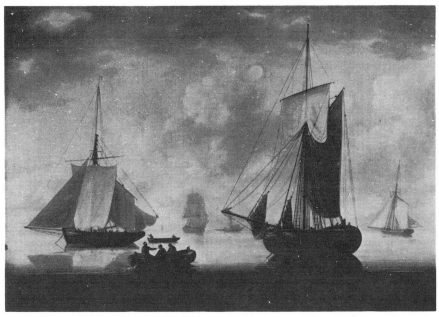

Shipping in a Calm—Fishing Boats at Anchor, oil painting attributed to Thomas Buttersworth of London, active 1813-1827 (see ANTIQUES, January 1964, p. 99).

to distribute widely the profits of a voyage; it also permitted a merchant to reduce the risks of investing all of his capital in a single ship. "A wise merchant neuer adventures all his goodes in one ship," Sir Thomas More once advised. When a Boston vessel sailed, she took with her men from the town and the wealth and hopes of the community.

The golden age of maritime activity in New England began with the opening of the Northwest fur trade with China as a result of the *Columbia's* first voyage (1787-1790), and ended with the Civil War and the decline of the supremacy of Donald McKay as the master builder of clipper ships in his East Boston shipyard when the economy demanded a different type of ship. In this era going to sea held challenge and opportunity for any adventuresome youth, "be it in a coaster from Maine to

the Indies, in a fisherman on the Banks from Gloucester, in a whale ship in the Arctic from Nantucket, in the China trade from Salem, slaving in Africa from Bristol, Rhode Island, aboard a packet to Liverpool . . . or rolling across the ocean to India with a load of ice from Boston or aboard a sealer from Connecticut in Antarctica" (Horace P. Beck, "A Maritime Heritage," *The American Neptune*, 25:55 [January 1965]). Shipping was a major source of wealth in early nineteenth-century New England and, as in the previous century, engaged all levels of society: captains and mates of vessels, master builders and shipwrights, skilled mechanics and wood carvers, carpenters and apprentices, sailmakers and ropemakers. The prosperity of both the seaports and the agricultural interior depended upon maritime commerce: "Commerce occupies all their ideas, turns all their heads, and absorbs all

their speculations," observed Brissot de Warville of the Bostonians in 1788.

Continuity is a marked characteristic of New England life; thus it is most suitable that the State Street Bank and Trust Company's officers and staff conduct their business daily surrounded by paintings and drawings, prints and maps, figureheads and stern boards, tavern signs and sailing posters, barometers and clocks, ship models and sea chests, fire buckets and ships' lanterns, harpoons and boarding pikes. This institutional collection of over a thousand examples of maritime arts and crafts is, to be sure, a rarity; it represents the collecting instincts and personal predilections of one man—the bank's versatile late president, Allan Forbes (1874-1955), whose combined qualities as businessman and antiquarian were as unusual as his company collection.

Allan Forbes grew up in Milton among the relics of the China trade. His paternal grandfather, Captain Robert Bennet Forbes, was an imaginative nineteenth-century shipmaster and merchant who built his house on Milton Hill in 1833 (ANTIQUES, October 1965, p. 434). His mother was the granddaughter of Nathaniel Bowditch, compiler of the *New American Practical Navigator;* his father, James Murray Forbes, had been in China with Russell & Company in the 1860's. Allan Forbes graduated

from Harvard College in 1897, became assistant treasurer of the State Street Trust Company early in 1899, vice-president and actuary in 1906, and president in 1911, a position he held until 1950, when he became chairman of the board.

Very early in his career, Allan Forbes began to develop his natural tastes for history and collecting in directions that gave him pleasure, and simultaneously, brought the bank to the attention of a vast number of potential customers . . . in 1906, [he] began the publication of a series of illustrated historical booklets that attracted the attention of a wide group of readers. From a 1906 booklet on State Street, the series had by 1955, with its thirty-ninth volume, reached an audience far beyond New England . . . The same might be said of the banking rooms, whose decoration was due to this same combined fondness for the past and canny eye to the present. (Whitehill, *Allan Forbes, 1874-1955,* 1955.)

Forbes' personal interests in collecting were catholic

Stern board of the ship *Orissa.* She ended her days on Cape Cod when driven ashore in January 1857 sheathed in ice; the stern board was finally recovered from the wreck in October 1894. Ship model of pilot boat no. 20 made by Captain Everard Jordan of Ellsworth, Maine, in 1888. The cherry table, with end drawers, is from a ship's cabin. The chairs are from the directors' room of the original State Street Trust Company.

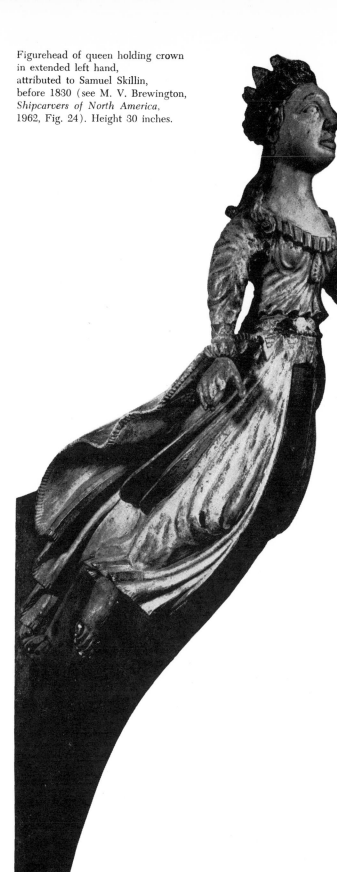

Figurehead of queen holding crown
in extended left hand,
attributed to Samuel Skillin,
before 1830 (see M. V. Brewington,
Shipcarvers of North America,
1962, Fig. 24). Height 30 inches.

(see ANTIQUES, July 1954, p. 40): he had a stable of good
polo ponies, rooms of old furniture, walls of whaling
prints (250 versions of Jonah and the whale were pre-
sented to the nautical museum at Massachusetts Insti-
tute of Technology in 1940), over 250 views of commu-
nities in Great Britain from which towns and cities in
New England take their names, and a comprehensive
collection of military currency (given to the Massachu-
setts Historical Society in 1952). Forbes was a "Boston
pack rat" in the best sense of the words, with "a sensitive
nose for game, combined with unobtrusive energy, dry
humor, and quiet friendliness, that led to remarkable ac-
complishments both in work and play." He collected for
his bank with the same zeal with which he collected for
himself; and, indeed, his own collections were donated in
the end to institutions of learning in the greater Boston
area.

The State Street Bank and Trust Company moved its
Trust Department in March of this year, and its head-
quarters in April, to a new thirty-three-story building,
located at 225 Franklin Street. The Trust Department's
collection, illustrated here in part, is displayed in an
office area of over seventeen thousand square feet. The
arrangement of the maritime objects in the main bank-
ing room in the old building, which is more familiar to
the public, has been left very much as it was; there, in
the words of Mr. Whitehill, "flagstone paving, granite
counters, oak and pine panelling, antique lanterns, ship
models hanging above the tellers' cages like votive offer-
ings in a Basque fishermen's church, innumerable prints
and ship portraits, tavern chairs, trestle tables and pewter
inkwells combined to create an atmosphere unique in
Boston business." William B. Osgood, a trust officer of
the bank and a distinguished collector in his own right,
had the responsibility for the installation of the Trust
Department's maritime collection in the new building
and serves as its curator.

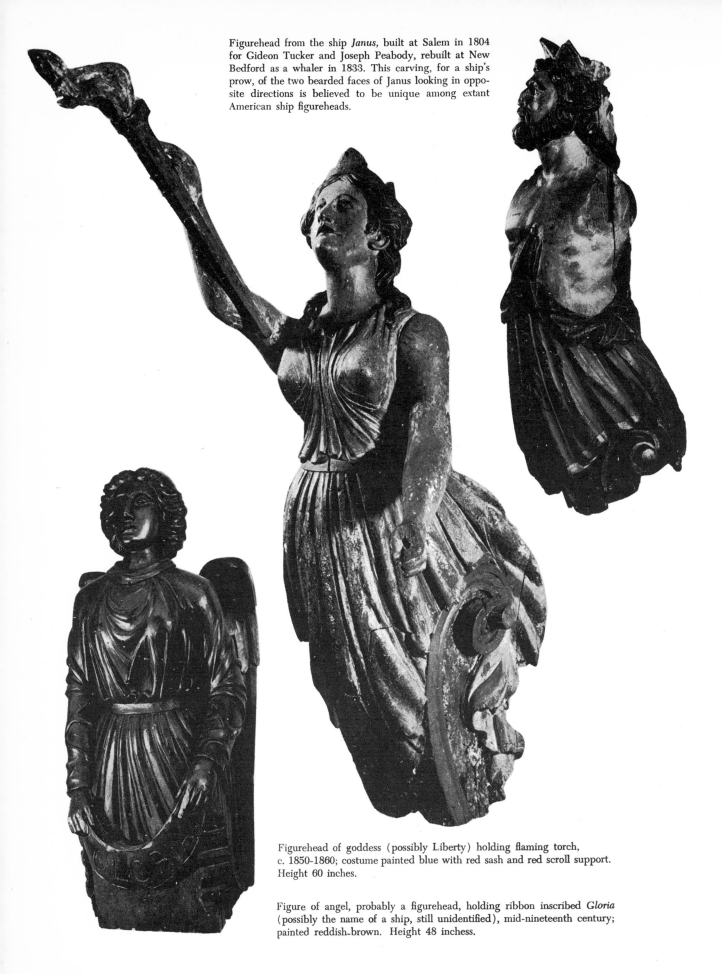

Figurehead from the ship *Janus*, built at Salem in 1804 for Gideon Tucker and Joseph Peabody, rebuilt at New Bedford as a whaler in 1833. This carving, for a ship's prow, of the two bearded faces of Janus looking in opposite directions is believed to be unique among extant American ship figureheads.

Figurehead of goddess (possibly Liberty) holding flaming torch, c. 1850-1860; costume painted blue with red sash and red scroll support. Height 60 inches.

Figure of angel, probably a figurehead, holding ribbon inscribed *Gloria* (possibly the name of a ship, still unidentified), mid-nineteenth century; painted reddish-brown. Height 48 inchess.

Stern board, gilded eagle carved in high relief
with spread wings, mounted on blue scroll. Width 60 inches.

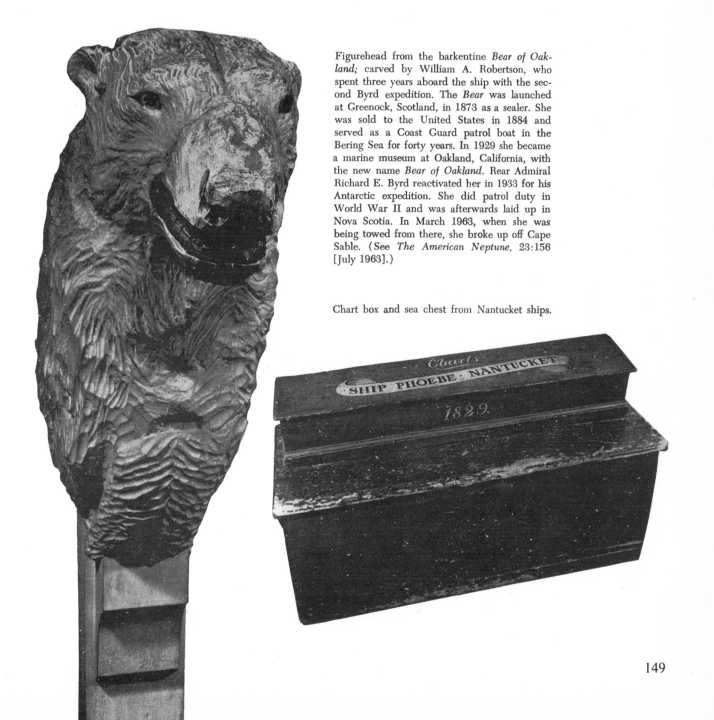

Figurehead from the barkentine *Bear of Oakland;* carved by William A. Robertson, who spent three years aboard the ship with the second Byrd expedition. The *Bear* was launched at Greenock, Scotland, in 1873 as a sealer. She was sold to the United States in 1884 and served as a Coast Guard patrol boat in the Bering Sea for forty years. In 1929 she became a marine museum at Oakland, California, with the new name *Bear of Oakland*. Rear Admiral Richard E. Byrd reactivated her in 1933 for his Antarctic expedition. She did patrol duty in World War II and was afterwards laid up in Nova Scotia. In March 1963, when she was being towed from there, she broke up off Cape Sable. (See *The American Neptune*, 23:156 [July 1963].)

Chart box and sea chest from Nantucket ships.

Ship model of *Glory of the Seas,* the last clipper ship built by Donald McKay in his East Boston shipyard, 1869. Last under sail in 1908; used as a floating fish cannery thereafter; burned May 1923 (*The American Neptune,* 19:106-107, Pl. xv, xvi [April 1959]). Hollow-hull model built by Elmer F. Tanner. Length 38 inches.

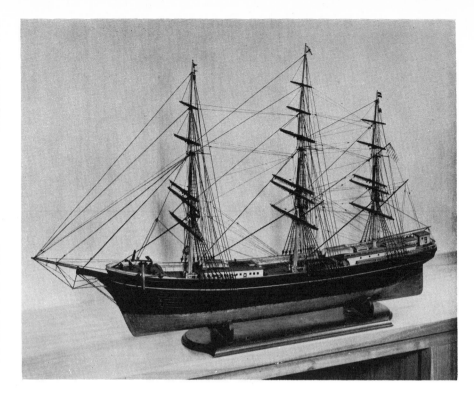

Exhibit of tools of Charles Gustavus Gooding (1834-1903), shipwright of Yarmouth, Maine; presented recently to the bank by his grandson. *Right:* molding planes, compasses, markers, drawshaves, and an adjustable molding plow; *left:* block, jack, and trying planes. Figurehead of naval officer is from a man-of-war, c. 1812-1815. Lithograph of New Bedford by Prang and Mayer, c. 1850-1860.

Cushing and White's copper weather vanes

BY MYRNA KAYE

Pl. I. Weather vane depicting the trotter Dexter, first manufactured by Cushing and White in 1868. Hollow copper with cast white-metal head; length 42 inches. Recently regilded. Widely circulated lithographs of Dexter, who was known as "King of the Turf," almost always depicted him in this head-down pose. Cushing's 1883 catalogue depicted Dexter on the title page. *Private collection; photograph by Richard Cheek.*

IN SEPTEMBER 1867 Leonard Wareham Cushing and Stillman White acquired a small copper weather-vane business in Waltham, Massachusetts, and set out to redecorate America's rooftops with gilded sculptures. During the next two decades, the firm and a handful of copper weather-vane manufacturers in New York and Boston dominated such a booming nationwide trade that their copper weather vanes quickly outnumbered the hand-wrought ones that had adorned rooftops for generations. By the 1880's a barn without a weather vane was an exception and a carriage house without one looked unfinished (see Fig. 1).

Fig. 1. Engraved letterhead on the stationery of L. W. Cushing and Sons, successors in 1872 to Cushing and White. The copperplate was cut in 1885. *Waltham Historical Society.*

Cushing's journals record the daily activities of the shop that produced much of America's nineteenth-century non-academic sculpture.[1] In the fourth, and last known, volume Cushing documents the genesis of some of the weather-vane models that Cushing and White (L. W. Cushing and Sons after 1872) continued to produce until 1933. He names the carvers of the wooden patterns, and records the steps used in transferring the designs from paper to wood, to cast-brass or cast-iron molds, and finally to beaten copper. The journal is a valuable addition to the 1883 catalogue of L. W. Cushing and Sons in documenting the many surviving vanes made by the company.

The copper weather-vane business that Cushing and White bought in 1867 had belonged to Alvin L. Jewell, who had been a pioneer in the industry. Jewell began in 1852 selling mostly cast-iron and brass products such as umbrella stands, dentists' spittoons, shelf brackets and the like, as well as lightning rods and weather vanes made of sheet copper hammered into shape in cast-iron molds. By 1865 Jewell's weather-vane trade was of prime importance, but on June 20, 1867, as he and a workman were erecting a sign, the staging collapsed and Jewell was killed. The business then was sold at auction.

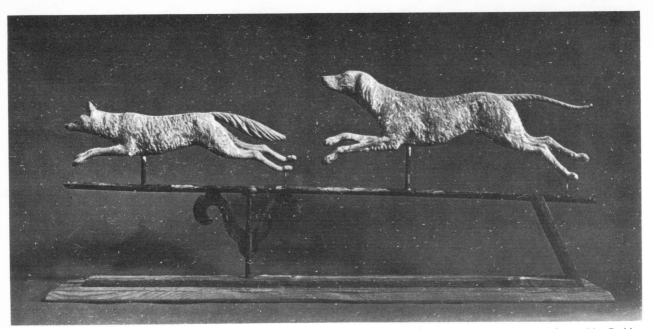

At the time Leonard Cushing, a civil engineer, was managing the machine shop of a watch factory in Providence, Rhode Island, and Stillman White was working for him as a machinist. Both were from Waltham, and in fact Cushing returned there weekly to see his wife and children. Although neither man knew anything about making weather vanes, acquiring Jewell's business appeared to them a good way to return to Waltham permanently. At the auction Cushing and White were outbid by Josephus Harris of Brattleboro, Vermont, who offered $7,975. Harris failed to meet the security, however, and Cushing and White bought the firm for $7,950.[2]

The new owners immediately began to add weather vanes to the existing line. Jewell had offered a vane depicting the champion trotter Dexter, two depicting the Morgan horse Ethan Allen, and two showing Ethan Allen drawing a sulky (see Fig. 2). Cushing and White added new models of the Ethan Allen and Dexter vanes (see Pl. I). To make the new models they needed concave molds of iron, brass, or bronze into which sheets of copper were hammered to shape. These molds, which assured virtually identical products each time, were cast from wooden sculptures of the weather vanes.

On December 12, 1867, Cushing went to Boston and "saw Mr. Leach a carver" and arranged to have Leach "carve some horses for us."[3] Henry (or Harry) Leach had had a varied career,[4] but in 1867 he was a pen dealer and fancy carver living at 2 Indiana Street, a neighborhood of many woodworkers and cabinetmakers.

On December 14, 1867, White bought pictures of the trotters Ethan Allen and Dexter. These were no doubt lithographs, as photographs at the time could not capture trotters in motion sufficiently clearly to make them useful to weather-vane makers.[5] The Ethan Allen lithograph was probably similar to that shown in Figure 3. Early the next month, according to his journal, Cushing made a drawing of Ethan Allen two-and-a-half-times larger than the lithograph to be used for the forty-five-inch vane, and he began another drawing twice the size of the print, to be used for the twenty-nine-inch version. The partners also worked up scale drawings from the lithographs for their twenty-eight-inch and forty-two-inch Dexter weather vanes.

Pl. II. Fox-and-hound weather vane, first manufactured by Cushing and White in 1869. Hollow copper; length 52 inches. *Collection of Philip DeNormandie; Cheek photograph.*

Pl. III. Deer weather vane, first manufactured by Cushing and White in 1869. Hollow copper; length 30 inches. The impressed mark on this piece is illustrated in Fig. 6. *Collection of Francis Andrews; Cheek photograph.*

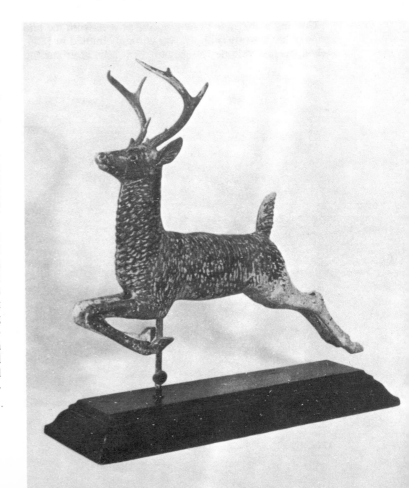

Fig. 2. Four-page price list of A. L. Jewell and Company, Waltham, Massachusetts, 1867. Many of the models that Jewell manufactured continued to be produced by Cushing and White and L. W. Cushing and Sons. *Waltham Historical Society; photograph by Mike O'Neil.*

The lithographs provided an outline and a detailed image of one side of the horses, but for a three-dimensional vane the other side had to be drawn as well. On January 13 Cushing went to Cambridge to see a Mr. Clark, ''found him at his shop and he drew me an Ethan Allen as well as he could.'' This is the only time Cushing mentions Clark or any artist aiding in the drawings. Since most lithographs of Ethan Allen and other horses represented the side of the horse with his legs extended, Clark presumably sketched the other side.

Cushing's ability to draw a horse, as seen from the title page of his journals (Fig. 4), was certainly limited in 1858, when the first volume was begun. However, after starting work on weather-vane designs, he carefully observed and sketched horses so that his drawing improved. The day after he saw Clark, Cushing drew and painted a final version of the side of the twenty-nine-inch Ethan Allen ''that Mr. Clark sketched for me yesterday.''

The next day Cushing started on the pattern, or wooden statue the size and shape of the finished copper vane. He cut out each half of the body separately with a jig saw, then glued the halves together. On January 22, Cushing took the pattern and pictures for the twenty-nine-inch Ethan Allen to Leach to carve, and on January 30 he picked up ''the carving of Ethan Allen a splendid thing.'' Cushing then cut the model up, as head, body, tail, and each leg

Fig. 3. *Ethan Allen*, lithograph by C. H. Crosby, 1868. *Smithsonian Institution.*

153

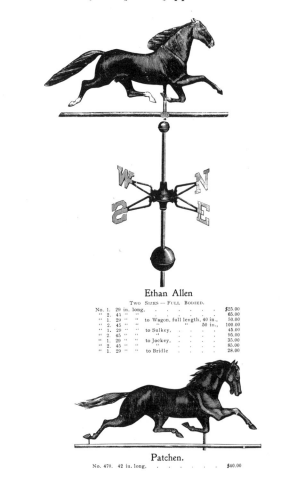

had to be cast separately and each part required a left and a right mold. On March 3 Cushing picked up the castings for the twenty-nine-inch Ethan Allen at Hooper's Brass Foundry in Boston.[6] By the end of March Cushing and White had the molds for their small and large Ethan Allen (see Fig. 5) and their small and large Dexter weather vanes.

The drawing for the large Goddess of Liberty vane (see Fig. 9, Pl. IV) was begun at the end of February 1868, but the wooden pattern was not worked on until April. On May 9, a painted wooden pattern was placed ''in the Window of H. C. Sawyer[7] where in the evening it attracted a thousand people.'' In September 1868 White himself carved the head and face of the small, thirty-inch, Goddess weather vane. At the end of March 1869 Cushing's journal records that he went ''to see Mr. Leach and had the large Goddess carved in'' (Fig. 10).

Henry Leach carved many animal patterns for Cushing and White, and no other animal carver is mentioned in Cushing's journals. During 1869 and 1870 Leach carved eagles, roosters, a fox and hound (Pl. II), a squirrel, a forty-two-inch cow, and a deer (Pl. III, Fig. 6). He probably also carved the pattern for the English setter vane (Figs. 7, 8), because the carving on the setter's coat resembles the carving on manes and tails of horses Leach carved. The carving of the setter's eyes is also similar to that of the eyes of the Dexter and Ethan Allen patterns that Leach is known to have carved. Leach presumably made the carving of the setter after March 1871, since it is not mentioned in Cushing's journals (which end in that month), but before 1872, when he is no longer listed in the Boston directory.

154

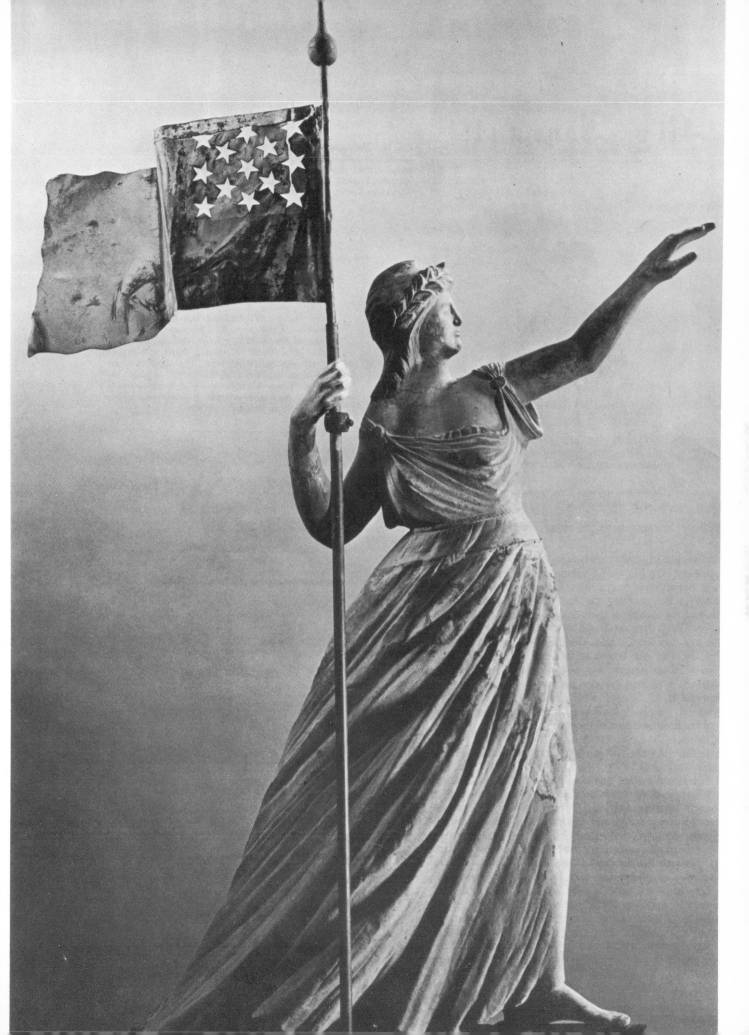

Leach did not, however, carve the pattern for the Angel Gabriel vane (Pl. V). In June 1869 when Cushing needed both the Angel Gabriel pattern and a seven-and-a-half-foot statue of Justice for a courthouse in Delaware, Ohio, he went to E. Warren Hastings on Commercial Street, Boston. Hastings had been doing ornamental carving for ships since at least 1865 and was well known for his figure carving.

In the next-to-last entry in the journals, Cushing noted that he went "to see about setting the Steam Fire Engine," a vane ordered by a firehouse in Somerville, Massachusetts, on February 13, 1871. The vane, which was probably similar to the one shown in Figure 11, was apparently the first fire-engine vane Cushing and White made. It was drawn, cast, formed, assembled, and painted between February 23 and March 21, 1871. To make the engine shown in Figure 11 was a complicated job, for it is an accurate copy of a real Amoskeag steamer. Some of the more intricate parts of vanes such as these were cast in zinc or lead rather than made of hammered copper. Most human figures and many animal heads were also castings.

Cushing notes that he painted the steam fire engine, but almost all the firm's vanes were gilded with twenty-three-carat gold leaf. Until May 1868, Cushing and White employed a gilder; thereafter Cushing did much of that work himself. The partners also employed Cushing's brother-in-law, Freeman Hodgdon, and several men who had worked for Jewell, including a Mr. Tweed, a Mr. Jackson, and Arch McKeller.

In 1872 White sold his share of the business to Cushing, who soon took in his sons Charles and Harry and formed L. W. Cushing and Sons. The weather vanes which L.

Facing page.

Pl. IV. Goddess of Liberty weather vane, first manufactured by Cushing and White in 1869. Hollow copper with cast lead torso; height to top of head, 42¼ inches. *Collection of Mrs. Jacob M. Kaplan; photograph by Otto E. Nelson.*

Pl. V. Angel Gabriel weather vane, first manufactured by Cushing and White in 1869. Hollow copper; length 32 inches. *Smithsonian Institution, Eleanor and Mabel Van Alstyne collection.*

W. Cushing and Sons produced until 1933 included some from the A. L. Jewell days, and a few models added in much later years, but most were designed during the five-year partnership of Cushing and White, and were carved by Henry Leach.

Fig. 6. Cushing and White's impressed mark on the weather vane shown in Pl. III. *Cheek photograph.*

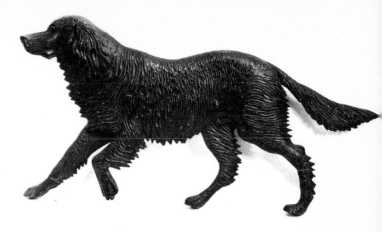

Fig. 8. Wooden pattern for Cushing and White's English setter weather vane (see Fig. 7), probably carved by Leach in 1871. Length 35⅝ inches. *Collection of Herbert W. Hemphill Jr.; photograph by Helga Photo Studio.*

Fig. 9. L. W. Cushing and Sons catalogue number 9, p. 19. According to a brochure of c. 1868, Cushing and White sold the same three sizes of Goddess of Liberty vanes at the same prices. The model for the squirrel weather vane was carved by Leach. *Author's collection.*

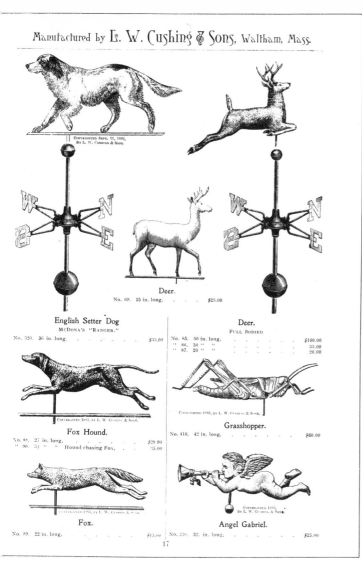

Fig. 7. L. W. Cushing and Sons catalogue number 9, p. 17. The leaping deer, the fox, and the hound were carved by Henry Leach in 1869 and 1870; the setter was probably carved by him in 1871. The Angel Gabriel was carved by E. Warren Hastings in 1869. The copyright dates do not date the origins of the models, but rather when the illustrations were first published. *Author's collection.*

[1] The four extant volumes of the journals extend from December 13, 1858, to March 26, 1871. They are in the Waltham Historical Society. See also Myrna Kaye, *Yankee Weathervanes* (New York, 1975).

[2] Harris and his son Ansel J. Harris went on to make and sell weather vanes and ornamental ironwork in Boston as J. Harris and Son.

[3] This and the other quotations in this article are taken from the Cushing journals cited in n. 1.

[4] Henry Leach sold maps at 21 Cornhill, Boston, in 1847 and 1848. By 1850 he was selling books at 1 Mercantile Wharf, and from 1855 to 1860 he sold clothing at the same address. He became a pen dealer in 1861, and in 1867 he also called himself an ornamental carver. After 1868 he was solely a carver. In 1872 Sarah A. Leach was still listed at 2 Indiana Street, but Henry was not, indicating that he may have died by this time.

[5] In November 1867 Cushing did acquire photographs of cattle and horses standing still.

[6] Many of Cushing and White's molds were brass, although most weather-vane molds were cast iron.

[7] Henry C. Sawyer had a shop on Main Street in Waltham, where he sold books, fans, paint, and the like.

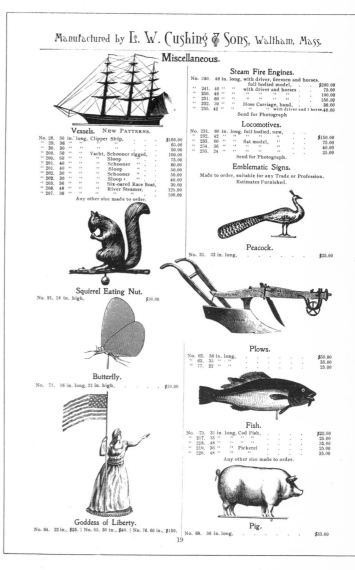

157

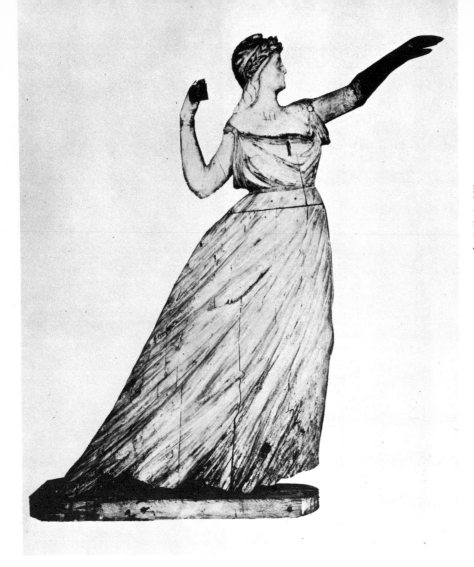

Fig. 10. Wooden pattern for Cushing and White's sixty-inch Goddess of Liberty weather vane carved by Leach in 1869. The feet are missing. The figure was once thought to be a ship's figurehead and was called "Columbia." *Shelburne Museum.*

Fig. 11. Steam-fire-engine weather vane marked CUSHING & WHITE WALTHAM MASS on the smokestack. Copper and brass; length 49½ inches. *Greenfield Village and Henry Ford Museum.*

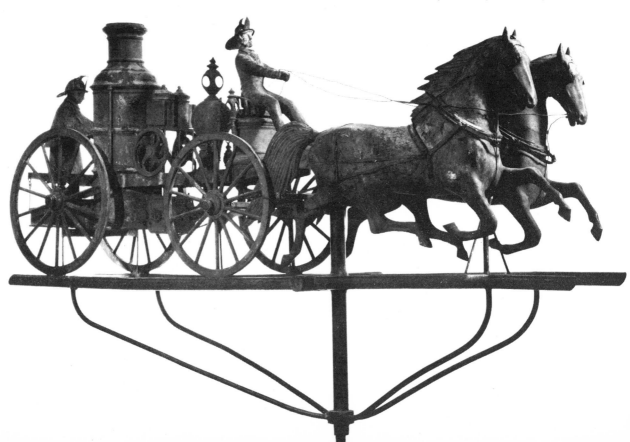

Winged Skull and Weeping Willow

By Virginia Warren Allen

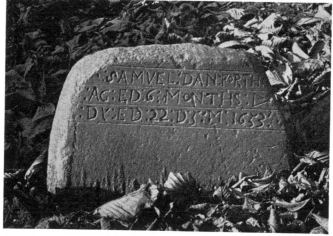

Introductory Note. Most persons who in the past have visited the burying grounds of colonial America have been so occupied with hunting for unusual and sometimes almost comic epitaphs that they have seldom paused to observe the artistic merits of the tablets upon which these mortuary messages have been inscribed. Of late years, however, the significance of early gravestones in the history of American craftsmanship has been recognized. *Old-Time New England* for October 1924 presents a brief article on the subject. In the same year Walter Rowlands of the Boston Public Library and Howland Shaw Chandler, Boston architect, published an invaluable portfolio, whose fifty heliotype plates picture as many *Curious Old Gravestones in and about Boston*. From this source, by special permission, ANTIQUES has reproduced several of the illustrations accompanying the following notes. The entire portfolio is, however, worth acquiring. In 1927 Houghton Mifflin Company issued *Gravestones of Early New England and the Men Who Made Them*, by Mrs. H. M. Forbes, which also merits attention.

Opinion is not entirely unanimous as to the source of the stones used in colonial cemeteries. The native material obtainable was not particularly enduring. Hence arose the custom of importing slate slabs from Wales, though question arises as to how long the practice continued. It is believed that native talent was responsible for the carving of both inscriptions and associated decorations. Some of the latter exhibit such skill and assurance of hand on the stonecutter's part as to make us wonder why, if such able artisans were available, we find so few evidences of their handiwork outside the confines of the cemeteries. Others are so genially crude as to be indubitably homemade. In order that the reader may not be led to assume that old and curious gravestones are peculiar to the New England territory, it has been deemed advisable to include an example or two from New York.
— *The Editor.*

SHADOWED by the roaring elevated in Roxbury, Massachusetts, surrounded by warehouses in Charlestown, and jarred by Upham's Corner traffic in Dorchester, the ancient sanctuaries of God's acre, verdant and inviolate, still safeguard the repose of men who helped to make history in the New England colonies. Within the iron enclosures of these now urban cemeteries the village peace of old-time New England lingers, and the ancient gravestones lean and droop as if in slumbrous revery.

The King's Chapel, Copp's Hill, and Granary burying grounds are rich in such curious old stones, some ornamental, some primitively amusing, which, in commemorating the pioneers of Boston, likewise testify to the artistic skill of our early stone carvers. But for real adventuring, one should follow the oft-repeated skull and willow patterns into the country, where, beneath the green foliage of maples and pines whose whispering echoes the boom of distant surf, the

slates stand out, cool and dark, against the white walls of a colonial church.

Burial Hill, at Marblehead, high above the blue harbor where shining sails circle in Lilliputian races, is a fine place for studying old slate markers. At Plymouth stands another hill dotted with headstones of long ago; but here we may not seek the names of the *Mayflower's* passengers, for the unmarked graves of those who perished in Plymouth's first winter were sown with waving wheat lest hostile Indians should learn how few remained to defend the settlement. The Winslow burying ground at Marshfield harbors the headstones of Peregrine White and Daniel Webster. Miles Standish is buried near the graves of Priscilla and John Alden in a woodsy little yard in Duxbury. Almost anywhere along the coast, from the Cape to Rockport, names familiar in New England history are cut beneath winged skulls and weeping willows on the slate markers of old churchyards.

The first impression these burying grounds convey is of the soothing similarity of shape and color in these markers. On closer observation, however, one discovers here and there a fan-shaped slab of very early date; an unusually wide slate that marks the grave of several children of a family; a brick table tomb; a shapeless field stone roughly carved.

The earliest graves were unmarked; heavy wooden rails and flat "wolf stones" to thwart animal or Indian raiders were their sole monuments; greenstone boulders and fan-capped slices of light-blue slate were the first decorative markers. By 1653 scroll-topped headstones appeared, and continued in favor for a hundred years. These handsome slabs of slate are usually thirty inches high, twenty wide, and two to five inches in thickness. After 1750 larger slates with pointed tops, Gothic arches, and cornice curves began to replace the scroll-topped forms.

Those early stonecutters knew how to letter. Try to copy one of the bold, clean-cut capitals carved on a seventeenth-century slate. Honest angles, fine curves, and sweeping serifs are not easy to draw with pencil on paper, much less to carve with chisel on slate. Although proper spacing of inscriptions is rare on old gravestones, and the spelling offers many a delightful surprise, the letters have a vigor of form that is rare in present-day alphabets. Square Roman capitals, used throughout, prove a slate earlier than a neighbor lettered in lower-case Roman or italics. In the Copp's Hill burying ground Joanna Ingles' stone, dated *1678*, is one of the oldest inscribed in lower case. One of the earliest examples of script is dated *1782*.

Fig. 1 — SIMPLE EARLY MARKER IN NATIVE STONE (*1653*)
One of the most ancient known in New England.
Roxbury, Massachusetts

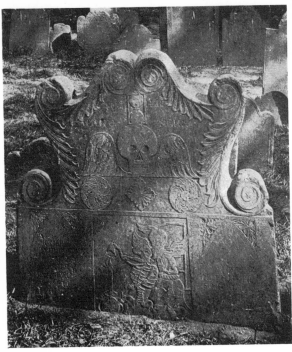

Fig. 2 — Elaborately Carved Stone (*1678*)
The lower panel depicts the march of Time, who is either assisting or vainly trying to prevent Death's suppression of life's shining candle. Above appear the customary winged skull and the mottoes *Fugit hora* and *Memento mori*.
King's Chapel, Boston

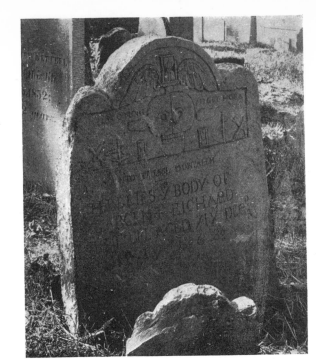

Fig. 3 — Crude but Effective (*1680*)
Besides the skull and hourglass symbols and the mottoes observable in the preceding example, the stonecutter has added good measure in the form of coffins, crossbones, more hourglasses, pick and shovel, and Time's scythe.
Charlestown, Massachusetts

Before Watts' hymns furnished appropriate couplets, epitaphs were rare on headstones, with the exception of one little verse that often appeared below the name, parentage, dates of birth and death that told the simple facts on each stone: *As I am now, so you must be,/Prepare for death, and follow me.* Later inscriptions often combined tributes to the dead with admonitions to the living. Yet humor, intentional or otherwise, brightens some of the inscriptions in the grimmest New England graveyards.

A winged skull was the popular motive for the top decoration of old grave markers. The skull, of course, symbolized death, while the wings suggested the heavenward flight of the spirit. Many are the variations of this winged-skull motive, ranging from bland, jack-o'-lantern countenances to glowering death's-heads, from the crude suggestion of a savage face on Benoni Coollidge's stone at Watertown (*Fig. 8*) to the realistic winged head of a gentleman on John Holyoke's marker in the Newton graveyard. One stonecutter in Duxbury carved wild-eyed heads with no mouths but with waving hair radiating from them. The Pilgrims, less somber than their Puritan neighbors of Boston, usually brightened the grim skull symbol with heart-shaped mouths and fantastic noses

elaborated with curlicues and flourishes. Father Time appears on some of these early slates. Joseph Tapping's stone in the King's Chapel yard, Boston, shows death as a skeleton extinguishing life's candle (*Fig. 2*). Other designs substituted for the usual winged skull were military insignia, coats of arms, and full-rigged ships, to indicate rank and station in life.

The warning words *Memento Mori* (be mindful of death) and *Fugit Hora* (the hour is fleeting) were often carved in a narrow border with coffins and bones, crossed pick and shovel, directly below the winged skull. Now and then an empty hourglass was added to the upper decoration, illustrating the couplet, *As runs the glass, Our life doth pass,* that children learned from their primers.

The designs in the borders of old gravestones are gayer. Perhaps the graceful garlands that Grinling Gibbons was carving in England for Sir Christopher Wren's fine buildings crossed the Atlantic in some stonecutter's sketchbook, and inspired the fruit and foliage forms in these borders. Here, in Christian symbolism, pomegranate and fig foretell resurrection; the grapevine whispers the nearness of Christ; wheat and barley picture the Promised Land; and the dove typifies constancy and devotion. At the top of these borders,

Fig. 4 — A New York Example (*1681*)
On one side, skull and crossbones surmounted by winged hourglass in strong relief. On the reverse the inscription.
Trinity Church, New York
Photographs for this and Figures 6 and 9 by Wurts Bros.

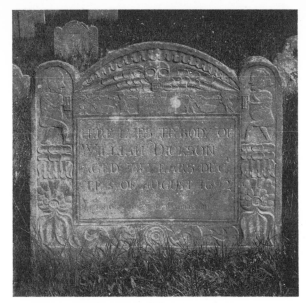

Fig. 5 — An Individual Expression (1692)
Carving ascribed to Joseph Lamson of Charlestown, who had ideas of his own regarding appropriate symbols.
Cambridge

Fig. 6 — A Handsome Armorial Stone (1745)
So far superior to local work in general as to suggest that both crest and inscription were carved abroad.
Trinity Church, New York

the calloused hands of pioneer stonecutters frequently carved floral rosettes, delicate as snowflakes. Joseph Lamson of Charlestown, one of the most talented stoneworkers of the early 1700's, added a new quirk to this rosette design. He carved small human faces instead, and on William Dickson's marker in Cambridge, dated *1692*, he topped the vertical borders with crudely carved figures of men equipped with arrows and hourglasses (*Fig. 5*). This same Lamson delighted to carve below the winged-skull design little winged men, carrying a pall or lowering a

coffin into the grave. Although these little creatures lack anatomical perfection, they are carved with unusual vitality.

Such surprises and variations occur oftener in border decoration than in the central design of early stones. It was not until the days of the Revolution that the winged skull had flowered into a cherubic winged countenance, and the urn and weeping-willow patterns introduced the stiff precision that ended a fine period in the art of stone carving in New England (*Figs. 10 and 11*). The weeping willow's vogue as funereal decoration reached

Fig. 7 — A Dramatic Design (1747)
Death and the fleeting hour. A competent bit of carving. Large and small Roman letters and italics in the inscription.
Copp's Hill, Boston

Fig. 8 — The Lowest Terms of Carving (1754)
The familiar death's-head reduced to a symbol of a symbol. An amateur or apprentice job.
Watertown, Massachusetts

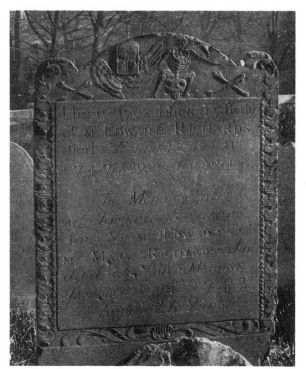

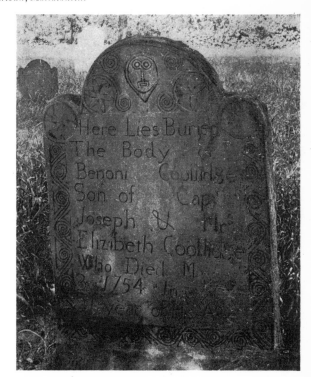

FVGIT

HORA

161

its height in the early nineteenth century. In 1793 ornate engravings of Marie Antoinette's last will and testament flooded picture-dealers' windows with drooping willows and funeral urns. The willow tree shading Napoleon's grave at St. Helena, so famous that Captain Joseph Leonard thought it worth while to carry from it a slip to plant at the tomb of Cotton Mather in the Copp's Hill burying ground, served further to popularize the weeping-willow motive. Thus on the gray slates surmounting nineteenth-century graves it replaced the winged skull.

A few simple designs used over and over again, skilful composition, direct and untrammeled carving, and inimitable lettering give to the handiwork of the colonial stonecutters a distinction that is a challenge to the costlier monuments of a machine age. Whosoever has postponed a visit to this exhibition of early American stone carving in the belief that it will

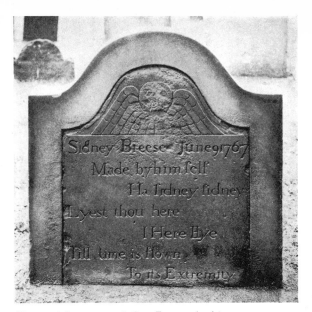

Fig. 9 — A Stonecutter's Own Epitaph (*1767*)
The inscription is worth repeating here: *Sidney Breese June 9 1767 / Made by himself / Ha sidney sidney / Lyest thou here / I Here Lye / Till time is flown / To its Extremity*. It will be observed that Sidney made and corrected an error in cutting the initial letter of the word *Lye* in the third line of his stanza. The resulting character, something between an *H* and an *L*, may not be inappropriate. This remarkable monument and its equally remarkable epitaph have hitherto escaped public notice, though the stone has been strengthened by its present frame within comparatively recent years. (The skeleton illustrated on this (*in reverse*) and the opposite page is reproduced from a gravestone of 1697 in the Granary Burying Ground, Boston.)
Trinity Church, New York

always be accessible should wait no longer. Some of these memorials to our forefathers are already shattered by frost, while others stand aslant, the lower lines of their inscriptions covered by the rising turf. So my advice would be: follow the winged skull and the weeping willow through the old burying grounds of New England and see with your own eyes the carvings of those early craftsmen who recorded their skill with mallet and chisel on smooth and enduring slate.

Although many of the unusual or amusing gravestone inscriptions have been frequently quoted, it seems fitting to conclude these notes with a sample epitaph. I have selected a hopeful sentiment composed for Hannah Langford, who died in 1796 at the age of fifteen.

"Nor youth nor inocence could save
Hannah from the insatiable grave
But cease our tears no longer weep
The little child doth only sleep
Anon she'll wake and rise again
And in her Savours Arms remain."

Fig. 11 — The Cherub Supersedes the Skull (*1792*)
Suggesting a more cheerful prospect than the gruesome death's-head.
Granary Burying Ground

Fig. 10 — Urn and Weeping Willow (*1784*)
An early example of a subsequently popular motive for memorial stones.
Granary Burying Ground, Boston

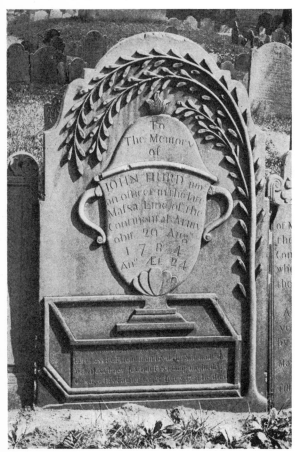

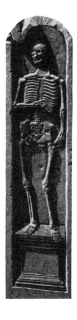

ME-

MENTO

MORI

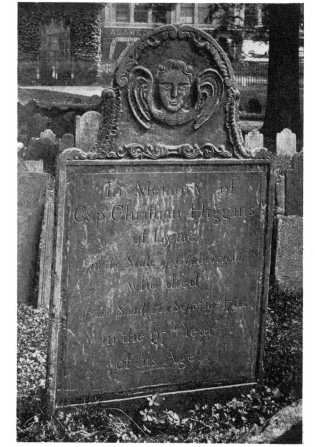

Massachusetts gravestones

A PHOTOGRAPHIC ESSAY BY DANIEL FARBER

IN THE EARLY graveyards of eastern Massachusetts the grim emblems of mortality—the fire-and-brimstone skulls, the winged cherubim, the scythe-bearing skeletons, the flat, idealized portraits—reflected a widespread preoccupation with the drama of death. Some students of New England stone carving have pointed out the complex imagery and allegory in these memorials; others have stressed the significance of these gravestones as Puritan art practiced within a craft tradition; still others have studied the epitaphs for their theological observations, humorous comment, or moral exhortation. Of course, this somewhat morbid interest in the grave was by no means limited to the Puritans of Massachusetts, nor did it soon decline. But to us, these expressive and noble photographs by Daniel Farber speak for themselves.

—THE EDITORS

Mr. Amos Bond, 1762, Watertown

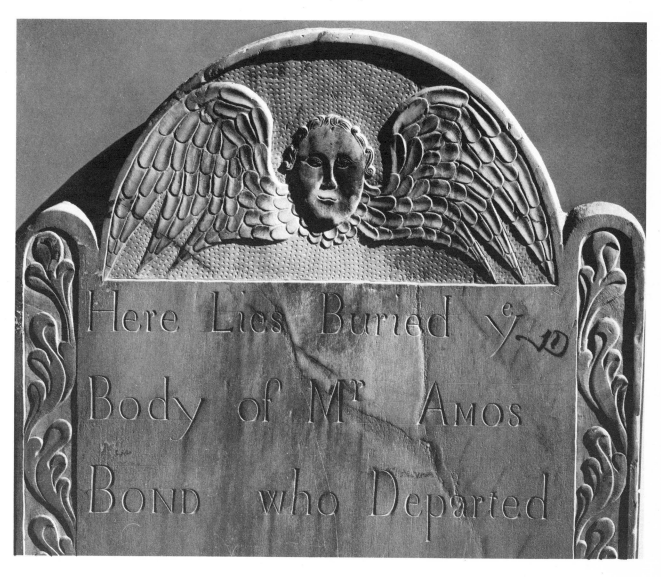

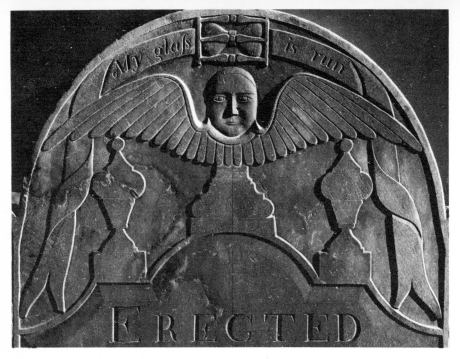

Mrs. Abigail Clap, 1790, Sudbury

Ensign Timothy Cutler, 1694, Charlestown

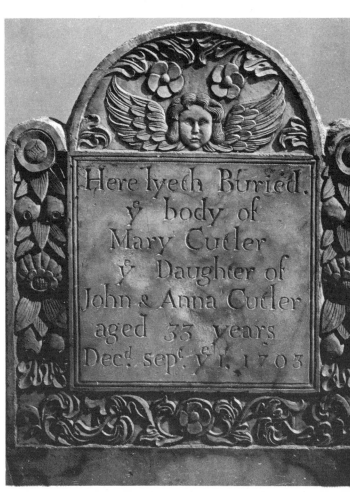

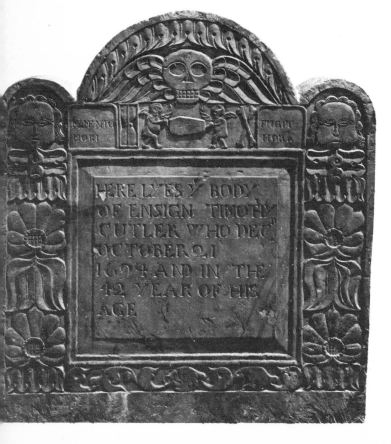

Mary Cutler, 1703, Charlestown

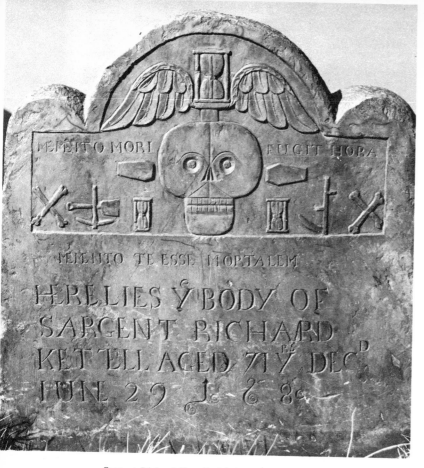

Sargent Richard Kettell, 1680, Charlestown

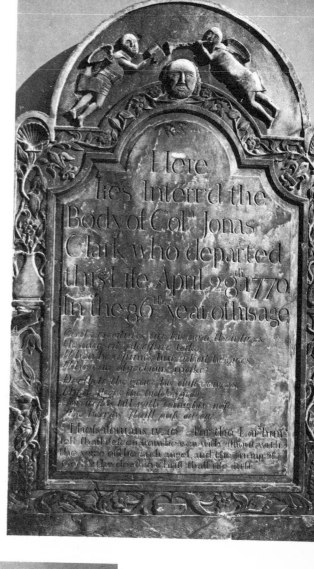

Coln. Jonas Clark, 1770, Chelmsford

Jonathan Davis, 1762, Dorchester

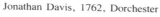

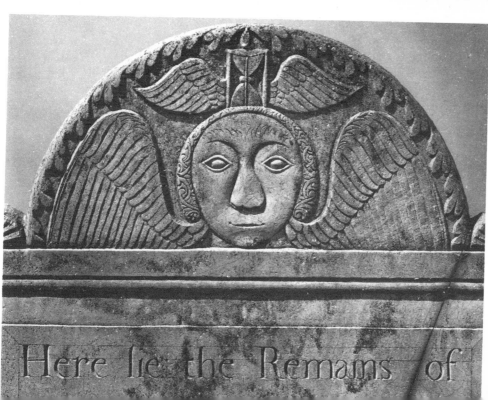

Here lie the Remains of

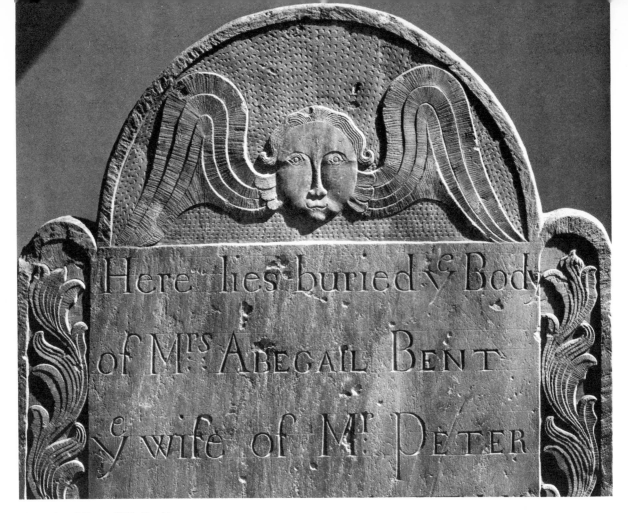

Mrs. Abegail Bent, 1768, Southboro

Mr. James Bell, 1793, Oakham

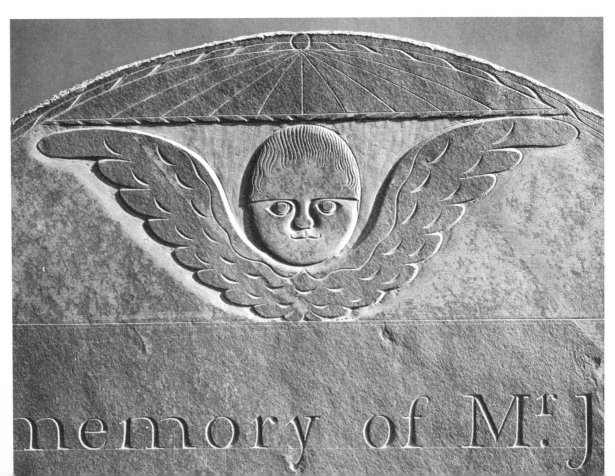

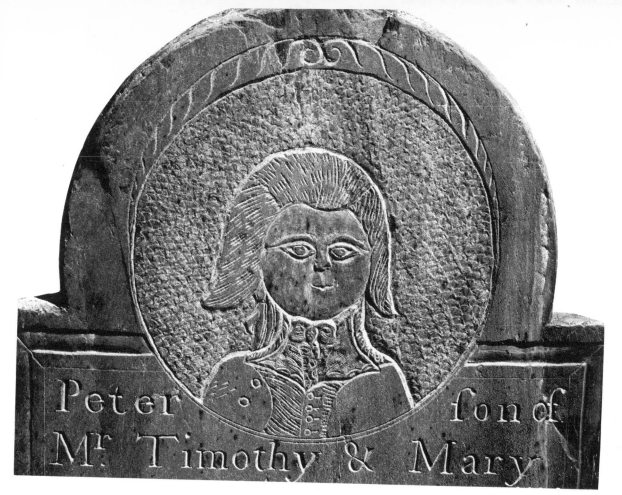

Peter Bancroft, 1786, Auburn

Mrs. Hannah Abbot, 1767, Billerica

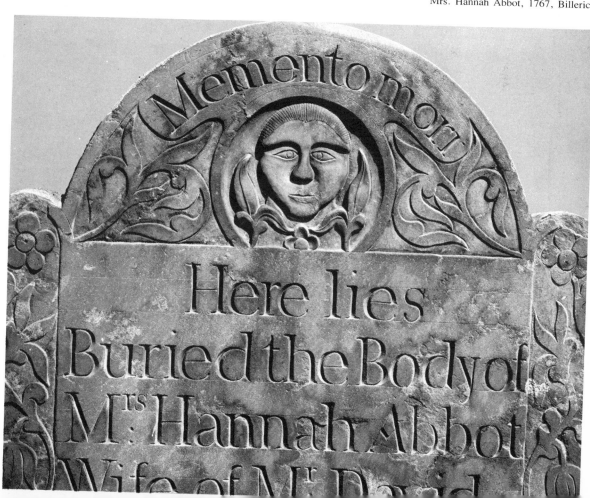

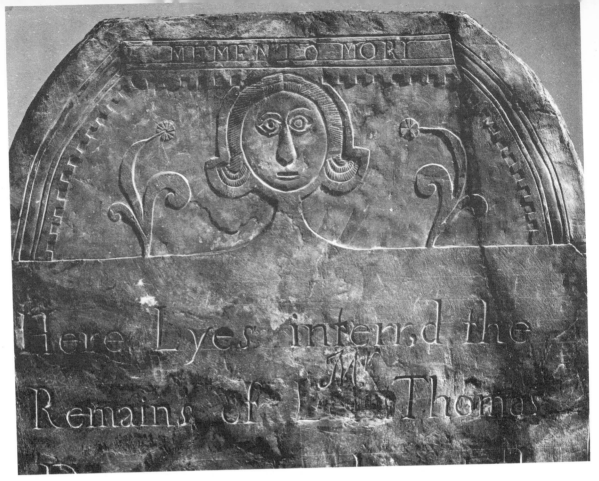

Mr. Thomas Drury, 1778, Auburn

James Foster, 1763, Dorchester

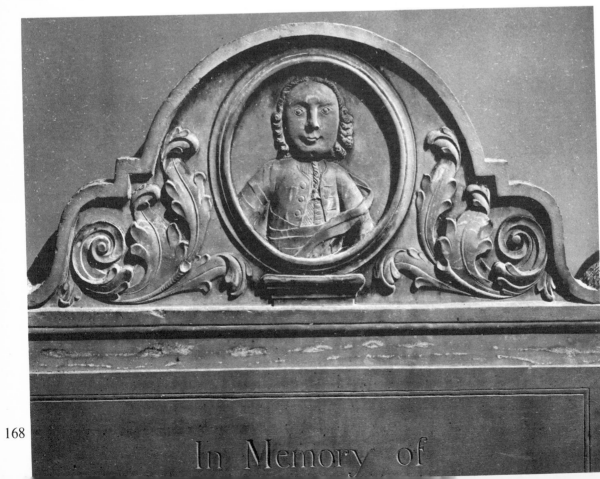

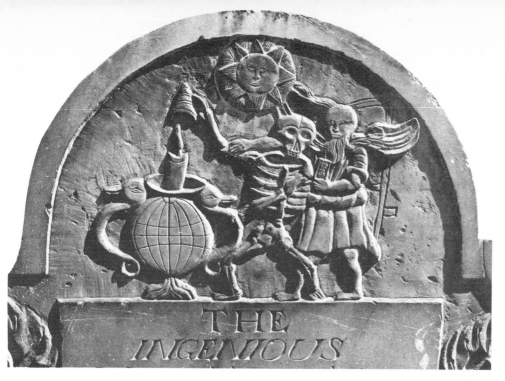

THE
INGENIOUS

John Foster, 1681, Dorchester

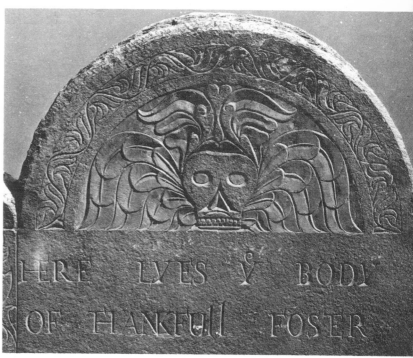

HERE LYES Y BODY
OF THANKFULL FOSER

Thankfull Foster, 1700, Dorchester

Polly Harris, 1787, Charlestown

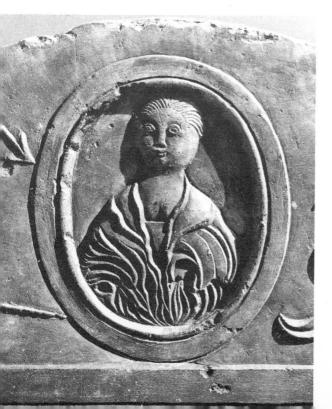

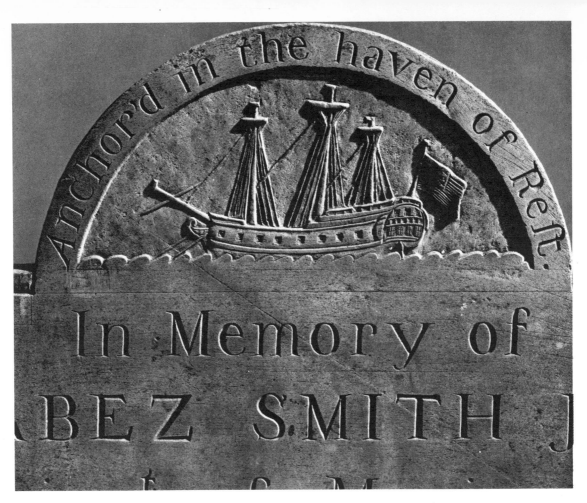

Jabez Smith, 1780, Granary Burying Ground. Boston

William Dickson, 1692, Cambridge

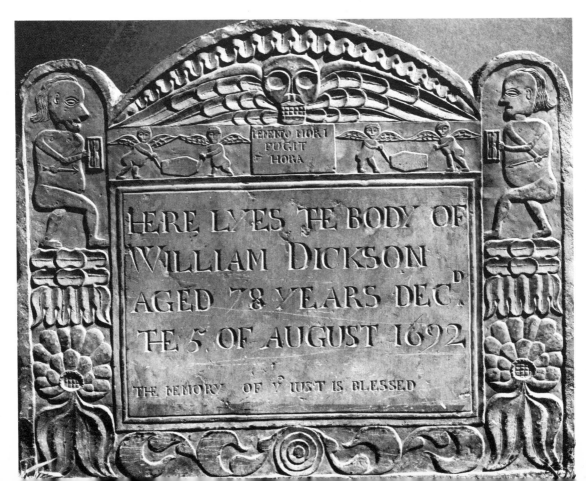

Bibliography

American Naive Painting of the 18th and 19th Centuries. 111 Masterpieces from the Collection of Edgar William and Bernice Chrysler Garbisch. New York: American Federation of Arts, 1969.

American Primitive Paintings from the Collection of Edgar William and Bernice Chrysler Garbisch. Washington: National Gallery of Art, 1954.

Ames, Kenneth L. *Beyond Necessity. Art in the Folk Tradition.* Winterthur, Del.: Henry Francis du Pont Winterthur Museum, 1977.

Andrews, Ruth, ed. *How to Know American Folk Art. Eleven Experts Discuss Many Aspects of the Field.* New York: E. P. Dutton, 1977.

Barba, Preston A. *Pennsylvania German Tombstones. A Study in Folk Art.* Pennsylvania German Folklore Society, Vol. 18. Allentown: Pennsylvania German Folklore Society, 1954.

Benes, Peter. *The Masks of Orthodoxy. Folk Gravestone Carving in Plymouth County, Massachusetts, 1689-1805.* Amherst: University of Massachusetts Press, 1977.

Bishop, Robert. *American Folk Sculpture.* New York: E. P. Dutton, 1974.

Black, Mary, and Jean Lipman. *American Folk Painting.* New York: Clarkson N. Potter, Inc., 1966.

Brewington, M. V. *Shipcarvers of North America.* Barre, Vt.: Barre Publishing Co., 1962.

Campbell, William P. *101 American Primitive Water Colors and Pastels from the Collection of Edgar William and Bernice Chrysler Garbisch.* Washington: National Gallery of Art, 1966.

Christensen, Edwin O. *Early American Wood Carving.* New York: World Publishing Company, 1952.

Forbes, Harriette M. *Gravestones of Early New England and the Men Who Made Them, 1653-1800.* Boston: Riverside Press, 1927.

Fried, Frederick. *Artists in Wood. American Carvers of Cigar-Store Indians, Show Figures, and Circus Wagons.* New York: Clarkson N. Potter, Inc., 1970.

———. *A Pictorial History of the Carousel.* New York: Bonanza Books, 1964.

Fuller, Edmund L. *Visions in Stone. The Sculpture of William Edmondson.* Pittsburgh: University of Pittsburgh Press, 1973.

Gordon, John. *Masterpieces of American Folk Art.* Lincroft, N.J.: Monmouth Museum, 1975.

Hemphill, Herbert W., Jr., ed. *Folk Sculpture USA.* New York: Brooklyn Museum, 1976.

Hemphill, Herbert W., Jr., and Julia Weissman. *Twentieth-Century American Folk Art and Artists.* New York: E. P. Dutton, 1974.

Henry Walton. 19th Century American Artist. Ithaca: Ithaca Museum of Art, 1968.

Holdridge, Barbara C. and Lawrence B. *Ammi Phillips: Portrait Painter 1788-1865.* New York: Clarkson N. Potter, Inc., 1969.

Jones, Agnes Halsey. *Rediscovered Painters of Upstate New York, 1700-1875.* Utica: Munson-Williams-Proctor Institute, 1958.

Jones, Louis C. and Agnes Halsey. *New-Found Folk Art of the Young Republic.* Cooperstown: New York State Historical Association, 1960.

Lesy, Michael. *Wisconsin Death Trip.* New York: Pantheon Books, 1973.

Little, Nina Fletcher. *The Abby Aldrich Rockefeller Folk Art Collection. A Descriptive Catalog.* Boston: Little, Brown and Company, 1957.

———. *Land and Seascape as Observed by the Folk Artist. An Exhibition of the Collection of Bertram K. and Nina Fletcher Little.* Williamsburg: Abby Aldrich Rockefeller Folk Art Collection, 1969.

Lipman, Jean. *American Folk Art in Wood, Metal and Stone.* New York: Pantheon, 1948.

———. *Rediscovery: Jurgen Frederick Huge.* New York: Archives of American Art, 1973.

———. *Rufus Porter, Yankee Pioneer.* New York: Clarkson N. Potter, Inc., 1968.

Lipman, Jean and Alice Winchester. *The Flowering of American Folk Art 1776-1876.* New York: Viking Press, 1974.

Ludwig, Allan I. *Graven Images. New England Stonecarving and Its Symbols, 1650-1815.* Middletown: Wesleyan University Press, 1966.

Muller, Nancy C. *Paintings and Drawings at the Shelburne Museum.* Shelburne: Shelburne Museum, 1976.

Schorsch, Anita. *The Morning Stars Sang: The Bible in Popular and Folk Art.* New York: Universe Books, 1978.

Shelley, Donald A. *The Fraktur-Writings or Illuminated Manuscripts of the Pennsylvania Germans.* Pennsylvania German Folklore Society, Vol. 33. Allentown: Pennsylvania German Folklore Society, 1961.

Stackpole, Edouard A. *Figureheads & Ship Carvings at Mystic Seaport.* Mystic: Marine Historical Association, Inc., 1964.

Tashjian, Dickran and Ann. *Memorials for Children of Change. The Art of Early New England Stonecarving.* Middletown: Wesleyan University Press, 1974.

Tillou, Peter H. *Nineteenth-Century Folk Painting: Our Spirited National Heritage. Works of Art from the Collection of Mr. and Mrs. Peter H. Tillou.* Storrs: The William Benton Museum of Art, 1973.

Tomlinson, Juliette, and Kate Steinway. *The Paintings and the Journal of Joseph Whiting Stock.* Middletown: Wesleyan University Press, 1976.

Welsh, Peter C. *American Folk Art. The Art and Spirit of a People from the Eleanor and Mabel Van Alstyne Collection.* Washington: Smithsonian Institution, 1965.

Woodward, Richard B. *American Folk Painting. Selections from the Collection of Mr. and Mrs. William E. Wiltshire III.* Richmond: Virginia Museum, 1977.

Index